HENRY MOORE
REMEMBERED

Henry Moore
PHOTO: John Hedgecoe

HENRY MOORE
Remembered

The Collection

at the Art Gallery of Ontario

in Toronto

Alan G. Wilkinson

Art Gallery of Ontario
Musée des beaux-arts de l'Ontario

Key Porter Books

Canadian Cataloguing in Publication Data

Art Gallery of Ontario.
 Henry Moore remembered

Published on the occasion of an exhibition held at
the Art Gallery of Ontario, Sept. 16, 1987–Feb. 7,
1988.
A revision of: The Moore collection in the Art
Gallery of Ontario.
Co-published by the Art Gallery of Ontario.
Bibliography: p.
ISBN 1-55013-040-4 (bound)
 1-55013-062-5 (pbk.)

1. Moore, Henry, 1898-1986 – Exhibitions. 2. Art
Gallery of Ontario – Exhibitions. I. Wilkinson,
Alan G. II. Moore, Henry, 1898–1986. III. Title.
IV. Title: The Moore collection in the Art Gallery
of Ontario.

NB497.M6A4 1987 730'.92'4 C87-094670-6

Key Porter Books Limited
70 The Esplanade
Toronto, Ontario
M5E 1R2

Design: Dragon's Eye Press
Typesetting: Q Composition
Colour separations: Colour Technologies
Printing and Binding: D.W. Friesen & Sons Ltd.
Printed and Bound in Canada
87 88 89 90 91 6 5 4 3 2 1

The Art Gallery of Ontario gratefully
acknowledges the generous support of
CMQ Communications Inc. and the
Henry Moore Foundation.

The Art Gallery of Ontario is generously funded
by the Province of Ontario, Ministry of Citizenship
and Culture. Financial support for the Gallery's
operation is also received from the Municipality of
Metropolitan Toronto and the Government of
Canada through the Museums' Assistance
Programme of the National Museums of Canada,
and the Canada Council.

All colour photographs of individual sculptures,
except for no. 175, are by Larry Ostrom. All
other photographs, unless otherwise noted, are by
Art Gallery of Ontario photographic services.

In memory of

HENRY MOORE, OM, CH

July 30, 1898 — August 31, 1986

Henry Moore
Photo: Bo Boustedt

Contents

Yousuf Karsh, Canadian, b. 1908
Henry Moore
Silverprint, 99.1 × 73.8 cm
Gift of Yousuf Karsh, 1974

© Karsh, Ottawa

Sponsor's Foreword

HENRY MOORE's gift of sculpture, drawings, and prints to the Art Gallery of Ontario and the people of Canada is unprecedented. It is the most important and comprehensive public collection of his works in the world.

At CMQ Communications, we are proud of our long association with the Gallery. It has always been our desire to support unique and important publications and exhibitions, and we will continue to provide assistance to the arts. It is a particular honour to support this book and the exhibition, Henry Moore Remembered: The Collection at the Art Gallery of Ontario in Toronto, which opens on September 16, 1987. Now, one prestigious book documents Moore's close association with Toronto and illustrates all the sculptures and drawings and a selection of the prints in the collection of the Gallery.

As suppliers of processed electronic financial information, we realize that a community grows not only by commerce but also by the strength of its cultural institutions. We are, therefore, pleased to join the Art Gallery of Ontario in bringing this magnificent collection to you.

DAVID M. CAMPBELL
President, CMQ Communications Inc.

Arnold Newman, American, b. 1918
Henry Moore, Much Hadham 1966–72
Silverprint (collage), 40.8 × 49.4 cm
mount; 26 × 33.2 cm comp.
Purchase, 1978

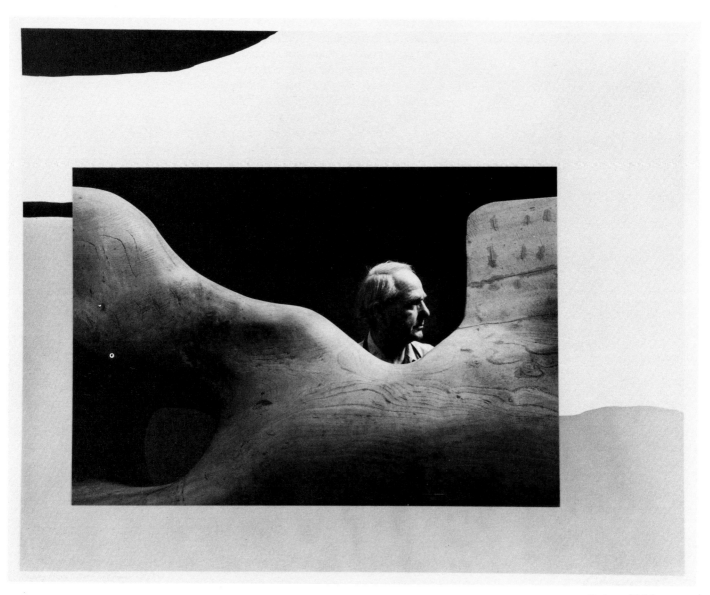

x

Director's Foreword

THIS BOOK has several purposes. It is a tribute to the pre-eminent sculptor of the twentieth century and, more specifically, an expression of gratitude by the Art Gallery of Ontario for a unique and, to date, unprecedented gift by an artist to a public, general art museum.

In 1979 the Gallery published *The Moore Collection in the Art Gallery of Ontario* written by Dr. Alan G. Wilkinson, who then held the title of Curator of the Henry Moore Sculpture Centre. This new publication, released on the date of the first anniversary of Mr. Moore's death, is written by the same author, now Curator of Modern Sculpture at the Art Gallery of Ontario, as a revision of the 1979 book. The first chapter of his text fully documents for the first time the answer, from the perspective of the AGO, to the often-asked question, "Why did Henry Moore choose Toronto?" The second chapter deals in general terms with Moore's ideas about his own work and the appreciation of three-dimensional form. This is followed by illustrations and notes on each of the 73 drawings and 131 sculptures in the permanent collection. The 21 prints illustrated here represent only a fraction of the 689 Moore graphics in the collection.

As Director, I hope that this publication may also stand as a celebration of an artist who was a unique human being. Many of us in the museum profession from all over the world were privileged to know him as a friend. Words could never adequately describe the human spirit that resided in that strong, stocky body. Even film fails to convey fully the warmth and openness of his personality. In the September 1, 1986, edition of the *New York Times*, art critic John Russell wrote this paragraph about Moore the man: "In all human exchanges, he came across as what he was — an archetypal plain dealer. As he felt, so he spoke. Prevarication was not his nature, and he treated everybody alike, whether they were prime ministers, heads of state or the unknown young students who knocked at his door and were rarely, if ever, sent away."

One of my most cherished memories of Henry Moore dates back to the opening of the Moore Centre at the Art Gallery of Ontario on October 26, 1974. Following the ceremonies, the artist was surrounded by eager autograph seekers. He asked me if he might have a chair and, comfortably seated, he talked to each and every person as he signed books, catalogues, posters, and scraps of paper for almost two hours. Although this had not been written into the original program, everyone agreed afterwards that it was the most important part of the event.

Another more personal memory, and one of a different order, involved one of my visits to his home in Perry Green. Mr. Moore loved to watch tennis on television, and by chance I arrived just as the finals at Wimbledon came on "the telly." I was invited to join the family around the TV set and assured that we could do "our business" later. So we all settled down *en famille*: Mrs. Moore, daughter Mary, his secretary, Mrs. Tinsley, Bill from Toronto, and the world-famous sculptor with his adored grandson, Gus, then eighteen months old, ensconced on his knee. Henry insisted that the sound on the set be turned down so that he could explain in detail to the youngster every nuance of the game. I shall never forget the rapturous attention of the child, the pleasure of the grandfather, and the bonding of all in the room on that blissful afternoon.

Many people deserve our thanks. First, in retrospect, the late Viljo Revell, architect of Toronto's new city hall, AGO board and committee members the late Sam Zacks and Ayala Zacks, Signy Eaton, Douglas Crashley, Edmund C. Bovey; John C. Parkin, the Gallery's architect for stages one and two; the late

John Robarts, former Premier of the Province of Ontario; and Philip G. Givens, Mayor of Toronto at the time when *The Archer* was acquired; all of these individuals played important roles in establishing the Moore Centre at the Art Gallery of Ontario. In connection with the continuing relationship with Mr. Moore and the consequent growth of the collection I wish to pay tribute to the major part played by the author of this book, Dr. Alan G. Wilkinson. Alan's close association with Mr. Moore as a result of his doctoral studies in England and his early association with the Centre as a staff member of the Art Gallery of Ontario account for the size and scope of the present collection.

We are very grateful to CMQ Communications Inc., and its President, Mr. David M. Campbell, for generously sponsoring the Art Gallery of Ontario's exhibition, Henry Moore Remembered, which opens on September 16, 1987 and the publication of this book. Our appreciation also goes to the Henry Moore Foundation for its support.

Finally, it is to the sculptor, Henry Moore, OM, CH, that we owe our deepest debt of gratitude for a life devoted to creativity of an unusually joyous and universally accessible kind, and for his great and uniquely generous gift of the fruits of this creativity to the people of Ontario.

WILLIAM J. WITHROW
Director

Acknowledgements

IN THE FIRST CHAPTER of this book, I have tried to make it clear that without the vision and perseverance of a number of dedicated individuals there would be no *Archer* in front of Toronto's new city hall and no Moore collection at the Art Gallery of Ontario. This book is in many ways a tribute to: the late Viljo Revell; the Hon. Philip G. Givens; the late Professor Eric Arthur; the late Hon. J. Keiller MacKay; Mr. and Mrs. Clair Stewart and family, and other private individuals whose financial generosity made the acquisition of *The Archer* possible; the late Roloff Beny; the late J. Allan Ross; William J. Withrow; the late Sam Zacks; Ayala Zacks; Mrs. John David Eaton; John C. Parkin; the late Hon. John Robarts; and Edmund C. Bovey. Their selfless efforts and commitment to Henry Moore and his work helped to bring about one of the most important turning points in the cultural life of the City of Toronto.

I am indebted to my colleagues at the Art Gallery of Ontario for their help: William J. Withrow, Director; Elizabeth Addison, Marketing Manager; Douglas Todgham, Head of Development; Maia-Mari Sutnik, Coordinator of Photographic Services; Faye Van Horne, Assistant, Photographic Services; Carlo Catenazzi, Head Photographer, Lawrence Pfaff, Deputy Librarian. I am most grateful to Maureen Dodge, Lisa Train, and my secretary, Teresa Baker-Roberts, for their help with the photographs and with typing the manuscript. I would also like to thank the staff of Key Porter Books, and in particular my editor, Margaret Woollard, for invaluable help and encouragement.

Much-appreciated advice and support have been provided by: Lucie Amyot, Mr. and Mrs. Clair Stewart, Mike and Sonja Stewart, Philip G. Givens, Lizanne Seabrook, Paddy Ann and Latham Burns, Kate and Fred Valentine, Prof. A.M. Beattie, Barbara and Murray Frum, Julia Brown, Robert O'Rorke, and Sir John and Lady Brown.

It is appropriate at this time to express my gratitude to members of the staff at Hoglands who over the years have taken a great interest in the formation of the Moore collection at the Art Gallery of Ontario. Under Moore's supervision, his assistants John Farnham, Michel Muller, and Malcolm Woodward painstakingly cleaned and restored the original plasters and spent several weeks in Toronto in October 1974 assembling works that had been cut into several sections during the casting process. At Hoglands, Frank Farnham supervised the crating of the original plasters and bronzes for shipment to Toronto. David Mitchinson, who has done a superb job of cataloguing Moore's graphic work, has given generously of his time in helping me put together for the Gallery an almost complete collection of Moore's lithographs and etchings. From 1974 onwards he ensured that Moore inscribed one of each of his prints, "For Toronto." David was also in Toronto for the opening and was most helpful with various aspects of the installations in the Moore Centre. I am grateful to Prof. Bernard Meadows, Acting Director of the Henry Moore Foundation, who in recent years has taken an active interest in the Moore Centre.

Mrs. Betty Tinsley, Henry Moore's secretary, began working at Hoglands in 1957. She is held in great affection by all who have known her over the years and by no one more than me. She has taken a special interest in the Moore Centre since the initial planning stages in the early 1970s. I cannot adequately thank her for all the advice and encouragement she has given me over the years. I shall always remember her warmth and hospitality and the many evenings I spent with her and her daughter, Joy, at "The Sheiling," their house a hundred yards or so from Hoglands. I often heard her say to "Mr. Moore" (and she was always "Mrs. Tinsley") when she knew a cast of a certain work was available: "Shall I reserve this one for Canada?" And Moore usually agreed. The Art Gallery of Ontario owes a great debt of gratitude to Mrs. Tinsley.

HENRY MOORE, O.M., C.H.
TELEPHONE: MUCH HADHAM 2566

HOGLANDS,
PERRY GREEN,
MUCH HADHAM,
HERTS.

December 8th/74

Dear Alan, What a very nice letter you have written to me. It is going to be a long time before all of us here at Hoglands forget the Toronto Experience.

We have, more or less, settled back to the old routine, but we go on talking about Toronto.

All of us here send our best wishes, + we look forward to seeing you, whenever it is, (the sooner the better) that you visit Hoglands

Yours ever
Henry. M

On my first visit to Hoglands in March 1969, Henry and Irina Moore made me feel welcome and at home in their cosy seventeenth-century farmhouse. Needless to say, this meant a great deal to a Canadian student living in England. Over the years Henry was unfailingly generous with his time amid a very hectic schedule and was always willing to sit down with me to discuss his drawings and sculpture when I knew perfectly well that what he really wanted was to go down to the privacy of his maquette studio and get on with his work. Working so closely with Henry Moore afforded me the unique privilege of a direct encounter with a great artist's knowledge of his own work and of the art of the past.

As I wrote in Chapter One of this book, Henry Moore's generosity to the Art Gallery of Ontario surpassed my wildest expectations. In early 1970 we had drawn up a list of 57 original plasters and bronzes that he intended to donate to the Gallery. None of us could have imagined that the collection would today number 893 drawings, sculptures and prints.

Moore wrote to me on December 8, 1974, six weeks after he, Irina, their daughter, Mary, and the assistants had returned to Hoglands after the opening of the Henry Moore Sculpture Centre. "It is going to be a long time before all of us here at Hoglands forget the Toronto Experience. We have, more or less, settled back to the old routine, but we go on talking about Toronto." To repay the compliment, those of us who knew and loved Henry Moore will never forget him. The "Moore Experience" at the Art Gallery of Ontario will continue to surprise, delight, and enrich the lives of visitors from Canada and abroad for generations to come. Henry Moore has altered our perception of ourselves and of our landscape. He has become part of our Canadian cultural heritage.

ALAN G. WILKINSON

Preface

MY 1979 PUBLICATION, *The Moore Collection in the Art Gallery of Ontario*, was a catalogue illustrating the collection's 73 drawings and 126 sculptures, as well as a selection of the graphic work. Of these works, Henry Moore had donated 101 sculptures, 57 drawings, and an almost complete set of his lithographs and etchings. This constituted, as it does today, by far the largest public collection of Moore's work in the world. Since 1979 the Art Gallery of Ontario has received four important bronzes: two from Mr. Walter Carsen, one from Mr. Allan Manford, and one from the late Mrs. Harry Davidson. In addition the Gallery purchased from Henry Moore in 1985 the bronze *Maquette for Three Way Piece No. 1* of 1964. In the present publication all 73 drawings and 131 sculptures in the Moore collection are illustrated, with notes on each work. The 21 prints illustrated in this book represent but a fraction of the 689 woodcuts, lithographs and etchings in the collection, dating from 1921 to 1984.

The numbers assigned to the drawings and sculptures in the 1979 publication have remained unchanged. The five additional bronzes have been integrated chronologically with the sculptures as they appeared in the 1979 catalogue.

In Chapter One of this book, the first detailed account is given of Moore's connection with Toronto, from the controversial purchase of *The Archer* in 1966 for Nathan Phillips Square to the opening of the Henry Moore Sculpture Centre in October 1974. The narrative highlights the ongoing special relationship between Henry Moore and the Art Gallery of Ontario that resulted in Moore's extraordinarily generous gift to the Gallery and that lasted until his death in August 1986. I have attempted to combine the chronology of events with my own personal reminiscences of Henry Moore, from our first meeting in March 1967 until the last time I saw him at Hoglands in early May 1986, three months before his death.

The second chapter of the text discusses Moore's childhood, his formative years, and his ideas about the art of sculpture. Moore's writings about his own work, about the sculpture of the past, and about the intrinsic interest of three-dimensional forms are the best vehicle I can imagine for converting the unconverted to an appreciation of sculpture and its relationship to the human body and the world of nature. It is my hope that Moore's insights and his extraordinary empathy with all sorts of shapes — his mother's back, a pear, an egg, a pebble, a mountain range — will open the eyes of the reader to the world of forms that nourished Moore's art and life for more than sixty-five years.

The notes that follow, on each of the drawings and sculptures in the collection, focus in greater detail on Moore's development and on many of the specific influences that shaped his art.

The abbreviations in the catalogue section refer to the following:

1 "LH": The five-volume catalogue *raisonné* of Moore's sculpture, published by Lund Humphries, London: *Henry Moore: Volume One, Sculpture and Drawings 1921–48*. Edited by David Sylvester; introduction by Herbert Read. Fourth edition (completely revised), 1957. *Henry Moore: Volume Two, Sculpture and Drawings 1949–54*. Introduction by Herbert Read. Second edition (revised), 1965. *Henry Moore: Volume Three, Com-*

plete Sculpture 1955–64. Edited by
Alan Bowness; introduction by Herbert Read. 1965.
Henry Moore: Volume Four, Complete Sculpture 1964–73. Edited by
Alan Bowness. 1977.
Henry Moore: Volume Five, Complete Sculpture 1974–80. Edited by
Alan Bowness. 1983.
The LH catalogue numbers, which
run consecutively through these five
volumes, are given beside the titles
of the sculptures in the present book.
A number of original plasters in the
collection that were never cast in
bronze, such as *Maquette for Head* of
1937 (no. 78), have not been catalogued in Lund Humphries. Such
works are identified as "not in LH."
Mention is made in the catalogue
notes of the original plasters that
were never cast in bronze.

2. "CGM": Gérald Cramer, Alistair
Grant, and David Mitchinson, *Henry
Moore Catalogue of Graphic Work*,
vol. 1 (1931–72), vol. 2 (1973–75),
Geneva: Gérald Cramer, 1973 and
1976; and Patrick Cramer, Alistair
Grant, and David Mitchinson, vol. 3
(1976–79), and vol. 4 (1980–84),
Geneva: Patrick Cramer, 1980 and
1986. The CGM numbers appear
beside titles of nos. 200–20.

3. References in the catalogue section to the 1977 Tate Gallery / Art
Gallery of Ontario exhibition catalogue, *The Drawings of Henry
Moore*, by Alan G. Wilkinson, appear
as "Wilkinson, 1977."

4. References in the catalogue section to David Mitchinson, *Henry
Moore Unpublished Drawings*, Turin:
Edizione d'Arte Fratelli Pozzo, 1971,
appear as "Mitchinson."

5. The initials "HMF" refer to the
Henry Moore Foundation at Much
Hadham.

Following the practice used in the
Lund Humphries catalogues, usually
only one dimension is given for each
sculpture — the length for a reclining figure, the height for a standing or
vertical figure. Occasionally, as for
example with the Time-Life Screen
maquettes and working model, both
height and width are given. In some
instances the dimensions of both figure and base are given.

HENRY MOORE
REMEMBERED

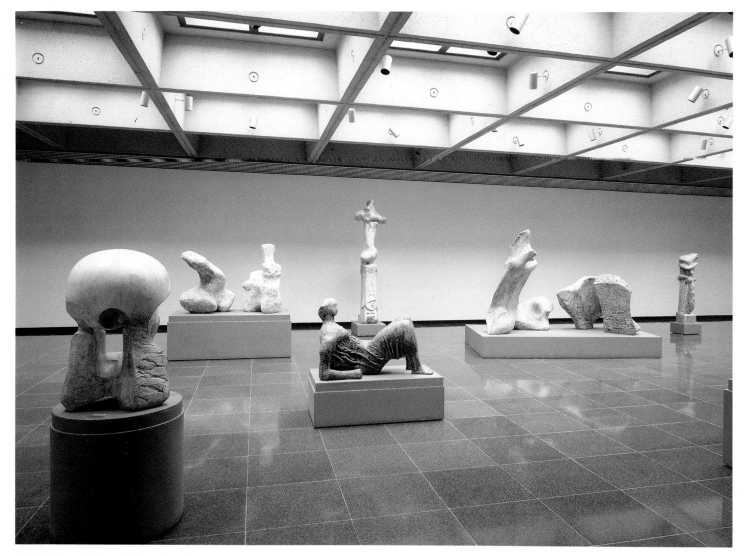

Original plasters in large Moore gallery, Art
Gallery of Ontario

1 "A stranger here": Moore in Toronto

"KENNETH CLARK once remarked to me that if the inhabitants of this planet found themselves having to send an ambassador representing the human race to the inhabitants of another planet, they could not choose better than to send Henry Moore."

With these words Sir Stephen Spender began his eloquent eulogy at the "Service of Thanksgiving for the Life and Work of Henry Moore OM, CH, 1898–1986," held at Westminster Abbey on Tuesday, November 18, 1986. Solemn only in its ritual, the service was held two and a half months after Moore was buried in the small Anglican churchyard at Perry Green in rural Hertfordshire, a few hundred yards from Hoglands, the home of the sculptor and his wife, Irina. It was a dignified yet joyous service, organized and executed with the ceremonial precision at which the English excel. At the Great West Door between 11:50 and 11:55 AM, the Dean and Chapter of Westminster received the Lord Mayor of Westminster; Lord Zuckerman, representing Her Majesty the Queen; and His Royal Highness the Duke of Gloucester. The service began at noon with "The Bidding," thanking God "for the gifts and talents he bestowed upon his servant Henry Moore"; selections from Mozart's *Requiem* followed, and the First Lesson was read by Dame Peggy Ashcroft: "Behold, the Lord knoweth all the works of men, their imaginations, their thoughts and their hearts ... " (2 Esdras 16:54–63). The great hymn "Immortal, invisible, God only wise" was sung by the congregation and the London Voices, accompanied by the Royal Philharmonic Orchestra conducted by Sir Georg Solti. The Second Lesson was read by His Royal Highness the Duke of Gloucester: "I saw a new heaven and a new earth ... " (Revelation 21:1–7).

It was obvious as we listened to Sir Stephen Spender's address that there was a startling contrast between the illustrious congregation and setting and the unpretentious simplicity of Moore's own life. "Henry," Sir Stephen said, "told me that in his whole life he never had any sense of anyone being socially superior or, for that matter, socially inferior to him. All people to him were equals, simply in being human." However, the seating plan in Westminster Abbey reflected the hierarchy of British society, with royalty, dukes, earls, members of the diplomatic corps, and prominent politicians, including Prime Minister Margaret Thatcher, seated in the raised choir. Some were there in an official capacity, but Henry's family and close friends attended in numbers, to show their love and respect. All here who had known Moore had their private memories and personal recollections. Both William Withrow and I, who were representing the Art Gallery of Ontario, were fortunate to have known Henry for almost twenty years. Nothing remarkable about this, one might say; Sir Stephen had known Moore for more than fifty years. And yet our relationship with the sculptor was unique. As the abbey bells rang out at the end of the beautiful and profoundly moving service, I was greeted by Dr. Elder, Moore's doctor before Elder's retirement some years ago. I hadn't seen him for ages. "Hello, Alan, how nice to see you," he said as we shook hands, and then, out of the blue: "What are all those Moore sculptures doing in Toronto when they should be at the Tate Gallery?" The question, "Why Toronto?", which I have been asked dozens of times, was one I didn't expect to hear on that day. I replied simply that we had seemed more determined and committed than the Tate to having a representative Moore collection at the Art Gallery of Ontario and to working closely with Henry on all aspects of the project. But Dr. Elder's question reminded me yet again that no one owed Moore a deeper debt of gratitude than the people of Canada.

Why Toronto? The question simply will not go away. The very reason for

asking it suggests that something extraordinary must have happened — and indeed it did. The reason why there is the Turner collection at the Tate Gallery or the Picasso Museum in Paris is self-evident. But a visitor to the Art Gallery of Ontario who comes unexpectedly upon the Henry Moore Sculpture Centre (which houses the world's largest public collection of Moore's work) may be pardoned for being baffled. Why did Moore donate 101 sculptures, 57 drawings, and an almost complete set of his graphic work to an art museum in a North American city that he had visited only three or four times? It is a remarkable and fascinating story.

In retrospect the events leading up to the opening of the Henry Moore Sculpture Centre in October, 1974 have an air of inevitability about them. And yet luck, chance, political controversy, and perseverance all played key roles in this extraordinary and unexpected collaboration between one of the greatest artists of our time and a public art museum.

The story of Moore's special relationship first with the City of Toronto and subsequently with the Art Gallery of Ontario has a logical structure, like a play with a beginning, a middle, and an end. It began in 1958 when the Finnish architect Viljo Revell (1910–64) won the international architectural competition for the design of a new city hall and civic square in downtown Toronto. Some 520 architects from around the world entered the competition, which was under the direction of Professor Eric Arthur, an eminent Toronto architect and formerly Professor at the University of Toronto's School of Architecture. It was an extraordinary achievement that Arthur was able to persuade the politicians of the day to hold an international competition. Revell envisaged a large public space, a forum, in the classical tradition of Greek and Roman architecture, a place where the public could meet. His lyrical design was a daring and inspired choice, the antithesis of the geometrical Bauhaus purity that was the trademark of Mies van der Rohe, who designed the Toronto-Dominion Centre. The new city hall was to become a world symbol of urban government and architectural excellence.

From the outset, according to John C. Parkin, the Finn's Canadian associate architect, Revell had envisaged a major sculpture for the civic square in front of the new city hall. "He made it very clear that if anything were to happen to him it would be his wish that we would carry on and commission Henry Moore." This was the first crucial step.

Revell, a great admirer of Moore's work for some time, had designed a small gallery for a private collector in Finland and persuaded him to acquire a Moore bronze. Like Moore, Revell believed very strongly that sculpture should not be merely a decorative appendage to a building. (In the 1920s Moore was very reluctant to accept architectural commissions because, as he wrote in *Henry Moore on Sculpture*, "relief sculpture symbolized for me the humiliating subservience of the sculptor to the architect, for in ninety-nine cases out of a hundred, the architect only thought of sculpture as a surface decoration, and ordered a relief as a matter of course.")

Revell, apparently acting on his own initiative, visited Moore at Much Hadham in about 1960 to discuss the possibility of acquiring or commissioning a large sculpture for the civic square. In recent discussions with Revell's daughter, Sonja Stewart, and her husband, Michael, I learned that the sculptor and the architect initially selected either *Two Piece Reclining Figure No. 2* of 1960 (no. 146) or a work very similar to it. As things turned out, the necessary funds were not available, and the project was shelved ... but not forgotten. On November 23, 1964, after a three-week visit to Toronto, Revell and his

Architect Viljo Revell views Toronto's new City
Hall under construction, October 1964
PHOTO: *The Globe and Mail*, Toronto

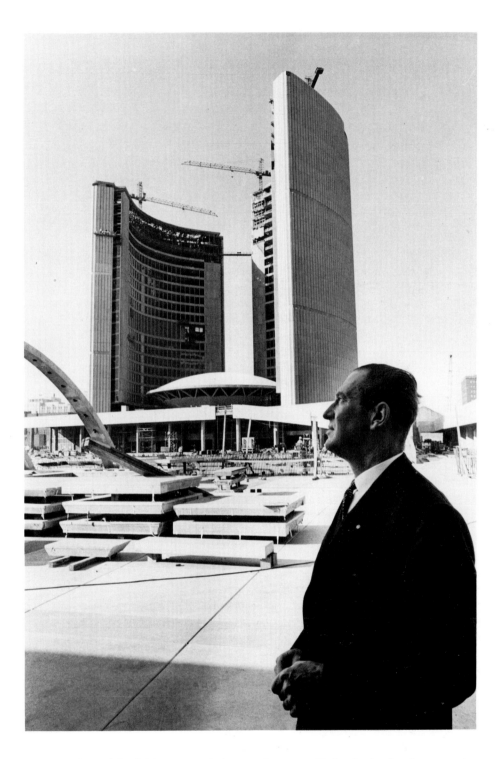

wife, Maire, visited Moore on their way home to Finland. Again they must
have looked at photographs of the model of the new city hall. Instead of
accepting a commission in which, as Moore told me, "a subject is imposed on
me," he preferred to select, in collaboration with the architect, a recent or
earlier sculpture that would suit the location and complement the rhythms of
the building. "We agreed that the sculpture I was doing at the time [*Working*

Model for Three Way Piece No. 2: Archer (no. 170a)], if enlarged, would be
suitable. As soon as Revell saw it he said it was right."

(That day, Revell also saw the original plaster of *Moon Head* [no. 166].
The smaller version of this work, Moore wrote in 1968 [in *Henry Moore*,
coauthored with photographer John Hedgecoe], "was originally called *Head in
Hand.* The hand being the piece at the back." When he enlarged the work,
he "gave it a pale golden patina, so that each piece reflected a strange, almost
ghostly light at the other.... It was because the whole effect reminded me so
strongly of the light and shape of the full moon that I have since called it *Moon
Head.*" As Sonja Stewart recalled recently. "Never had a work of art meant
so much to my father as did *Moon Head.* On the flight home to Finland that
evening that piece changed something within him. He had never wanted to
own a work of art, but he desperately wanted to acquire this sculpture. My
father died the following day." According to Sonja, when Mrs. Revell saw her
husband a few moments after his death, she said that "his head and hand
lay against the pillow, just like the sculpture." I cannot think of a more deeply
moving example of life imitating art. Mrs. Revell immediately sent a cable to
Moore asking him to reserve for her one of the casts of *Moon Head,* and Henry
agreed.)

Revell's premature death a year before the city hall was completed was a
great loss to contemporary architecture. One can only hope that, during the
few hours he had to live after visiting Moore, Revell believed that *The Archer*
would somehow find its way to Nathan Phillips Square. What Revell could
never have imagined was the heated controversy that would follow; nor, more
importantly, that his initiative in selecting *The Archer* was the catalyst that
ultimately led to the establishment of the Henry Moore Sculpture Centre. The
Moore collection is in many ways a memorial to Viljo Revell.

Earlier that year, in June 1964, a committee had been formed under the
chairmanship of Professor Eric Arthur to advise in regard to the embellishment
of the new city hall by works of art. Members included Jean Sutherland Boggs,
Mrs. Harry Davidson, Douglas Duncan, Mrs. T.P. Lownsbrough, the Hon.
Roland Michener, William Withrow, and sculptor Frances Loring. John C. Par-
kin represented Revell, who was ill at the time. From the July 1965 minutes
of the Board of Control it appears that the budget was set at $125,000. Items
such as regimental crests and medals were discussed as well as a memorial
to Revell. On Friday, October 29, 1965, the Art Advisory Committee – New
City Hall met at the York Club. Among those present were Professor Arthur,
William Kilbourn, Controller William Dennison, William Withrow, and
Frances Loring. This would appear to be the first meeting at which the possi-
bility of purchasing *The Archer* was discussed. Professor Arthur advised the
committee that after Revell's death Moore had gone ahead and enlarged the
sculpture, even though he had heard nothing from the City of Toronto. The
committee asked Professor Arthur to write to Moore, indicating their interest
and excitement about the sculpture and asking for more time to approach City
Council for funds or to explore other means of raising the money. On March
7, 1966, the Art Advisory Committee advised City Council "that it has received
an offer of an original sculpture from one of the world's greatest sculptors,
Henry Moore, which was created by him for the Civic Square, after conversa-
tions with his friend, the late Viljo Revell, designer of the City Hall; that the
sculpture can be obtained for the sum of approximately $123,410 (£41,000) laid
down in Toronto; and that the Committee favours the purchase of this sculp-
ture and so recommends to City Council." On March 16, 1966, Mayor Philip
Givens put forward a motion to purchase *The Archer* for £40,000.

There were, unfortunately, only ten votes in favour, with the mayor and Controller Archer among them, as compared to thirteen against, with Controller Dennison in the latter group. Revell's dream appeared to have died.

The following morning, however, the process of revival began. Mr. and Mrs. Clair Stewart (of Toronto) and their sons, Tim and Mike, sat at breakfast reflecting on the sad state of affairs. The Stewarts' son Mike was engaged to Revell's daughter Sonja. Like Revell, the Stewarts greatly admired Moore's work and over the years had collected several sculptures and drawings. Stewart telephoned Eric Arthur (who was likewise very depressed about the outcome of the vote) to pledge $10,000 towards a fund to purchase *The Archer*. His sons, Tim and Mike, would each contribute $5,000, and an additional $25,000 would be forthcoming from the McLean Foundation (a foundation connected to Mrs. Stewart's family). Needless to say, Professor Arthur was thrilled. Clair Stewart vividly remembers Arthur's reaction: "Well, that's it. We've got it." On that morning one Toronto family and its charitable foundation had generously pledged $45,000. A committee was formed, headed by the Hon. J. Keiller MacKay, a former Lieutenant-Governor of Ontario, to raise the balance ($75,000) needed to acquire *The Archer* by private subscription.

It may not seem particularly surprising that the proposal to buy *The Archer* using public funds caused impassioned debates in City Council. But why the debate hotted up and remained in the political arena when Mayor Givens subsequently attempted to raise funds from private sources is unclear and seems, in retrospect, somewhat ludicrous. Givens, who had strongly supported the acquisition of *The Archer* during the debates in City Council, now continued his crusade with a passion and a commitment to a work of art seldom found in the realm of politics. In early May, Givens announced that he had raised all but $48,000 of the $120,000 needed. On May 7, 1966, the chief protagonists — Givens and his future opponent, Controller William Dennison — expressed their views in the *Toronto Daily Star*. Dennison argued against allowing "the establishment" (that is, artists, architects, collectors, and museum directors) to impose its taste on the general public. "The standard of what constitutes art should be guided basically by what most people enjoy and take pleasure in.... When I see a Tom Thomson I can appreciate the love and depth of feeling that inspired his masterpieces." What Dennison failed to recognize was that at first both Thomson's work and that of the Group of Seven had been ridiculed by public and press alike. Had museums been guided by "what most people enjoy and take pleasure in," rather than by the knowledge and foresight of discriminating collectors and museum directors, none of the work of these artists would have been acquired at an early stage by our public institutions. Dennison went so far as to state: "no form of decoration should be allowed to hide or detract from the building"; and yet the architect himself had seen the building and the sculpture as complementing each other. For Givens, *The Archer*, like the new city hall, was a symbol of excellence. "Toronto," he recently told Roger Berthoud (Moore's biographer), "was a hick town, and I was interested in seeing that it turned the corner of becoming a great metropolis. Having a Henry Moore work was to be the dawn of a new era." Givens, as he wrote in the *Toronto Daily Star* on May 7, wanted to make "a palpable contribution to our culture that will speak for generations to come. If I'm not allowed to contribute something in this way, I don't want to be Toronto's mayor." Givens's persistence did eventually make an enormous contribution (more than he could imagine at the time) to the cultural life of Toronto, but not without unfortunate consequences for his own political career.

Two weeks later, on May 19, 1966, the scene shifted to London, England, where Canadian photographer Roloff Beny, acting as Givens's emissary, met Moore for a drink at the Athenaeum Club, to discuss *The Archer*. Beny told Moore about the political controversy of the past few months and about the efforts that were being made to raise the funds privately. By then approximately $100,000 had been pledged, $20,000 short of the asking price. In the first of countless acts of generosity to the City of Toronto and the Province of Ontario, Moore offered to reduce his price to $100,000, a donation in memory of his friend Viljo Revell. Givens credited Beny with "clinching the deal." That day Moore inscribed a book on his work as follows: "For Roloff, with admiration and thanks for today's discussion and decision about 'The Archer' for Toronto." "For Toronto" — these two words would subsequently appear on hundreds of lithographs and etchings that Moore donated to the Art Gallery of Ontario.

On September 14, 1966, it was reported by the Board of Control that the Hon. J. Keiller MacKay, acting as trustee for the fund for the purchase and placing of Henry Moore's sculpture *The Archer*, had asked that the city accept the sculpture on behalf of the citizens of Toronto. Mayor Givens asked the members of City Council to consider the recommendation of the Board of Control to vote on the following:

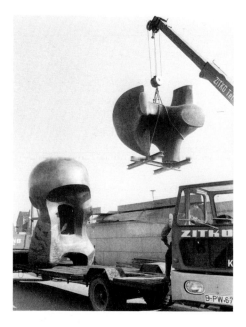

The Archer, en route to Toronto, from the H. Noack Foundry, West Berlin, 1966
PHOTO: dpa-Bild, Deutsche Presse-Agentur

1) that the City accept and acknowledge with sincere thanks the gift of the contributors;
2) that the sculpture of Henry Moore entitled The Archer be placed on a plinth on Nathan Phillips Square.

The yeas — nineteen, including Controller Dennison. The nays — one, Alderman Beavis.

On the evening of October 27, 1966, some ten thousand people turned out to watch the ceremonial unveiling of *The Archer* at Nathan Phillips Square in front of the new city hall. At 8:30 PM, to the sound of a trumpet fanfare and a gunfire salute by the Royal Regiment of Canada, the Hon. J. Keiller MacKay pulled the rope and released the blue canvas, exposing the gleaming bronze sculpture to public view for the first time. *The Archer* was then officially presented to Mayor Givens and the people of Toronto on behalf of the anonymous donors. Eric Arthur, who had fought for the Moore sculpture as he had fought for the international competition for the new city hall, said in his speech: "The philistines have retired in disorder." Mayor Givens proclaimed: "What has been brought here is a work of public art that Toronto people will learn to cherish." (After the dignified official ceremony, and in contrast to it, there was the inevitable demonstration. A group of architecture students from the University of Toronto produced their own masterpiece, a junk sculpture entitled *The Archer Tester*, made of a bicycle wheel, old shoes, a bedpost, et cetera. The accompanying banner, the most current opinion poll of the day, read: "9 OUT OF 10 PIGEONS PREFER ARCHER TESTER."

On the whole, however, enthusiasm outweighed mockery. As Robert Fulford wrote the next day in his column in the *Toronto Daily Star*: "It was impossible to resist the notion that last night was some kind of turning point in the history of the City of Toronto." For Mayor Givens, Professor Eric Arthur, Roloff Beny, and those individuals who in a very quiet Canadian way had donated the necessary funds to acquire *The Archer*, the evening was a triumph of faith,

Unveiling ceremony for *The Archer*, Nathan Phillips Square, Toronto, October 27, 1966 (left to right: Mayor Philip G. Givens, Hon. J. Keiller MacKay, Professor Eric Arthur)

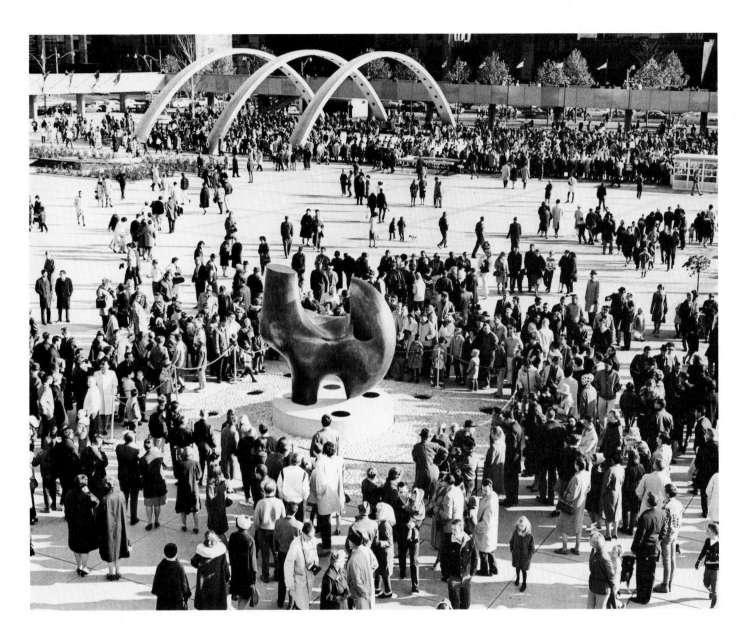

Torontonians inspecting *The Archer*,
Nathan Phillips Square, late October 1966
PHOTO: Toronto Fire Department

determination, and the pursuit of excellence. Later events were to vindicate them still further. As we shall see, the acquisition of a single work of art has rarely had such a profound effect on the cultural life of a city.

In a telephone interview on October 27, Moore said he was sorry that he could not be present at the ceremony, but that he was happy the affair had been such a great success. He praised Mayor Givens for working so hard to acquire *The Archer*. And he added: "I expect to be in Canada in the spring. I definitely want to see the work in its new setting." Act One of what could have been a calamity of errors and lost opportunities had ended happily. Five months later, Act Two was to begin, tentatively at first, violating the classical unity of time, but not of place and action.

On March 14, 1967, Moore visited Toronto for the first time to see *The Archer in situ*. He was met at the airport by Philip Givens, whose recent defeat as

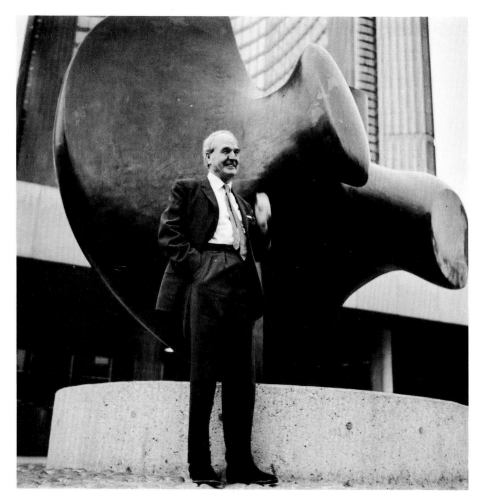

mayor was, ironically, partly the result of his efforts to acquire the sculpture. In the photograph of the two men in the *Toronto Daily Star* (March 14), they look like old friends happily reunited after a long absence, although in fact they had never met before. Moore was obviously delighted finally to meet the man who had fought so hard to acquire *The Archer*. Givens told Moore: "It was worth the battle." There were moments, Moore said in his reply, "when no one believed *The Archer* would come here. You and I were the only ones.... It's heartening to meet a man who would jeopardize his political position for a work of art." Moore was pleased with the relationship of the sculpture to the building, which he greatly admired. (However, he did tell me some years later that, had he realized how tall and overwhelming the city hall actually was, he would have made *The Archer* considerably larger.)

After he had inspected *The Archer*, Moore attended a reception in his honour at the new city hall. It was then, Givens has reported, that J. Allan Ross, former President of P.K. Wrigley Co., Ltd., approached Givens with a proposal that must have seemed outrageous at the time. He suggested that the former mayor approach Moore about the possibility of acquiring some additional works for Toronto.

"Look, Allan, you go over and ask him," Givens replied. To his amazement, Ross did just that. As Givens recalled:

I thought Moore would flip, but he took it in his stride, and said: "Well, you know, I'm British" — which was the understatement of the day — "and I feel I owe a debt to the country I come from ... however, I don't think the Tate is going to be big enough to handle all my work. There may be something remaining, and with regard to that, perhaps something might be possible."

Two key figures at the reception who overheard the discussion were AGO President Samuel J. Zacks and Director William J. Withrow. A modest expansion of the AGO was planned, and both Zacks and Withrow knew that, if the Gallery could obtain a significant collection of Moore's work, this would be not only a great attraction in itself but also a vital bargaining tool in raising funds from the Ontario government. The following day Moore met with Withrow and Zacks to discuss in very general terms the possibility that the City of Toronto might acquire additional works. Ross had offered a substantial sum of money to build a Moore gallery. On March 16, Moore was quoted in the *Toronto Daily Star* as saying: "I'd like the sculpture to go to London for sentimental reasons, but offers from somewhere else might help the Tate Gallery to make up its mind." Moore's openness and generosity meant that he was often receptive to new projects — another book or exhibition — and would agree at least in principle to new ventures. He no doubt felt when he flew back to London that Ross's proposal was a pipe-dream that would soon be forgotten. But one thing was certain. A special relationship between Moore and Toronto had been established. He had been received with warmth and affection. The English flavour of the city made him feel at home. And, most important of all, Moore was aware of how much Toronto cared about him and his work.

Events in England prior to and soon after Moore's visit to see *The Archer* in mid-March 1967 were, in the fullness of time, to work in favour of Toronto. On February 26, 1967, London's *Sunday Telegraph* announced that the sculptor had offered between twenty and thirty works to the nation. They would no doubt be housed in the Tate Gallery, which would probably have to build a special gallery as part of the planned expansion. Reactions were mixed. On the one hand Moore was praised for his generosity; on the other he was accused of trying to pre-empt the verdict of time on the historical value of his work. Some writers suggested that London's parks or the Salisbury Plain would be more suitable settings for his work. But these suggestions, if they made Moore feel somewhat uneasy, were relatively tame and inoffensive by comparison with an event that occurred several weeks after he returned to England from Canada. At the Royal Academy's annual dinner, Prime Minister Harold Wilson announced that his government was prepared to provide £200,000 towards the cost of housing Moore's proposed gift, provided the trustees of the Tate Gallery were able to raise a similar amount for the new extension. "But," as Roger Berthoud has pointed out, "the way he had blurred together the display of the Moores and the funding of the Tate extension was to prove very troublesome."

The message, as perceived by the younger generation of British painters and sculptors, was clear: a great deal of exhibition space at the Tate Gallery would be devoted to the work of one artist — Henry Moore. Forty-one artists, including Anthony Caro and Phillip King — two of Moore's former assistants, both of whom he liked and admired — wrote a collective letter to *The Times* protesting the allocation of funds. The Tate, with its limited space, could not

fulfil its role as London's only permanent gallery of contemporary painting and sculpture "by devoting itself so massively to the work of a single artist." What Harold Wilson had failed to make clear was that the £200,000 promised to house the Moore gift was in addition to the funds earmarked for the Tate extension. Despite the misunderstanding, the damage had been done. Moore was hurt and angry. "Had he not," Berthoud commented, "almost single-handed made British sculpture a credible force across the world? Had he not taught for 20 years and served on committees in the name of the art they all believed in? Was this to be his thanks for his act of generosity?" As things have turned out, the Tate has not been swamped by Moore's work, nor has a special Moore gallery been built. In 1978, on the occasion of his eightieth birthday, Moore donated thirty-six bronzes and original plasters to the Tate, and these have been integrated with the modern sculpture collection.

To return to Toronto — the excitement generated by Moore's visit in mid-March of 1967, and by the possibility of a gift from the sculptor, gathered momentum. In the last week of March, Withrow met with Ross to discuss the logistics of building a Moore gallery. In a letter to Ross dated March 30, Withrow suggested that, "in view of the problems of security and maintenance, not to speak of responsible display and promotion by trained museum curators, ... the gallery is the logical organization and location for this possible bequest." In contrast to the lack of commitment by the Tate Gallery, Sam Zacks, President of the AGO, wrote to Moore stating that a new expansion was planned and that he hoped it would include a separate Moore gallery:

I would like to point out that a handsome Moore Gallery and sculpture court on the site of our own gallery would be most meaningful, not only to Toronto, but to this whole continent, which holds your work in the highest esteem. In the city there are close to one hundred pieces of your work, and many would be donated to the gallery and added to the ones you might donate, so we could assemble a very imposing group of your creations.

In early December 1967, Moore visited Toronto for the second time to discuss in more detail the possibility of a special gallery to house his work. Again, he appreciated the friendliness and hospitality afforded him. After his return to Hoglands, Moore wrote to Withrow on December 12 about the importance of his visit, even though, as yet, there was no formal commitment on either side: "I am sure it was necessary for me to come and meet you all, and I hope, and I am sure, there will be fruitful consequences." Though hardly a firm commitment, this letter must have given Withrow and the trustees much more than a faint glimmer of hope.

A year later Moore's letter of December 9, 1968, to Edmund Bovey was the most concrete indication to date of Henry's commitment. The AGO needed something in writing in order to proceed with a fund-raising effort directed at both the provincial government and the private sector. Moore wrote:

... this letter is to say that it is my firm intention to donate to the Art Gallery of Ontario a sufficiently large and representative body of my work to make it worthwhile building a special pavilion or gallery for its permanent display.

The Gallery now had a firm commitment and could proceed in good faith with the building program.

During these years of delicate negotiations with Moore, the Art Gallery of Ontario was fortunate to have as its presidents first Samuel Zacks and then (in January 1969) Edmund C. Bovey. In mid-January of 1969, Ed Bovey, Premier John Robarts, William Withrow, Sam Zacks, and John C. Parkin (architect for stage one of the expansion) happened to be in London together. Bovey, as perceptive as he is optimistic, thought this might be a perfect opportunity for Moore and Robarts to meet. He telephoned them both and, miraculously, they were free for dinner the following evening. Robarts insisted that there was to be no talk of money in front of Moore. They met at London's famous White Tower restaurant, where they were joined by Norah Robarts, Ed and Peg Bovey, Bill and June Withrow, Sam and Ayala Zacks, and John Parkin. As Bovey told Roger Berthoud:

We had Henry and Robarts sitting together in the middle of a big oblong table in a private room, and they got on famously, telling each other jokes and really having a lot of fun. At the end we were singing Yorkshire songs. It was a really useful thing, and they both told me independently afterwards how well they thought of each other.

(Social gatherings played a key role in the Moore story. The Moore-Beny meeting at the Athenaeum Club, when Moore reduced the price of *The Archer* by $20,000; the reception for Moore at the new city hall on March 14, 1967, when Allan Ross first approached the sculptor about acquiring additional works for Toronto; and the impromptu dinner party at the White Tower restaurant that helped pave the way for the Ontario government's $12.5 million expansion grant for the AGO — these all helped establish and maintain the links of friendship and goodwill that were so crucial in the negotiations at every stage.)

From the outset, it had been understood that Moore would become involved in the design of the main gallery in which his large original plasters would be exhibited. During that productive week in mid-January 1969, Parkin, Withrow, and Sam and Ayala Zacks spent a day in London with Moore visiting various museums to study the lighting systems. Henry liked the top lighting at the Whitechapel Gallery in the east end of London. The recently completed Hayward Gallery, on the other hand, with its low ceilings, highly textured background, and lack of natural light, was the antithesis of what Moore had in mind. It was, as John Parkin has remarked, "a terribly important day," when Henry was able to point out what he approved of and what he wanted to avoid. The result of this close collaboration — the large Moore gallery — is in my opinion one of the most beautiful spaces anywhere for exhibiting sculpture. During this brief visit to London, Withrow and Zacks also visited Sir Anthony Blunt, Director of the Courtauld Institute of Art and the AGO's advisor on acquisitions of European art. They said that they were looking for a future curator for the Moore Centre. Sir Anthony remembered that there was a young Canadian student at the Courtauld working on an MA thesis on Moore's drawings and telephoned my supervisor, Alan Bowness. It was then that Withrow and Zacks were given my name, though I was not hired until November 1969 to be, in Withrow's words, "our man in Much Hadham."

I had first met Henry Moore in Ottawa in mid-March of 1967 just before or just after he had visited Toronto to see *The Archer*. My cousin John Matthews was working as one of Moore's assistants at Much Hadham and had arranged for his sister, Jennifer, to have a small dinner party for Moore in Ottawa. At the time I was working as a curatorial attaché for Dr. Robert H. Hubbard, Chief Curator at the National Gallery of Canada. Bob and I picked up "Mr. Moore"

at Earnscliffe, the residence of the British High Commissioner. I was somewhat nervous. Quite simply, there was no living artist whom I wanted to meet more than Henry Moore. I first glimpsed Moore as he walked down the stairs at Earnscliffe. His warmth and friendly, unassuming manner quickly dispelled my nervousness. As a conversation piece, I had brought along one of his small bronze maquettes, *Seated Figure: Cross Hatch*, which I had recently acquired. I asked him about the work and, in particular, the reason for the cross-hatching. Moore explained that he had intended to make the sculpture a little larger, and to do this he had cut into the dry plaster maquette in order to create a rough surface texture to which wet plaster could easily adhere. This was the first of many occasions when the sculptor's observations cast helpful light on his work.

During that first meeting, I mentioned that I was going to London in September to study art history at the Courtauld Institute. "Do come and visit me," Moore said, "and I'll show you around the studios and grounds." I saw him briefly that autumn when I visited my cousin John at his little thatched cottage across the village green from Hoglands, Moore's seventeenth-century farmhouse. On that visit I also met Henry Moore's secretary, Mrs. Betty Tinsley, and her daughter, Joy, and another link was established in the expanding network of personal relationships that was ultimately so important in bringing the Moore gift to Toronto. Over the years, Mrs. Tinsley was to become my greatest ally in the delicate negotiations with Henry Moore.

By Christmas 1968 I had to submit my thesis topic to the Courtauld Institute for approval. When I suggested to my supervisor, Alan Bowness, that I would like to work on Moore's drawings, he was enthusiastic, although at that time I don't believe any Courtauld student had applied to do research on a living artist. Alan, who knew Henry Moore well, made arrangements through Mrs. Tinsley for me to visit the sculptor on March 5, 1969. I prepared a list of twenty questions, arranging them in order of importance, as I knew there probably would not be time to deal with all of them. After about an hour and a half it was tea time and the end of our session, but ten questions remained unanswered. I knew how incredibly busy Moore's schedule was and thought that would be the end of it. But Henry must have sensed my disappointment, for to my delight he said, "Come back next week and we can carry on where we left off."

And carry on we did. Before submitting my thesis in mid-May, I had seven more sessions with Moore, whom I should have credited as the co-author of my thesis. Alan Bowness was working on an ongoing catalogue *raisonné* of Moore's sculpture, but little attention had been paid to the drawings. The six surviving sketchbooks of the 1920s were virtually unknown and unpublished. In addition, there were hundreds of unpublished drawings in drawers and cupboards. I realized that in my MA thesis I had barely scratched the surface and received approval to continue research for an M Phil and, subsequently, a PhD. Moore was extraordinarily generous with his time and would often say, "Now, my boy, is there anything we need to discuss before I go down to the studio?" We went through his early sketchbooks page by page.

It is impossible to overestimate the art-historical value of working directly with a living artist. No amount of research or speculation can unearth the kind of invaluable factual information and insights that Moore provided. He would point to a small sketch and say, "This is a study for a sculpture which I did but which got lost or destroyed." Or he would say, "This figure shows some influence of Negro art," or, "This sketch may be a copy after Rubens."

He also discussed in more general terms the various categories of his drawings: life drawings, drawings for sculpture, pictorial drawings, and his famous shelter drawings. For example, his early studies of the female nude were exercises in what he called "the science of drawing" that also developed his understanding of the human figure on which almost all his sculpture was based. He had a marked preference for full, Rubenesque figure types. In the life classes, if a particular model was rather thin, he said, "I would fatten her up in my drawings." One of our most remarkable conversations was about the beautiful series of nude studies of his wife, Irina, dating from 1929 to 1935. Most show her seated on an armchair or sofa. The legs are heavily shaded compared with the rest of the figure. Although Moore set the pose and chose the low viewpoint, the sense of immediacy and closeness to the model has a simple explanation. In their small sitting-room in which his wife posed, Moore said, he was unable to draw anything from any great distance, and his model seemed to loom up in front of him as he worked. He described one of these drawings in terms of a landscape painting: the legs may be read as foreground, the head and torso as the middle distance, and the back of the chair and the faintly indicated wall as background.

Moore often read through and corrected my completed chapters. Of the pre-Columbian *Chac Mool* reclining figure, the most important formative influence on his work, I had written that Moore admired above all the pose of the figure. "Oh, really?" he said, and proceeded to do a little pencil sketch, from memory, in which the pose of the *Chac Mool* was indicated by thin, linear lines. Yes, it was the pose, but equally important, he said, was the massiveness of the figure, "its stillness and alertness, a sense of readiness, and the whole presence of it, and the legs coming down like columns" (see fig. 17).

The nerve centre at Hoglands was Mrs. Tinsley's small office in the front room overlooking the village green. Henry would appear at about 9:30 A M and make a few telephone calls before going off to the studio. Morning tea was served at 11:00 A M, with the Moores, Mrs. Tinsley, archivist David Mitchinson, assistant John Farnham, the cook, and the housekeeper. In this relaxed atmosphere, the conversation revolved around the day's events, expected visitors, a sculpture to be sent to London, exhibitions, and so on. Henry would often reminisce about the old days, trips to Paris, and the artists he had known. He had visited Picasso at the time the artist was working on *Guernica*. Picasso's horror at the brutal bombing of the civilian population of the Basque capital was unquestionably deeply felt; nevertheless, in a wry moment during the visit he took a piece of toilet paper and placed it against the hand of the semi-naked woman on the right of the painting. She was caught in the bathroom when the bombing occurred, he remarked. Moore also recounted the well-known story of Picasso's only visit to England, in 1950. He was met at Victoria Station by the English painter Victor Pasmore. The latter's French was not strong, and in any case what does one say on first meeting Picasso? In the taxi, Pasmore said, "*Je suis un peintre*," to which Picasso replied: "*Moi aussi*."

I spent several weeks in Toronto in the autumn of 1969. By this time I had heard about the plans for the Moore Centre and had written to Bill Withrow for further information. By chance I also met Helen Bradfield, the Gallery's Cataloguer, Curatorial Department, and discussed the matter with her. She very kindly wrote a memo to Withrow saying that I was in town and seemed interested in somehow becoming involved. I met with Bill on October 3, and it was agreed that I would be employed to work with Moore on a tentative list of sculptures that might be available for Toronto and to begin to collect photo-

graphs and archival material for the Moore Centre. On October 7, Withrow
wrote to the artist outlining the discussion and asking if Moore approved of my
involvement in the project. Moore replied on October 21, saying how pleased
he was that I would be working with him on the list and suggesting that I
"(in the fullness of time) might be appointed curator of the HENRY MOORE
CENTRE." For me it meant the beginning of an extraordinarily exciting and
challenging curatorial responsibility.

During the first six months of 1970, my elation about working on this project
was tempered by a strange sense of unreality. Would funds be available to
build the Moore Centre? What about Moore's proposed gift to the Tate Gallery?
Without a firm commitment in writing, would Henry really be prepared to
part with a substantial number of his works? Everything seemed very tentative,
to say the least. Nevertheless, by February 10, 1970, Henry and I had drawn
up a list of fifty-seven original plasters and bronzes that might be available. On
paper, at least, things were beginning to look very promising.

On June 17, 1970, Moore, Ed and Peg Bovey, and I met for lunch in London
at the Café Royal, one of Moore's favourite restaurants. Moore loved to eat
out, to relax and enjoy himself away from the pressures of work. He was at his
best on such occasions, and one could not ask for a more genial and amusing
companion. Following a delicious lunch (the wine was as plentiful as the
food) Henry and Ed and I took a taxi to the City to meet with Moore's solici-
tors. Moore and Bovey signed an agreement between: "HENRY SPENCER MOORE,
OM, CH, of Hoglands, Perry Green, Much Hadham, in the County of Hertford,
Sculptor (hereinafter called 'Mr. Moore') of the one part and THE TRUSTEES
OF THE ART GALLERY OF ONTARIO (hereinafter called 'the Trustees') of the other
part.... " Sixty-five sculptures were listed in the three schedules attached to
the agreements: completed bronzes; works to be cast in bronze at the expense
of the trustees; and original plasters from which bronze editions had already
been cast and from which no more casts can ever be made "since the maximum
number of castings has already been made from each of such Works." Any
lingering doubts I might have had that the Moore Centre would become reality
were laid to rest forever on that memorable day. During the next four years,
my responsibility was to work closely with Henry on all aspects of the Moore
Centre, but above all to try to make the collection as comprehensive as possi-
ble. I knew that the list of works in the agreement was merely a blueprint;
that certain sculptures would be deleted and others added. Not surprisingly, I
was from time to time pressured to provide the "definitive" list but, as I wrote
to Bill Withrow on a number of occasions, we had to be patient. "One must
approach Mr. Moore at the right moment."

Henry was kept abreast of events in Toronto. On November 6, 1970, Withrow
wrote to Moore with the good news that "a request for capital funds to build
The Moore Centre and expand the gallery has been passed by the cabinet of
the Government of the Province of Ontario." In late December, Henry received
another letter from Withrow that caused considerable amusement in Mrs.
Tinsley's office. The artist was invited to come to Toronto for "the sod-turning
ceremony." He read the letter aloud with a look of bafflement and disbelief.
Interpreting our linguistic differences was not part of my contract, but on this
occasion Henry asked for an explanation. "Sod" in England is usually under-
stood to mean "sodomite," not "turf." Moore must have begun to question the
genteel English atmosphere of Toronto that he had so enjoyed on his first visit
in 1967. I soon set the record straight and, once assured that such an event

would not tarnish his or our reputation, Moore replied that he would: "do my best to come over for the 'sod-turning' ceremony" (Henry Moore's quotation marks).

Ayala Zacks had succeeded her late husband, Sam, as chairperson of the Henry Moore Sculpture Centre Committee. She and I spent the afternoon at Hoglands on January 9, 1971, to go over with Moore the architectural plans Parkin had drawn up for the Moore Centre. Moore was very pleased with the size and proportions of the large gallery, but was surprised to find that the overhead natural lighting consisted of a narrow strip around the outer edges of the ceiling. It was ideal for paintings, but were we going to hang the large sculptures on the walls? he asked. "I am wondering," he wrote diplomatically to the architect on January 11, "if this will not concentrate too much light only on the walls, leaving the middle of the room with much less direct light than the walls will have. With this kind of lighting the sculptures in the middle of the room might appear in silhouette against the lighted walls, and the areas of the gallery between the walls and the well-lighted part at the entrance could end up as dead areas." He traced over the drawing and reversed the design, indicating that as much natural light as possible should radiate from the centre of the gallery. With a solid area around the outer edges of the ceiling, the walls would be somewhat darkened. Henry's suggestion was followed, with admirable results.

In 1971 Bill Withrow asked me to approach Henry in the hope that he would be willing to donate a major sculpture to the AGO to mark the beginning of the construction of stage one. It was one thing to draw up a list of works that Moore intended to give to the Gallery; it was quite another to approach him at this relatively early stage with a request for an outright gift. Mrs. Tinsley went through her book in which each of the recent sculptures was listed with details of the size of the edition and of which works had been sold and which were still available (or, as I heard her say so often to dealers, "might be available"). We thought the beautiful polished bronze *Working Model for Three Piece No. 3: Vertebrae* of 1968 (no. 180) would be an impressive indication of Moore's commitment. To disguise my nervousness, I somewhat offhandedly asked Moore if he would consider donating this work to the AGO and, to my astonishment, he readily agreed. Its value in 1971 was approximately that of *The Archer* in 1966.

Henry, Irina, and their daughter, Mary, spent four days in Toronto in mid-October 1971. On October 14, Moore attended an Empire Club luncheon at the Royal York Hotel, and later in the afternoon Ayala Zacks presided over the unveiling of Moore's bronze vertebrae sculpture outside the AGO. The following day Henry met with the building committee to continue discussions about the design of the centre, and that evening the Moores attended a black-tie dinner in their honour in the Walker Court of the Gallery. On Saturday Moore was awarded an honorary degree from York University. When the Moores departed for London on the morning of October 17, we knew that it was just a matter of time before the Henry Moore Sculpture Centre became a reality.

Once Henry had approved all aspects of the large Moore gallery — the lighting, the dimensions of the room, the colour of the walls and floor — little more could be done until stage one of the expansion program was near enough completion to provide adequate storage space for the large sculptures. There was, however, one time-consuming task to be carried out at Much Hadham by Moore's assistants, John Farnham, Michel Muller, and Malcolm Woodward:

A.Y. Jackson and Henry Moore,
Empire Club Lunch, Royal York Hotel, Toronto,
October 14, 1971

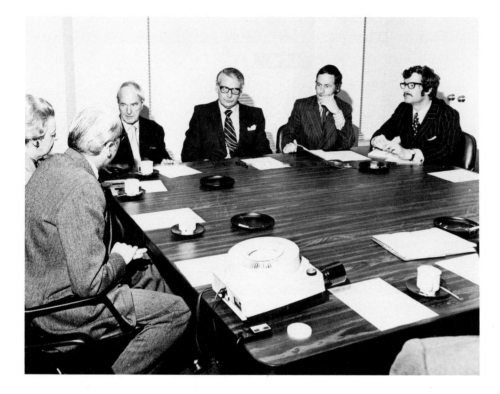

to clean and repair the original plasters that were destined for Toronto. The significance of these works, which comprise by far the largest and most important category of sculptures in the collection, is often overlooked and is little understood. Unlike Rodin's plasters, they are not casts taken from clay or terracotta originals. They are the true originals, which Moore worked on directly himself. Being by nature a carver and not a modeller, Moore preferred to work in plaster, which, once it has dried, can be carved and chipped away at like stone or wood.

The small original plaster maquettes were entirely the work of his own hand. The working models and monumental sculptures were enlarged by assistants under Moore's supervision, with the final details and surface textures completed by the sculptor. When an original plaster was completed, it was sent to the foundry to be cast in bronze. In order to cast a large work, the original plaster was cut into a number of sections from which the moulds were taken, cast into bronze, and then welded together. At one time Moore had intended to destroy the original plasters after the bronze edition of each work was complete so that no casts would be made after his death. Yet as the true originals, the plasters were greatly valued by him; indeed he preferred them to the bronzes that had been cast from them. Under Moore's supervision, John, Michel, and Malcolm removed from the plasters most of the dark shellacs that had been applied during the casting process; this revealed more clearly the extraordinary variety of surface details and textures. Each of the original plasters has its own unique surface colouring and tonality.

Moore's builder, Frank Farnham, and the London firm of Bolton and Fairhead were responsible for the delicate and at times nerve-wracking operation of packing, crating, and loading the works into containers to be shipped by sea and rail to Toronto. Needless to say, there was great excitement at the AGO when the first shipment arrived, in late September 1973. The second

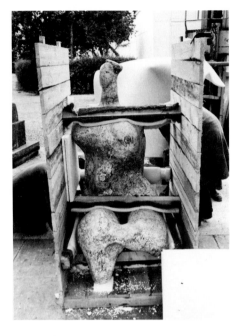

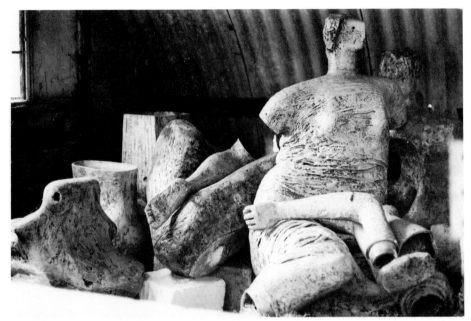

Above: *Woman* 1957–58 (no. 131) being crated at Hoglands for shipment to Toronto
PHOTO: A.G. Wilkinson

Above right: Sculpture shed at Hoglands with, at left, *Upright Motive No. 1: Glenkiln Cross* 1955–56 (no. 106); at right, *Draped Seated Woman* 1957–58 (no. 127)
PHOTO: A.G. Wilkinson

Pierre Trudeau, Henry Moore, David Frost, and Barbra Streisand at the opening of *Funny Girl*, London

shipment left England in late January 1974. When I bought the *Evening Standard* in London on the day the ship sailed for Canada, the headlines announced the worst storms in the north Atlantic for many years. But, as with so many of the events connected with the project, all was well, and the shipment arrived safely.

At the north-east corner of the Henry Moore Sculpture Centre, an outdoor site had been earmarked for a large bronze. In the late 1960s, Moore's *Large Two Forms* was in the process of being enlarged, not by the usual means of plaster built up on a wooden armature, but with blocks of polystyrene, a much lighter and more manageable material. I thought that this sculpture would be an ideal work for the outdoor setting, and Moore generously agreed to let us have it at casting cost, about $85,000. Henry and I flew to West Berlin to visit the Noack Foundry where the *Large Two Forms* was being cast in bronze. It was fascinating to see the work in progress, with the many welded joints clearly visible, and to learn something of the complexities and skill involved in the casting process. On that visit Henry and I visited the famous Egyptian Museum. I noticed a head made of plaster and remarked that I hadn't realized that this material was often used in Egyptian sculpture. Henry said: "Well, if that plaster has lasted for three thousand years, so should my plasters in Toronto."

With the Moore Centre scheduled to open in October 1974, I knew in the spring of that year that the time had come to approach Henry about donating additional works that were not listed in the attachments to the official agreement. I was determined that we should have a small but representative group of Moore's drawings but, when Bill Withrow and I first approached Henry, he said that he did not think any were available. It was our first refusal, and we left Hoglands somewhat despondent. I knew it was one of those days when Moore was distracted and irritable. This would sometimes happen when the pressures of work and the endless stream of visitors got too much. Several weeks later, when Henry was in a relaxed mood, I thought I had nothing to lose in trying again. Perhaps he had forgotten our previous discussion. I pointed out that there were some three or four thousand drawings in the Musée Rodin

and that, as the Moore Centre would house the world's largest public collection of his work, it would not be complete without a representative group of drawings. "All right," he said. "You make a selection of what you think you need, and I'll come and approve what you have chosen." I laid out about seventy unframed drawings on the floor of his big sitting-room and then asked Henry to come and have a look. When he said, "Now how many life drawings do you think we need?", I knew he was in a frame of mind in which his generosity was boundless. "Oh, about a dozen," I replied, and an hour later I left Hoglands with a portfolio of fifty-seven Moore drawings, dating from 1921, his first year at the Royal College of Art, through to 1973. A few weeks later, I approached him about his original plaster maquettes, and again he asked me to make a preliminary selection. By the end of the day, he came down to the maquette studio and without hesitation presented the A G O with forty of these priceless original plasters. Waiting for the right moment had paid off. After discussions among myself, Moore, and David Mitchinson, who looked after the graphic work, Henry also agreed to donate, if available, one of each of his prints, the earliest of which dates from 1931. Also he would reserve one of each edition of any subsequent lithographs and etchings and sign it simply "For Toronto." Finally, he agreed to donate the edition (100) of his 1974 lithograph *Four Reclining Figures: Caves* for us to sell to A G O members to raise money for

Left to right: William J. Withrow, Philip G. Givens, John Robarts, Marvin Gelber — reception in the Members Lounge, Art Gallery of Ontario, at which Givens and Robarts were each presented with Moore's 1974 lithograph *Four Reclining Figures: Caves*, Autumn 1974

 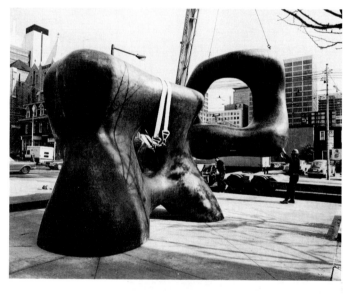

acquisitions. (The proceeds from the sale of this lithograph that October realized $65,000. The edition sold out in two days.) As I wrote to Bill Withrow on June 18, 1974: "Quite extraordinary things are happening, beyond my wildest and most far-reaching dreams ... and like Keats I wonder, 'Do I wake or sleep?' "

In May 1974, Henry and his daughter, Mary, spent several days in Toronto to advise on the installation of the *Large Two Forms* at the corner of Dundas and McCaul streets. Although he was far from happy with this busy intersection as the site for such a major work, Moore realized that the sculpture would help highlight visually the separate architectural identity of the Moore Centre. While the monolithic quality of *The Archer* at City Hall makes the sculpture relatively inaccessible, the *Large Two Forms* encourages active participation. I

Above: *Large Two Forms* (no. 175) being sited outside the Art Gallery of Ontario, May 19, 1974

Above left: Alan G. Wilkinson, Henry Moore, and Mary Moore watching *Large Two Forms* (no. 175) being sited outside the Art Gallery of Ontario, May 19, 1974
PHOTO: *The Globe and Mail*, Toronto

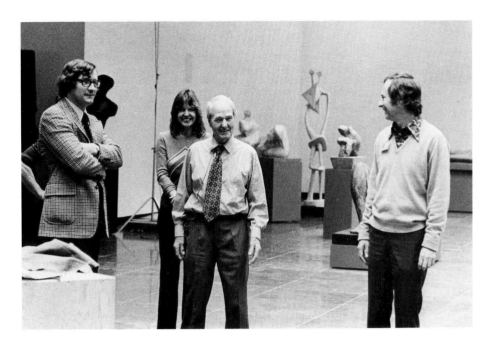

have seen workmen comfortably reclining in the largest of the two forms during their lunch hour. School children jump and dive through the holes of the sculpture, as if the work had been created for an amusement park. Few public sculptures so strongly invite physical involvement.

Henry, Irina, and Mary arrived in Toronto a week before the official opening of the Henry Moore Sculpture Centre and stage one of the Gallery's expansion program. Prior to their arrival, John Farnham, Michel Muller, and Malcolm Woodward had been hard at work on the original plasters, repairing minor damage and, more important, reassembling the sculptures that had had to be shipped to Toronto in several sections. David Mitchinson assisted me with the installation of the drawings and prints.

Once the plasters had been safely placed on their pedestals, the fun began. To enable these heavy works to be moved easily, the pedestals have wheels on each corner. Everyone got into the game of musical Moores, as Henry directed the exact positioning of each work in the large gallery. The final result was a breathtaking and powerful display of sculpture.

On October 26, 1974, when Premier William Davis declared stage one of the expansion program officially open, Moore sat among the dignitaries in the Walker Court. He hated to speak at openings or public functions, but his brief remarks on this occasion did convey a genuine affection for Toronto: " ... from the very first foot I put in Toronto, I felt so happy ... to arrive here was like arriving in a wide open, free atmosphere ... it was something new, fresh." It was a little more than seven years since Allan Ross had approached Moore about the possibility of acquiring more of his work for the City of Toronto. The Moore Centre had been built. The sculptor, in an act of generosity beyond anyone's expectations had donated 101 original plasters and bronzes, 57 drawings, and an almost complete collection of his graphic work. I don't think we could quite believe what had happened.

During the next five years, the Henry Moore Sculpture Centre Committee, headed by Mrs. John David Eaton, bought additional sculptures and drawings to supplement Moore's gift. As there were no early carvings in the collection,

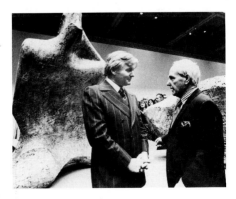

Premier William Davis and Henry Moore at the opening of the Henry Moore Sculpture Centre, October 26, 1974

we acquired the beautiful alabaster *Seated Figure* of 1930 (no. 74). Several important drawings were also purchased, and a number of bronze maquettes were acquired directly from Henry at very favourable prices. The money allocated by the Gallery's acquisition committee was supplemented by the funds raised from the sale of two more editions of Moore's lithographs that he had donated to the AGO. In 1982, on Henry's recommendation, the Henry Moore Foundation presented the Art Gallery of Ontario with a cheque for £100,000 ($210,000 Canadian) to be invested and the income used to support exhibitions and publications.

Since the opening of the Moore Centre in the autumn of 1974, the Gallery has circulated two exhibitions of sculptures, drawings, and prints that have travelled to ten museums and universities throughout Ontario. In 1977, the Art Gallery of Ontario and the Tate Gallery, London, organized the first retrospective exhibition of Henry Moore's drawings. Not only has the Moore Centre been a major attraction in itself, but also the depth of its collection has done much to enhance the international reputation of the Art Gallery of Ontario. Important sculptures and drawings have been lent to retrospective exhibitions of Moore's work at the Orangerie in Paris (1977), and at New York's Metropolitan Museum of Art (1983).

It had always been Henry's wish that his gift to the Art Gallery of Ontario would stimulate interest not only in his own work, but also in the work of other masters of modern sculpture. Apart from the lack of early carvings, which we could no longer afford, by the late seventies the Moore collection was so extensive that we felt it would be pointless to continue adding to it. In 1980, the Modern Sculpture Committee, chaired by Dr. Murray Frum, was formed to replace the Moore Committee. During the next five years, this committee, often with the generous financial support of the Volunteer Committee, acquired important carvings and bronzes by Gauguin, Picasso, Brancusi, Epstein, Gaudier-Brzeska, Giacometti, and Hepworth. In 1986, under the new Chairman Michael Scott, three important sculptures by Naum Gabo were acquired. Moore took a great interest in these purchases when I showed him photographs of our most recent acquisitions. I knew that he was pleased with the direction of our collecting policy.

In 1973 Moore received a letter from Michael Lambeth, Chairman of the Toronto chapter of the Canadian Artists Representation (CAR), asking him to withdraw his name from the Moore Centre (to be renamed the Tom Thomson Wing) and to forbid the permanent display of his work at the Art Gallery of Ontario. Like the forty-one British artists who had written to *The Times* protesting a special gallery for Moore's work at the Tate, Canadian artists believed that the Moore Centre would be a threat to contemporary Canadian art. Bill Withrow argued at the time that the Moore Centre was part of stage one of the Gallery's expansion program, to be followed by stage two, which would provide large permanent exhibition spaces for Canadian historical and contemporary art. By accepting the Moore gift and providing adequate space to exhibit it, the Art Gallery of Ontario would acquire a unique collection of the work of an artist of international renown — an acquisition that would greatly enhance the reputation of the Gallery both at home and abroad.

On January 23, 1974, Moore replied to Lambeth's "Dear Sir Henry" letter. (Moore had turned down a knighthood some years before because he felt that if his assistants addressed him each morning as Sir Henry he wouldn't be able to get any work done.) His response was a summation of his belief, dating from his student years, "that art is *international*, and should be made available to as many people as possible throughout the world. In fact, the history of art shows that influences from one culture to another and from one period to

Yehudi Menuhin in the Moore gallery for the filming of the CBC series *Music and Man*
PHOTO: Harold Whyte

another have been the major fertilizing element in art." As examples, he cited the influence of Greek art on the artists of the Italian Renaissance, Turner's debt to Claude, and Cézanne's debt to the Old Masters. "I have no doubt that in my own case," Moore continued, "if I'd had to depend on learning only from English sculpture (if I had not studied in the British Museum where the history of sculpture throughout the world is so well represented, travelled to Paris and Italy, read and seen many books on world sculpture), what would I have learned out of England alone?" Through the Moore Centre, he hoped "that sculpture and sculptors will be given extra encouragement.... I do hope that in your well-understood and natural desire to help your fellow Canadian artists you will not shut out the knowledge and influence of art from outside Canada. To do so, in the long run would be a disservice."

In the thirteen years since the Moore Centre opened in 1974, sculpture has indeed been given "extra encouragement." While many art museums steer clear of exhibitions of sculpture, the Art Gallery of Ontario welcomes the challenge. As well as the AGO's two travelling exhibitions of Moore's sculpture, drawings, and prints, in 1981 the Gallery organized a major loan exhibition, *Gauguin to Moore: Primitivism in Modern Sculpture*. In 1985–86, the AGO showed an exhibition from the Dallas Museum of Art, *Naum Gabo: Sixty Years of Constructivism*. A selection from the Gallery's Margaret and Ian Ross Collection of Baroque bronzes was circulated to provincial museums in 1985; and Picasso's 1909 bronze *Head of a Women (Fernande)* travelled to four Ontario museums in 1986 as part of the Gallery's Masterpiece Exhibition Series. And currently, a selection of nineteenth- and twentieth-century European sculptures from the permanent collection is being circulated to five provincial museums. Loans to important international exhibitions do much to enhance our reputation abroad. In addition to the constant requests for loans from the Moore collection, a number of our most important nineteenth- and twentieth-century sculptures have been included in major exhibitions in the United States and Europe. The fact that five carvings and bronzes from the AGO — works by Gauguin, Picasso, Brancusi, Matisse, and Moore — were included in

the Museum of Modern Art's "*Primitivism*" *in 20th Century Art: Affinity of the Tribal and the Modern* (1984) testifies to the depth and quality of the Gallery's collection of modern sculpture.

One of the great pleasures of visiting an art museum is to come across, knowingly or unexpectedly, a collection of works that is unique to that institution. The Turner bequest at the Tate Gallery is one such; the Moore collection at the Art Gallery of Ontario is another. Visitors seeing the Moore gallery for the first time often draw in their breath, overwhelmed by the sheer power of so many large sculptures under one roof. And when they have caught their breath and had a look around, the question "Why Toronto?" is almost inevitable. It has been a long and detailed story. "Art," as Moore wrote to Michael Lambeth in January of 1974, "should be a giving and exchange between nations.... Nationalism can only be the enemy of art." Professor Eric Arthur realized this when he headed the international architectural competition for the new city hall. Revell realized this when he selected *The Archer* for Nathan Phillips Square. Givens and the private donors realized this in their efforts to acquire *The Archer*. Allan Ross, Sam Zacks, Bill Withrow, Ed Bovey, and John Robarts realized this during the planning, funding, and construction of the Moore Centre. And above all, Henry, in making the most generous and important gift by an artist in the annals of Canadian museum history, responded to the enthusiasm and commitment of these dedicated men. That is why the names of Moore and Toronto have become so closely and happily linked.

During the last several years of his life, Moore's health deteriorated rapidly. He could no longer walk and was restricted to an armchair beside his bed in the large sitting-room at Hoglands. He spent the long days watching television with Irina and doing a little drawing from time to time in his notebook. Every afternoon Henry made the effort to go out for a drive with Frank Farnham, "to see nature, the countryside, the trees, the sky, to be renewed and refreshed." His love of family continued to be reflected in his personal life. Nothing in his old age gave him more pleasure and happiness than the visits of his daughter, Mary, and his grandchildren, Gus, Jane, and Henry. Love and affection radiated from his kind aging face on these occasions.

On some days Henry seemed confused and did not recognize his close friends or even his secretary, Mrs. Tinsley. On other days he was alert and talkative. When Canadian filmmaker Harry Rasky visited Hoglands on December 7, 1983, to shoot an hour-long interview with Henry for a documentary film, *The Mystery of Henry Moore*, I was apprehensive that Moore might be having one of his off days. Quite the contrary. Perhaps it was the challenge of the interview and all those lights and cameras. Moore sat in his chair, sipping a glass of whisky. His recall was extraordinary. He told Rasky that he was able to identify each of the girls at his school in Castleford by the shape of her legs. He reminisced about one of his earliest tactile experiences, when as a young boy he rubbed his mother's arthritic back with oil. The female back, he said, is a terribly important feature in his work. Here he paused, then added, "though the back has perhaps less incident than the front." There was one moment when Henry's alertness flagged, however. Because of the CBC funding and the connection with the Moore Centre in Toronto, Rasky naturally wanted to include some "Canadian content" in his film. Near the end of the interview, he asked Moore out of the blue, "Why are there so many of your sculptures in Toronto?" Moore looked completely blank, then replied, "I don't know, I didn't send them there." Cut.

The Drawing Lesson: Henry Moore and his
grandson, Gus, at Hoglands
PHOTO: John Hedgecoe

I visited Henry for the last time on May 1, 1986. I knew immediately that
he was having one of his good days. When I walked into the sitting room he
said, "Oh hello, Alan, aren't you a bit early this year? You usually come at
the end of June for the Wimbledon tennis." We had afternoon tea together and
chatted about everything from the weather to tennis. (Over the years I had
spent many happy hours with the Moores watching Wimbledon.)

My visit was short, as Henry tired easily and had dozed off several times.
His aging face reminded me for a moment of one of Rembrandt's late self-por-
traits. We shook hands. I think I knew intuitively that I was saying goodbye
for the last time. Henry died in the early hours of Sunday morning, August 31,
1986, a month after his eighty-eighth birthday. Irina later told me that she
and Mary were beside him. Henry opened his eyes for a moment, looked at
them both, then closed his eyes and died peacefully in his sleep.

Henry Moore's hands
PHOTO: John Hedgecoe

At Westminster Abbey, on November 18, 1986, Sir Stephen Spender concluded his address with images of Moore's hands, which, he said, seemed to have a consciousness of their own:

Wonderful hands which, throughout his adult life and until his strength failed him, continued working, drawing when he could no longer sculpt. At the end of his life when he could no longer even draw they were forever restlessly moving as though shaping invisible forms out of the air. His first sculpture was of hands and he once said that he found hands, after the face, the most obvious part of the body for expressing emotion. Hands are for praying and for giving thanks that he lived the life and created the art in which his sense of the sacred was realized so I am happy to end these remarks with the image of his endlessly creating hands.

The family's only request with regard to the planning of a posthumous service was for the inclusion of "The Salutation," a poem by Thomas Traherne, the seventeenth-century English divine and mystic. At Westminster Abbey a setting of the poem was sung by soprano soloist Felicity Lott. One stanza seems to me somehow relevant to the story of Moore and Toronto. It also expresses something of the feeling of wonder a visitor might experience on first seeing the Moore collection:

A Stranger here
Strange things doth meet, strange Glory see.
Strange Treasures lodg'd in this fair World appear,
Strange all and New to me:
But that they *mine* should be who Nothing was,
That Strangest is of all; yet brought to pass.

2 "Sculptural energy is the mountain": The Art of Henry Moore

ON NOVEMBER 18, 1986, many of those attending the memorial service for Henry Moore must have reflected on the startling contrast between the magnificent, historic setting of Westminster Abbey and the small Victorian terrace house (two up, two down) at 30 Roundhill Road, Castleford, where the sculptor was born on July 30, 1898. Moore's choice of vocation defies any logical explanation; he seems to have known very early on what he would do with his life. By the age of eleven, after hearing a story in Sunday School about Michelangelo, he had decided "that when I grew up I was going to be a great sculptor."[1] Throughout his life Moore never lacked the self-confidence or singleness of purpose to realize his ambition. Many years later he told his secretary, Mrs. Tinsley, that he had never doubted he would one day make it to the top.

Moore's work has received more public exposure through exhibitions than that of any other sculptor in history. Since his first one-man show at the Warren Gallery, London, in 1928, dozens of exhibitions of his sculpture, drawings, and prints have been organized by the British Council, museums and art dealers at home and abroad. In urban centres throughout the world, Moore's large monumental bronzes serve diverse functions: to honour a city (*The Archer*, Toronto City Hall), to identify an office building (*Three Piece Reclining Figure No. 1*, Canadian Imperial Bank of Commerce, Montreal), or to complement a museum (*Mirror: Knife Edge*, the National Gallery of Art, Washington, DC).

More than any other artist of the twentieth century, Moore has given sculpture a high profile that had been sadly lacking. To say that modern sculpture has been ignored by museums and private collectors is an exaggeration, but certainly in terms of acquisitions and exhibitions, paintings, drawings, and prints have received far more attention. Among the fine arts, sculpture would appear to be the least understood and appreciated by the general public. This may result from its three-dimensional presence — or from the fact that the subject of most sculpture is the human figure, and we are perhaps extra sensitive about such reflections of ourselves. A most remarkable and perhaps unique quality of Henry Moore's genius, quite apart from the historical importance of his contribution to modern sculpture, is, in the words of William S. Lieberman, "the very great capacity to communicate directly and without confusion. The spectator responds easily to the clear expression of his metaphors. In the twentieth century, such visual empathy is rare. That ability to transmit emotional impact, however, is the substantive greatness of his art."[2] Moore's work seems to have universal appeal — to school children, to a general public with little knowledge of sculpture, as well as to artists, collectors, architects, art historians, and museum directors and curators. And yet a number of critics and academics find Moore's art "old hat," his traditional humanism an anachronism compared, for example, with the cool, impersonal, cerebral forms of minimal sculpture. However, it need not be a question of either-or. We all respond differently to works of art — whether music, poetry, novels, paintings, or sculpture. If a collector or curator has a great affinity with, for example, the sculpture of Anthony Caro, well and good; but this should not blind one to the achievements of others.

The universal appeal of Moore's work may in part be attributed to its ability to help us look at familiar or common shapes in fresh ways. He has broadened our understanding of three-dimensional form and made us more aware of our bodies and the forms and textures of nature. His sculptures echo elements of landscape: the shape of mountains, cliffs, sea-worn headlands, gently rolling hills, and the crinkled skin of the earth. "Found" objects such as bones, shells, pebbles, and flint stones have been the genesis of many sculptures. Moore

frequently received parcels filled with natural forms that individuals thought might be of interest (and perhaps inspire some future sculpture), suggesting that Henry's work had influenced the way they perceived the bones, or pebbles, or whatever they had collected.

In 1951 Moore wrote:

And the sensitive observer of sculpture must also learn to feel shape simply as shape, not as description or reminiscence. He must, for example, perceive an egg as a simple single solid shape, quite apart from its significances as food, or from the literary idea that it will become a bird. And so with solids such as a shell, a nut, a plum, a pear, a tadpole, a mushroom, a mountain peak, a kidney, a carrot, a tree-trunk, a bird, a bud, a lark, a lady-bird, a bullrush, a bone. From these he can go on to appreciate more complex forms or combinations of several forms.[3]

We tend to forget that our day-to-day perception of the world about us involves tactile experiences with countless three-dimensional objects. We touch and hold a coffee cup, a spoon, an egg, a pen, a walking-stick, a pebble on a beach. But above all, we experience ourselves, our bodily feelings and the touch of others. One of Moore's greatest legacies has been to make us more aware of the sculptural qualities of the objects in our immediate surroundings. Several weeks after Moore's death, a friend told me that she was out in a boat in Georgian Bay on the day Moore died. Looking around the rugged Ontario landscape of rocks and islands, she felt surrounded by Moore sculptures. I think Henry would have been pleased that on an imaginative level such a connection had been made.

Moore was the seventh child of Raymond Spencer Moore, a coal miner, and Mary Baker. Born in the last years of Queen Victoria's reign, Henry was brought up in a disciplined but loving family atmosphere, by parents of strong and independent character. He respected his father: "it was the Victorian idea of the family and he was the head of it. He was the boss and he expected absolute, complete control."[4] Moore had a happy childhood, full of physical enjoyment and exercise. As he recalled late in life: "There were seven of us children in that one little house, no bedroom to yourself. In fact, there were three or four in one bed!"[5] Those childhood experiences were particularly relevant in the formation of Moore's sculptural sensibility and in the subsequent imagery of his art. "One of the first and strongest things I recall were the slag heaps [of coal] like pyramids, like mountains, artificial mountains."[6] As a young boy he visited the massive rock formation (which he later named Adel Rock) in the countryside outside Leeds: "For me, it was the first big, bleak lump of stone set in a landscape and surrounded by marvellous gnarled prehistoric trees. It had no feature of recognition, no element of copying of naturalism, just a bleak, powerful form, very impressive."[7] Another experience was more personal and directly tactile. His mother suffered from rheumatism, "and would often say to me in winter when I came back from school, 'Henry, boy, come and rub my back.' Then I would massage her back with liniment."[8] Memories of these three visual and tactile experiences remained with Moore throughout his life: sculptural (and later human) forms with the power of great mountains; rock formations in a landscape, impressive in themselves yet independent of any representational connotations; the broad expanse of his mother's back and the notion that the outer surfaces of the human body are the result of the inner structure of bones pressing outwards.

Henry Moore's father, Raymond Spencer Moore, 1871 (aged twenty-two)

Adel Rock, outside Leeds, Yorkshire

30 Roundhill Road, Castleford, Yorkshire, where
Henry Moore was born (house demolished 1974)

Henry Moore's mother, Mary (*née* Baker) Moore,
1908 (aged forty-eight)

As Moore wrote:

One of the things I would like to think my sculpture has is a force, is a strength, is a
life, a vitality from inside it, so that you have a sense that the form is pressing from
inside trying to burst or trying to give off the strength from inside itself, rather than
having something which is just shaped from outside and stopped.[9]

Miss Alice Gostick, the art teacher at the local grammar school in Castleford,
was Moore's first mentor: "She was wonderfully enthusiastic about the art
lessons. Most of the boys and girls didn't seem to care about it, but I found that
once I went to the grammar school I knew it was the one lesson of the week
that I looked forward to. She was wonderfully helpful in asking me to tea
every Sunday, and showed me copies of *Colour* magazine and so on. I owe a
great deal to her enthusiasm."[10] Moore's sculptural and adolescent sensibilities

at times developed in tandem. He once told his friend Herbert Read that he was able to recognize the girls in school by the shape of their legs: "If their bodies and features had been hidden by a board below which only the legs showed from the knees down, I could still have given a name to each pair."[11] The story is more than an amusing anecdote from Moore's school days. It is an early indication of a subsequent aim in Moore's sculpture that is of vital importance in understanding his art:

You don't need to represent the features of his face to suggest the human qualities that are special to a particular person. My aim has not been to capture the range of expressions that can lay over the features but to render the exact degree of relationship between, for example, the head and the shoulder; for the outline of the total figure, the three-dimensional character of the body, can render the spirit of the subject treated.[12]

As Moore once perceptively remarked: "You can recognize a friend two hundred yards away solely by his proportion and by the way he moves and holds himself."[13]

Moore's formal academic training began in September 1919 when he enrolled in the two-year course at the Leeds School of Art. His first year was devoted entirely to drawing from life and from plaster casts of well-known examples of Greek sculpture. He found the closed, academic outlook stultifying, but realized that he must persevere in order to pass the Board of Education examinations and try to win a scholarship to study in London. At the time, Moore was fortunate to have met Sir Michael Sadler, the Vice-Chancellor of Leeds University. He was, in Moore's view, one of the most enlightened men in England and "really knew what was going on in modern art."[14] Sir Michael invited the students from the art college to his house, where Moore was exposed for the first time to works by Gauguin, Cézanne, Rouault, Matisse, de Chirico, and Kandinsky, as well to examples of African sculpture. Even more important was Moore's fortuitous discovery in the Leeds library of Roger Fry's *Vision and*

Henry Moore with his early carvings, 3 Grove Studios, Hammersmith, London, 1926

Design, a book whose influence on the formation of his ideas about sculpture cannot be overemphasized. Certain passages in the chapters entitled "Negro Sculpture" and "Ancient American Art" not only prepared the young Yorkshire sculptor for the great ethnographic collections of the British Museum, but also shaped his ideas on two important concepts: direct carving (the doctrine known as truth to materials), and the full, three-dimensional realization of form. Fry praised African carvers for their "complete plastic freedom; that is to say, these African artists really do conceive form in three dimensions,"[15] and for "an exquisite taste in [their] handling of material."[16] He described their sculptures as having a "disconcerting vitality, the suggestion that they make of being not mere echoes of actual figures, but of possessing an inner life of their own."[17] (This last passage could equally well have been written by Moore about his own work.) In the chapter entitled "Ancient American Art," Fry speaks of "the magnificent collection of Mexican antiquities in the British Museum," and remarks in the following paragraph that Aztec and Mayan sculpture have inspired a number of modern artists. "This is, of course, one result of the general aesthetic awakening which has followed on the revolt against the tyranny of the Graeco-Roman tradition."[18] As Moore wrote: "Once you'd read Fry the whole thing was there. I went to the British Museum on Wednesday and Sunday afternoons and saw what I wanted to see."[19] And so by 1921, when Henry began his studies at the Royal College of Art in London, the general direction his art would follow was clearly established in his mind.

Another book Moore read, either at Leeds or soon after he arrived in London, was Ezra Pound's *Gaudier-Brzeska: A Memoir* (1916). Born in France in 1891, Gaudier spent most of his brief working life as a sculptor in London, where he lived from late 1910 or early 1911 to 1914, when he returned home to join the army. He was killed in action in June 1915. In the history of twentieth-century British sculpture, Epstein and to a lesser extent his friend Gaudier were the pioneering, *avant-garde* figures. The work of both sculptors during the years 1913–14 was profoundly influenced by African and Oceanic sculpture. Gaudier wrote that the work of the modern sculptor "has no relation to classic Greek, but that it is continuing the tradition of the barbaric peoples of the earth.... "[20] This was the tradition that Moore was to follow in the 1920s. In fact, several of Moore's stone carvings of the 1920s were directly inspired by the work of Gaudier. The opening up of the human figure (the use of "the hole") was not the invention of Moore. It had appeared as early as 1912 in the work of Archipenko, and was a prominent feature in Gaudier's *Ornement Torpille* of 1914 (AGO). Gaudier's impassioned account of the role of the modern sculptor and his comments on the nature of sculpture undoubtedly had a profound effect on Moore's thinking. In fact a number of phrases and concepts that appear in Moore's own writing are almost a paraphrase of certain passages by Gaudier quoted by Pound in his book:

Gaudier: "Sculptural energy is the mountain.... Sculptural feeling is the appreciation of masses in relation."[21]

Moore: "The sculpture which moves me most is full-blooded and self-supporting, fully in the round, that is, its component forms are completely realised and work as masses in opposition, not being merely indicated by surface cutting in relief; it is not perfectly symmetrical, it is static and it is strong and vital, giving off something of the energy and power of great mountains."[22]

Gaudier: "The Indians felt the hamitic [African] influence through Greek spectacles."[23]

Moore: "This removal of the Greek spectacles from the eyes of the modern sculptor ... has helped him to realize again the intrinsic emotional significance of shapes instead of seeing mainly a representational value."[24]

Moore must have identified with the heroic struggles of the young French sculptor in an environment hostile to modern art. The two had common interests in direct carving, in Primitive art, and in the British Museum. And during the 1920s Moore was, to quote his own description of Gaudier, "a young sculptor discovering things."[25]

In 1921 Moore was awarded a scholarship to study sculpture at the Royal College of Art in London. "For the first year I was in a dream of excitement. When I rode on the top of a bus I felt I was travelling in Heaven almost, and that the bus was floating in the air. And it was Heaven all over again in the evenings in my horrid little room in Sydney Street, where I could spread out the books I'd got out of the library and know that I had the chance of learning about all the sculptures that had ever been made in the world."[26]

Moore, in his interest in tribal art and in many other non-European sculptural traditions, was very much a part of what Fry called "the revolt against the tyranny of the Graeco-Roman tradition." It is important to keep in mind, as Professor Gombrich has pointed out, that "most movements in art erect some new taboo, some new negative principle, such as the banishing from painting by the Impressionists of all 'anecdotal' elements."[27] For Moore, as for Gauguin before him (Gauguin maintained that "the great error is the Greek, however beautiful it may be"[28]), the negative principle was the Graeco-Roman tradition. Moore recalled how he made a conscious effort during his formative years to steer clear of classical art. The negative and positive slogans were firmly fixed in his mind. "There was a period when I tried to avoid looking at Greek sculpture of any kind. And Renaissance. When I thought that the Greek and Renaissance were the enemy, and that one had to throw all that over and start again from the beginning of primitive art."[29] And start from the beginning he did, following his own words of advice inscribed in a sketchbook of 1926: "Keep ever prominent the world tradition / the big view of Sculpture." In discussing the global history of sculpture, Moore emphasized that classical Greek art had flourished for a relatively brief period and that, despite its enormous influence, it should no longer blind us to the sculptural achievements of other cultures. The numerous drawings found in his sketchbooks of the 1920s reveal that he made a comprehensive study of the history of world sculpture. Moore's copies of works of art include drawings of some of the earliest known sculptures, such as the Palaeolithic *Venus of Grimaldi* (fig. 7) as well as of Sumerian, Egyptian, early Greek, Etruscan, Indian, pre-Columbian, Peruvian, north-west coast Indian, Eskimo, African, and Oceanic art. Few if any twentieth-century artists had Moore's encyclopaedic knowledge of the history of sculpture, from prehistoric to modern times.

Of all the varied styles and cultures that Moore discovered in books and, above all, on his weekly visits to the British Museum, he was most attracted by pre-Columbian sculpture.

Mexican sculpture, as soon as I found it, seemed to me true and right, perhaps because I at once hit on similarities in it with some eleventh-century carvings I had seen as a boy on Yorkshire churches. Its "stoniness," by which I mean its truth to material, its tremendous power without loss of sensitiveness, its astonishing variety and fertility of form-invention and its approach to a full three-dimensional conception of form, make it unsurpassed in my opinion by any other period of stone sculpture.[30]

Wedding of Henry Moore and Irina Radetsky, July 1929

"Hoglands," Perry Green, Much Hadham, Hertfordshire. Henry and Irina Moore moved to this seventeenth-century farm house in 1940

Henry Moore with his daughter, Mary, c. 1947

"Truth to material ... a full three-dimensional conception of form ... " — these are clear echoes of Roger Fry's writings on African and pre-Columbian sculpture.

Moore's affinity for pre-Columbian stone sculpture and his interest in direct carving were complementary. At the outset of his career, in the early 1920s, the doctrine of truth to materials (or in Moore's words: "the need for direct carving, for respecting the particular character of each material"[31]) was already well-established, as exemplified in the sculpture of Gauguin, Picasso, Brancusi, Modigliani, Epstein, and Gaudier-Brzeska. Brancusi had declared: "Direct carving is the true path towards sculpture."[32] Moore believed not only in the necessity of continuing this tradition, but that "carved sculpture was better than modelling, because there had been more human effort to make it, to shape it, you'd had to struggle, you'd had to work to do it."[33] Moore was by nature a carver and not a modeller. He enjoyed the physical effort involved, the need "to overcome the resistance of the material by sheer determination and hard work."[34] Direct carving, in Moore's sense of the term, was unheard of in academic circles. As he wrote: "During the Victorian period sculpture had become a process whereby the artist would model a figure which was then passed on to workmen to copy in marble."[35] Although by the late 1930s Moore had abandoned a doctrinaire belief in direct carving, he remained essentially a carver throughout his life, working in stone and wood, or in plaster (to be cast in bronze), which can be carved once it has hardened. In a very real sense, Moore's plasters are carvings and as such have the same status as original, unique works of art.

During the 1920s, the two major themes in Moore's *oeuvre* — the reclining figure and the mother and child — were firmly established. "From very early on," Moore wrote, "I had an obsession with the mother and child theme — it has been a universal theme from the beginning of time and some of the earliest

sculptures we've found from the Neolithic Age are of a mother and child. I discovered, when drawing, I could turn every little scribble, blot or smudge into a Mother and Child."[36] Of the three fundamental poses of the human body, "the reclining figure gives the most freedom compositionally and spatially. The seated figure has to have something to sit on. You can't free it from its pedestal. A reclining figure can recline on any surface. It is free and stable at the same time. It fits in with my belief that sculpture should be permanent, should last for eternity."[37]

The range, diversity, and emotional power of Moore's work extends far beyond the endless cartoons that have stereotyped the artist as simply "the sculptor of the hole." The many hundreds of life drawings made between 1921 and the mid-1930s are among the most beautiful studies of the female nude in English art. Moore's pre-Columbian–inspired carvings of the 1920s made an important contribution to the history of Primitivism in twentieth-century art, as did a number of subsequent sculptures based on Oceanic, Peruvian, and Inuit art.

During the 1930s his links with the Surrealist movement resulted in some of Moore's most obscure and seemingly abstract work, and yet, on closer examination, one discovers clues that point to representative, figurative elements. It is important to remember Moore's comment that, "the humanist organic element will always be for me of fundamental importance in sculpture, giving sculpture its vitality."[38] Some of his work may be described as semi-abstract, but, as he wrote, "I can't cut my sculpture off from living, and the forms that one sees in nature, in people, in trees...."[39]

Moore's shelter drawings of 1940–41, with their almost visionary intensity, are among the supreme achievements in English art. They also mark a decisive turning point in his career — the resolution of that conflict between the Graeco-Roman tradition that for so long had been "the enemy" and Moore's interest in primitive art. The subject matter itself and the more naturalistic treatment of the human figure "did get through to the public and make a difference in our relationship; anyway it's from that moment that I didn't need to teach for a living."[40] The public outrage and hostility was beginning to subside.

During the 1950s, as Moore's reputation grew at home and abroad, he received several important commissions: a stone screen for the Time-Life building in London (nos. 90–93) that included the classically inspired *Draped Reclining Woman* of 1952–53 (no. 88) for the first-floor terrace behind the screen. There was also a large carving for the UNESCO headquarters in Paris (see nos. 122, 123). His great series of two- and three-piece reclining figures of 1959–65, in which a landscape becomes a metaphor for the human figure, culminated in the monumental bronze *Reclining Figure* (see no. 164) of 1963–65, commissioned for the Lincoln Center for the Performing Arts in New York. *The Archer* of 1964–65 (see no. 170a) is the progenitor of the AGO's Moore collection and of this book.

What of Moore's late work? As Alan Bowness has pointed out, if we survey the history of the art "we are aware that a handful of great men have lived to a full life span and produced in their last decades work of a very special order that can at once be recognized as a distinct 'late style' — Titian and Rembrandt, Michelangelo and Cézanne; the last quartets of Beethoven; the last plays of Shakespeare and Goethe."[41] Bowness has summed up the characteristics of Moore's late style in which the works "have indeed become increasingly concerned with human relationships. It had always been a major

preoccupation, from the earliest Mother and Child sculpture, but it seems to me that what we are offered in the late works is a paradigm of the human relationship, with figures groping, touching, embracing, coupling, even merging with each other. At the centre of the *Oval* [see no. 182] are the points that reach out and almost meet; in the *Locking Piece* [see no. 163] the forms are gripped in a tight embrace, like a copulating couple — an impression that the *Large Two Forms* [no. 175] also clearly suggests."[42] The dominant themes of Moore's art have remained unchanged, but in his early work Moore saw the need to simplify, while in the late work we sense a greater formal complexity, a freer and more profound interpretation of the mystery of the human condition.

It must be abundantly clear to the reader that Moore was the most lucid and perceptive commentator on his own life, work, and ideas. "Words," he explained late in life, "can never explain, though. They can point out a direction of how you should look at sculpture but no more than that. This is as it should be, as all art should contain an element of mystery. Nothing reveals itself completely in life or art. There is always more behind it than you think. This is true of the things we are most familiar with — nature, the human body."[43]

One of Moore's maquette studios at Hoglands
PHOTO: A.G. Wilkinson

As the poetry of T.S. Eliot contains a wealth of literary allusions, so Moore's art is rich in associations and, at times, direct references to nature and to the art of the past: to prehistoric fertility goddesses (no. 131); to Cycladic sculpture (no. 74); to the pre-Columbian *Chac Mool* reclining figure (no. 23); to Monet (no. 146); to Seurat and Adel Rock outside Leeds (no. 145); to Peruvian pottery (no. 87); to African sculpture (no. 166); and to the work of Picasso (no. 40).

Moore's work is not only an echo and a continuation of past traditions, however; it also alters our perception of those traditions. Enobarbus's famous description of Cleopatra's barge from Shakespeare's *Antony and Cleopatra* is utterly changed for readers familiar with T.S. Eliot's paraphrase of it in *The Waste Land*. In other words, Eliot has influenced our reading of Shakespeare. When I saw the *Chac Mool* reclining figure in Mexico City, images of several

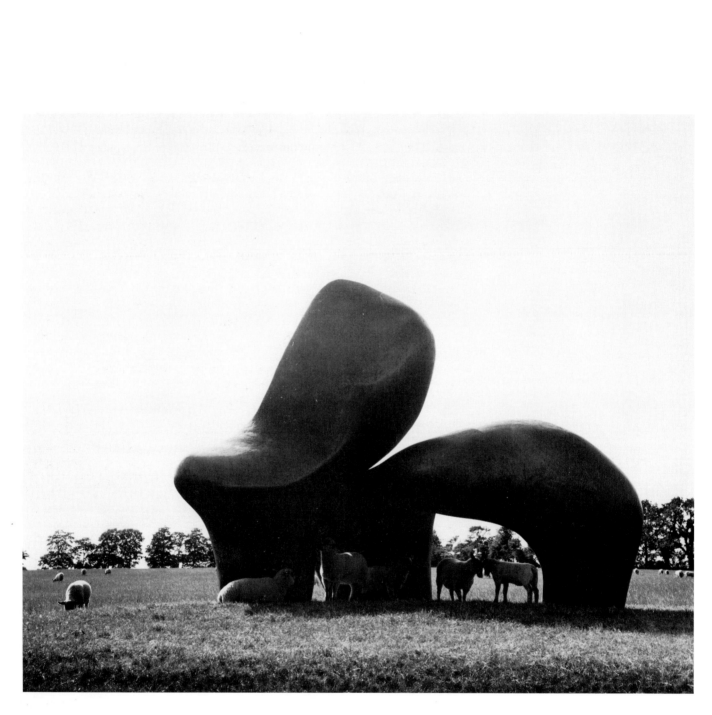

Sheep Piece 1971–72,
in field at the bottom of the garden, Hoglands

Moore sculptures that were directly inspired by it came immediately to mind. That so many landscape settings around the world remind people of Moore's reclining figures attests to the universality and richness of the sculptor's poetic imagination.

From his formative years as a student in London in the early 1920s until his death at the end of August 1986, Moore's development as a sculptor was "an attempt to understand and realize more completely what form and shape are about, and to react to form in life, in the human figure, and in past sculpture."[44] His life and art retained a singleness of purpose and direction from which he never wavered. Picasso's genius was brilliant, explosive, and volatile. Moore's was tenacious and steady.

He was constant and true to the many friends who loved him. As Sir Stephen Spender said in his memorial address: " ... in the fifty-odd years of our friendship he changed less than anyone I can think of, except in those outward, external circumstances of his life, and they changed more than those of any other of my friends."

Henry once told me that he had one of the largest earned incomes of anyone in England. Yet his lifestyle remained unchanged. It simply meant that he could afford to have his sculptures enlarged on whatever scale he wanted and pay the very considerable costs of having the works cast in bronze. And he and Irina could afford to collect important works of art — among them a Cézanne oil and two superb drawings by Degas — that in their younger days would have been far beyond their means. Large sums also went to the Henry Moore Foundation, formed in 1977, which since its inception has generously supported artists, acquisitions for museums in Britain, exhibitions, and other grants related to the arts, including a donation of $210,000 in 1982 to the Art Gallery of Ontario for exhibitions and publications.

We have examined some of the external experiences that shaped Moore's life and his approach to sculpture. Identifying influences is one of the favourite pastimes of the art historian; this is the detective work of our profession. Only once, during the many hours that I spent with Henry did he get visibly irritated. We were looking at a photograph of one of his early carvings of a standing figure, and I asked him if there was a possible influence of Eskimo sculpture. "Oh, you art historians are *always* looking for influences," he said and then proceeded to give me a lecture, pointing out the obvious: that all standing, seated, and reclining figures, from whatever culture or period, share certain formal characteristics. "And anyhow, don't you think an artist can create a work from his own imagination without always being influenced by something else?" "Yes," I said, in a somewhat deflated and embarrassed tone of voice.

The sources of creativity and the workings of the imagination are, as Moore wrote in the last year of his life, mysterious and complex matters:

It is impossible to turn to a single influence in any work of art, it can only come by the development and experience of a lifetime combined with all these influences. And then it is only the truly great artists who can emerge to create their own individual style. Then with the artist's own ideas and abilities one hopes that an added vitality will be embraced within the work he produces. But nobody can say where that added force comes from other than it comes from within the artist himself.... Who is to tell if an experience which occurred yesterday, or ten years ago, or a lifetime ago was an influence or not? I can't.[45]

THE COLLECTION

THE DEVELOPMENT and evolution
of six decades of Moore's art and
ideas are discussed in detail in the
notes that follow on the 73 drawings
and 131 sculptures in the collection
of the Art Gallery of Ontario. For
obvious reasons there are few pre-
1950 sculptures in the collection:
many of the pre-1950 works were
unique carvings, which, by the time
Moore drew up a list of works for
Toronto, were in public or private
collections or belonged to his wife
and daughter. However, the superb,
representative group of drawings,
dating from 1921 to the early 1970s,
compensates to some extent for this
lacuna. Particularly important in
this regard are the preparatory studies
for many of Moore's most important
early carvings of the 1920s and 1930s.

The inscriptions on a number of
the drawings were added long after
the drawings were done. The word
"recent" in parentheses after an
inscription indicates that the inscrip-
tion most probably dates from the
late 1960s or early 1970s.

The Art Gallery of Ontario has the
most comprehensive collection of
Moore's prints outside the archives of
the Henry Moore Foundation at Much
Hadham. Almost all were donated
by the artist. Moore's complete
graphic oeuvre numbers 719 prints,
of which 689 are in the permanent
collection of the AGO. Regretably
space allowed for only 21 woodcuts,
lithographs and etchings to be
illustrated in this book.

3 Drawings

1 *Head of an Old Man* 1921 (recto)
Pencil, 15.8 × 16 cm
Inscr. upper right *Moore* (early);
lower right *Moore 21* (recent)
Gift of Henry Moore, 1974

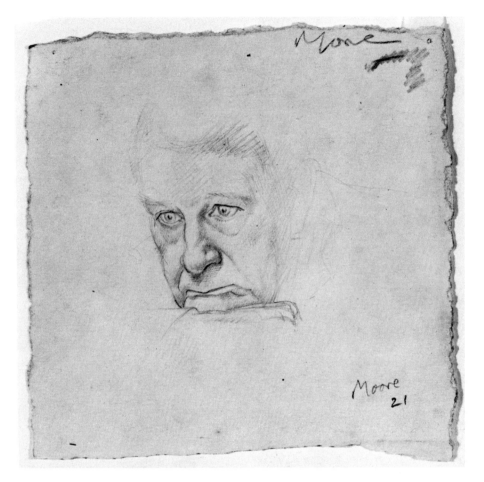

HENRY MOORE'S earliest surviving life drawings date from his first term at the Royal College of Art in the autumn of 1921. Among these are five sheets of drawings of an old man. The artist has described this study, the earliest drawing in the collection, as "portrait drawing of the purely academic type." In this exercise in tonal values, the volumes are defined by delicate hatchings and cross-hatchings. The staring eyes are given particular emphasis so that the face has, in the artist's own words, "a sense of life" that is absent in another sheet of drawings of the same model, *Portrait Heads of an Old Man* (recto), also of 1921, in a private collection. In the latter studies, the eyes have been left out, which gives the heads somewhat the appearance of plaster casts. *Portrait Head of an Old Man,* the verso of this sheet, shows a single study closely related to no. 1. The other known 1921 drawings of this model are: *Portrait of an Old Man,* a half-length clothed study; *Old Man with a Hat,* seated, clothed; and *Seated Male Nude,* in the HMF, the only known nude study of this model.

All the drawings of the old man were done in the modelling class in the sculpture school at the Royal College of Art, not in the life class in the painting school. "Some days," Moore said, "we did portraits, other days life drawing." The clay *Portrait Bust* of 1921 (LH 1) was based on the same model.

Architectural Studies 1921 (verso)
Pencil
Inscr. *6 × 6¼; longer [larger?] plate*

2 *Head and Figures c.* 1922
Pen and ink and chalk, 29.2 × 28.6 cm
Inscr. lower left *M O O R E*
Gift of Henry Moore, 1974

M O O R E told the author that these studies were probably architectural designs done at the Royal College of Art, but he was unable to identify the exact subject matter.

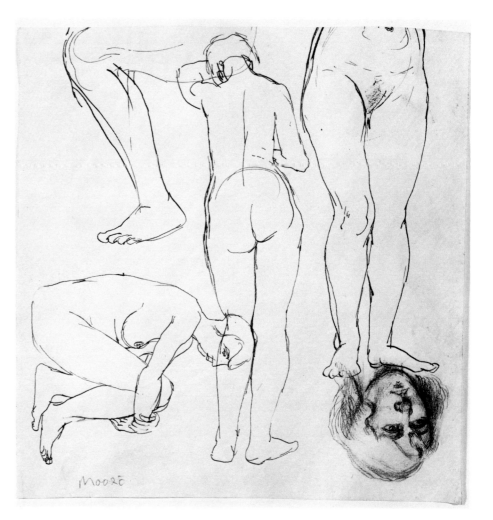

A L M O S T A L L Moore's life drawings are of a single figure from a fixed point of view, but here he has made five studies, no doubt all of the same model. Also unusual is the purely linear technique of the four figure studies. With the exception of the Paris drawings (see no. 18) Moore's life drawings are for the most part vigorous, strongly modelled studies, using light and shade to describe three-dimensional form. Also unusual here is the portrait head of the model. In only a few of his life drawings, particularly those of his wife (Wilkinson, 1977, nos. 42, 44, and 47), did Moore attempt to portray the facial features and expressions of his models. Two drawings in the H M F include studies of the same model in similar poses. In *Three Seated Figures* of *c.* 1922 (H M F) the seated figure in profile is close to the seated figure in profile in no. 2. In *Two Female Figures* of *c.* 1922 (H M F) the standing figure, back view, is an almost identical pose to that in no. 2.

3 *Kneeling Nude* 1923
Pen and ink, brush and ink, 32.3 × 50.4 cm
Inscr. lower left *Moore 23* (signature
probably early, date recent)
Gift of Henry Moore, 1974

4 *Reclining Figure* 1922
Pencil, pen and ink, 20.5 × 27.9 cm
Inscr. lower left M O O R E 22; top *alter
head*
Gift of Henry Moore, 1974

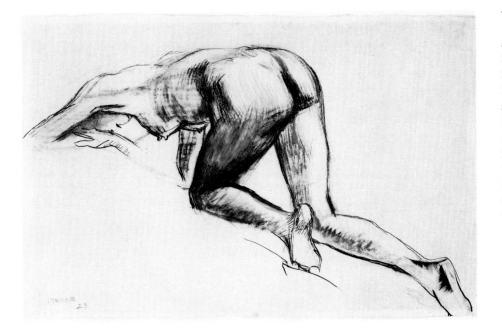

◄

A L T H O U G H most of the life draw-
ings from his student years were
made in the painting school at the
Royal College of Art, Moore occa-
sionally drew in the modelling classes
in the sculpture school (see no. 1),
as was the case in this unusual study,
for which the artist himself set the
pose. He said that Sir William Roth-
enstein, the Principal of the Royal
College of Art, had seen and admired
this drawing.

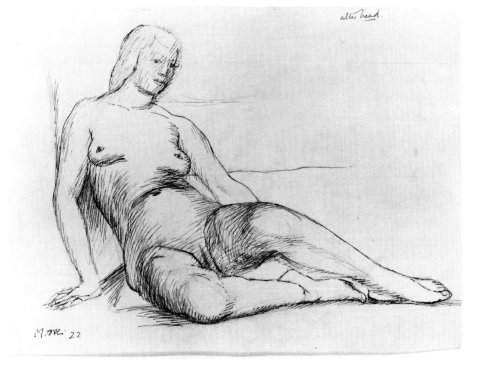

◄

I N U S I N G several media in a single
drawing, Moore often began by
sketching the general outline of the
figure in pencil, as in this study. Here
pen and ink were used to establish
the exact outline of the figure and in
the hatchings and cross-hatchings
to provide added density to the
shaded areas.

5 *Nude with Clasped Hands* 1923 (recto)
Pencil, pen and ink, gouache, 52 × 18.4 cm
Inscr. lower left *Moore 23* (recent)
Gift of Henry Moore, 1974

*Standing Nude with Hands
under Breasts* 1923 (verso)
Pencil and charcoal
Inscr. lower left *20½ × 7*

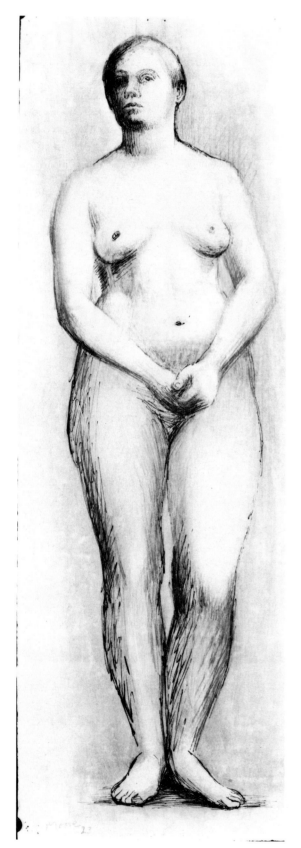

THIS IS one of the most carefully worked, highly finished early drawings in the collection. Moore in fact reworked the drawing in the early 1970s with pen and ink, giving firmer definition to the eyes, nose, mouth, ear, and hands and adding shading under the chin. The pen-and-ink shading between and beside the feet (also a later addition) gives the figure a ground on which to stand.

The artist said of this drawing: "If I had a criticism of this drawing, it would be that I haven't got the boniness of the different parts — the knees and the area above the breasts. This is a weakness — there is no contrast between the hardness and softness." (See Wilkinson, 1977, no. 8, for another drawing of the same model.)

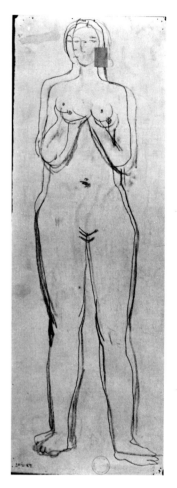

WHEN MOORE was asked about this study, he said that the model may not have been the same as the one on the recto. "I often used the other side of the paper several months later, to save paper. I never thought these drawings would be kept. None of the Leeds drawings was kept."

6 *Page 155 from No.3 Notebook: Study for Manchester "Mother and Child" 1924*
Pencil, pen and ink, brush and ink, 16.6 × 17.3 cm
Inscr. left of squared study *poising / of weights / (2½) / 5 × 3 × 3*
Gift of Henry Moore, 1974

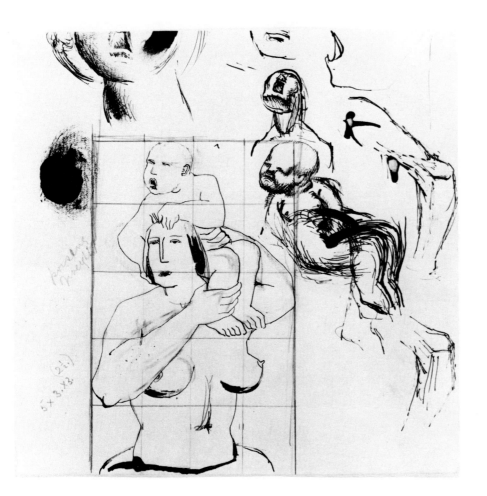

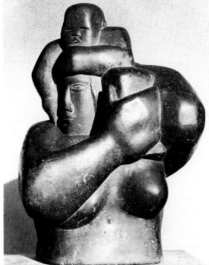

Fig. 1 *Mother and Child* 1924–25
City Art Gallery, Manchester

THIS trimmed sheet (a strip 3.8 cm deep has been cut from the top of the sheet) from No. 3 Notebook of 1922–24 (HMF) is the most important early drawing for sculpture in the collection. It includes the definitive study for the Hornton stone *Mother and Child* of 1924–25 (LH 26; fig. 1) in the City Art Gallery, Manchester. Moore began work on the carving in the autumn of 1924 and left it unfinished when he went to Italy on a travelling scholarship in January 1926. He returned to England in mid-July and completed the sculpture that autumn.

The six known sheets of studies for the Manchester carving allow us to follow the genesis of the idea through a number of stages. Probably the first drawing in the series (fig. 2)

was the pencil sketch at centre left of the fragment of page 154 from No. 3 Notebook of 1922–24 showing, as the inscription states, "man carrying child." (The left side of page 154, including this small sketch, has been trimmed and destroyed.)[1] The child sits on the right shoulder of the man. The man's legs are lightly sketched, and there is a heavier horizontal line below the navel, indicating that Moore intended to do a half figure. Also on this sheet are a study of the child's head and, below this, the head, arms, and shoulders of the child, probably on the man's back (the figure beneath has been cut out), similar to the thumbnail study at centre left.

In the page 141 drawing from No. 3 Notebook (HMF), inscribed "Child

riding on mother's back," several major changes have occurred. Here it is the mother who supports the child, who, instead of perching on one shoulder as in fig. 2, sits astride, with legs wrapped around the mother's neck and arms around her head. This composition was more fully realized in the drawing at the bottom of page 23 from No. 4 Notebook (fig. 3). The large drawing *Mother and Child* of 1924 (private collection) was also based on this latter sketch. In these studies, apart from the head of the child, which is turned sharply to the left, the composition is symmetrical. This was probably why Moore rejected these drawings and based the carving on the asymmetrical pose in no. 6, a more varied and compelling composition. Moore's preference for asymmetry is discussed in his article for *Unit One*, London, 1934.[2] In fact, the earliest known inscription, which appears at the top of the inside front cover of No. 2 Notebook of 1921–22 (HMF), notes "Carving with unsymmetrical design."

Page 47 from No. 4 Notebook of

Fig. 2 *Page 154 from No. 3 Notebook* 1924
(part only)
Henry Moore Foundation PHOTO: A.G. Wilkinson

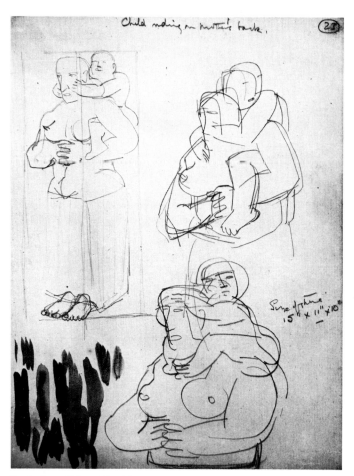

Fig. 3 *Page 23 from No. 4 Notebook* 1924
Henry Moore Foundation

Fig. 4 *Page 47 from No. 4 Notebook* 1924
Henry Moore Foundation

1924–25 (fig. 4) shows three studies that are closely related to the definitive drawing in no. 6. In fact the inscription at the top of fig. 4 reminded Moore of "Other views of mother and child on p. 155 of last notebook [no. 6]." The two studies at the top in fig. 4 are closely related to the squared drawing in no. 6 and may well have been based on it.

How closely did Moore follow a drawing in translating an idea into three dimensions? In some of the carvings of the 1920s he often hesitated, in his own words, "to make the material do what I wanted until I began to realize that this was a limitation in sculpture so that often the forms were all buried inside each other and heads were given no necks.

As a result you will find that in some of my early work there is no neck simply because I was frightened to weaken the stone."[3] The limitations imposed by the materials in the carvings were not, of course, encountered in the drawings. In the definitive study (no. 6) for the Manchester *Mother and Child* (fig. 1), the forms of both figures — the heads, necks, and arms — are clearly defined. In other words, the original conception was far less monolithic than the forms appearing in the completed carving. This drawing gives some indication of the appearance the sculpture might have taken had Moore felt freer to release the forms from the solid mass of the stone.

7 *Seated Blue Nude* 1924 (recto)
Pen and ink, brush and blue ink
43.5 × 34.3 cm
Inscr. lower left *Moore 24* (recent)
Gift of Henry Moore, 1974

THIS IS one of the freest and most
spontaneous of Moore's early life
drawings. Brush and blue ink estab-
lish the outlines of the figure and
give the broad shading on the back
and right arm. These shaded areas are
given added weight by the hurried
zig-zag motion of the pen-and-ink
lines. For other drawings of 1924
using a similar pen-and-ink and brush
technique, see Wilkinson, 1977,
nos. 15 and 16.

Three Standing Nudes 1924 (verso)
Pencil (blue ink spots)

THESE three delicate studies, proba-
bly made from the same model, are
in marked contrast to the bold hand-
ling of the recto.

8 *Two Female Nudes c.* 1924
Pencil, pen and ink, 24.8 × 34.1 cm
Inscr. lower left *Moore* (recent)
Gift of Henry Moore, 1974

Fig. 5 *Page 28 from No. 3 Notebook c.*1924
Henry Moore Foundation

PAGES 28, 30, and 54 from No. 3 Notebook of 1922–24 show a number of Cézannesque studies of female bathers that the artist has said were done after he had seen the Pellerin Collection in Paris in 1922, a collection that included Cézanne's *Grandes baigneuses*, now in the Philadelphia Museum of Art.[4] One of the figure groups on page 28 (fig. 5) was squared for transfer; *Two Seated Nudes* (HMF) was based on this notebook study. This suggests that no. 8, squared in pencil, was also based on a smaller compositional study, though no preliminary sketch is known. This drawing recalls Picasso's pen-and-ink studies of bathers of the early 1920s — works such as *Deux baigneuses* of 1920 (Zervos IV, 181).

9 *The Two Thieves, St. John and Roman Soldiers* 1925
Pen and ink, 20.7 × 24.5 cm
Inscr. lower right *Moore / Italy 1925* (recent)
Gift of Henry Moore, 1974

THIS DRAWING, done in Italy in
1925, was copied from an as yet un-
identified drawing or painting of the
Crucifixion, probably a northern
Italian work from the second half of
the fifteenth century. The faintly
indicated figure at centre has not
been identified.

10 *Copies of Figures from* The Visitation,
*anonymous early fifteenth-century drawing,
Uffizi, Florence* 1925 (recto)
Pencil, pen and ink, wash, 33.8 × 24.5 cm
Inscr. lower left *Moore* (recent)
Gift of Henry Moore, 1974

THIS IS one of two drawings in the
collection done in Italy in 1925 dur-
ing Moore's travelling scholarship
(see also no. 9). This sheet includes
six of the seven figures in the Uffizi
drawing (fig. 6) of the School of
Giotto *The Visitation*, in the Lower
Basilica of San Francesco at Assisi.
They are, in the upper half of the
sheet, from left to right: the elderly
woman fourth from the left; the
woman carrying a basket; the elderly
woman third from the left; Mary; a
face in profile to the left, probably of
the woman standing in the doorway
of Elizabeth's house; the aged Eliza-
beth. The other two large figures
are, at left, the aged Elizabeth bend-
ing forward and grasping Mary's arm
and, just right of centre, the young
woman standing in the doorway of
Elizabeth's house. The two studies of
heads in the lower third of the page,
which do not appear in the Uffizi
drawing, have not been identified.
They may have been based, as Dr.
Barbara Dodge has suggested, on a
mid-fifteenth–century Florentine
work.

Fig. 6 Anonymous Florentine
The Visitation, fifteenth century
Uffizi, Florence

Three Heads 1925 (verso)
Pencil

11 *Standing Nude* c. 1925 (recto)
Pen and ink, chalk, 42.2 × 25.2 cm
Inscr. lower right *Moore*
Gift of Sam and Ayala Zacks, 1970

THESE HEADS were possibly copied
from a work seen by Moore in Italy.

THE ARTIST has suggested that this
drawing and *Standing Nude* of c.
1925 in the Tate Gallery (no. 22 in
Wilkinson, 1977) may be of the same
model. Moore gave this drawing to
his friend Raymond Coxon, with
whom he had studied at the Leeds
School of Art and at the Royal Col-
lege of Art. The drawing was later
bought by Sam and Ayala Zacks of
Toronto, who presented it to the Art
Gallery of Ontario in 1970.

Female Torso with Arms above Head c. 1925 (verso)
Charcoal, brush and ink (figure from recto traced in pastel)

12 *Two Standing Figures c.* 1925
Pencil and wash, 38.3 × 28.1 cm
Gift of Henry Moore, 1974

IT IS UNUSUAL to find a life drawing and a study for sculpture on a single sheet. This figure appears to be related to the 1924–25 carving *Woman with Upraised Arms* (LH 23).

MOORE'S PREFERENCE for the bulky, weighty figure type is in evidence both in his life drawings and in his copies of works of art. For example, in the 1920s he made several drawings of the Palaeolithic *Venus of Grimaldi* (fig. 7; see no. 69 in Wilkinson, 1977), as well as a number of copies of figures from Rubens' paintings (see figs. 110, 112, and 114 in Wilkinson, 1977). In explaining his admiration for the small Cézanne oil *Trois baigneuses* of 1877–78 (fig. 8), which he once owned, Moore said:

"Perhaps another reason why I fell for it is that the type of woman he portrays is the same kind as I like.... Not young girls but that wide, broad, mature woman. Matronly."[5] In these studies of the same model, her enormous bulk, broad hips, and heavy legs have much in common with the proportions of the small Palaeolithic Venus that Moore copied in No. 6 Notebook in 1926 (fig. 7). Moore told the author that he thought the model in no. 12 was a Miss Bowker, nicknamed Bowk, who "offered to pose for me and Raymond Coxon."

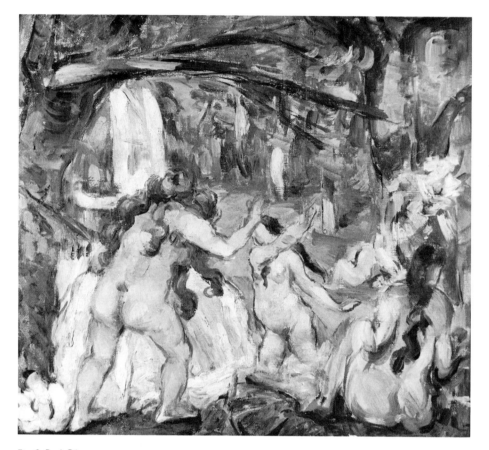

Fig. 8 Paul Cézanne
Trois baigneuses 1877–78
Private collection PHOTO: Errol Jackson

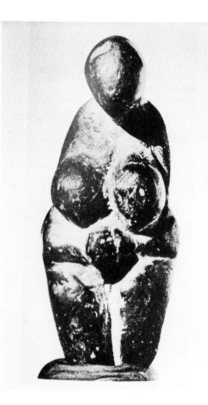

Fig. 7 *Venus of Grimaldi*
Palaeolithic period
Musée de Saint Germain

13 *Seated Girl* 1925
Brush and ink, chalk, 42 × 31.3 cm
Inscr. lower right *Moore 25* (recent)
Gift of Mrs. Saul A. Silverman, 1975

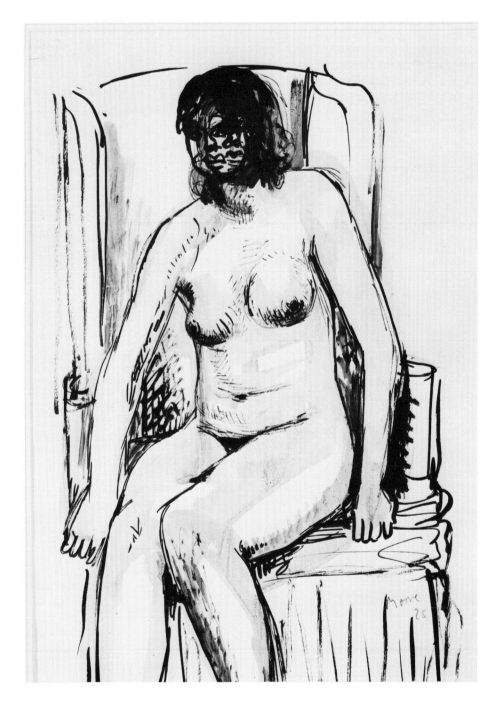

A FEATURE shared by Moore's life drawings and his sculpture is the representation of the human figure in repose. He was never attracted to what he called "the gesture school of poses." Unlike Degas and Rodin, he was not interested in portraying the body in movement or violent action, or in making hurried sketches while the model roamed freely around the studio. Nor did he draw the figure in the erotic poses and foreshortened perspectives that characterize many drawings by Rodin, Klimt, and Schiele. Of the three fundamental poses of the human body — standing, sitting, and reclining — almost all Moore's life drawings are of standing and seated figures. There are few drawings of reclining figures, one of the most important subjects of his sculpture. Characteristically, no. 13 shows the model in an uncomplicated, straightforward seated pose. The incisive pen-and-ink outlines of the figure, the densely worked head, and the bold handling of the chair contrast with the delicate patches of brushed tonal modelling of the arms, legs, and torso.

14 *Ideas for Sculpture: Study for "Torso"* c. 1925
Pencil, pen and ink, brush and ink, 24.9 × 29.4 cm
Inscr. lower right *Moore* (recent)
Gift of Henry Moore, 1974

15 *Crouching Figure* 1926
Pen and ink, 31.4 × 22.9 cm
Inscr. lower left *Moore 26*
Gift of Henry Moore, 1974

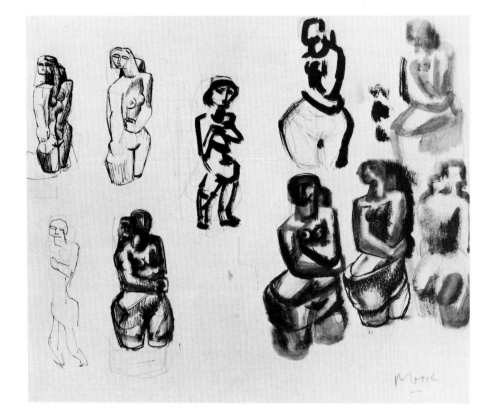

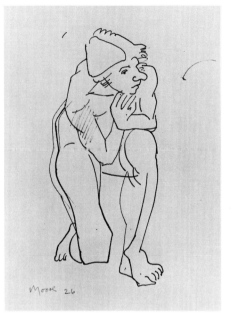

THIS SPONTANEOUS, unmodelled linear drawing is in marked contrast to most of Moore's figure studies, which are characterized by their sculptural quality, primacy of modelling, and use of as many as four media in a single drawing. Moore repeatedly urged that an artist should begin by doing highly finished, three-dimensional drawing and later simplify. He cited the examples of Matisse and Picasso:

Pure outline drawing is a shorthand method of drawing, to be arrived at later in an artist's career. Matisse and Picasso often used this method, but they began their careers with this kind of highly finished three-dimensional drawing using light and shade, and then later simplified their styles. This is the real way to understand form and drawing.[6]

MOORE IDENTIFIED the sketch at upper left as the drawing for the cast concrete *Torso* of c. 1926 (LH 37; fig. 9). In this study the angular rhythms of the figure, the flat plane beneath the right hand, and the diagonal position of the breasts reflect the influence of Cubist sculpture, particularly the early work of Lipchitz. There are three known sheets that are stylistically closely related to no. 14: *Six Studies for Sculpture*, signed and dated 1925, in the British Museum; *Ideas for Sculpture*, c. 1925, HMF; and *Studies for Sculpture in Portland Stone*, c. 1925, in a private collection.

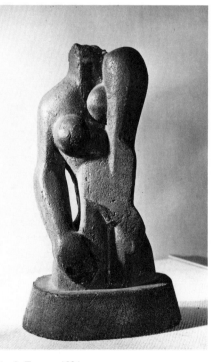

Fig. 9 *Torso* c.1926
Private collection PHOTO: Robert Garcia

The linear style of this drawing is reminiscent of many of Gaudier-Brzeska's outline figure studies. The facial features, particularly the long nose, give the face somewhat the appearance of a caricature. Moore described no. 15 as "drawing in a slightly abandoned way" and suggested that it may have been done in Paris (see no. 18).

16 *Standing Nude, Hand on Hip* 1927
Pencil, chalk, brush and ink,
55.9 × 22.4 cm
Inscr. lower right *Moore 27* (recent)
Gift of Henry Moore, 1974

17 *The Artist's Mother* 1927
Pen and ink on newspaper, 27.4 × 21.3 cm
Inscr. lower right *Moore 27* (recent)
Gift of Henry Moore, 1974

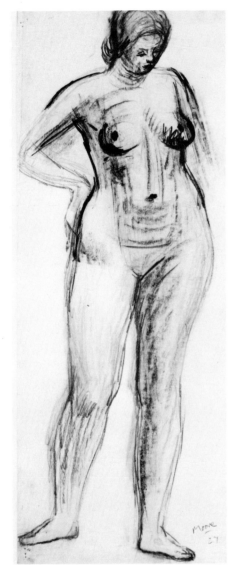

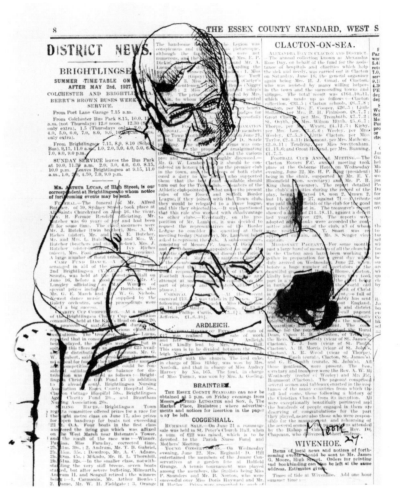

ALTHOUGH the model's face has
not been depicted in a detailed or
realistic manner, the downward posi-
tion of the head and the summary
facial features suggest a reflective,
somewhat contemplative mood.

THIS IS one of four drawings on
newspaper (*The Essex County Stan-
dard*) of the artist's mother, Mrs.
Mary Moore (fig. 10). (The three
others are in the HMF; one is no. 27
in Wilkinson, 1977.) Here, as in the
other three, she is shown knitting, as
in the small study on page 29 from
No. 6 Notebook of 1926 (Mitchinson,
no. 46). We know of two other draw-
ings of Mrs. Mary Moore: the superb
Portrait of the Artist's Mother of 1927
(Wilkinson, 1977, no. 26), and *The
Artist's Mother*, also of 1927, in the
HMF. For a discussion of the role
of portraiture in Moore's work, see
Wilkinson, 1977, pages 14 and 15.

Fig. 10 Mrs. Mary Moore, c.1930

18 *Reclining Nude* 1928
Crayon, brush and ink, 30.8 × 41.8 cm
Inscr. lower left *Moore 28* (recent)
Gift of Henry Moore, 1974

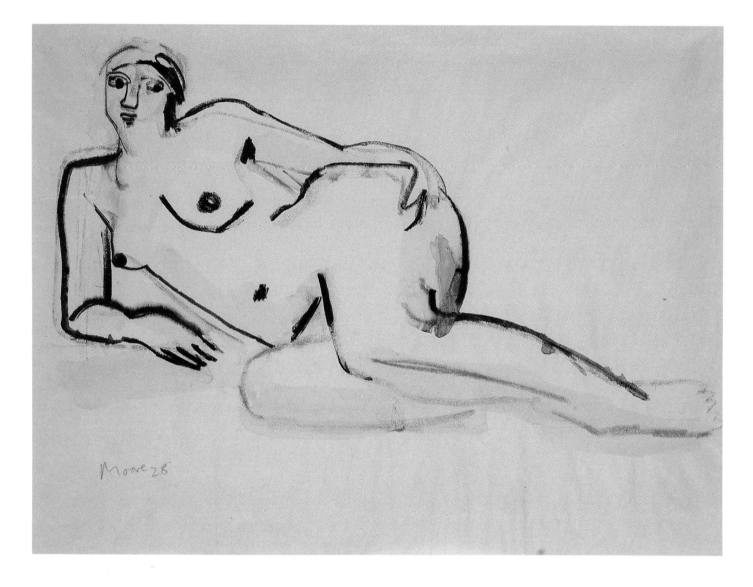

ON HIS FREQUENT TRIPS to Paris in the 1920s and 1930s Moore enjoyed drawing from life at the Colarossi and Grande Chaumière academies. In the afternoon classes, Moore said, a pose usually lasted for several hours, and this enabled him to complete a fully worked drawing similar to those he had done at the Royal College of Art. In the evening classes, however, the rhythm changed. The first pose might last a full hour, with subsequent poses becoming progressively shorter: twenty minutes, five minutes, and several of one minute each. The present Paris drawing, one of many dated 1928, was undoubtedly executed with great haste in a five-minute or possibly one-minute pose. These short poses demanded a spontaneous response and resulted in drawings totally different in handling and feeling from the strongly modelled sculptural studies. (For further discussion of the Paris drawings, see Wilkinson, 1977, pages 15 and 16, and catalogue entries 30–36.)

19 *Seated Figure* 1928(?) / 1929
Pencil, charcoal, chalk and wash, 43 × 29.6 cm
Inscr. lower left *Moore 29* (recent)
Gift of Henry Moore, 1974

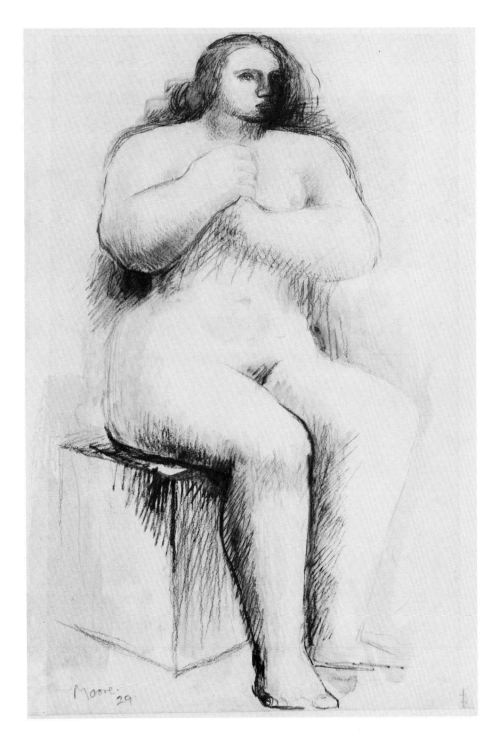

THIS DRAWING is closely related to the naturalism of Moore's life-drawing style of the late 1920s. It has obvious affinities to Picasso's heavy-limbed, monumental figure studies of 1920–21, such as the 1921 oil *Nu assis et draperie* (Zervos IV, 329). Moore himself has stated that he was familiar with Picasso's "Pompeiian" nudes. No. 19 would appear to be related in style and pose to the 1928 terracotta *Study for Wall-Light* (LH 50; fig. 11), and if so may date from 1928. The drawing, signed and dated *Moore 29*, appears to have been based on the smaller study on page 65 from the Sketchbook for the Relief on the Underground Building of 1928 (HMF). The same figure type appears in *Figure on Steps* of 1930 (Wilkinson, 1977, no. 87).

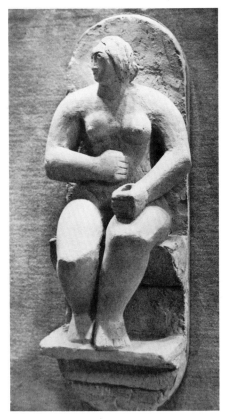

Fig. 11 *Study for Wall-Light* 1928
Destroyed

20 *Idea for Sculpture: Figure Seated on a Block* 1928
Brush and ink, chalk, 43.2 × 32.1 cm
Inscr. lower right *Moore 28* (recent)
Gift of Henry Moore, 1974

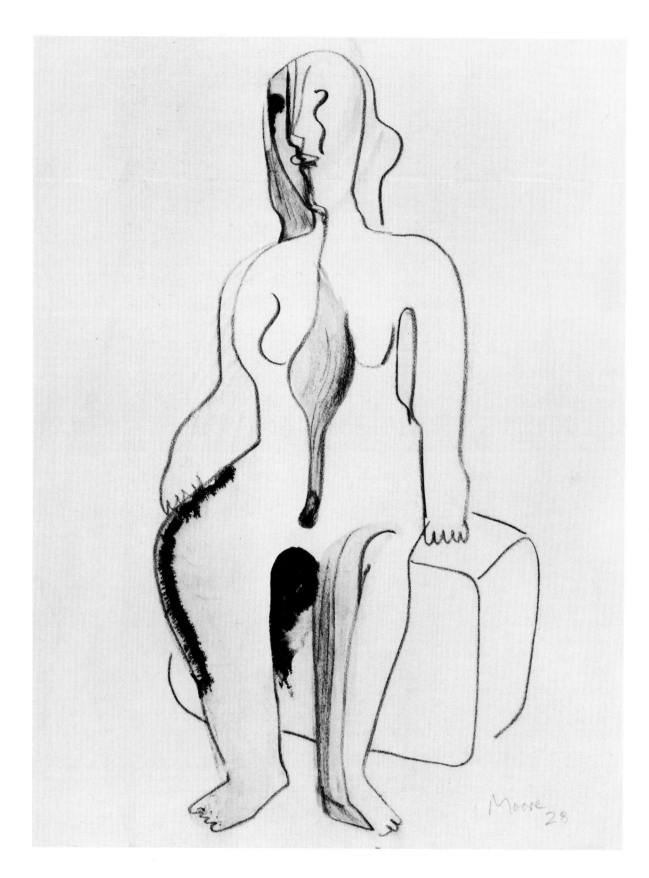

THIS DRAWING is related in a general way to the cast concrete *Seated Figure* of 1929 (LH 65), although it is not the definitive study for it. Of particular interest is the line running down from the neck and curving around and up again between the breasts. The shaded area down the centre of the figure suggests a hollow, much like the space between and below the breasts in the cast concrete *Half Figure* of 1929 in the collection of the British Council (LH 67; fig. 12). See also the drawing in Wilkinson, 1977, no. 85. This gradual cutting into the form was to lead ultimately to the first sculptures with holes, in the early 1930s. In no. 20 the fluid curves of the body, the suggestion of, if not a double head, several fractured planes, and the simplified treatments of hands and feet may well reflect the influence of the decorative rhythms of curvilinear Cubism, as exemplified in such works as Picasso's *Seated Woman* of 1926–27 in the Art Gallery of Ontario (fig. 13). In another drawing of 1928, *Ideas for Sculpture: Seated Figures* (HMF), the figure seated on a block, with the curvilinear line down the head and the tight ridges of the fingers, is stylistically very close to no. 20. Other drawings in the HMF, *Four Standing Women* and *Drawing for Sculpture: Heads and Seated Figures* of 1928 are also closely related to no. 20. In the latter, the way in which the head of the seated figure has been partitioned by the continuous line from the eyebrow to the chin is a feature found in a number of drawings and sculptures of the late 1920s such as *Seated Woman with Clasped Hands* of c. 1929, Auckland City Art Gallery (Wilkinson, 1977, no. 45) and the cast concrete *Mask* of 1929 (LH 62).

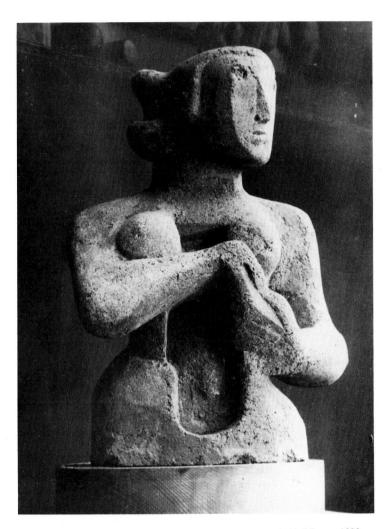

Fig. 12 *Half Figure* 1929
British Council, London

Fig. 13 Pablo Picasso *Seated Woman* 1926-27
Art Gallery of Ontario
© Picasso 1987/Vis-Art

21 *Three Reclining Nudes* c. 1928 (recto)
Chalk, brush and coloured washes, 30.8 × 51.1 cm
Gift of Henry Moore, 1974

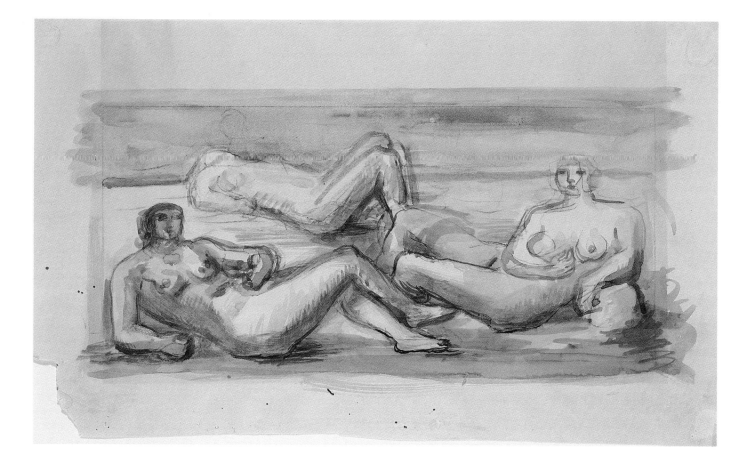

ALTHOUGH UNDATED, this draw-
ing is so closely related in style and
subject matter to *Three Figures in a
Landscape* (signed and dated *Moore
28*) as to suggest the same year. In
contrast with other drawings of the
period, such as the verso of no. 21,
and no. 23, which were influenced by
pre-Columbian art, the present study
and a number of modelled sculptures
of the period (LH 43 and LH 50) relate
to the naturalism of the figure draw-
ings of the late 1920s.

Reclining Figure c. 1928 (verso)
Brush and coloured washes

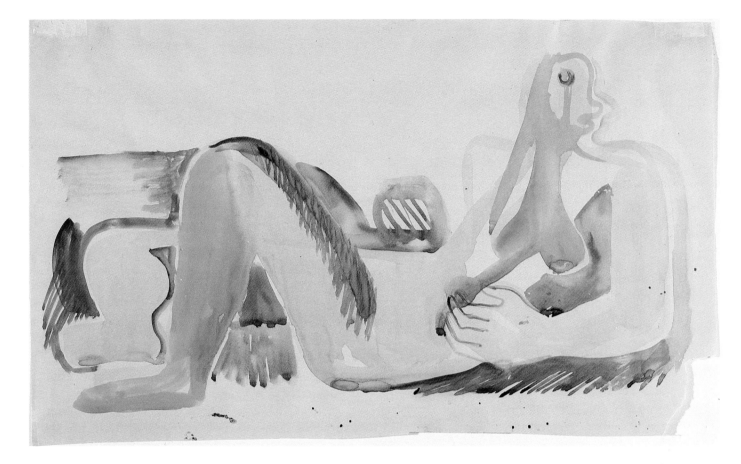

WHEREAS THE FIGURE STUDIES
on the recto belong both in style
and subject matter to the European
tradition of the reclining-figure
theme, this drawing is closely linked
with the Mexican *Chac Mool* sculp-
ture (fig. 17) that was to have such a
profound influence on Moore's work
in the late 1920s. In this bold and
powerful study the pose echoes that
of the *Chac Mool*; head and torso are
supported by the left arm, and the
left leg is raised and brought in
towards the body. It is relevant to
quote Moore's reply to the question
of why the *Chac Mool* made such
a tremendous impact on him. "Its
stillness and alertness, a sense of
readiness — and the whole presence
of it, and the legs coming down like
columns."

22 *Ideas for North Wind Relief* 1928 (recto)
Pen and ink, brush and ink, 36.6 × 22.6 cm
Inscr. lower left *Moore 28* (recent)
Gift of Henry Moore, 1974

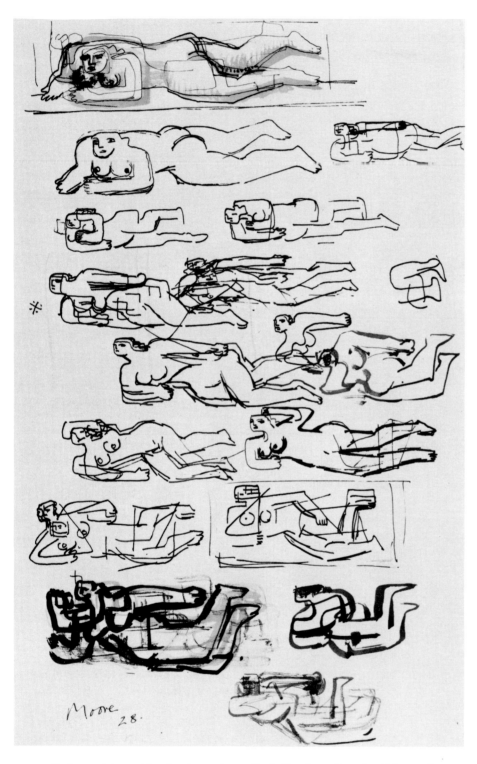

IN 1928 the architect Charles H. Holden commissioned seven sculptors to carve architectural decorations for his new building, the headquarters of London Transport at St. James's Park Station. Epstein did two large groups entitled *Day* and *Night*. Henry Moore, Eric Gill, Allan Wyon, Eric Aumonier, A.H. Gerrard, and F. Rabinovitch were asked to do eight reliefs of horizontal figures, representing the four winds, for the central tower of the building. Gill carved three of them; the other five sculptors each did one.

Moore was somewhat reluctant to accept his first public commission. Relief sculpture was the antithesis of the full spatial richness for which he was striving in his own work. But Holden was very persuasive, and Moore began a series of preparatory drawings in the *Sketchbook 1928: The North Wind Relief.* In the first twenty pages of this sketchbook, the static poses and simplified naturalism of the figures (fig. 14) are reminiscent of some of the life drawings of the period and of the cast concrete *Reclining Woman* of 1927 (LH 43). These studies were superseded by drawings showing the reclining figure in motion, in keeping with the subject of the commission, a relief personifying the north wind (LH 58; fig. 15).

None of the many studies of reclining figures in the sketchbook was used as the definitive drawing for the Portland stone carving. In addition to the sketchbook (owned by the HMF), three large drawings and two smaller sheets of studies are known: this drawing (no. 22), one in the collection of the Arts Council of Great Britain, signed and dated

Fig. 14 Page 17 from *Sketchbook 1928: The North Wind Relief* (detail) 1928
Henry Moore Foundation

Ideas for North Wind Relief 1928 (verso)
Pen and ink

Moore 27, and the remainder, includ-
ing the two smaller sheets, belonging
to the H M F. No. 22 includes the study
at lower left in which the definitive
pose for the relief is established.

The numerous sketchbook studies
for *North Wind*, as well as the larger
drawings, which comprise well over
one hundred sheets of studies of
reclining figures, mark the beginning
of Moore's obsession with this
motive. He had made, it is true, a
number of drawings of reclining fig-
ures in Notebooks 2–6, as well as five
earlier sculptures of this theme (LH
24, 30, 31, 38, and 43). But with the
profusion of studies for *North Wind*,
the subject seems to have taken hold.
Moore has explained the importance
of the reclining figure as one of the
dominant themes in his work:

The vital thing for an artist is to have a
subject that allows [him] to try out all
kinds of formal ideas — things that he
doesn't yet know about for certain but
wants to experiment with, as Cézanne
did in his *Bathers* series. In my case the
reclining figure provides chances of that
sort. The subject matter is *given*. It's
settled for you, and you know it and like
it, so that within it, within the subject
that you've done a dozen times before,
you are free to invent a completely new
form-idea.[7]

By March 1929, when he began work
on the Leeds *Reclining Figure* (LH
59; fig. 16), it is evident that Moore
had found his subject: "The subject
matter is given."

Fig. 15 *North Wind* 1928 / 29
Headquarters of London Transport

THESE STUDIES for the *North
Wind* relief are similar to those on
the recto. It is interesting to note,
in some of the spaces between the
reclining figures, the groups of small,
non-figurative, block-like forms and
L-shaped lines intersecting each other
at right angles. It is as if Moore was
consciously forcing himself to adopt a
more angular, geometrical approach.
This is also reflected in several of
the figurative passages: the series of
right angles of the head and cubic
bun of hair just left of centre in the
overlapping reclining figure, at the
bottom of the sheet, and the horizon-
tal rectangles of the figure second
from the top of the page. One is
reminded of Gaudier-Brzeska's
remark about drawings such as
Standing Nude 1912: "I draw square
boxes altering the size, one for each
plane, and then suddenly by drawing
a few lines between the boxes they
can see the statue appear."[8]

23 *Study for Leeds "Reclining Figure"* 1928
Pencil (the figure has been cut out and mounted),
12.1 × 18.1 cm mount size; L 14.5 cm image size
Inscr. lower right *Moore 28* (recent)
Gift of Henry Moore, 1974

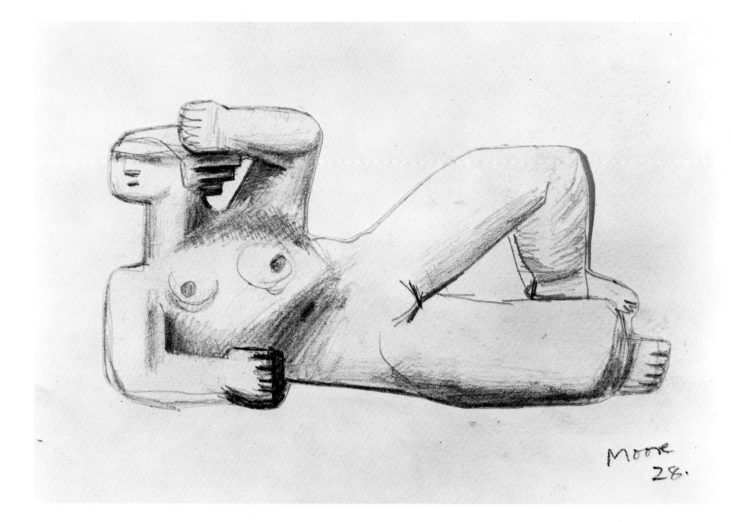

THIS DRAWING, without doubt
the most important study for sculp-
ture in the collection, is the definitive
drawing for the brown Hornton stone
Reclining Figure of 1929 (LH 59;
fig. 16) in the Leeds City Art Galler-
ies. This carving was the first sculp-
ture to show the influence of the
eleventh–twelfth century Toltec-
Maya *Chac Mool* (fig. 17), which
Moore has described as "undoubtedly
the one sculpture which most influ-
enced my early work." This drawing
and related material are discussed
in detail in Wilkinson, 1977, no. 80.

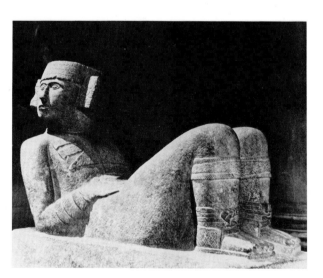

Fig. 17 *Chac Mool* AD eleventh–twelfth century
Toltec-Maya, from Chichen Itzá
Museo Nacional de Antropología, Mexico City

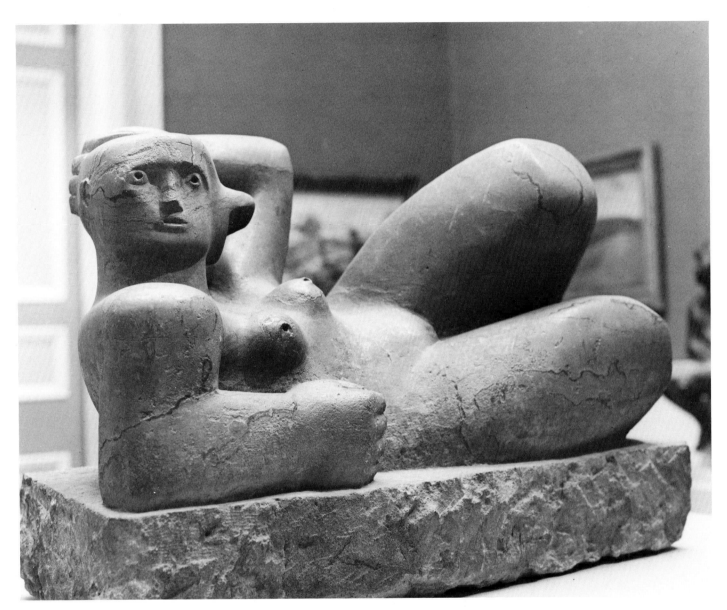

Fig. 16 *Reclining Figure* 1929
Leeds City Art Galleries

24 *Ideas for Sculpture: Masks* c. 1929
Pencil, 13.3 × 13.8 cm
Inscr. lower right *Moore 29* (recent)
Gift of Henry Moore, 1974

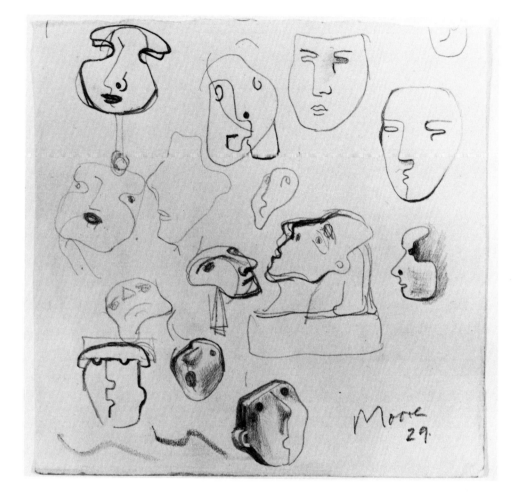

IN VOLUME I of the Lund Humphries catalogue of Moore's sculpture, eight masks are listed for the years 1928–29. For the previous seven years only four masks are catalogued. Moore's interest in this subject in the late 1920s may well have been stimulated by a book he acquired in 1928, *L'Art précolombien* by Adolphe Basler and Ernest Brummer (Paris 1928), which includes numerous illustrations of masks. As well as the eight masks Moore executed in 1928–29,

the heads in several carvings of the period, for example the Leeds and Ottawa reclining figures, and in some of the life drawings of 1929–30 (Wilkinson, 1977, nos. 45 and 48) have mask-like features.

In addition to the Toronto drawing, two related studies of heads and masks are known: *Drawing for Mask Carving* of c. 1929, in a private collection, and *Studies of Heads* of c. 1929, Staatsgalerie, Stuttgart.

25 *Drawing for Sculpture: Mother and Child c. 1929*
Pencil, ink and brush, 19.8 × 14.8 cm
Gift of Henry Moore, 1974

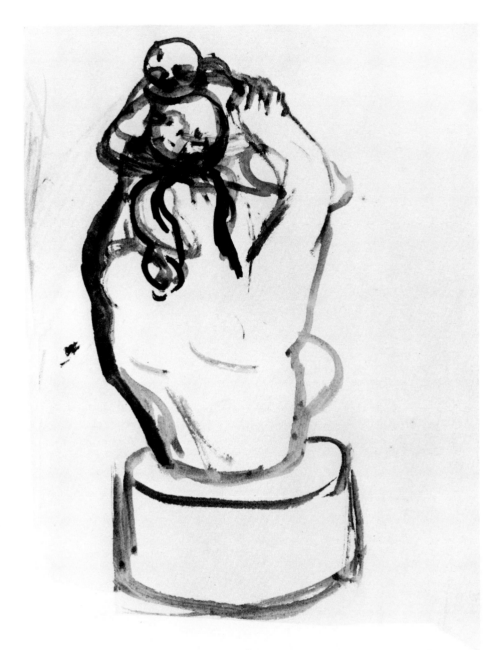

AS JOHN RUSSELL has written, "The period of 1929–39 is rich, as will be seen, in brief obsessions of the kind that had to be worked through and got out of the way. But the obsession with the Reclining Figure has stayed with Moore forever."[9] The same is true of the mother-and-child theme.[10]

No. 25 is probably a fragment cut from a sketchbook page, possibly to use in a montage (see no. 26). In subject matter and technique it is closely related to the study at lower right in *Montage of Mother and Child Studies* of c. 1929–30, no. 26. Moore's interest in the mother-and-child theme was particularly strong from 1929–31 when he produced twelve carvings of this subject.

26 *Montage of Mother and Child Studies* c. 1929–30
Pencil, pen and ink, brush and ink, chalk, coloured washes, 80 × 70 cm
Inscr. lower right *Moore*; at bottom centre *To Joseph from Henry*;
below this in Irina Moore's hand *Montage by Irena*, Purchase, 1976

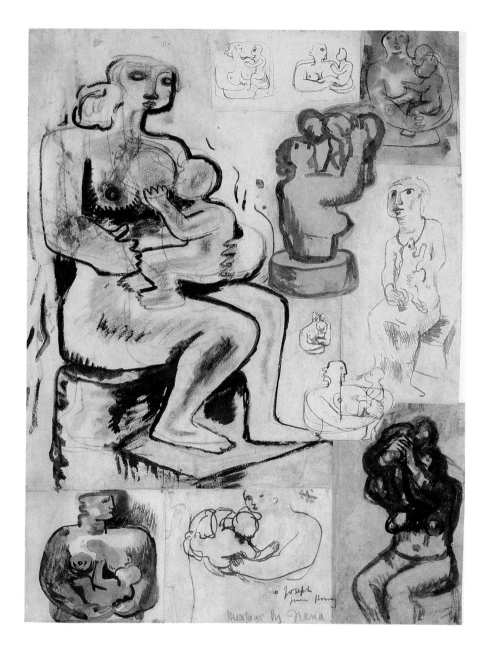

THIS IS the only known montage of mother-and-child studies, and the first montage to be assembled by the artist's wife, Irina[11] (spelt "Irena" in the inscription in her hand at the bottom of the sheet). She cut from Moore's notebooks all but the largest of the small mother-and-child studies shown here and arranged them in their present order before pasting them down on a board. The big seated mother and child, which is much larger than the dimensions of any of the surviving notebooks of the 1920s, is related to but not the definitive study for the green Hornton stone *Mother and Child* of 1932 (LH 121). The sketch at lower left is the study for the small *verde di prato Mother and Child* of 1929 (LH 75; fig. 18). Of the three small sketches at the top of the drawing, the central pen-and-ink study is for the Ancaster stone *Mother and Child* of 1930 (LH 82; fig. 19). Not all the drawings were done at the same time. For example, the two studies of the mother holding the child above her head are stylistically related to a number of drawings of 1925–26, such as *Three Studies for Sculpture* (signed and dated 1926) in the British Museum, whereas the studies for LH 75 and 82 date from 1929–30.

Four other early montages are known: *Studies for Sculpture: Reclining Figures*, c. 1930, National Gallery of Victoria (Wilkinson, 1977, no. 86); *Montage of Reclining Figures and Ideas for Sculpture* of 1932, in a private collection; *Montage of Reclining Figures* of 1933, LH vol. 1, page 187, in a private collection in Australia and not, as stated, in the National Gallery of Victoria, Melbourne; and *Montage of Ideas for Sculpture* of 1933, in a private collection.

27 *Transformation Drawing: Ideas for Sculpture* 1930
Pencil, brush and ink, 20 × 23.8 cm
Inscr. lower left *Moore 30* (probably recent);
upper left, page inverted, *head*; beside this *hair*;
upper right *1* [?] *1¼/10*; centre right *Reclining figures*
Gift of Henry Moore, 1974

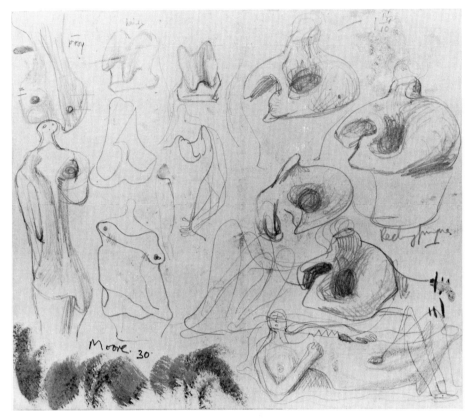

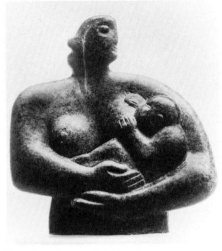

Fig. 18 *Mother and Child* 1929
Private collection

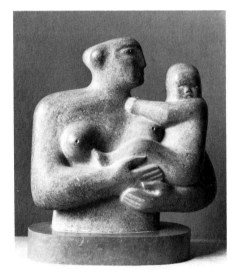

Fig. 19 *Mother and Child* 1930
Private collection PHOTO: Alfred Cracknell

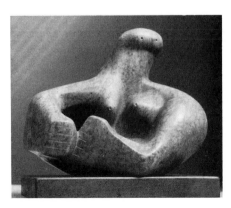

Fig. 20 *Composition* 1931
Private collection

THE EARLIEST VISUAL RECORD of Moore's interest in natural forms is the inscription, surrounded by what is probably an outline of a pebble, "remember pebbles on beach," which appears on the inside front cover of No. 6 Notebook of 1926. On his frequent visits to the Natural History Museum in London, he often took a sketchbook and made drawings of bone and shell samples. The drawings of natural forms comprise two types. There are straightforward sketches, such as *Studies of Lobster Claw* of 1932 (Wilkinson, 1977, no. 92), made without altering the forms of the objects drawn. Far more important are the studies in which the original shape of the bone, pebble, shell, or flint stone has been altered. In these drawings Moore began by sketching the natural forms and then proceeded to transform the organic shapes into human forms. This process is well illustrated in this drawing, one of the earliest known transformation studies. At upper left, the sketch of a bone is inscribed *head*. Below this, Moore has transformed another bone into a standing figure. It is interesting to follow the original outlines of the natural forms and work out the additions — in this example the small head, the left and possibly the right arm, and the bottom portion of the figure. The reclining figure at the bottom of the page would appear to have evolved from a jaw-bone. The four studies above this are for the Cumberland alabaster *Composition* of 1931 (LH 102; fig. 20). A drawing in the HMF *Page from Sketchbook: Bone Forms and Reclining Figures* of 1930, is closely related to no. 27. For other transformation drawings see nos. 31–33.

28 *Ideas for Sculpture* 1930 (recto)
Pen and ink, 18.1 × 11.4 cm
Inscr. lower left *Moore 30*
Gift of Henry Moore, 1974

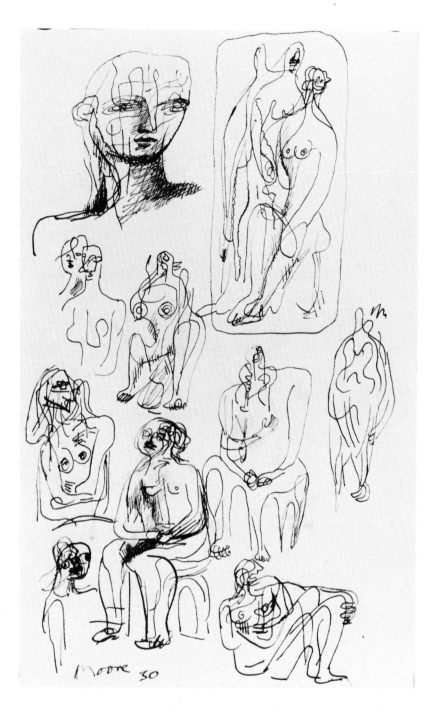

WORKS LIKE THIS DRAWING, the Hornton stone *Composition* of (LH 99) and the preparatory studies for it (Wilkinson, 1977, no. 88) mark an abrupt change in direction in Moore's approach to the human figure. His work of the previous decade had been enriched by his study of Egyptian, Archaic Greek, Etruscan, pre-Columbian, and African sculpture in the British Museum, and by the books he had read on the history of world sculpture. Two major carvings, the Leeds *Reclining Figure* of 1929 (fig. 16) and the *Reclining Woman* of 1930, in the National Gallery of Canada, may be said to mark the culmination of Moore's forma-tive years. The radical change in direction in Moore's art in the early 1930s, as reflected in the present drawing and in the 1931 *Composition*, was provoked by the work of his contemporaries in Paris — Arp, Giacometti, and above all Picasso. Moore's association with the Surrealist movement liberated his imagination in the direction of a more elusive, more evocative organic abstraction.

No. 28 may well reflect the influence of André Masson's automatic drawings, which were begun, as William S. Rubin has written, "with no subject or compositional distribution in mind. Letting his pen travel rapidly across the paper in a mediumist fashion, he soon found hints of images — anatomical fragments and objects — manifesting themselves within the 'abstract' web."[12] Compare this to Moore's own explanation of his working method, in which he would begin drawing "with no preconceived problem to solve, with only the desire to use pencil on paper, and make lines, tones and shapes with no conscious aim; but as my mind takes in what is so produced, a point arrives where some idea becomes conscious and crystallises, and then a control and ordering begin to take place."[13] Whereas in Masson's automatic drawings there are often only the most tenuous suggestions of concrete images of objects or figurative elements, in Moore's work the "lines, tones and shapes" seem to be wilfully controlled and directed, so that the final outcome results in figurative images. For example, in no. 28, the meandering, swirling lines of the figure group within the rectangular frame have much of the freedom and spontaneity of Masson's automatic drawings but, as Moore has written, the ideas have become conscious and crystallized.

Five Studies 1930 (verso)
Pen and ink

29 *Page from No. 1 Drawing Book: Ideas for Mother and Child* 1930
Pencil, 20.2 × 16 cm
Inscr. lower left *This afternoon mothers & children / & animals*; lower right *Do this morning / some top halves / for large things / Like bone one / & perhaps some heads*
Gift of Henry Moore, 1974

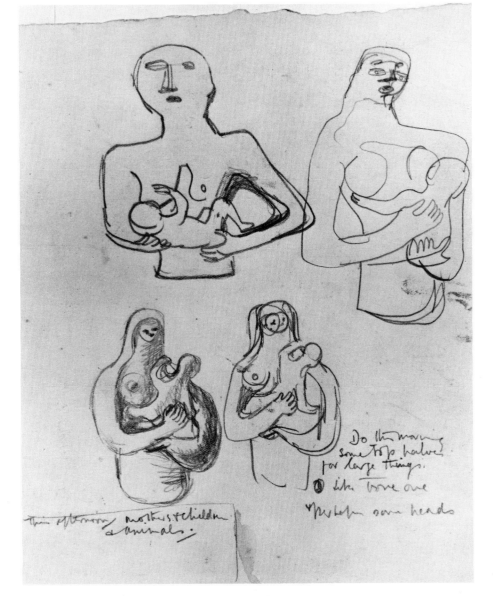

WHEN SHOWN these studies, Moore identified the large sketch at centre as an animal form. The others are possibly room plans.

THIS SHEET, one of many drawings of the period of the mother-and-child theme, includes at upper left the study for the Burgundy stone *Mother and Child* of early 1931 (LH 100; fig. 21).

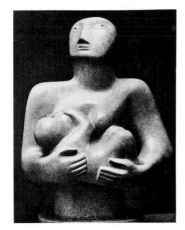

Fig. 21 *Mother and Child* 1931
Private collection

30 *Education Projects and Study for St. Louis "Reclining
Figure" c.* 1932 (recto)
Pencil, 19.7 × 18 cm
Inscr. below three compositions at top of the sheet:
*Education brings poise & balance / learning & wisdom /
or something connected with life*; in central composition,
upper centre: *(12x − y + 2b)*
Gift of Henry Moore, 1974

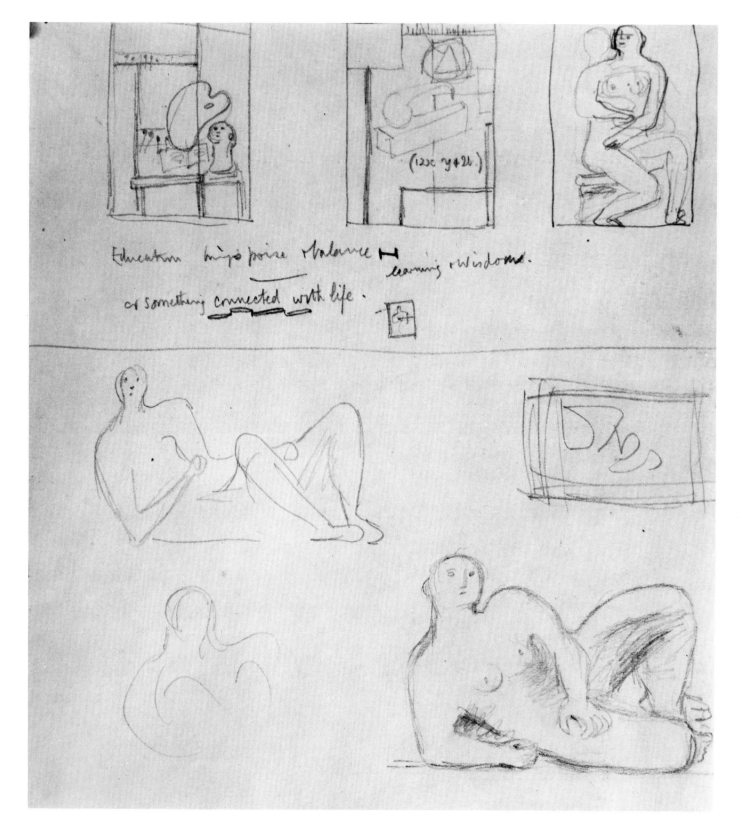

Ideas for Sculpture c. 1932 (verso)
Pencil

◄

THE STUDY at lower right is the definitive drawing for the carved reinforced-concrete *Reclining Figure* of 1932 in the City Art Museum, St. Louis (LH 122; fig. 22).

The three compositions at the top of this sheet are connected, as the inscriptions below them indicate, with the theme of education. Possibly these studies were made much later than the reclining figures on the bottom half of the sheet, in connection with the relief sculptures for the Senate House of the University of London (see no. 46).[14] The seated figure at upper right is closely related to the preparatory drawings for this project (fig. 40).

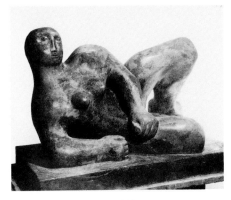

Fig. 22 *Reclining Figure* 1932
City Art Museum, St. Louis, Mo.

THIS SHEET includes series of half figures and heads, and a small reclining figure inscribed in a rectangular frame. Of particular interest is the linear network of lines and dots within the outlines of some of the forms. In the half figure at upper left, the two heavy dots, representing the eyes, are joined by a single straight line. In the head of the figure to the right of this, four dots in the head area are likewise joined by four straight lines. This line-and-dot technique is almost certainly derived from Picasso's pen-and-ink drawings of 1924 (Zervos V, 276–79) and is

discussed in more detail in the notes on *Page from Shiny Notebook 1933–35: Ideas for Reliefs* of c. 1934, no. 38 (see also fig. 30).

31 *Transformation Drawing* 1932 (recto)
Pencil, 23.8 × 19.8 cm
Inscr. lower left *Moore 32* (recent)
Gift of Henry Moore, 1978

*Transformation Drawing and Study
for "Composition"* 1932 (verso)
Pencil and chalk

NO. 31 COMPRISES three cut-outs,
possibly from different notebooks.
The natural forms appear to be bones,
which, as in no. 27, have been trans-
formed into human forms (see notes
for no. 27).

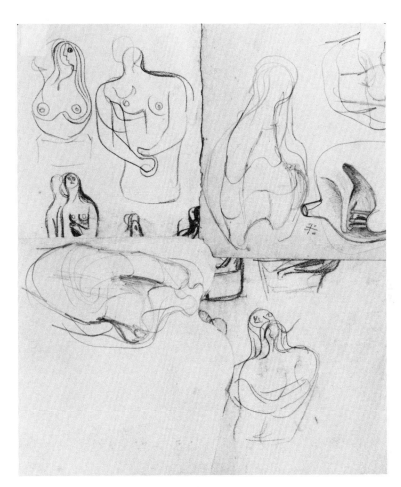

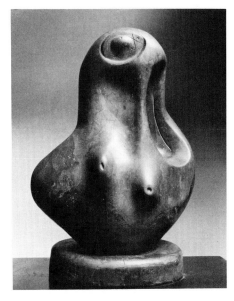

Fig. 23 *Composition* 1933
British Council, London

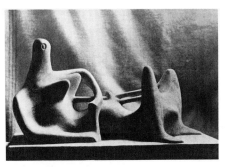

Fig. 24 *Reclining Figure* 1933
Washington University, St. Louis, Mo.

THIS SHEET includes at upper left
the sketch for the carved concrete
Composition of 1933 in the collection
of the British Council (LH 133;
fig. 23). The profile of the head
appears in the sculpture as incised
lines, foreshadowing Moore's carvings
of the mid-1930s, such as two works
of 1934, *Two Forms* (LH 146; fig. 38)
and *Four Piece Composition: Reclin-
ing Figure* (LH 154; fig. 34). Similar
incised lines are found in Hepworth's
carvings of the period, such as *Sculp-
ture with Profiles* of 1932. Just above
centre right, with the page turned
ninety degrees to the right, is a study
of a half figure. The three parallel
bars or struts that cut across the hol-
lowed-out area and connect the small
arm with the lower portion of the
figure are features found in the sculp-
ture *Reclining Figure* of 1933 (LH

134; fig. 24). These structural sup-
ports are distinctly reminiscent of
Giacometti's *Reclining Woman Who
Dreams* of 1929. (See also no. 44.)
To the left of the small, tubular head
is an X surrounded by four dots, an
indication that Moore considered this
study of particular interest. Of the
hundreds of sketches in the note-
books, only a relatively small number
were destined to be translated into
three dimensions. By marking certain
sketches with an X, Moore high-
lighted the best of the sculptural
ideas, possible candidates later to be
realized in three dimensions.

A larger version of this half figure
appears in *Studies for Sculpture* of
1932 (Christie's, Tuesday, December
5, 1978, lot 180).

32 *Transformation Drawing: Ideas for Sculpture c.* 1932
Pencil, 17.5 × 11.1 cm
Gift of Henry Moore, 1974

33 *Ideas for Sculpture (New Ireland)* 1932
Pencil, 24.1 × 17.9 cm
Inscr. lower right *Moore 32* (recent);
below study at centre right *hole / through*;
above drawing at centre *New Ireland*
Gift of Henry Moore, 1974

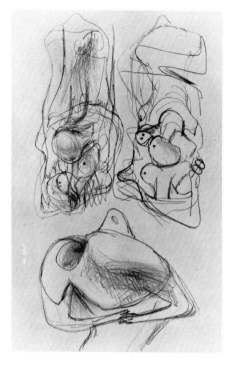

IN THE HALF FIGURE at the bottom of the sheet, one can clearly see the outline of the natural form before the additions of the small head, thin arms, and waist. Above and to the right of this, with the page turned 90 degrees to the right, is a more complex image of a reclining figure, in which it is far more difficult to isolate and locate the natural form. The small head with two eyes near the centre of the reclining figure suggests a child nestled around the breasts of the mother. To read the third study the page should be turned 180 degrees. Here can just be seen the outlines of an object on which figurative elements — head, breast, and arms — have been imposed. Directly below the head, the circular shape near the breast and the suggestion of an arm clearly depict the form of a child.

MOORE SAID that the sketch below the *New Ireland* inscription was not based on an actual carving, but rather reminded him of the way New Ireland carvers "made forms inside another form — enclosed." A work such as the 1939 *Bird Basket* (LH 205) was directly inspired by New Ireland sculpture, of which Moore has written: "Yet the carvings of New Ireland have, besides their vicious kind of vitality, a unique spatial sense, a bird-in-a-cage form."[15]

34 *Figure Studies* 1933
Pencil, pen and ink, chalk and wash,
38 × 56.7 cm
Inscr. lower right *Moore 33*
Purchase, 1976

THIS DELICATE and sensitive
drawing includes the major motives
of Moore's figurative work: standing,
sitting, and reclining figures, and
the mother-and-child theme. At
centre, two groups of four women sit
facing each other, as if attending a
ritualistic gathering. At upper left,
the three figures standing behind a
reclining woman anticipate the
three-figure compositions of the
1940s, culminating in *Three Standing
Figures* of 1947–48, in Battersea Park,
London (LH 268). The diagonal
brushstrokes are found in a number
of other drawings of 1933: no. 35;
Drawing for Sculpture (Wilkinson,
1977, no. 98); *Studies for Female
Figure*, Tel Aviv Museum, Israel;
Reclining Figures, private collection,
South Africa.

35 *Mother and Child Studies* c. 1933
Pencil, pen and ink, and wash,
30.6 × 24.9 cm
Inscr. lower left *Moore*
Gift of Henry Moore, 1974

36 *Ideas for Sculpture: Studies for "Two Forms" and "Carving"* 1934 (recto)
Pencil, 19.7 × 17.8 cm
Inscr. top of sheet *Symbolic / Humanitarian ideas*; below this *th ...* [theme?]
Gift of Henry Moore, 1974

◄

THE COMPOSITIONAL FORMAT
of the drawing, with a large mother-
and-child study filling most of the
sheet and much smaller sketches of
the same subject down the right and
left sides, is closely related to two
other drawings of 1933: *Reclining
Figure and Ideas for Sculpture* (Wil-
kinson, 1977, no. 94) and *Mother and
Child: Ten Studies* (Wilkinson, 1977,
no. 96). In the notes for no. 28,
Moore describes one method of gen-
erating ideas for sculpture — a kind
of automatism. The present draw-
ing clearly exemplifies a second
approach, which he describes as
follows:

Early in the morning I used to find one
would start off with a definite idea, that,
for instance, it was a seated figure I
wanted to do. That in itself would lead
to a lot of variations of the seated figure;
you would give yourself a theme and
then let the variations come, and choose
from those which one seemed the best.[16]

IN 1934, a year of cardinal impor-
tance in Moore's development, he
executed a series of two-, three-,
and four-piece compositions (LH 140
and 149–54). Some are clearly com-
posed of individual forms that are
organically related parts of a single
figure; others represent dismembered
elements of a single human figure
(fig. 34). These carvings have much
in common with such works as Arp's
Bell and Navel of 1931, Giacometti's
Project for a Square of 1931,
Suspended Ball of 1930–31, and
Woman with Her Throat Cut of 1932.
(Moore's *Composition* of 1934, LH 140,
appears to have been directly inspired
by the latter.) The Moore carvings

are also related in a general way to
Picasso's drawings of the summer
of 1928, such as Zervos VII, 203.

This drawing (no. 36) includes, to
the immediate left of the seated
woman holding a child, the sketch
for the pynkado wood *Two Forms* of
1934, in the Museum of Modern Art,
New York (LH 153; fig. 25). The title
of this sculpture, as with many carv-
ings of the 1930s, offers no assistance
in interpreting the subject. When
confronted with Moore's seemingly
abstract work of the mid-1930s it
is worth keeping in mind a statement
he made in 1937:

Each particular carving I make takes on

Fig. 25 *Two Forms* 1934
Museum of Modern Art, New York
PHOTO: Errol Jackson

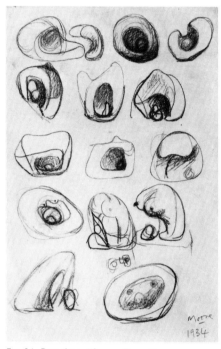

Fig. 26 *Page from "Square Forms"
Sketchbook* 1934
Private collection

in my mind a human or occasionally animal character and personality, and this personality controls its design and formal qualities, and makes me satisfied or dissatisfied with the work as it develops.[17]

It was in this respect that Moore's art differed from Barbara Hepworth's sculpture of the mid-1930s. During this period, as Alan Bowness has pointed out, she created "pure abstract forms that existed in their own right without reference to anything outside themselves."[18] Moore's work never reached such total abstraction.

Another sheet of studies related to the 1934 *Two Forms* (LH 153) leaves us in no doubt that the mother-and-child theme was the human character that controlled the design and formal qualities. *Page from "Square Forms" Sketchbook* of 1934 (fig. 26) includes studies of the mother-and-child theme. Two of the studies show a torso with full, swelling breasts arching above the small embryonic form of the child. In the Toronto drawing, the definitive study for *Two Forms* uses this basic relationship of a large and small form, but on a more abstract level. The hole is indicated through the larger form, which appears to protect and shelter the embryo, yet simultaneously evokes feelings of menace, with associations of a devouring orifice.

In 1937 Moore wrote: "My sculpture is becoming less representational, less an outward visual copy, and so what some people would call more abstract; but only because I believe that in this way I can present the human psychological content of my work with the greatest directness and intensity."[19]

Far from being an outward visual copy, *Two Forms* should be read, as Moore wrote at the top of the Toronto drawing, on a "symbolic" level. Years later he wrote of the

carving: "Perhaps it can be thought of as a Mother and Child. I just called it *Two Forms*. The bigger form has a kind of pelvic shape in it and the smaller form is like the big head of a child."[20]

A large finished drawing of studies of two-piece compositions is the 1934 *Ideas for Two Piece Composition*, Rijksmuseum Kröller-Müller, Otterlo (see notes for this drawing in Wilkinson, 1977, no. 101).

At bottom centre is the sketch for *Carving*, also of 1934 (LH 148; fig. 27). Another sketch for or closely related to LH 148 appears above centre in *Drawing for Carving* of 1934 (HMF). The drawing for a two-piece carving, directly above the sketch for LH 148 in no. 36, is closely related to the Cumberland alabaster *Head and Ball* of 1934 (LH 151; fig. 28). Moore pointed out the similarity between the seated mother and child just below centre and the 1932 green Hornton stone *Mother and Child* (LH 121), which was, however, made several years before this drawing.

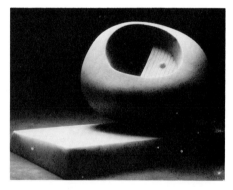

Fig. 27 *Carving* 1934
Destroyed

Ideas for Sculpture: Study for "Mother and Child" 1934 (verso)
Pencil
Inscr. at top of sheet *Both for grown ups and children and anyhow in time the children / will grow up, though its reall* [these two words crossed out] *children not having such fixed opinions are likely to accept and respond /directly to a new conception before* [crossed out] *than adults will* [crossed out]; above study top row centre *Balance*

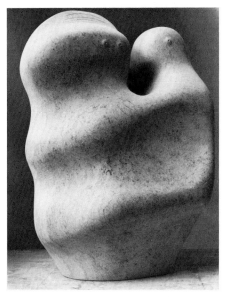

◀ THE SKETCH at centre right is the drawing for the Ancaster stone *Mother and Child* of 1936 in the collection of the British Council (LH 165; fig. 29).

Fig. 29 *Mother and Child* 1936
British Council, London

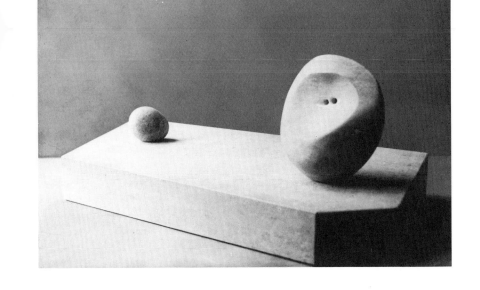

Fig. 28 *Head and Ball* 1934
Private collection

37 *Reclining Figures* 1933
Pencil, pen and ink, chalk and wash,
37.1 × 27.1 cm
Inscr. lower right *Moore 33* (recent)
Purchase, 1974

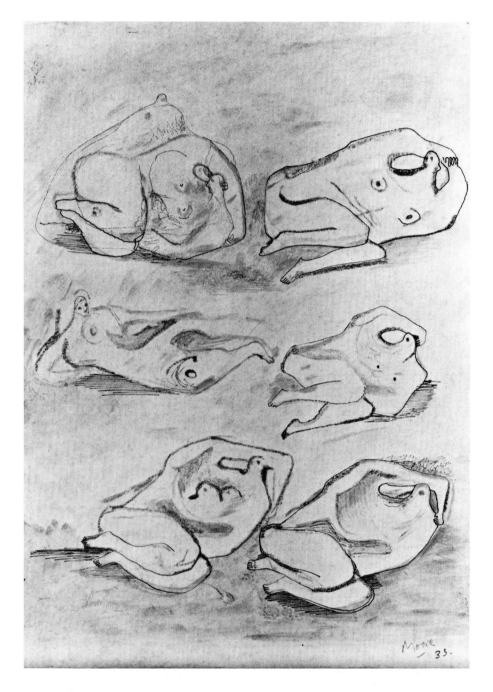

IN THIS UNUSUAL DRAWING,
the reclining figures, with the
legs atypically drawn into the body, seem
to have been flattened into thin reliefs
against the background of the paper.
The tiny heads contrast with the
wide, expanded bodies. The chest of
the figure at lower right appears hol-
lowed out and concave, as if eroded
by the sea. At upper left the bunched,
reclining nude seems to be resting
against or superimposed over an
enormous breast form.

38 *Page from Shiny Notebook 1933–35: Ideas for Reliefs c.* 1934
Pen and ink, 24.1 × 18.1 cm Inscr. top centre *A Sheet for Reliefs* (in pencil)
Gift of Henry Moore, 1974

Fig. 30 Pablo Picasso *Musical Instruments* 1924
Private collection © Picasso 1987/Vis-Art

WHEREAS the linear incisions on certain of Moore's carvings of the mid-1930s (LH 164 and 167) have affinities with the paintings and reliefs of Ben Nicholson, there can be little doubt that this drawing was directly inspired by Picasso's 1924 pen-and-ink drawings illustrating Balzac's *Le Chef-d'oeuvre inconnu* (fig. 30), which Alfred Barr has described as "constellations of dots connected by lines or, better, lines with dots where the lines cross or end."[21] No. 38 includes abstract designs for reliefs as well as figurative elements. The study at left, second row from the top, suggests two heads in lively conversation and linked by the lines connecting the small circles and dots. At upper left is a reclining figure. The study at left, second row from the bottom, might be suitably realized as a wire sculpture and may owe a debt to Picasso's iron wire *Construction* of 1928 (Alfred H. Barr, *Picasso: Fifty Years of His Art*, New York, 1966, p. 153). Although no. 38 was made several years after the two reliefs of 1931 (see nos. 75 and 76), several compositions, such as the one at lower left, are reminiscent of them.

Other line-and-dot drawings closely related to no. 38 are *Ideas for Relief Sculpture* of 1934 (recto and verso) and *Page from Shiny Notebook: Ideas for Reliefs* (recto), both in the HMF. No. 38 is the only known separate sheet from the 1933–35 Shiny Notebook in the HMF.

39 *Study for Recumbent Figure* 1934
Chalk, brush and ink and wash,
27.7 × 38.7 cm
Inscr. lower left *Moore 34*
Gift from the Junior Women's Committee Fund, 1961

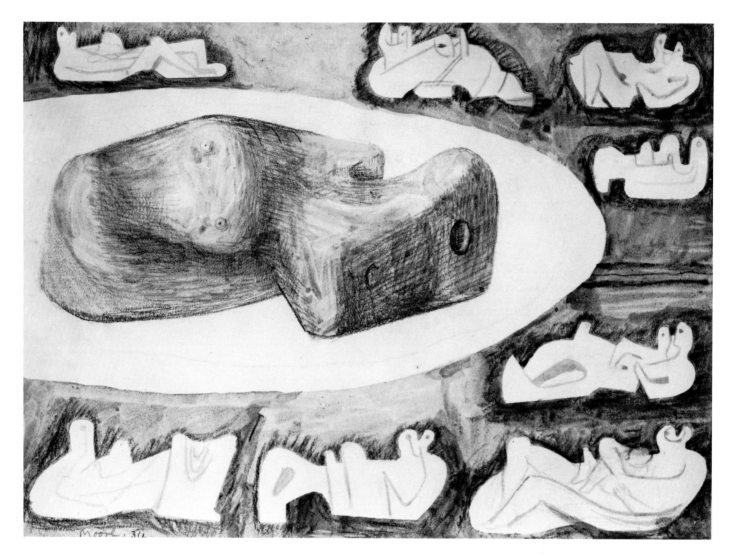

THE STRANGE FORM floating in the empty oval space is suggestive of a primordial creature long extinct. As in many of Moore's most abstract works of the mid-1930s, there are clues that suggest the animal or human world — in this form, the small eyes. In *Studies for Sculpture* of 1934, in the Museum of Modern Art, New York, the modelled, sculptural forms are related to the central image in the Toronto drawing (see 1977 Paris catalogue, no. 144). In no. 39, reclining figures surround the central image on three sides. At lower right a child is held firmly in its mother's arms.

40 *Ideas for Metal Sculpture* 1934
Pen and ink, chalk and washes,
27.9 × 63 cm
Inscr. lower right *Moore 34* (probably recent)
Gift of Henry Moore, 1974

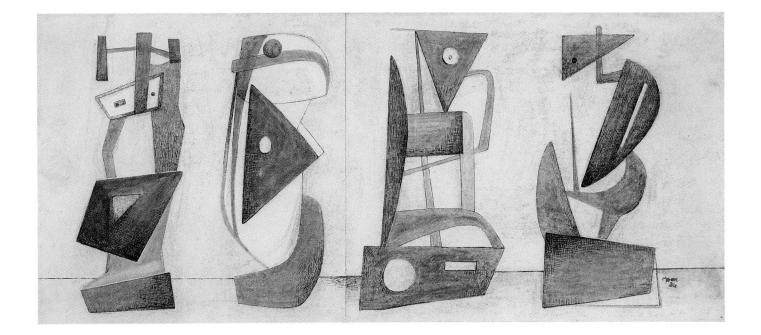

THESE FOUR CONSTRUCTIONS
(on two sheets), reminiscent of the
welded metal forms in contemporary
sculpture, reflect the continued influ-
ence of Picasso, in particular *An
Anatomy* of 1932 (fig. 31). The Moore
forms are, however, more mechani-
cal, with none of the highly charged,
sometimes witty sexuality found in
the Picasso figures.

The two forms in the right sheet
in no. 40 were based on the two right-
hand studies, bottom row, in *Ideas
for Metal Sculpture* of 1934 (fig. 32,
private collection). Doubtless the
two forms in the left sheet were based
on similar smaller drawings. In fig. 32,
the arrangement of three horizontal
rows of studies is another feature
reminiscent of the regular ordering of
the forms in Picasso's *An Anatomy*
(fig. 31). *Drawing for Metal Sculp-
ture*, also of 1934 (private collection),
contains two large studies that are
closely related to those in the
Toronto drawing.

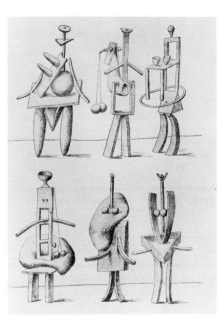

Fig. 31 Pablo Picasso *Page from "An Anatomy"*
(detail) 1932
Private collection © Picasso 1987/Vis-Art

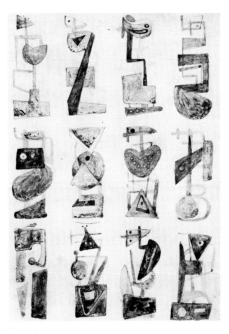

Fig. 32 *Ideas for Metal Sculpture* 1934
Private collection

41 *Ideas for Sculpture: Studies for "Four Piece Composition: Reclining Figure"* 1934
Pencil and charcoal, 20 × 26.7 cm
Inscr. lower right *Moore 34* (recent)
Gift of Henry Moore, 1974

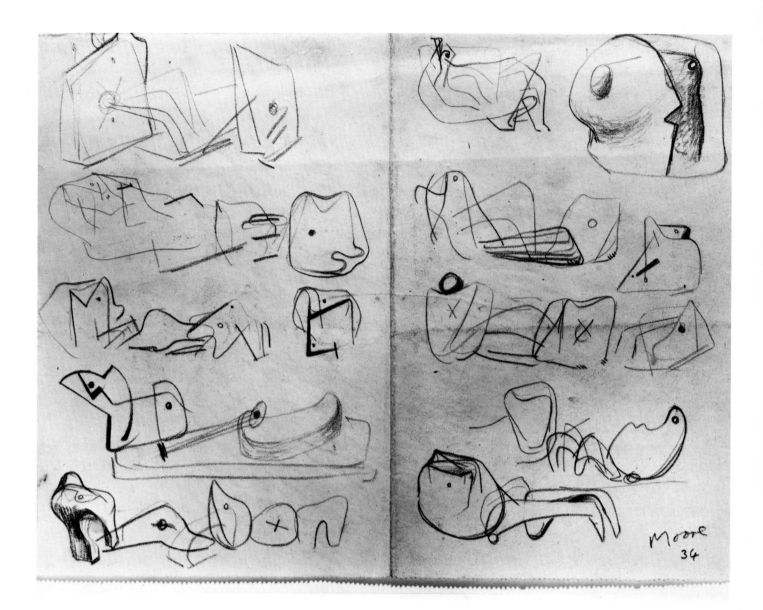

THIS IS one of two known sheets of sketchbook studies directly related to the Cumberland alabaster *Four Piece Composition: Reclining Figure* of 1934 (LH 154; fig. 34), in the Tate Gallery. Few preparatory drawings are more revealing of the genesis and evolution of a sculpture than these fascinating studies for one of Moore's finest carvings of the mid-1930s. The larger of the two drawings directly related to the sculpture is *Sheet of*

Studies for Several Piece Composition of 1934, fig. 35 (see Wilkinson, 1977, no. 102). This shows the way in which Moore made separate studies of the various dismembered parts of the human anatomy he intended to use — the head, body, and legs — before assembling them to form a multi-part composition. At the top of the upper right quarter of the sheet the inscription reads *Head end of several piece*; at the top of the lower

left quarter the inscription reads *Legs for several piece sculpture*. Above the three rows of studies at the bottom of the lower left quarter, the inscription states *body and one leg or body alone*. From these sketches it appears that Moore was considering making a three-part composition of a head, body, and leg section. However, in the compositional studies in the upper left quarter of the sheet, in which the component parts are

brought together and arranged on a base, three of the six studies include an additional small, circular form that was included in the carving itself.

Like the compositional studies at upper left in fig. 35, the Toronto drawing no. 41 shows the various body images brought together to form several-part reclining figures. The sketch to the left of the signature is the closest to the Tate carving, although in the latter one of the arched forms rests on its side (fig. 34). Here the small, circular shape is lodged between the head form at left and the leg form, whereas in the reclining figure at the centre of this half of the sheet it rests in the concave area at the top of the head.

For a more detailed analysis of the Tate carving and the related drawings see Richard Morphet's article "Four Piece Composition: Reclining Figure," in *The Tate Gallery 1976–8 Illustrated Catalogue of Acquisitions.*

In 1934 Moore also made a number of drawings of ideas for several-piece wood constructions, of which four sheets are known. Moore told the author that he did several

wooden sculptures of this kind, but none has survived. Two large finished drawings are also related to the Tate carving: *Reclining Figure* of 1933 (Wilkinson, 1977, no. 99) and *Study for Reclining Figure as a Four Piece Composition* of 1934 (LH vol. 1, p. 192).

The head at upper right is the drawing for the Hopton-wood stone *Head* of c. 1935 (LH 163; fig. 33).

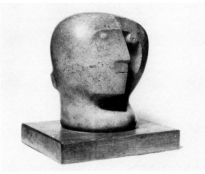

Fig. 33 *Head* c.1935
Private collection

Fig. 34 *Four Piece Composition: Reclining Figure* 1934
Trustees of the Tate Gallery, London

Fig. 35 *Sheet of Studies for Several Piece Composition* 1934
Henry Moore Foundation

42 *Page from Square Forms Sketch-book: Study for "Mother and Child"* 1934 (recto)
Pencil, 27.3 × 18.3 cm
Gift of Henry Moore, 1974

THIS SHEET includes, just below centre, the drawing for the green Hornton stone *Mother and Child* of 1936 in the collection of Leeds City Art Galleries (LH 171; fig. 36). The shaded sketch at the top of the sheet, just right of centre, is related in a general way to the white marble *Sculpture* of 1935 (LH 161), although it does not appear to be the definitive drawing for the carving.

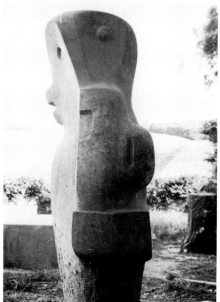

Fig. 36 *Mother and Child* 1936
Leeds City Art Galleries

*Page from Square Forms
Sketchbook* 1934 (verso)
Pencil and chalk

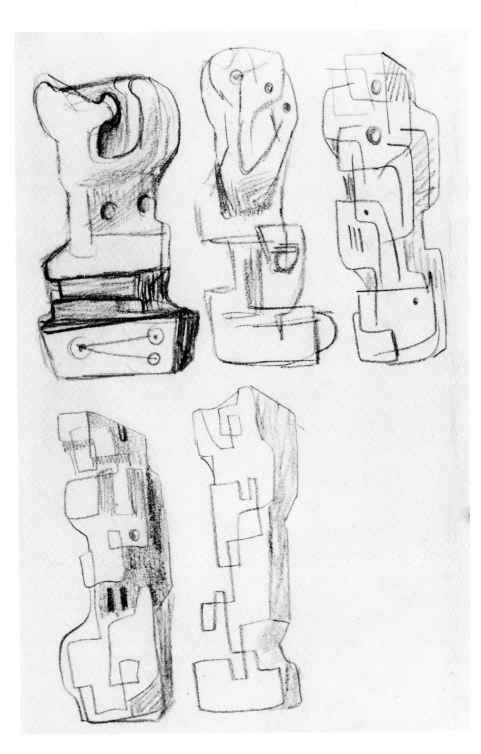

MOORE'S SQUARE-FORM draw-
ings and sculpture of the mid-1930s
run parallel to Nicholson's white
reliefs and paintings of the period.
In the travertine marble *Carving* of
c. 1936 (LH 164; fig. 37), the incised
circles and L-shaped relief have
obvious affinities with such works by
Nicholson as *White Relief: Circle
and Square* of 1934. Herbert Read, in
his charming essay "A Nest of Gentle
Artists," has described the years in
the 1930s when "Henry Moore, Ben
Nicholson, Barbara Hepworth, and
several other artists were living and
working together in Hampstead, as
closely and intimately as the artists
of Florence and Siena had lived and
worked in the Quattrocento."[22] In
this drawing, the rhythms of the
forms are, for the most part, dictated
by rectangles and squares, with a
number of circles indicating hollowed-
out areas, much like the circles in
Nicholson's reliefs of the period. For
related drawings, see no. 43 (recto)
and Wilkinson, 1977, no. 109.

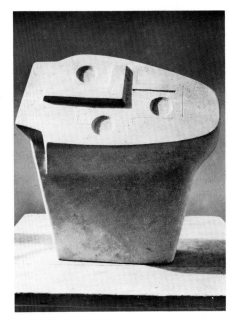

Fig. 37 *Carving* c.1936
Private collection

43 *Page from Square Forms Sketchbook* 1934 (recto)
Pen and ink, brush and ink,
27.3 × 18.3 cm
Inscr. lower right *Moore* (recent)
Gift of Henry Moore, 1974

*Page from Square Forms Sketchbook:
Ideas for "Two Forms"* 1934 (verso)
Charcoal

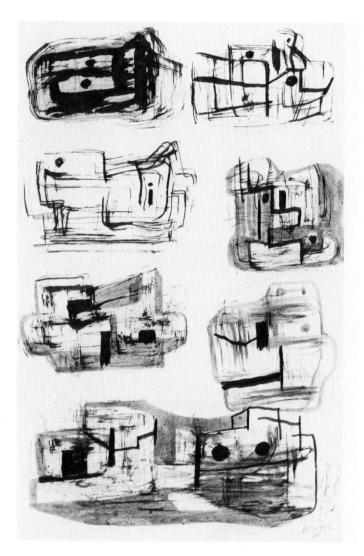

THIS DRAWING and no. 42 formed part of the same sketchbook.

It is the human organic element in Moore's work of the mid-1930s that distinguishes it from the total abstractions of his friends and contemporaries Hepworth and Nicholson. In no. 43, for example, several of the studies are unmistakably square-form or, better still, rectangular-form reclining figures — at upper right and the second from the top, left row of drawings. No. 43 is closely related to the seven studies in *Square Form Reclining Figures* of 1936 (Wilkinson, 1977, no. 109).

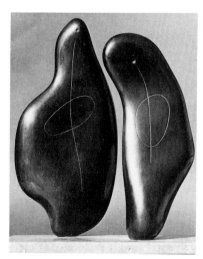

Fig. 38 *Two Forms* 1934
Private collection PHOTO: Errol Jackson

THESE STUDIES are closely related to the ironstone *Two Forms* of 1934 (LH 146; fig. 38). Like another ironstone work of 1934, *Sculpture* (LH 145), *"Two Forms"* probably evolved from pebbles Moore found on a beach in Norfolk. If this was the case, the present drawing may have been based on the found objects, as were the transformation drawings that used natural forms as a point of departure (see nos. 31–33). Two of the forms in the drawings approximate those in LH 146: the form at right in the two sketches at upper left, and the form at left in the two studies below this. In *Two Forms* a line runs down each form from the incised eye near the top, and crosses the oval incisions near the centre. Some of the studies in no. 43 include a more complex network of lines and dots than appears in the sculpture itself.

44 *Three Ideas for Sculpture: Study for "Reclining Figure"* 1935
Pencil, pen and ink, chalk and wash,
27.6 × 37.5 cm
Inscr. lower right *Moore 35*
Gift of Henry Moore, 1974

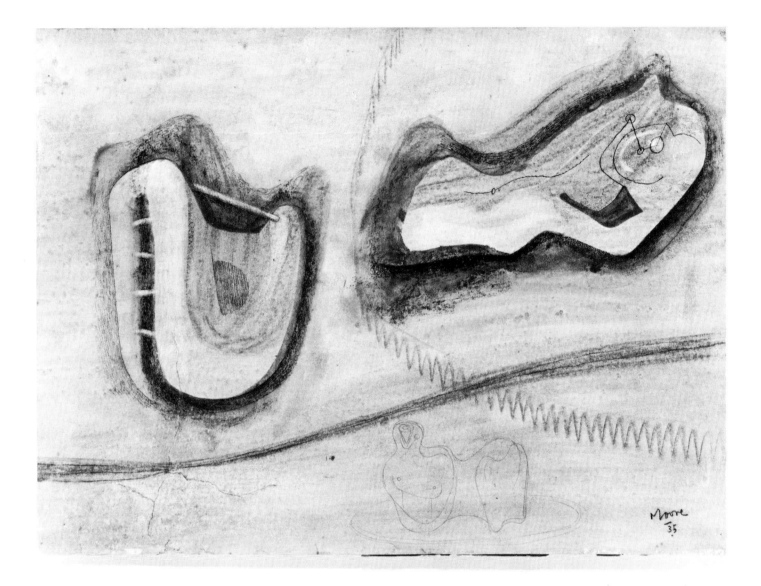

THE SMALL PENCIL SKETCH at the bottom of the sheet is the drawing for the *Small Reclining Figure* of 1935 (not in LH; fig. 39). Another study for this sculpture appears in *Page from Sketchbook: Ideas for Sculpture* of 1935, in the HMF. The large reclining figure, with the pen-and-ink lines, circles, and dots within the outlines — a sort of internal wiring system — is closely related to another work of 1935, *Drawing for Sculpture: Reclining Figure* (private collection). Similar reclining figures also appear in three other drawings of the period, also in private collec-

tions. The sculptural form in the left half of the sheet has a single structural bar similar to those found in the figure in no. 31 (verso) and in *Reclining Figure* of 1933 (LH 134; fig. 24). The way in which the bar cuts across the open space between the two projections at the top of the form anticipates the stringed-figure drawings and sculpture of 1937–40 (see no. 79 and fig. 55).

Fig. 39 *Small Reclining Figure* 1935
Private collection

45 *Page from a Sketchbook c.* 1938 (recto)
Pencil, 17.8 × 19 cm
Gift of Henry Moore, 1974

NONE of the ideas on the recto and verso was realized in sculpture.

Page from a Sketchbook c. 1938 (verso)
Pencil
Inscr. at centre in top half of sheet
Sculptural ideas?

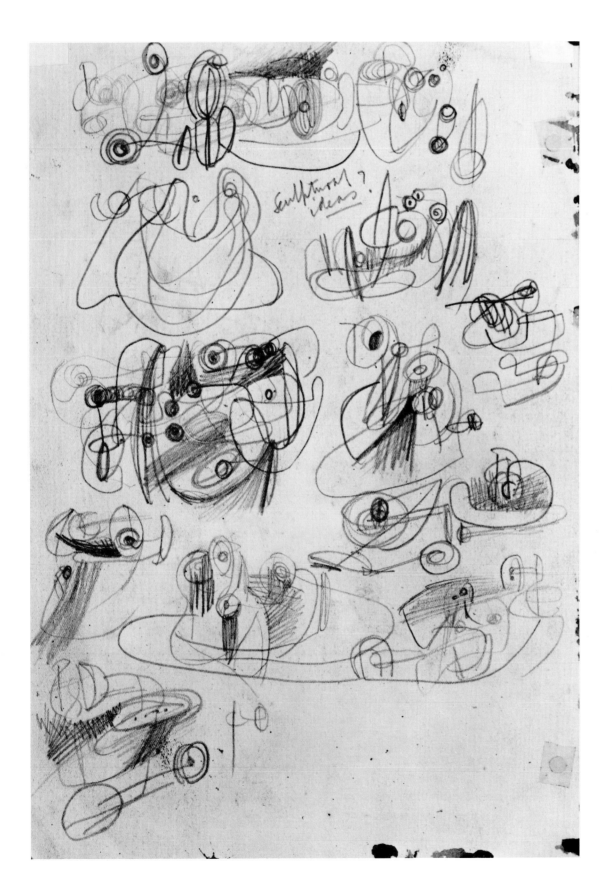

46 *Projects for Relief Sculptures on London University* 1938
Pen and ink, chalk and wash,
37.4 × 27.6 cm
Inscr. lower right *Moore 38*; to the left of this *Projects for relief-sculptures on London University*
Purchase, 1975

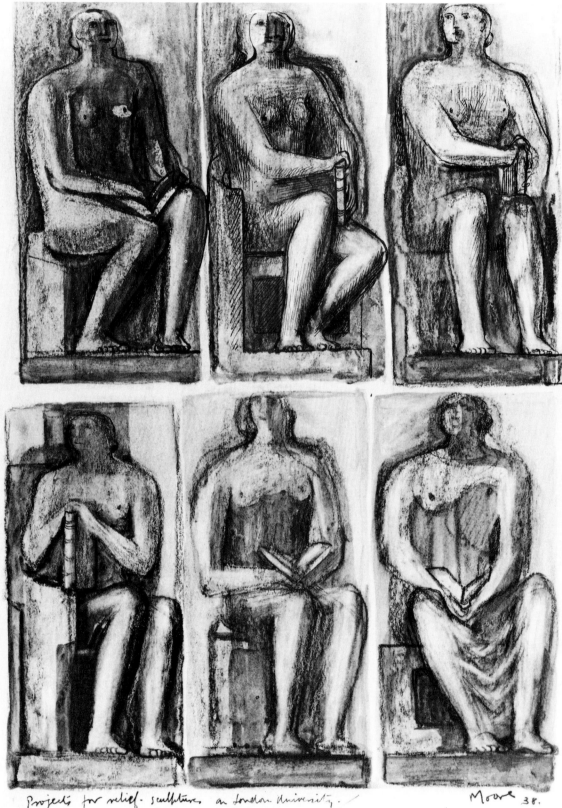

THE ARCHITECT Charles Holden, who had commissioned in 1928 the *North Wind* relief (see no. 22), approached Moore again and asked if he would consider doing a series of relief sculptures for the Senate House, University of London.[23] Moore said that at the time he preferred not to do relief sculpture and was against the use of sculpture merely as decoration on buildings. Holden left Moore to think about his proposal, and said that if he changed his mind, perhaps he would indicate the dimensions of blocks of stone required. In 1938 Moore made a number of preparatory studies, of which no. 46, formerly in the collection of Sir Philip Hendy, was the most fully realized. (See also no. 30 recto.)

Of the four known, less-finished drawings, one is shown here. In fig. 40 the inscriptions are of particular interest as a record of Moore's thematic approach to the commission. At upper left he wrote: *Figure with cloak, enclosing and encouraging or havening youth.* Although he considered doing an abstract relief (see sketch at lower left in fig. 40), almost all the preparatory studies were figurative. Another drawing in the HMF, *Page from Sketchbook: Ideas for Relief* of 1938, was undoubtedly one of the preparatory drawings for no. 46. The inscription at the bottom of the sheet *And just two shapes symbolising the Arts, the Sciences* indicates that Moore was, as in fig. 40, considering the possibility of a symbolic, purely abstract work. On another of the four known, less-finished sheets of studies is the following inscription: *Think of subject matter / Mother and Child — the University the mother — child the students....* In each of the six studies in the Toronto drawing, the subject matter is a seated female figure holding a book, which Moore said was an appropriate symbol for a univer-

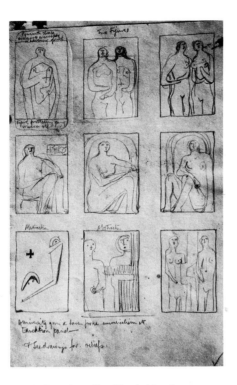

Fig. 40 *Page from Sketchbook: Ideas for Relief* 1938
Henry Moore Foundation

sity. From this drawing, Holden and Moore worked out the proportion for the blocks. The project got as far as boasting (rough-surfacing) the five stone blocks and placing them on the Senate House, where they have remained unfinished to this day (fig. 41).

Fig. 41 One of the five stone blocks on Senate House, University of London (east side)
PHOTO: A.G. Wilkinson

47 *Two Women on a Bench in a Shelter* 1940
Pen and ink, wax crayon, chalk and wash, 34.4 × 42.7 cm
Inscr. lower right *Moore 40*
Purchase, 1974

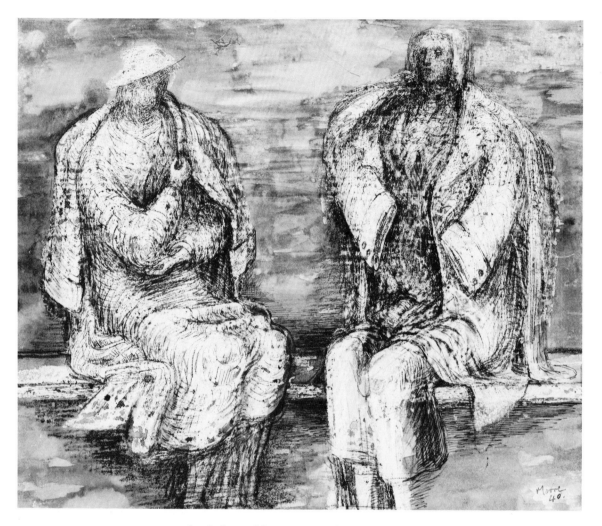

THIS VERY BEAUTIFUL early shelter drawing, formerly in the collection of the late Lord Clark, was based on the study on page 40 of the First Shelter Sketchbook, now in the British Museum (fig. 44). For a detailed account of the shelter drawings and their influence on Moore's subsequent sculpture, see Wilkinson, 1977, pp. 28–36 and nos. 137–68.

Fig. 42 Dome of St. Paul's Cathedral rises high above the smoke clouds, while German raiders shower fire bombs over London, December 1940
PHOTO: Herbert A. Mason

Fig. 43 East London Underground Station, November 1940
PHOTO: Bill Brandt

Fig. 44 *Page 40 from First Shelter Sketchbook* 1940
Trustees of the British Museum

48 *Group of Shelterers during an Air Raid* 1941
Pen and ink, wax crayon, chalk and water colour, 38 × 55.5 cm
Gift of the Contemporary Art Society, 1951

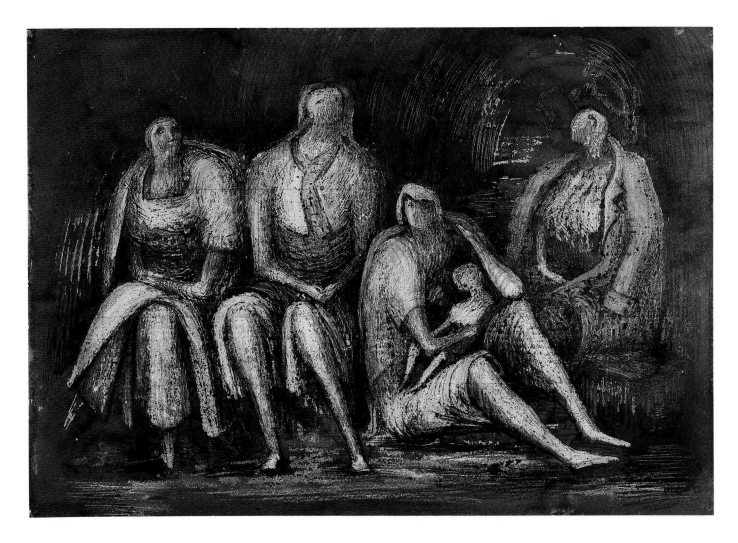

IT APPEARS that all the shelter drawings Moore chose to enlarge were based on sketchbook studies. In the sketch for this drawing, on page 17 from the Second Shelter Sketchbook (fig. 45), the squared pencil lines are clearly visible. The squared lines in no. 48 are also visible. Ideas related to earlier drawings and sculpture do surface in a few sheets in the Second Shelter Sketchbook, as in the two reclining figures at the top of fig. 45. Although Moore did not choose to enlarge any of the purely sculptural ideas that appear in the shelter sketchbooks, some of the figure studies combine both naturalistic elements and the more abstract language of his sculptural preoccupa-

tions. In no. 48, for example, the thin, axe-like head of the figure at right anticipates the head of the bronze *Warrior with Shield* of 1953–54 (LH 360, no. 99).

Fig. 45 *Page 17 from the Second Shelter Sketchbook* 1941
Private collection

49 *Sleeping Figures* 1941
Pencil, 12.7 × 10.8 cm
Inscr. at top *Sleeping figures*; at
lower left *Moore 41* (recent)
Purchase, 1977

50 *Two Sleeping Figures* 1941
Pencil, 12 × 10.8 cm
Inscr. at top *Two sleeping figures*; at
lower left *Moore 41* (recent)
Purchase, 1977

51 *Sleeping Head and Hand* 1941
Pencil, 12.4 × 10.5 cm
Inscr. at top *Sleeping Head and hand*;
lower left *Moore 41* (recent)
Purchase, 1977

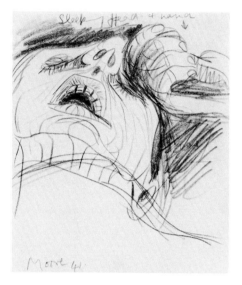

UNIQUE AMONG Moore's shelter drawings are these four spontaneous pencil sketches (see also nos. 50–52), formerly in the collection of the late Mark Tobey. They are all related to the series of sketchbook studies and large, fully worked drawings of blanketed sleeping figures seen from a low viewpoint, with only the heads and arms exposed (see Wilkinson, 1977, nos. 161 and 163–68). Although the four drawings have been framed together, they are catalogued individually here. Moore told the author that these four sketches were done in a little notebook he may have had with him in the Underground. Although he did not make detailed drawings *in situ*, he occasionally made rapid studies of the shelterers, sketching unnoticed in a corner. In this sketch, the composition is related to *Four Grey Sleepers* of 1941, in the Wakefield Art Gallery and Museums. Amid the tangle of lines, a boldly drawn sectional line runs across and down the left arm of the sleeping figure just above the centre.

The almost frenzied, expressionist violence of this drawing seems to violate the images of motionless, sleeping figures.

THIS DRAWING is closely related in style and subject matter to no. 49.

THIS DRAWING and no. 52 are closely related to the studies of four heads on page 68 of the Second Shelter Sketchbook, to the single head on page 69, and to the heads in nos. 163–65 and 167–68 in Wilkinson, 1977. In all these drawings, the gaping mouths and extreme foreshortening are features reminiscent of the sleeping apostles in Mantegna's *The Agony in the Garden* in the National Gallery, London (fig. 46).

Fig. 46 Andrea Mantegna *The Agony in the Garden* (detail) 1459
National Gallery, London

52 *Sleeping Head* 1941
Pencil, 11.7 × 10.5 cm
Inscr. at upper right *Sleeping head*;
at lower left *Moore 41*
Purchase, 1977

53 *Page from Coalmine Sketchbook: Types of Roads* 1942
Pen and ink, crayon and wash,
25.6 × 17.8 cm
Inscr. at top *Types of Roads (Tunnels) — Bars & legs — steel girdered etc.*;
lower left *Moore 42* (probably recent)
Gift of Henry Moore, 1974

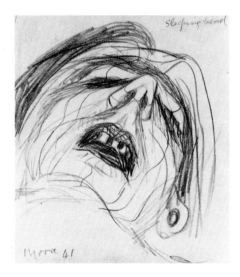

SEE no. 51.

Fig. 47 Henry Moore sketching down the mine,
December 1941
Wheldale Lane Colliery, Castleford, Yorkshire
PHOTO: "Illustrated"

THE THREE COAL-MINE drawings
in the collection formed part of the
largest of the three coal-mine sketch-
books. The other two sketchbooks
have been entitled Coalmining Note-
book and Coalmining Subject Sketch-
book. (See Wilkinson, 1977, nos. 169
and 170.) No. 53 shows six studies
of roads and tunnels leading to the
coal-face. Related drawings appear
on page 15 in the Coalmining Subject
Sketchbook inscribed *types of tunnel
settings*, and in *Page from Coalmine
Sketchbook: Rock and Coal Forma-
tions* (private collection). For a more
detailed discussion of the coal-mine
drawings, see Wilkinson, 1977, pp.
36–40 and nos. 169–87.

54 *Page from Coalmine Sketchbook: Study for Miners' Poses and Positions* 1942
Pencil, pen and ink, and chalk,
25 × 17.7 cm
Inscr. across top *Two sheets lying down poses — Do background in crayon of some;*
below last sentence *Group of miners / at snap time & resting;*
lower right *Moore 42* (probably recent); squared in pencil
Gift of Henry Moore, 1974

Fig. 48 *Miners' Poses and Positions* 1942
Private collection, London

cramped spaces near the coal-face. In fact, the artist said, the miners were so accustomed to working in such a pose that they often remained in this position at snap time (meal time) or during a break.

The entire sheet has been squared for enlargement. In the lower half of the drawing, the studies of a miner with a pickaxe are closely related to *Miner at Work* (HMF). All the figure studies are included in the large drawing *Miners' Poses and Positions* (in a private collection; fig. 48), which was based on no. 54.

THIS AND a similar sheet in the Victoria and Albert Museum show studies of miners at work and at rest. The freely drawn sketches in the upper third of the page in no. 54 are stylistically related to the drawings for sculpture of the late 1930s (see no. 45). In one of these, the almost abstract form at right just above centre — the circular shape of the helmet lamp, with the light radiating from it — is the only tenuous link with the subject. The two large studies of miners squatting on their haunches show one of the most typical poses of the men in the low,

55 *Page from Coalmine Sketchbook: Study for Miners Resting during Stoppage of Conveyor Belt* 1942
Pencil, pen and ink, crayon and wash, 25.6 × 17.6 cm
Inscr. across top *22 × 13. Miners resting during stoppage of conveyor belt 4⅛; above lower left drawing Two Men working in Drift — ankle deep water; water coming from roof; above lower right drawings Miners walking along low road; bits of coal on ground; at right below upper study Moore 42* (probably recent); top composition squared in pencil
Gift of Henry Moore, 1974

THE BEAUTIFUL DRAWING in the top half of the sheet, squared in pencil, is the preparatory study for *Miners Resting during Stoppage of Conveyor Belt* of 1942 in the Leeds City Art Galleries (fig. 49). Although Moore has said that he was not at the time particularly aware of Seurat's drawings, the masterful handling of light and shade is nevertheless reminiscent of the *conté* crayon drawings of Seurat's maturity that in later years Moore came to admire so greatly.

Many of the studies in the pages from the Coalmine Sketchbook were based on less-finished sketches in the two smaller notebooks. In no. 55, *Miners Resting during Stoppage of Conveyor Belt* was based on a sketch on page 23 of the Coalmining Subject Sketchbook. *Two Men Working in Drift* and *Miners Walking along Low Road* were based on studies on page 15 from the same sketchbook.

Fig. 49 *Miners Resting during Stoppage of Conveyor Belt* 1942
Leeds City Art Galleries

56 *Cover Design for Poetry
London* 1942
Pencil, pen and ink, crayon and
wash, 24.8 × 18.7 cm
Inscr. across top *London / Poetry /
No. 7 July & August*; at bottom
centre *The Lyre Bird*; lower right
Moore 42 (recent)
Gift of Henry Moore, 1974

57 *Drawing for "Family Group"* 1944
Pencil and blue crayon,
27.3 × 20 cm
Inscr. lower right *Moore 44*
Gift of Henry Moore, 1974

THIS IS ONE of six known cover
designs of lyre birds that Moore
made in 1942 for the magazine *Poetry
London.* Five are signed and dated
Moore 42. In addition there is the
less-finished sheet *Page from Sketch-
book* of 1935 and 1942 (fig. 84) based
on carvings from New Ireland. See
notes for no. 106.

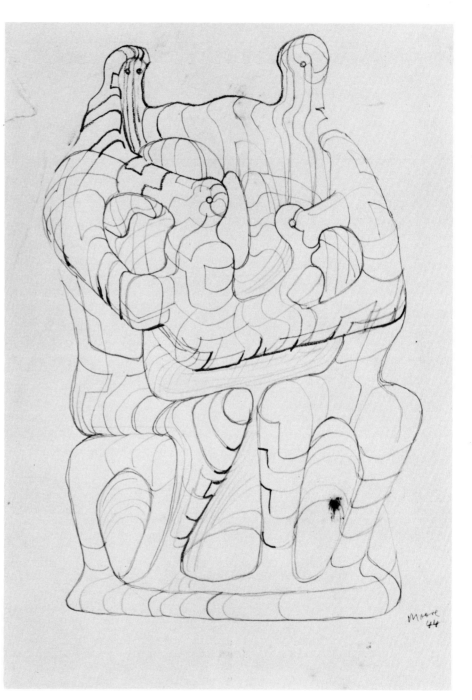

THE NORTHAMPTON *Madonna and
Child* of 1943–44 (LH 226) was fol-
lowed by a series of drawings and
maquettes of family groups of
1944–45 (LH 227–40). Before the war
Walter Gropius had asked Moore if
he would consider doing a sculpture
for his school at Impington, near
Cambridge. Moore suggested a family
group might be a suitable subject,
but there were no funds available at
the time. Henry Morris, Director of
Education for Cambridgeshire, had
tried unsuccessfully to raise money
by private subscription. About
1944 he told Moore that he thought
he could find the necessary money.
Moore agreed to start work on the
project and began making note-
book drawings of the family-group

58 *Mother and Child: Irina Nursing Mary* 1946
Pen and ink, 16 × 16.2 cm
Inscr. lower left *Moore 46* (probably recent)
Gift of Henry Moore, 1974

59 *Child Studies: Mary* 1946
Pen and ink, 20.3 × 16.2 cm
Inscr. lower right *Moore 46* (probably recent)
Gift of Henry Moore, 1974

theme. (For the artist's account of the family-group sculptures see *Henry Moore on Sculpture*, pp. 224–29.)

No. 57 is a study for the *Family Group* of 1947 (LH 267; no. 81 and fig. 61), made three years after the drawing. Here Moore uses what he called the two-way sectional-line method of drawing, a stylistic innovation that first appeared in some of the life drawings of 1928 (see Wilkinson, 1977, nos. 31 and 39). He has defined this linear technique as drawing "both down the form as well as around it, without the use of light and shade modelling." (For a more detailed discussion of the sectional-line drawings, see Wilkinson, 1977, pp. 16–17.) Whereas in no. 57 the linear sectional lines alone define the three-dimensional forms of the figures, in other drawings, such as *Family Group* of 1948, no. 60, the sectional lines are used with light-and-shade modelling. The much larger finished drawing, *Family Group: Twins*, also of 1944, was based on no. 57 (fig. 50). In the sculpture the heads of the children are not connected to the bodies of the parents. The original plaster of *Family Group* (LH 267) is in this collection (no. 81), though in fragmentary form, without the children and most of the arms of the parents.

IN 1946 Moore made a series of charming drawings of his daughter, Mary, who was born on March 7, 1946. Of the thirty-one known drawings, twenty-two were executed in pen and ink, nine in pencil. The subjects of these studies are the naked child after her bath (no. 59) and drawings of the mother nursing her child (see also Wilkinson, 1977, no. 57.) During the previous twenty-five years, the mother-and-child theme had been one of the two most important subjects of Moore's drawings and sculpture. In his drawings for sculpture, the artist has said, it was as if he were conditioned to see this subject emerge from random doodles on the page: "I could turn every little scribble, blot or smudge into a Mother and Child."[24] Now his own family life afforded him the opportunity to draw directly one of the themes that continued to be a fundamental obsession and that has given his work such universal significance.

THIS IS one of the pen-and-ink studies of 1946 of Mary after her bath (see also Wilkinson, 1977, no. 58). With great spontaneity and economy of line, Moore portrays the tiny, wriggling child, shown here lying on her back and, above the signature, lying on her stomach. Moore has spoken of his fascination with very young babies, with "the big head, the frog-like quality of the body, and their kicking vitality."[25]

In 1947 Moore made a number of more finished drawings of his daughter, using pencil, pen and ink, wax crayon, and watercolours (see Wilkinson, 1977, no. 60). Mary was also the subject of a number of drawings of the 1950s: two portrait sketches of 1954, and nine studies, dated 1956, of her at her desk doing her homework.

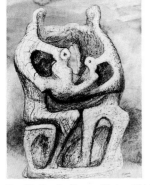

Fig. 50 *Family Group: Twins* 1944
Private collection

60 *Family Group* 1948
Pen and ink, crayon and wash,
56.4 × 69.7 cm
Inscr. lower right *Moore 48*
Purchase, 1974

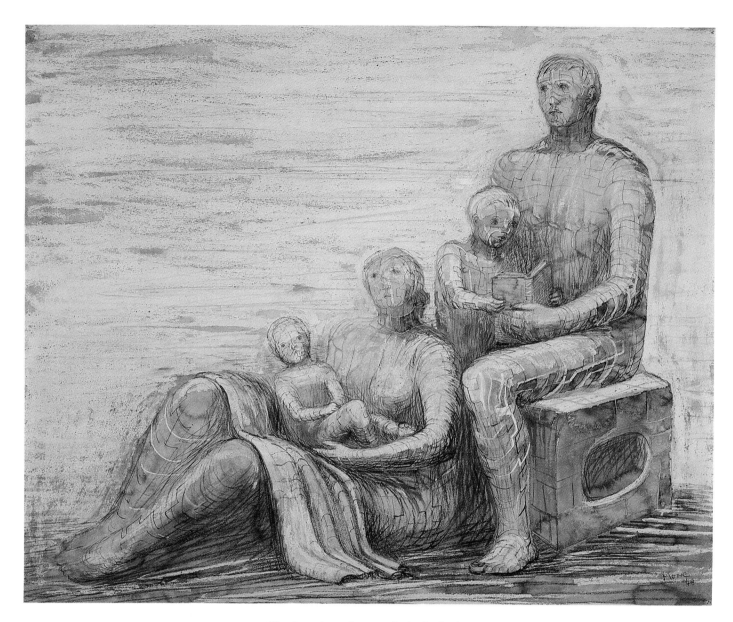

SCENES OF FAMILY LIFE —
women bathing a child, reading,
knitting or winding wool and family
groups — were the subjects of a
number of very large drawings of the
late 1940s, most of which date from
1948 (see Wilkinson, 1977, nos. 207,
209, 210, and 218). As Lord Clark
wrote, these untroubled, tranquil
drawings of domestic life "show his
view of happiness based on human
affection, but they entirely lack the
demonic power of the reclining figure
drawings, and seem to have no rela-
tionship with his great sculpture."[26]
A similar drawing, of the same title
and date, is in the Massey Collection
of English Painting in the National
Gallery of Canada.

61 *Seated Group of Figures* 1950
Pencil, crayon, and coloured washes,
37.8 × 29 cm
Inscr. lower right *Moore 50*
Gift of Sam and Ayala Zacks, 1970

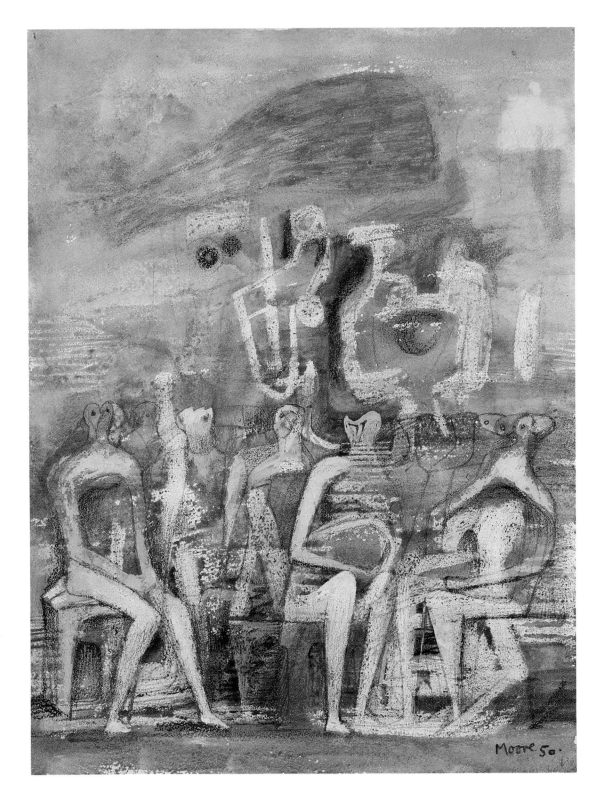

ALTHOUGH none of these studies
was to be realized in sculpture, the
taut knees and legs of the two figures
at right recall those of the father in
Family Group of 1948–49 (LH 269;
fig. 62).

62 *Seated Nude* 1954
Pencil, chalk, brush and ink, and
wash, 45.3 × 32.3 cm
Inscr. lower right *Moore 54* (recent)
Gift of Henry Moore, 1974

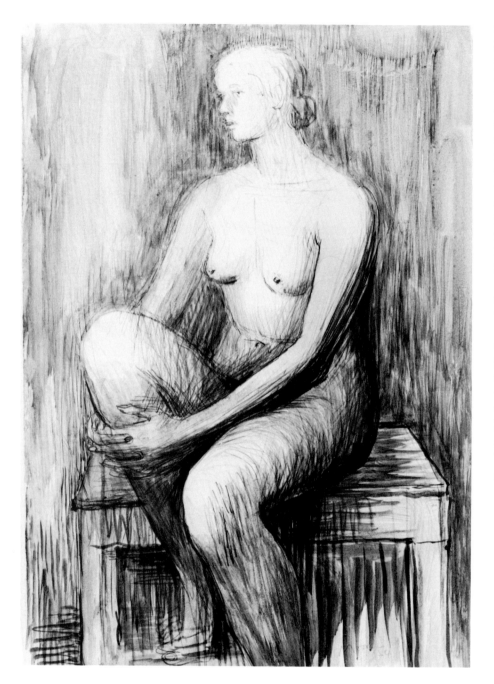

NO LIFE DRAWINGS of the female
nude are known to have been exe-
cuted between 1935, the year of the
last in the series of the artist's wife,
and 1954, when Moore hired a model
and made a series of life studies at
Swan Court, Hampstead, in the flat
of Peter Gregory, where he was stay-
ing. Like most of the life drawings
of the 1920s and 1930s, the poses in
the thirteen known drawings are
of standing (four) and seated (eight)
figures. There is only one reclining
figure in the series. Originally drawn
in pencil, no. 62 is one of six draw-
ings that were reworked in the early
1970s and transformed from rough
sketches into more fully realized,
three-dimensional drawings.

Moore commented on the
extremely pretty model who posed
for these drawings: "I couldn't ignore
this prettiness — I couldn't make
these drawings detached." In no. 62,
the seated pose, with the raised right
leg, is reminiscent of the drawings
of the artist's wife of 1932–35 (see
Wilkinson, 1977, nos. 51, 52, 54, and
55).

Studies of Heads 1966 (verso)
Pencil (inscriptions), felt pen (from recto), and chalk
Inscr. at upper right *Do set of photos of heads — / all of them, small and large) / showing variety of invention*

63

THE THREE HEADS at the bottom of the sheet and the one just left of centre appear to be charcoal imprints from another sketchbook page. The outline at centre right is almost cer-tainly an original drawing on this sheet. The felt pen lines and spots have soaked through the paper from the drawing on the recto.

63 *Studies for Square Sculpture* 1961 (recto)
Crayon, marker pen, and wash,
29 × 23.8 cm
Inscr. at top *Square sculpture*; at lower left *Moore 61*
Purchase, 1978

64 *Study for Concerto c.* 1967
Ballpoint pen and wash,
29.2 × 24 cm
Gift of Henry Moore, 1974

◄

FROM the mid-1950s to the late 1960s, Moore concentrated almost exclusively on his sculpture and produced relatively few drawings. The last sculpture for which there were preparatory drawings appears to be the *UNESCO Reclining Figure* of 1957–58 (LH 416; see no. 123).

Although Moore was no longer using drawing as a means of generating ideas for sculpture, the sculptural studies of the early 1960s, of which no. 63 is a fine example, are certainly related in a general way to the bronzes of the period. See, for example, *Two Reclining Figures* and *Two Piece Reclining Figures* of 1961 (Wilkinson, 1977, nos. 228 and 229), two drawings closely related to no. 63. All three formed part of the same sketchbook, which has been taken apart.

MANY of Moore's lithographs and etchings were based on preparatory drawings, the earliest being the lithograph *Spanish Prisoner* of 1939 (CGM 3; no. 201) based on a drawing of the same title, no. 129 in Wilkinson, 1977. This drawing is a preparatory study for *Concerto* of 1967, etching and aquatint (CGM 87).

65 *Page from Sketchbook 1970–71:*
Cow Grazing in Field, with Farm Building 1970
Pen and ink and wash, 17.5 × 25.4 cm
Inscr. lower right *Moore 70*; on verso
Hedgerow & Farm Buildings
Gift of Henry Moore, 1974

MOORE'S RENEWED INTEREST
in drawing dates from late 1969,
when he made a few notebook stud-
ies of an elephant skull that Sir
Julian Huxley had given him several
years earlier, before embarking on
the 1969–70 *Elephant Skull Album* of
etchings (CGM 109–46; no. 207).
But it was not until 1970, when
Moore did some sixty-five pen-and-
ink exercises, that his renewed inter-
est in drawing began to gather
momentum. From 1921 to the mid-
1950s his drawings for sculpture were
a means to an end: a means of gener-
ating ideas to be translated into three
dimensions. Having in the late 1950s
made a complete break between his
sculpture and his drawing, Moore
produced relatively few drawings.
With the pen exercises of 1970 he

began to draw for its own sake, as an
activity independent of sculpture.
In these spontaneous drawings,
nos. 65–71, one senses that Moore
was limbering up, as it were, and
getting his hand in again. These
seven sheets, all dated 1970, formed
part of a sketchbook that was taken
apart in 1971, at which time some
of the studies were redrawn. With
their rather calligraphic shorthand,
these pen exercises depict a range
of subjects: a peaceful rural scene in
no. 65; sculptural motives in nos. 66,
67, and 70; and the mother-and-child
theme in no. 69. (See also *Horsemen
Crossing a Mountain Crevasse* of
1970 in Wilkinson, 1977, no. 235.)
There is no doubt that the style of
some of the pen exercises owes a debt
to Rembrandt's drawings, which

Moore greatly admired. For example
Storm at Sea of 1970 (Wilkinson,
1977, no. 236) appears to be an adap-
tation of Rembrandt's *Christ in the
Storm on the Sea of Galilee* of 1654–
55 in the Kupferstichkabinett, Dres-
den, although the initial idea, Moore
has said, was inspired by a storm he
had watched at his summer house
at Forte dei Marmi, north of Pisa.

No. 65 shows a rural scene typical
of the Hertfordshire landscape where
Moore lived and worked after 1940.
Cows grazing in a field appear in two
much earlier landscape drawings:
Sculpture Object in Landscape of 1939
(Wilkinson, 1977, no. 124), and
Sculpture in Landscape of 1942
(Wilkinson, 1977, no. 191).

66 *Page from Sketchbook 1970–71:*
Nine Sculpture Motives 1970
Pen and ink, chalk, 25.4 × 17.5 cm
Inscr. lower left *Moore 70*
Gift of Henry Moore, 1974

67 *Page from Sketchbook 1970–71:*
Six Sculpture Motives No. VIII 1970
Pen and ink, chalk, 25.2 × 17.5 cm
Inscr. lower right *Moore 70*
Gift of Henry Moore, 1974

AMONG THE 1970 pen exercises is a series of drawings of sculptural motives, such as this study and nos. 67 and 70. The free, short, decisive pen strokes and the open contours produce a variety of lines reminiscent of Chinese calligraphy. Brush and wash create at least the suggestion of mass amid the nervous tangle of lines. The crayon lines linking the forms were undoubtedly an afterthought.

A NUMBER OF Moore's graphics of 1970–71 were based on the pen exercises from the 1970–71 sketchbook. No. 67 is the preparatory study for the etching *Six Sculpture Motives* of 1970 (CGM 154).

68 *Page from Sketchbook 1970–71:*
Two Standing Figures No. V 1970
Pen and ink, 25.4 × 17.5 cm
Inscr. lower right *Moore 70*
Gift of Henry Moore, 1974

69 *Page from Sketchbook 1970–71,*
Pen Exercise No. VI: Mother and
Child Studies 1970
Pen and ink, 25.4 × 17.5 cm
Inscr. lower right *Moore 70*
Gift of Henry Moore, 1974

THIS DRAWING appears to be the
study for the 1970 etching *Two
Standing Figures No. V* (CGM 160).
It is one of sixteen drawings of stand-
ing figures from the 1970–71 sketch-
book. See also no. 71.

IN THE THREE ABSTRACT "doo-
dles" at the top of the sheet, Moore
had started to draw, as he once
wrote, "with no preconceived prob-
lem to solve, with only the desire
to use pencil on paper, and make
lines, tones and shapes with no con-
scious aim."[27] In the row beneath,
mother-and-child forms begin to
emerge. In the studies at centre and
right in this row, the presence of the
child is indicated in the most sum-
mary way by a circular line suggest-
ing the head. Each row of studies,
from top to bottom, becomes progres-
sively larger as the subject becomes
more clearly defined. In the two large
sketches in the bottom half of the
page, the mother-and-child theme
"becomes conscious and crystallises,
and then a control and ordering
begin to take place."[28]

70 *Page from Sketchbook 1970–71: Sculpture in Landscape* 1970
Pen and ink, brush and ink, chalk and wash,
17.3 × 25.4 cm Inscr. lower right *Moore 70*
Gift of Henry Moore, 1974

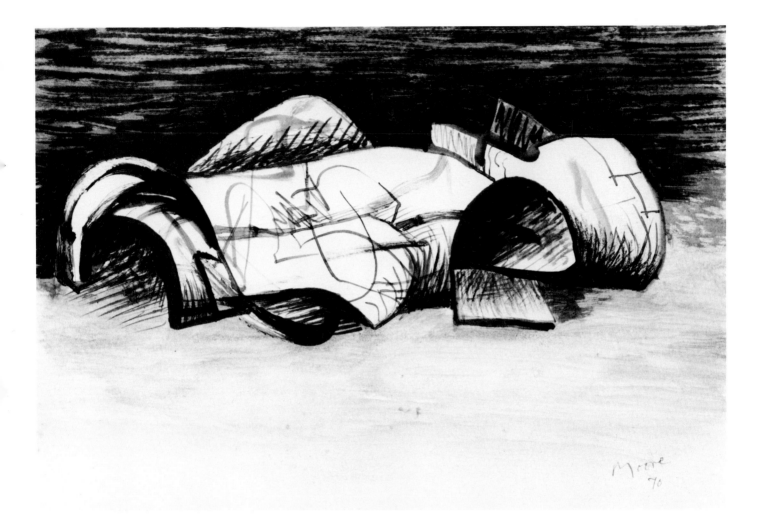

THIS IS one of the most fully
worked three-dimensional studies
from the 1970–71 sketchbook. In con-
trast to the linear technique in
nos. 66–68, Moore has used brush
and wash to define the dark, threat-
ening sky and to give the horizontal
sculptural form a feeling of weight
and mass.

71 *Page from Sketchbook 1970–71:*
Two Standing Figures No. XIV: Man and Woman 1970
Pen and ink, brush and ink, chalk and wash,
25.3 × 17.3 cm Inscr. lower right *Moore 70*
Gift of Henry Moore, 1974

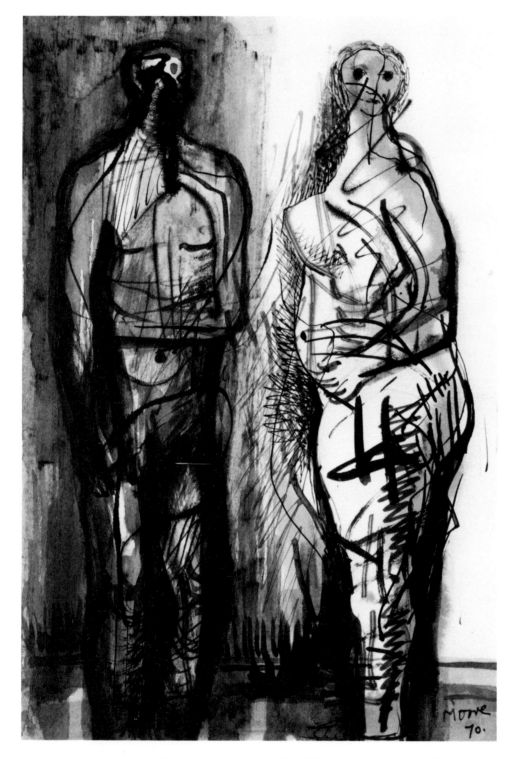

THIS DRAWING, one of the series of standing figures (see no. 68), is the study for the 1973 lithograph *Man and Woman* (CGM 272) in the portfolio of Auden poems / Moore lithographs. Lithographs were also done of each of the figures in no. 71: see *Woman* 1973 (CGM 251), and *Man* 1973 (CGM 264).

72 *Reclining and Seated Figures* 1972
Marker pens and wash, 38.1 × 28.4 cm
Gift of Henry Moore, 1974

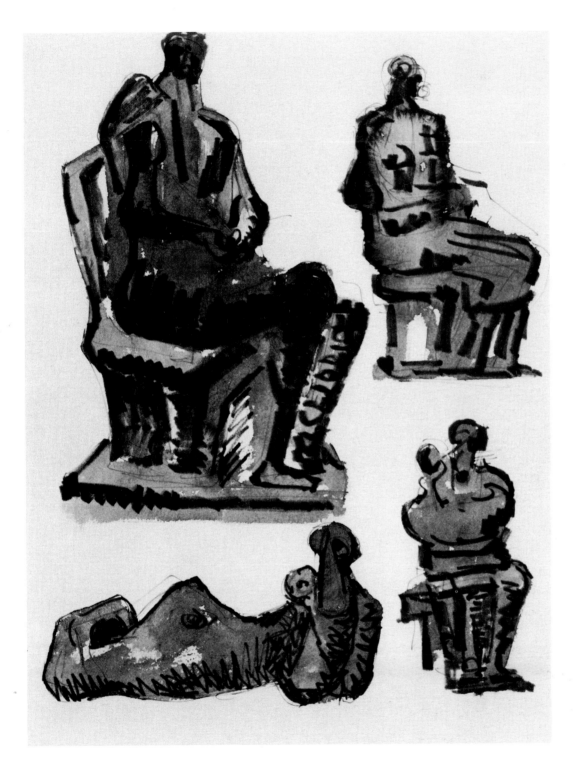

MOORE used felt marker pens in a number of drawings of the 1960s and 1970s (see no. 73 and Wilkinson, 1977, nos. 228, 229, 233, and 234).

The largest of the seated figures in no. 72 is the preparatory study for the 1973 lithograph *Seated Figure* (CGM 292).

73 *Reclining Figure* 1972
Coloured marker pens, 16 × 26 cm
Gift of Henry Moore, 1974

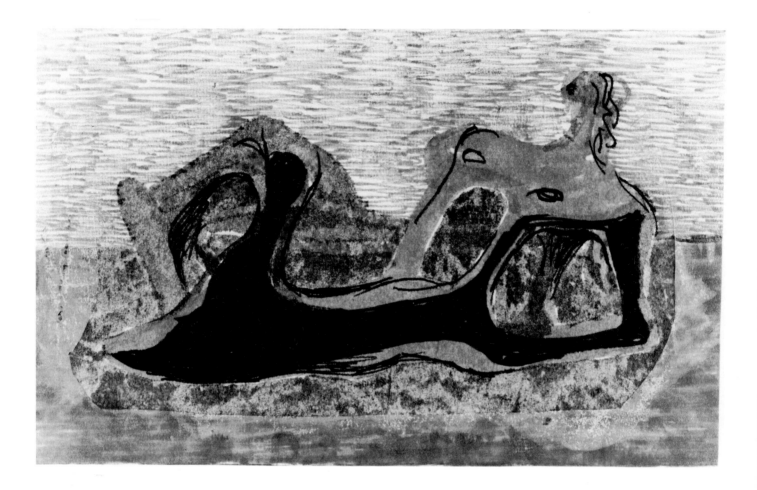

THE RECLINING FIGURE has been
cut out and stuck down on a larger
sheet. The marker-pen background in
the top half of the drawing was done
after the cut-out reclining figure had
been fixed to the larger paper. Sty-
listically this hollowed-out figure
looks back to a number of sculptures
of the late 1930s and 1940s — for
example, the lead *Reclining Figure*
of 1939 in the Victoria and Albert
Museum (LH 202) and the *Reclining
Figure* of 1946 (LH 261).

4 Sculpture

74 *Seated Figure* 1930 (LH 92)
Alabaster, H 47 cm
Purchase, 1976

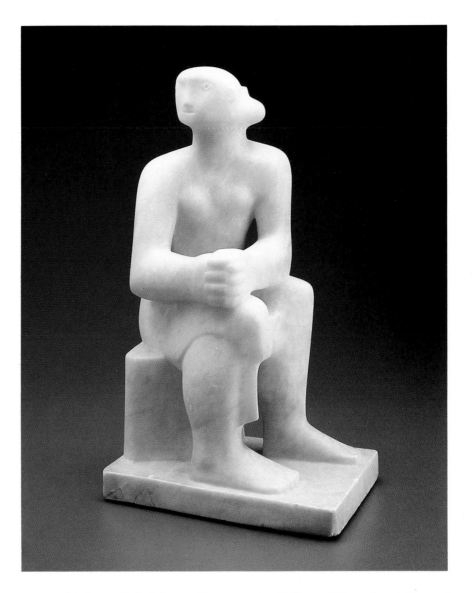

WHEN this beautiful alabaster figure (from the collection of the late A.J. McNeill Reid of Alex Reid and Lefevre Ltd., London) was acquired in 1976, it represented not only the earliest Moore sculpture in the collection, but also the first and, to date, only carving. Although the collection includes a representative selection of drawings of the 1920s, 1930s, and 1940s, there are only ten sculptures from these years: eight from the 1930s and two from the 1940s. It must be remembered that Moore was seventy when he wrote to Edmund C. Bovey, President of the

Art Gallery of Ontario, on December 9, 1968, stating that it was his firm intention to donate to the Gallery "a sufficiently large and representative body of my work, to make it worthwhile building a special pavilion or gallery for its permanent display." Obviously, by this time, most of the carvings done between 1921 and 1950 were in public and private collections and therefore could not be included in the gift. From the outset the donation was to consist of original plasters and bronzes of the 1950s and 1960s; the strength of the sculpture collection is in these two decades

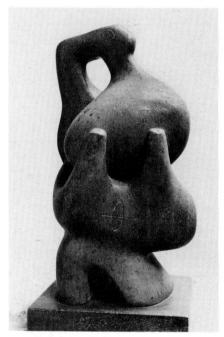

Fig. 51 *Composition* 1931
Private collection

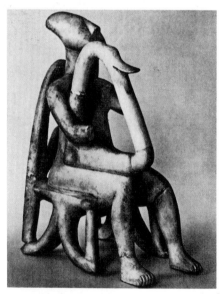

Fig. 52 *Lyre-Player* Cycladic period,
2300–2000 B C
National Museum, Athens

and in the bronzes of the 1970s, acquired from the artist since 1974. After the opening of the Moore Centre in 1974, the Henry Moore Sculpture Centre Committee hoped to acquire an early work, to represent more fully the evolution of Moore's art.

Seated Figure of 1930 was executed a year before the blue Hornton stone *Composition* of 1931 (LH 99; fig. 51). Whereas the latter carving heralds a radical and sudden transformation in Moore's art (see Wilkinson, 1977, no. 88), allying it to the work of Picasso and to biomorphic forms of the Surrealists, *Seated Figure* may be said to mark the culmination of the previous decade, reflecting some of the major influences that informed Moore's work in the late 1920s. Certain features of this carving have obvious affinities with his earlier sculpture and drawing. For example, the mask-like face and cubic bun of hair are related to the head of the Leeds *Reclining Figure* of 1929 (LH 59; fig. 16). The shape of the feet is also close to those of the Ottawa *Reclining Woman*, which may ultimately derive from the *Chac Mool* figure (fig. 17). The seated pose was a favourite subject in many of Moore's finest life drawings of 1928–35 (see Wilkinson, 1977, nos. 40, 47, 48, 52, 54, and 55), but the only sculpture that approaches the style of the life drawings is the lead *Seated Figure* of 1930 (LH 81).

As one has come to expect in Moore's work, everything about the pose in no. 74 is asymmetrical: the head is turned to the right, the clasped hands rest on the right knee, the figure is twisted to the right at the waist in a kind of *contrapposto* movement, the left foot is slightly ahead of the right. Even the base and the block on which the figure sits are asymmetrical. Of particular interest is the use of drapery for the first time in Moore's sculpture. Here

it is shown in a simplified, schematic way, stretched between the knees, in front of the right leg and curving round the side of it just above the ankle. (For one of the earliest drawings in which drapery appears, see Wilkinson, 1977, no. 91, *Draped Standing Studies*, 1931.)

The carving is rich in associations with the art of the past. Moore himself has compared *Seated Figure* to a Cycladic sculpture that he much admired, the *Lyre-Player* in the National Museum, Athens (fig. 52). (Moore's early interest in Cycladic sculpture is well documented in the drawings on page 133 of No. 3 Notebook of 1922–24, showing at top a sketch of a Cycladic head, and below two studies of the *Double-Flute Player*, National Museum, Athens.) Moore pointed out to the author the remarkable way in which in the *Lyre-Player* the carver opened out the stone and hollowed out certain areas, completely freeing the chair and the figure from the original block

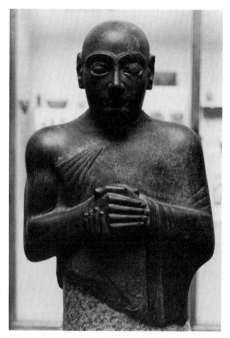

Fig. 53 *Gudea, Ruler of the City State of Lagash* Sumerian c.2100 B C
Trustees of the British Museum, London
PHOTO: A.G. Wilkinson

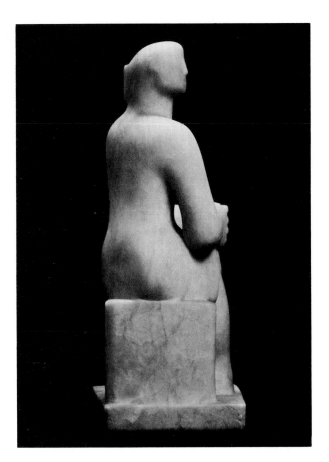

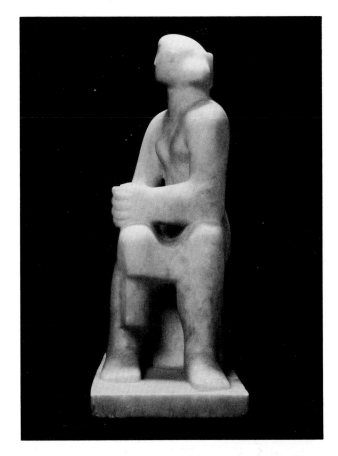

of marble. Although in no. 74 the figure is more massive and solid than the Cycladic musician, Moore has carved through the alabaster in five areas: between each arm and the body, under the left arm between the knees, and between each leg and the block upon which the figure sits. When one compares *Seated Figure* with a work from the mid-1920s like the Manchester *Mother and Child* of 1924–25 (LH 26; fig. 1) one realizes that Moore was no longer intimidated by the material or "frightened to weaken the stone."[29]

Mention is rarely made of the possible influence of Sumerian sculpture on Moore's early work. In his article "Primitive Art," in *The Listener*, vol. xxv, no. 641, August 24, 1941, page 598–99, London, 1941, Moore wrote of the Sumerian sculptures in the British Museum, "some with a contained bull-like grandeur and held-in energy, very different from the liveliness of much of the early Greek and Etruscan art in the terracotta and vase rooms."[30] In *Seated Figure* and other carvings of the period, such as *Figure with Clasped Hands* of 1930 (LH 93, British Council), the clasped or cupped hands may well owe a debt to such sculptures as the Sumerian *Gudea, Ruler of the City State of Lagash c.* 2100 BC in the British Museum (fig. 53).

Moore used alabaster in sixteen carvings of the 1920s and 1930s, of which *Reclining Figure* of 1929 (LH 71) *Seated Figure*, and *Four Piece Composition: Reclining Figure* of 1934 (LH 154; fig. 34) were undoubtedly the most important. Interestingly, Moore told the author that he eventually stopped using alabaster because of his concern that people would be attracted more by the soft, sensuous quality of the material than by the form of the sculpture itself.[31]

Seated Figure, with its vestiges of the art of the past that had interested Moore during the first decade of his career, marks the end of the first major period in his art — a period that was, for the most part, nourished by his study of early Greek, Sumerian, pre-Columbian, and primitive art. (See Wilkinson, 1977, pp. 143–50, "Copies of Works of Art.") The influences already discussed have been assimilated; the handling of the material is confident and assured. Although on a much smaller scale, *Seated Figure* must rank with the Leeds and Ottawa reclining figures as one of the most mature carvings of this period. With the liberating influence of Picasso and the Surrealists just around the corner, Moore could absorb and interpret the radically new forms with the confidence of a mature stone carver.

75 *Relief* 1931 (LH 103)
Bronze, edition of 3, 45.4 × 20.3 cm.
Inscr. lower right *Moore 3 / 3*
Gift of Henry Moore, 1974

76 *Relief* 1931 (LH 104)
Bronze, edition of 3, 45.4 × 20.3 cm
Inscr. lower right *Moore 3 / 3*
Gift of Henry Moore, 1974

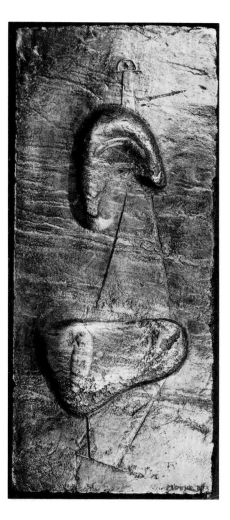

THERE ARE relatively few reliefs among the more than 920 sculptures Moore produced during his long and prolific career. His first public commission was also the first major relief sculpture — a carving of 1928 personifying the *North Wind* (LH 58; fig. 15) for the headquarters of London Transport at St. James's Park, for which a preparatory drawing is in the collection (no. 22). Moore was reluctant to accept his first commission because, as he has said, "Even when I was a student I was totally preoccupied by sculpture in its full spatial richness"[32] (see notes for no. 22). The next two reliefs, nos. 75 and 76, were executed in plaster but not cast in bronze until 1968. In no. 75, two abstract forms in low relief are linked by incised lines, thus anticipating a drawing in the collection *Page from Shiny Notebook 1933–35: Ideas for Relief* of c. 1934 (no. 38). Moore's relief sculpture is well represented in the collection with *Corner Sculpture* of 1952 (no. 89), maquettes 1–3 for the Time-Life screen and the working model (nos. 90–93), the three bronze maquettes of 1955 for the *Wall Relief* at Bouwcentrum, Rotterdam (nos. 100–02), and the maquette and *Relief No. 1* of 1959 (nos. 137–38). See also the fine drawing of 1938, *Projects for Relief Sculptures on London University* (no. 46).

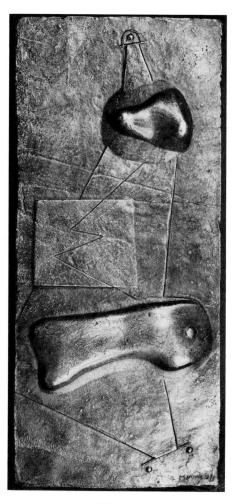

THIS RELIEF, like no. 75, was originally made in plaster but only cast in bronze in 1968. Here too incised lines connect the two abstract forms, but with an additional low rectangular relief between the two more organic forms.

77 *Half Figure* 1935 (LH 160a)
Terracotta, H 10.4 cm
(Bronze edition of 6)
Gift of Henry Moore, 1974

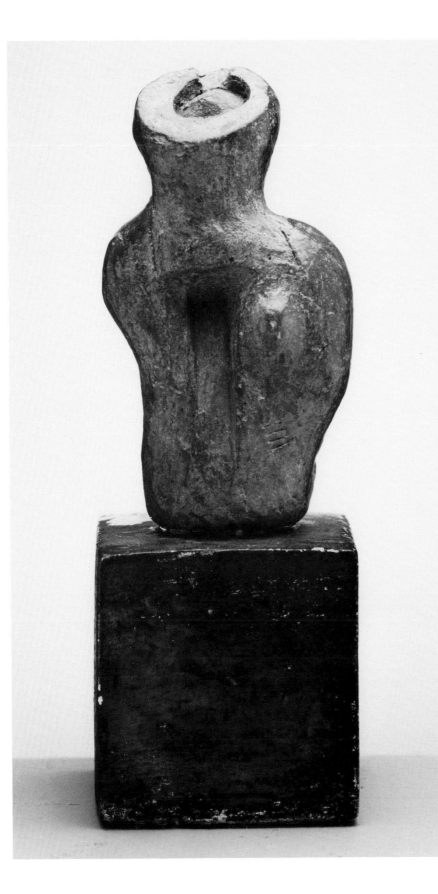

A DRAWING of 1933–35, *Page from Shiny Notebook: Ideas for Sculpture* (fig. 54), includes several studies related to no. 77. In the half figure at left, in the lower half of the sheet, the general outline is established, as well as the shaded, hollowed-out area, the single breast, and the line down the figure beside the breast. However, the head in no. 77 is much closer to the study to the right of this than to the V-shaped gouge in the sketch at left. In the sculpture the top of the head has been sliced off in an even plane at forty-five degrees, with a hollowed-out area in the centre, within which is a circular, dome-like relief. This creates the impression that the head is looking up, as in Moore's early carving of c. 1924–25, *Woman with Upraised Arms* (LH 23). The gouging out of the head is a feature in a number of sculptures of the late 1930s (see LH 192, 193, 202, 204, and 208). The incised lines on the terracotta follow those in the study at left, lower half of the page, in fig. 54. A cast of no. 77 appears in the centre, top row, in *Wall Relief: Maquette No. 3* of 1955 (LH 367).

Fig. 54 *Page from Shiny Notebook: Ideas for Sculpture* 1933–35
Henry Moore Foundation

78 *Maquette for Head* 1937
(not in LH)
Original plaster, H 8.3 cm
Gift of Henry Moore, 1974

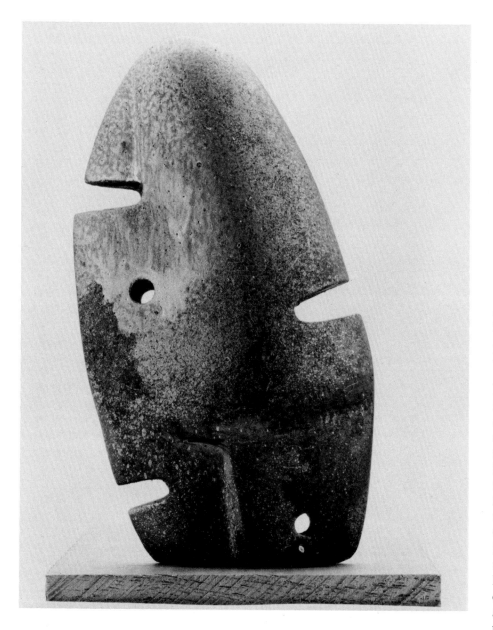

THE GREEN SERPENTINE *Head* of
1937 (LH 182a; carved 1968) was
based on this small maquette, which
has never been cast in bronze. This
is one of three sculptures of the period
(see also *Square Form* of 1936, LH
168, and *Head* of 1937, LH 177) that
appear to have been inspired by
hachas (the Spanish word for axes)
from the Gulf coast of Mexico and
from Guatemala. As Manfred
Schneckenburger has written in his
article "Pre-Columbian Stone Sculp-
ture and Modern Art," "Their aes-
thetic value lies not only in their
high degree of abstraction, but even
more in the perfect combination of
natural form and abstract art form."[33]
Schneckenburger illustrates an AD
fifth- to eighth-century *hacha* from
Antigua (Guatemala) beside Moore's
Hopton-wood stone *Head* of 1937
(LH 177). As he points out, in the
heads and square forms of the period
in question Moore "consciously
adopts the hacha type: in the outline
shape, the implication of a head with
strong curved lines, the sparsely
imposed low relief, the graphic sensi-
tivation of the surface by etching."[34]
No. 78, with the two holes through
the thin form, is even closer to the
Guatemalan prototype than LH 177.
In the view of no. 78 shown here,
a face is clearly indicated down the
left side of the sculpture, with an
eye, the gaping mouth near the base,
and the suggestion of a peaked hel-
met above the eye.

A cast of a work related to no. 78
appears in the right-hand row, second
from the top in *Wall Relief: Maquette
No. 6* of 1955 (LH 370, no. 102).

79 *Stringed Head* 1938 (LH 186g)
Bronze, edition of 5 (cast *c.* 1968), H
8 cm
Gift of Henry Moore, 1974

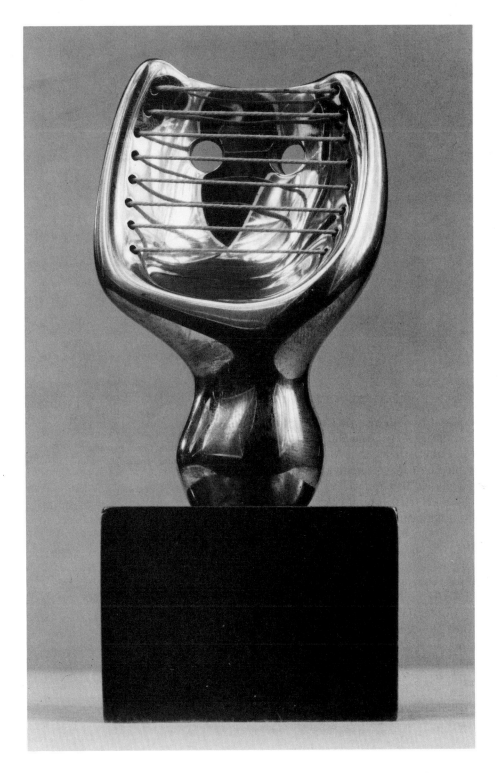

"UNDOUBTEDLY," Moore has
said, "the source of my stringed fig-
ures was the Science Museum. Whilst
a student at the RCA I became

involved in machine art, which in
those days had its place in modern
art."[35] He became particularly fasci-
nated by the mathematical models in

the Science Museum, which he had
described as "hyperbolic paraboloids
and groins and so on, developed by
Lagrange in Paris, that have geomet-
ric figures at the ends with coloured
threads from one to the other to show
what the form between would be. I
saw the sculptural possibilities of
them and did some. I could have
done hundreds."[36]

Although all the stringed-figure
drawings and sculptures were exe-
cuted between 1937 and 1940, they
were anticipated in a number of ear-
lier drawings. For example in the
study at lower right in *Ideas for Two
Piece Composition* of 1934 in the
Rijksmuseum Kröller-Müller (Wil-
kinson, 1977, no. 101), the single line
across the empty space, connecting
the heads of mother and child, looks
forward to the stringed-figure draw-
ings of the late 1930s. Likewise the
strut or bar in the figure at left in
Three Sculptural Ideas of 1935
(no. 44) has the same function as
the strings, cutting across the con-
cave space and joining the outer pro-
jections of the sculptural form.

No. 79 was almost certainly based
on a drawing, although no study
has been found to date. Moore's
stringed-figure studies are among his
most inventive drawings. As he has
written: "In one afternoon I could
draw fifty or sixty ideas, all of which
would, if I had carried them out,
have been interesting and intricate,
so much so that it was more a matter
of invention than imagination"[37] (see
fig. 55).

Although Moore has stated that
the mathematical models in the Sci-
ence Museum were the source of
his own stringed-figure sculpture, he
was undoubtedly aware of the work
of Naum Gabo, who had moved to
London in 1935. Gabo's stringed-figure
drawings predate Moore's work on
the same theme, as seen for example
in *Sketch for a Stone Carving* of 1933
(fig. 56), and they may well have

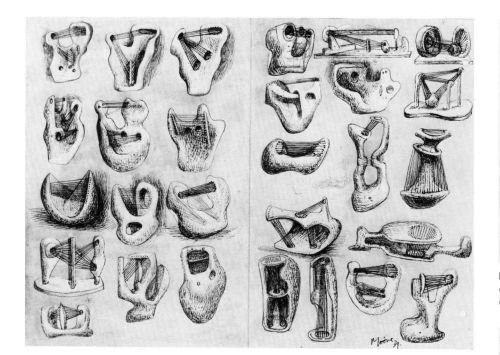

Fig. 55 *Ideas for Sculpture in Metal and Wire* 1939
Private collection

Fig. 56 Naum Gabo *Sketch for a Stone Carving* 1933
© Nina and Graham Williams

Fig. 57 *Prehistoric Greek implement*
National Museum, Athens

influenced the work of both Moore and Hepworth in the late 1930s.

Unlike the abstract stringed sculptures of Gabo and Hepworth, almost all Moore's stringed works are figurative. In *Head* (no. 79) eight parallel, horizontal strings cut across and make tangible the space within the concave head. As David Sylvester has written: "Movement of the eye along the length of the strings sharpens awareness of the space the sculpture encloses."[38] The two holes or eyes may have been suggested by the holes in two prehistoric Greek implements (fig. 57) in the National Museum, Athens, that Moore had copied in a 1937 sketchbook (fig. 58). Two holes also appear in the back of Moore's first internal / external form sculpture, *The Helmet* of 1939–40 (LH 212; fig. 59), another work that was almost certainly influenced by the Greek implements. (See Wilkinson, 1977, p. 144, "Copies of Works of Art.")

Moore's last stringed-figure sculpture, *The Bride* (LH 213), was executed in 1939–40. Although he enjoyed doing them, he found the stringed-figure sculptures "too much in the nature of experiments to be really satisfying.... Others, like Gabo and Barbara Hepworth, have gone on doing it. It becomes a matter of ingenuity rather than a fundamental human experience."[39]

Fig. 59 *The Helmet* 1939–40
Private collection

Fig. 58 *Page from Sketchbook* 1937
Private collection

79a *Stringed Head* 1939 (LH 195)
Bronze and string, edition of 6,
H 16.3 cm with base
Inscr. on back *Moore 3 / 6*
Gift of Allan Manford, 1980

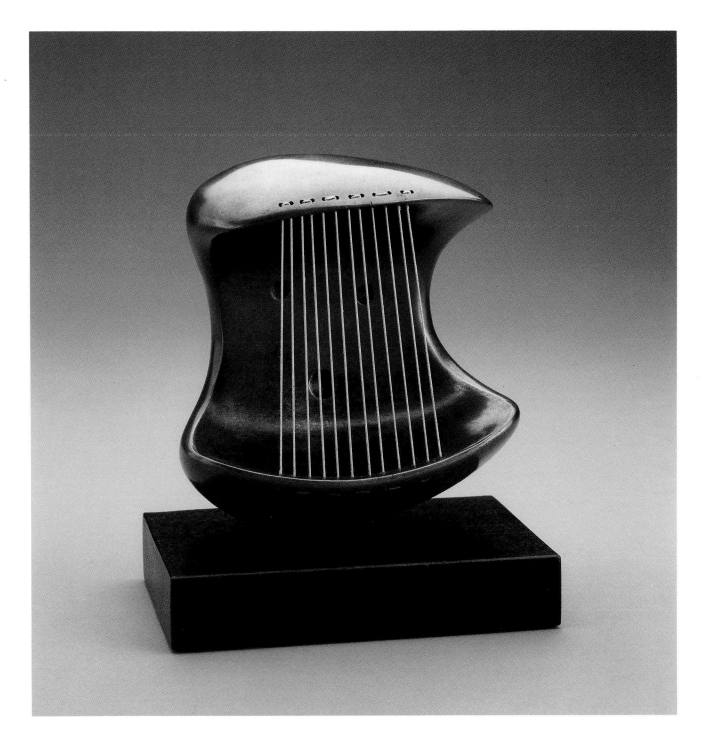

IN THIS BRONZE, a variation on
no. 79, the strings run vertically,
rather than horizontally, in front of
the concave head. Facial features are
indicated by the three incised circles,
representing the eyes and either the
nose or mouth. As in *Spanish*

Prisoner, a lithograph of 1939
(no. 201) there is the suggestion that
the face is imprisoned behind bars.
For a detailed discussion of Moore's
stringed-figure drawings and sculp-
tures, see notes for no. 79.

80 *Reclining Figure* 1938 (LH 186d)
Original plaster, L 12.5 cm
(Bronze edition of 7, cast 1967)
Gift of Henry Moore, 1974

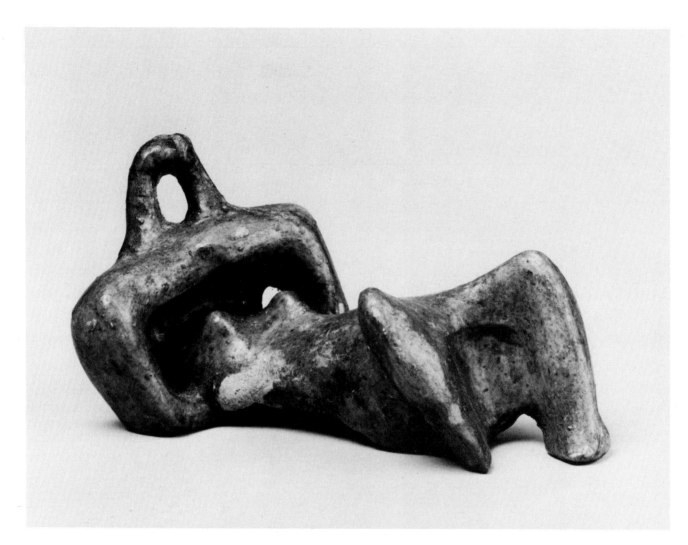

LIKE ALMOST ALL Moore's sculpture from the 1920s through to the early 1950s, the small reclining figure was probably based on a sketchbook drawing similar to the 1938 sheet with the study for the Tate Gallery's *Recumbent Figure* (LH 191; see Wilkinson, 1977, no. 120). Although such a preliminary sketch is not known, there is a large finished drawing of 1938, *Reclining Figure* (fig. 60), in which no. 80 appears. This large drawing may well have been based not on the original sketchbook idea but on the completed maquette, no. 80. As Moore himself has stated: "There are a few examples where a maquette which was made from a hasty drawing was used in the realization of a more finished drawing."

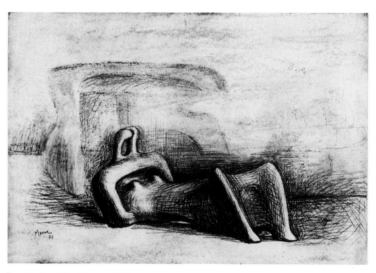

Fig. 60 *Reclining Figure* 1938
Private collection

81 *Family Group* 1947 (LH 267)
Original plaster, H 40.6 cm
(Bronze edition of 7)
Gift of Henry Moore, 1974

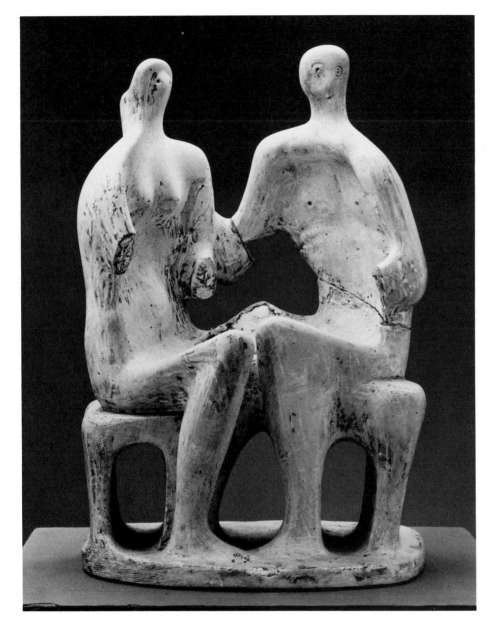

THIS IS the only sculpture in the collection for which there is also the preliminary sketch, *Drawing for Family Group*, of 1944 (no. 57). (See notes for no. 57 for a discussion of the family-group projects.) The maquette for no. 81, (*Family Group* LH 240), almost certainly based on this drawing, was made in 1945. The large family-group drawing of 1944 (fig. 50) is obviously a larger and more finished version of no. 57 and not based on the maquette LH 240, which was executed in 1945. In no. 81 the two children are missing, as are the arms of the parents (see bronze cast, fig. 61). In all probability these sections of the sculpture were cut out to be cast separately and were lost or destroyed at the bronze foundry.

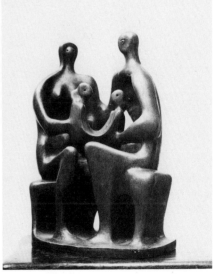

Fig. 61 *Family Group* 1947
Private collection

82 *Seated Figure* 1949 (LH 272)
Original plaster, H 24.8 cm
(Bronze edition of 7)
Gift of Henry Moore, 1974

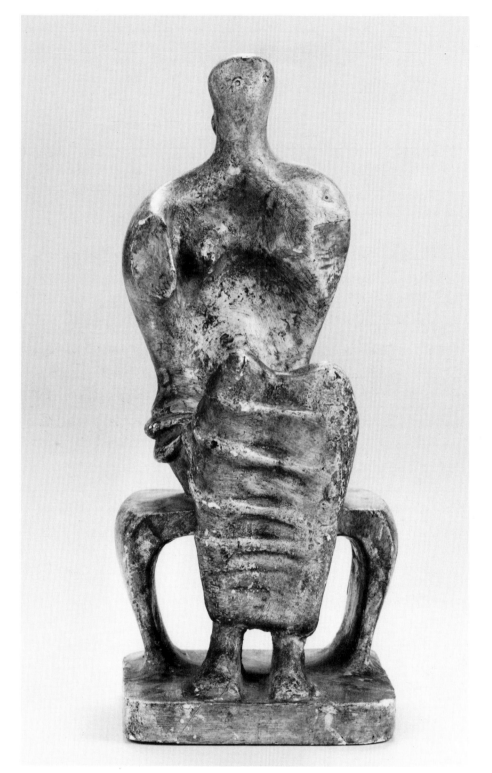

THIS FIGURE is very closely related
to the mother in the large bronze
Family Group of 1948–49 (LH 269,
fig. 62). See also the 1949 *Seated Man*
(LH 269a), a version of the male fig-
ure in *Family Group*.

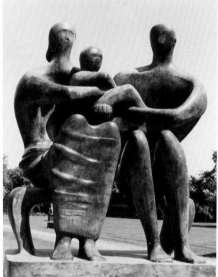

Fig. 62 *Family Group* 1948–49
Trustees of the Tate Gallery, London
PHOTO: Errol Jackson

83 *Interior for Helmet* 1950
(not in LH)
Clay and wire, H 14.6 cm
Gift of Henry Moore, 1974

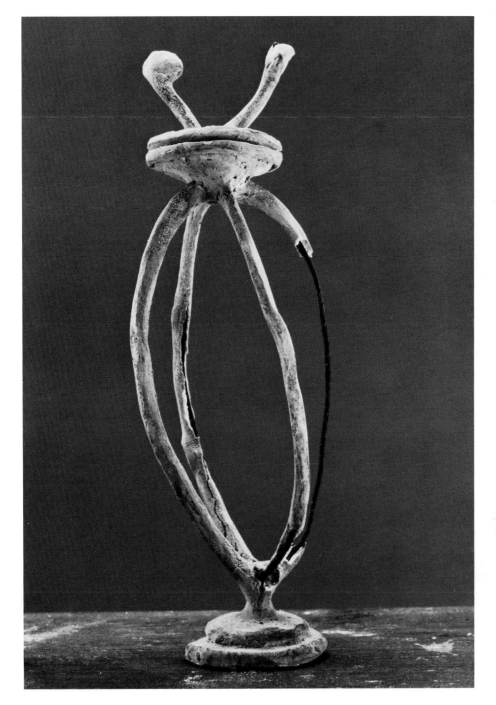

THE ARTIST told the author that this piece was made at the same time as the lead *Five Figures: Interiors for Helmets* of 1950 (LH 282; fig. 63). The first helmet head was executed in 1939–40 (LH 212; fig. 59), one of the last sculptures made before Moore began work on the shelter drawings of 1940–41 (see notes for no. 79). In 1950 he returned to the helmet-head theme and did five sculptures of this subject (LH 278–81 and 283), of which *Interior for Helmet* was a study made in connection with this series. Some of the clay has broken off the wire armature. No. 83 was never cast in bronze.

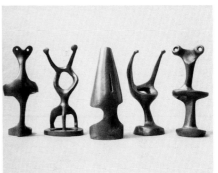

Fig. 63 *Five Figures: Interiors for Helmets* 1950
Henry Moore Foundation

84 *Standing Figure* 1950 (LH 290)
Fibreglass, edition of 3 (cast 1970),
H 219.8 cm
(Bronze edition of 4)
Gift of Henry Moore, 1974

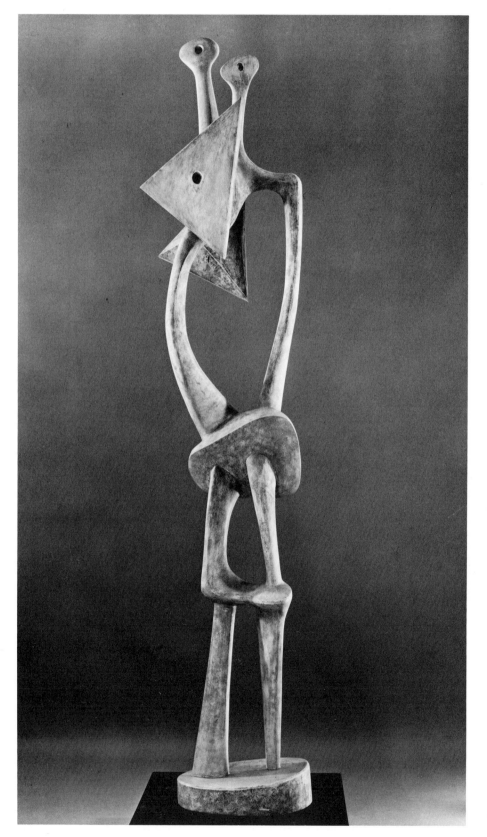

AS HERBERT READ has written, none of the major or minor sculptures of the years 1945–48 "prepares us for the radical innovation of the *Standing Figure* of 1950."[40] This, the first in a series of vertical figures of the 1950s culminating in the *Glenkiln Cross* of 1955–56 (LH 377, no. 106), marks as abrupt a departure from Moore's sculpture of the 1940s as did the 1931 *Composition* (fig. 51) from his work of the 1920s.

The small maquette for no. 84, *Standing Figure* of 1950 (LH 289a), was based on the sketch at centre, bottom row, in *Standing Figures: Ideas for Metal Sculpture* of 1948 (fig. 64). In the late 1960s and early 1970s Moore had a number of sculptures cast in fibreglass to use for exhibition purposes. No. 84 is the earliest of three fibreglass casts in the collection (see also nos. 153 and 184).

The stark, tubular forms suggest a skeletal structure in which, as Read has said, the human frame has been split "along the lines of force indicated by arms and legs with a nodular joint at the shoulders, hips and knees."[41] The two triangular forms are reminiscent at once of shoulder blades and small shields, protecting the vulnerable areas of the neck and chest. In the double necks and small heads the split forms of the rest of the figure are brought to their logical resolution.

Moore told his friend Herbert Read that (in Read's words) "the preliminary idea had come from a photograph he had seen of some tall African tribesmen who stand perfectly still in the marshes of a river delta intent on spearing fishes."[42] If the photograph accounts for the preliminary idea, the forms of the sculpture — the small heads, the rectangular shields, and the stick-like legs — are distinctly reminiscent of the standing figures in Picasso's 1932 Surrealist drawing *An Anatomy* (fig. 31). This is not to suggest a

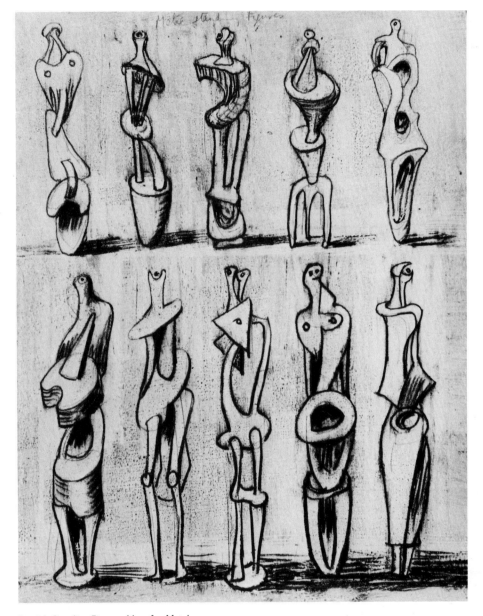

Fig. 64 *Standing Figures: Ideas for Metal Sculpture* 1948
Private collection

ture against a quiet expanse of water. It was an effect produced by very sharp contrast — a gaunt figure rising in agitated verticals from the verge of a calm, flat sheet of water that seemed the very essence of horizontalism."[43]

A bronze cast of this work is beautifully sited in Scotland, on the estate of Sir William Keswick at Shawhead, Dumfries (fig. 65), not far from casts of the *King and Queen* of 1952–53 (LH 350) and the *Glenkiln Cross* (no. 106 and fig. 82). This fibreglass cast (no. 84) was shown in Moore's magnificent outdoor exhibition at the Forte di Belvedere in Florence in 1972. Like a sentinel, it was placed high on a wall, as if keeping watch over the exhibition.

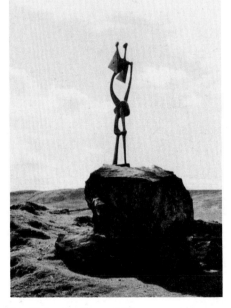

Fig. 65 *Standing Figure* 1950
Sir William Keswick, Dumfries, Scotland

direct borrowing from any of the studies in the Picasso drawing, but rather that Moore had assimilated the freedom and distortions of Picasso's body imagery of the period and made of it something very much his own. Although individual details of *Standing Figure* are close to some of the features in fig. 31, as a composite work the sculpture has none of the playful, often grotesque sexuality found in much of Picasso's work of the early 1930s.

The bronze version of this sculpture was first exhibited in Battersea Park, London, beside the Boating Lake. Moore has written: "I was delighted to see a piece of my sculp-

85 *Small Maquette No. 1 for*
Reclining Figure 1950 (LH 292a)
Bronze, edition of 9, L 24.1 cm
Inscr. on sinister edge *Moore 2 / 9*
Gift of Walter Carsen, 1985

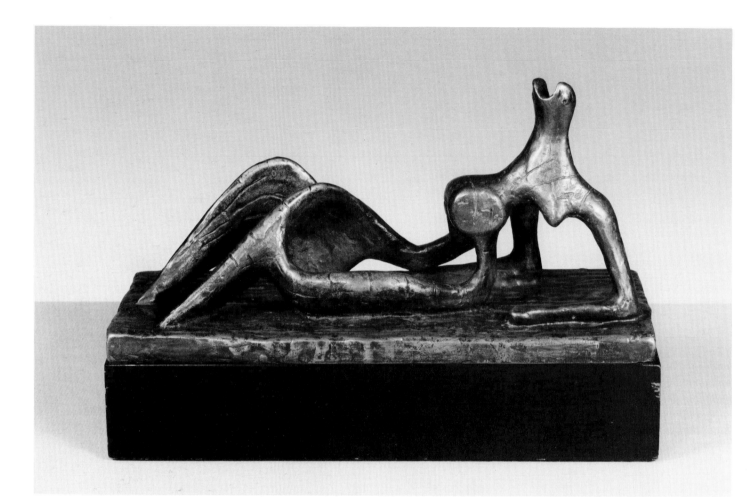

THIS MAQUETTE, one of two preparatory studies for the Festival, *Reclining Figure* of 1951 (no. 85a) was based on the sketch at right, second from the bottom, in *Page 35 from Sketchbook 1950–51: Studies for Festival "Reclining Figure"* of 1950 (fig. 66). This is the definitive study for no. 85. The second small version, *Small Maquette No. 2 for Reclining Figure*, also of 1950 (LH 292b), was based on the drawing at lower right in fig. 66. For a more detailed discussion of the Festival of Britain commission, see notes for no. 85a.

Fig. 66 *Page 35 from Sketchbook 1950–51: Studies for Festival "Reclining Figure"* 1950 (misdated 1949)
Whereabouts unknown

85a *Reclining Figure* 1951 (LH 293)
Plaster cast, L 231.2 cm
(Original plaster in the Tate Gallery)
(Bronze edition of 5: Arts Council
of Great Britain; Musée National
d'Art Moderne, Paris)
Gift of Henry Moore, 1974

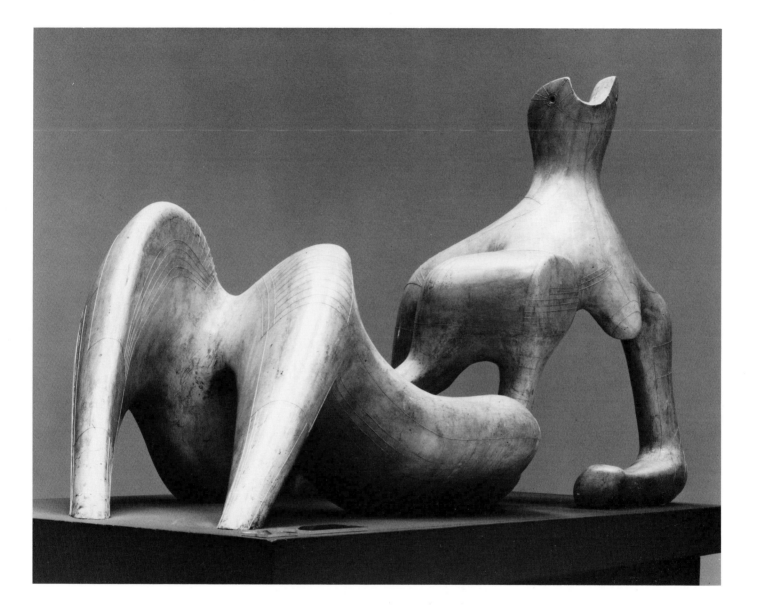

NO. 85a was based on *Small Maquette No. 1 for Reclining Figure* of 1950 (LH 292a, no. 85), which in turn was based on the study at right, second from the bottom, in *Page 35 from Sketchbook 1950–51: Studies for Festival "Reclining Figure"* of 1950 (fig. 66).

This sculpture, often called the *Festival Reclining Figure*, was, as Moore has written:

commissioned by the Arts Council for the Festival of Britain in 1951. But I knew that the South Bank would only be its temporary home, so I didn't worry about where it was placed. If I had studied a Festival site too carefully, the figure might never have been at home anywhere else. As it was, I made the figure, then found the best position I could. I was simply concerned with making a sculpture in the round....[44]

Reclining Figure is an important landmark in Moore's development. In his earlier work the holes created spaces in the sculpture, so that a hole was "a shape in its own right, the solid body was encroached upon, eaten into, and sometimes the form was only the shell holding the hole."[45] No. 85a, Moore wrote, "is perhaps my first sculpture where the space and the form are completely dependent on and inseparable from each other. I had reached the stage where I wanted my sculpture to be truly three-dimensional.... Now the space and the form are so naturally fused that they are one."[46]

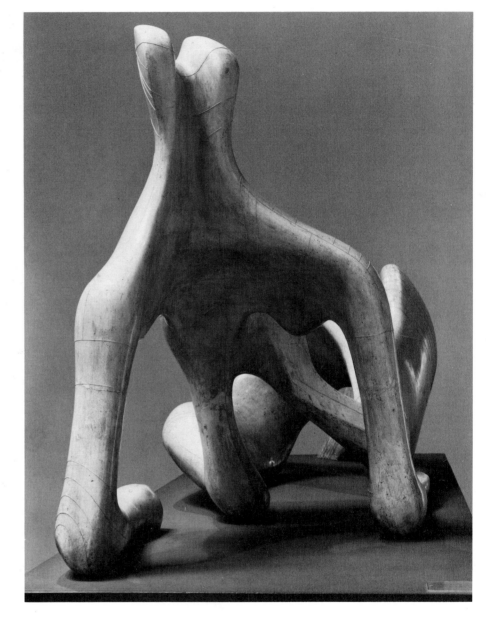

An innovative feature of *Reclining Figure* is the use of strings glued to the surface both in the original plaster in the Tate Gallery and in no. 85a. These strings serve the same function as the two-way sectional lines in the drawings (no. 57); that is, they move in two directions, both down and across the forms, thus leading our eye over the three-dimensional shape beneath. Similarly the incised lines in a number of the sculptures of the 1930s, such as *Two Forms* of 1934 (fig. 38), not only break the smooth surfaces, but serve to indicate the subtle curves and hollows. The strings in no. 85a do not cut into the surface but rise fractionally above it and form crisp contours around and down the forms.

Lines in low relief also appear in the four leaf figure bronzes of 1952 (LH 323–26) and in *Head: Lines* of 1955 (HL 397; fig. 85). In the small maquette for the latter work (no. 117) the lines have been drawn in pencil (see notes for no. 117).

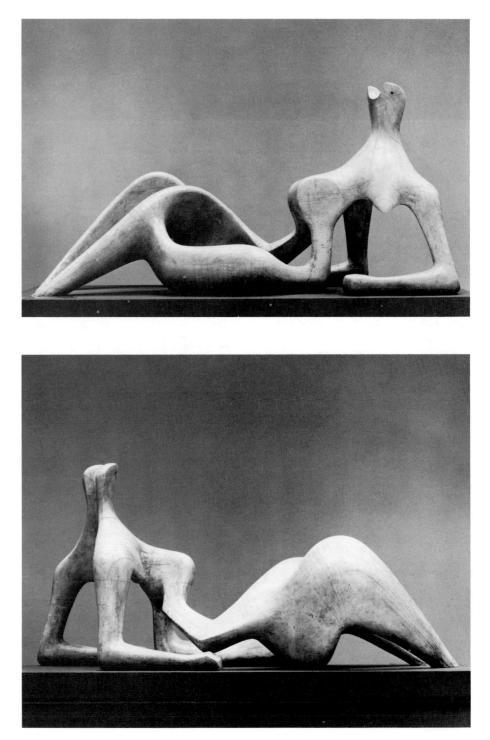

86 *Working Model for Upright Internal and External Forms* 1951 (LH 295)
Bronze, edition of 7, H 64 cm
(Other casts: Rhode Island School of
Design, Providence; Kunstmuseum, Basel)
Gift from the Women's Committee Fund, 1951

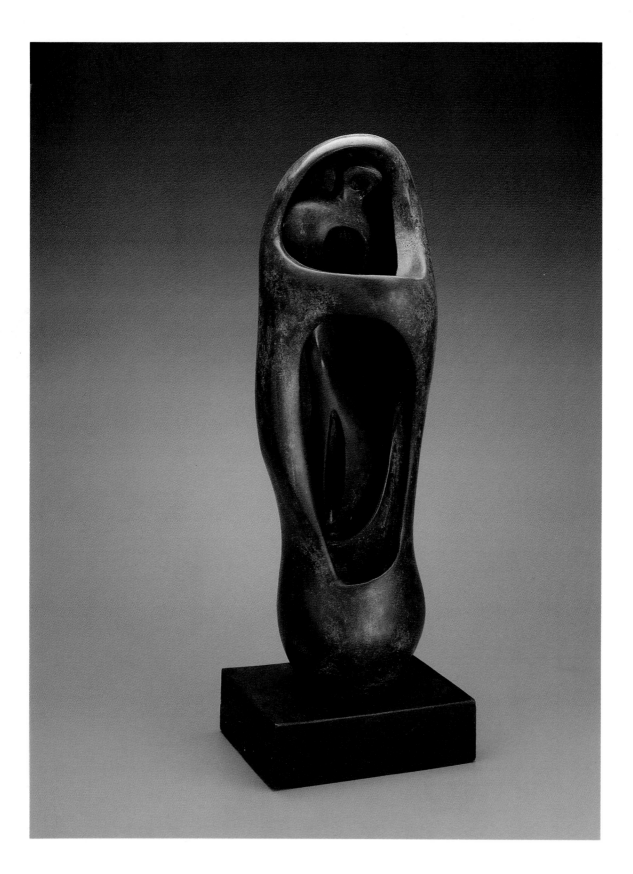

ALTHOUGH MOORE had explored the internal / external-form theme first in *The Helmet* of 1939–40 (LH 212; fig. 59) and then in the 1950 series of helmet heads (LH 278–83), the four versions of no. 86 (LH 294–97) were the first sculptures to represent a complete figure. The maquette for no. 86 (LH 294) was based on a drawing of 1948 *Ideas for Sculpture: Internal and External Forms* (fig. 67) in the Smith College Museum of Art, Northampton, Mass.

It is interesting to compare Moore's description of this work with that of Erich Neumann in *The Archetypal World of Henry Moore*. The artist writes: "I suppose in my mind was also the Mother and Child idea and of birth and the child in embryo. All these things are connected in this interior and exterior idea."[47] It is worth quoting Dr. Neumann's psychological interpretation of this work, so rich in symbolic associations:

What we see here is the mother bearing the still unborn child within her and holding the born child again in her embrace. But this child is the dweller within the body, the psyche itself, for which the body, like the world, is merely the circumambient space that shelters or casts out. It is no accident that this figure reminds us of those Egyptian sarcophagi in the form of mummies, showing the mother goddess as the sheltering womb that holds and contains the dead man like a child again, as at the beginning. Mother of life, mother of death, an all-embracing body-self, the archetypal mother of man's germinal ego consciousness — this truly great sculpture of Moore's is all these in one.[48]

Moore's interest in the internal / external-form motive dates from a series of drawings of the mid-1930s, of which *Page from Sketchbook B: Form inside Forms* of 1935 (HMF) is an example. This drawing includes a sketch of a *malanggan* figure from New Ireland, Oceania, similar to the one shown here (fig. 68). Moore was greatly impressed by the inner and outer framework of such works — by the extraordinary craftsmanship required to create forms within forms. In the HMF drawing, Moore also made a sketch in which he transformed the tribal carving into an idea for sculpture — the progenitor of a number of subsequent internal- and external-form sculptures, of which the first was *The Helmet* of 1939–40 (fig. 59). The Oceanic-inspired drawings of 1935–40 are the ancestors of the 1948 drawing *Ideas for Sculpture: Internal and External Forms* (fig. 67) and hence of no. 86. *Working Model for Upright Internal and External Forms*, was the first Moore sculpture to enter the collection of the Art Gallery of Ontario (the Art Gallery of Toronto, as the institution was called in 1951).

Fig. 67 *Ideas for Sculpture: Internal and External Forms* 1948
Smith College Museum of Art, Northampton, Mass.

Fig. 68 New Ireland (Oceania) *Malanggan figure*
Trustees of the British Museum, London

87 *Half Figure* 1952 (LH 316)
Bronze, edition of 5, H 17.2 cm
Gift of Walter Carsen, 1985

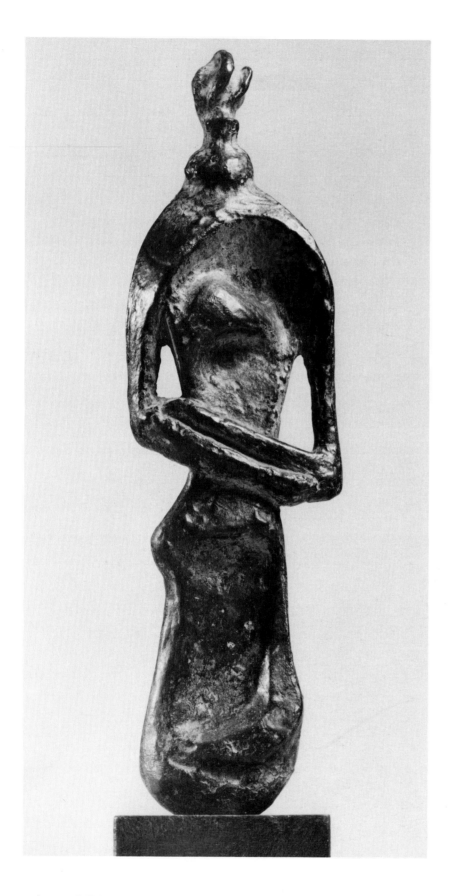

DURING the early 1950s Moore created a series of sculptures in which the thin forms are the antithesis of the full-bodied female forms that characterized his work throughout his career. *Standing Figure* of 1950 (no. 84), one of the first in the series, was, Moore told his friend Herbert Read, inspired by a photograph he had seen of tall African tribesmen. In *Half Figure* the thin, flat forms of the body and the position of the crossed arms are distinctly reminiscent of Cycladic sculpture, which Moore had admired since his student days. The two parallel, projecting planes of the head anticipate the axed head of the *Warrior with Shield* of 1953–54 (no. 99). *Half Figure* is also closely related to the *King and Queen* of 1952–53 (LH 350) one of Moore's most favoured and best loved sculptures. The maquette was made in 1952 (fig. 69). I once asked Moore why he did not include the metal frame around the two figures in the life-size version of the *King and Queen*. In one of his most down-to-earth comments about his work, he replied: "Oh, on a larger scale, they would look as if they were keeping goal in a soccer match."

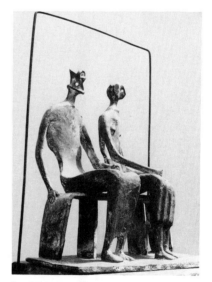

Fig. 69 *Maquette for King and Queen* 1952
Private collection

87a *Mother and Child* 1953 (LH 315)
Original plaster, H 52 cm
(Bronze edition of 7 + 1: Tate
Gallery, extra cast)
Gift of Henry Moore, 1974

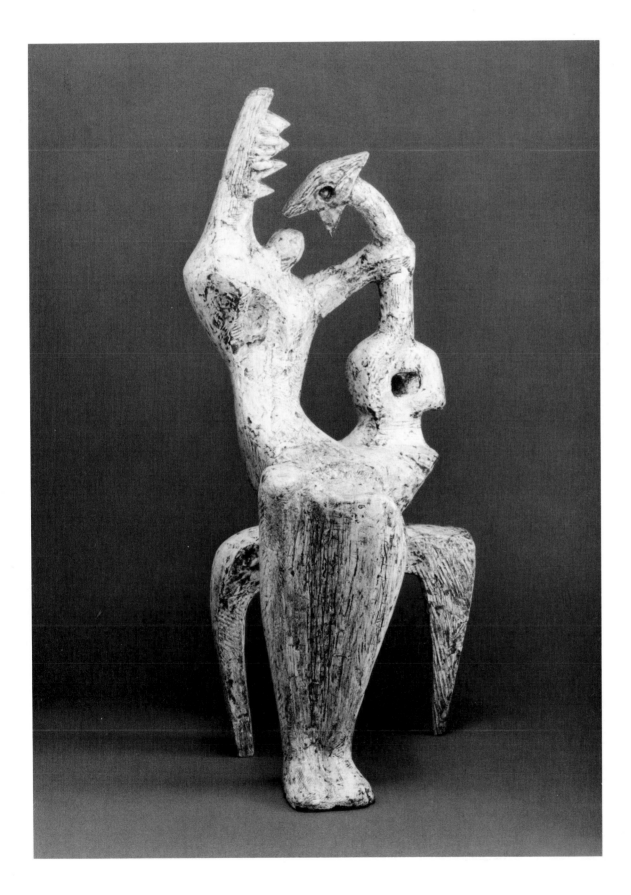

FOR ERICH NEUMANN this extraordinary sculpture represents "perhaps the most negative expression of the mother-and-child idea in the whole of Moore's work."[49] Herbert Read has speculated:

This group is so close an illustration of the psycho-analytical theories of Melanie Klein that it might seem the sculptor had some first-hand acquaintance with them; but the artist assures me that this is not so. It may be that, in Neumann's words, "it is a picture of the Terrible Mother, of the primal relationship fixed forever in its negative aspect," but if so, it is a picture that comes from the artist's unconscious: it has no direct connections with any psycho-analytical theory.[50]

The preparatory sketch for this sculpture, at lower left in *Drawing for Sculpture: Studies for Seated Figures* of 1951 (private collection), which was followed by *Maquette for Mother and Child* in 1952 (LH 314), derived neither from the psychoanalytical theories of Klein nor from the artist's unconscious. The idea was based on the low relief on a Peruvian pot (fig. 70) illustrated in Ernst Fuhrmann's *Peru 11* (1922), of which the artist owned a copy. The exact identity and significance of the forms in the Peruvian work are unclear. At left is a man with the head of a bird, and on the right a fish with an enormous mouth and a face like a crescent moon. The bird man holds with both hands a long neck with a birdlike head, which the fish is about to devour. Moore has transformed this complex image into a seated mother and child. The snake form with the head of a bird becomes the child with gaping mouth, straining to reach the single breast of the mother. The serrated head of the mother, her breast, and the outstretched arm derive from the teeth, tongue (?), and arm (?) of the fish form.

This negative and disturbing expression of the mother-and-child relationship is unlike anything else in Moore's entire *oeuvre*. The beaklike mouth of the child strains to devour rather than feed at the breast, but is held back by the outstretched arm of the mother, whose hand appears to be strangling the extraordinarily long neck of the child. Moore's obsession with the mother-and-child theme is nowhere better illustrated than in the extraordinary metamorphosis of the Peruvian work. It is worth quoting again the artist's remark, "so that I was conditioned, as it were, to see it in everything."[51]

Fig. 70 Peruvian pot
Whereabouts unknown

88 *Draped Reclining Figure* 1952–53 (LH 336)
Original plaster, L 160.4 cm
(Bronze edition of 3: Time-Life
Building, London; City of Cologne;
The Hirshhorn Museum and Sculp-
ture Garden, Washington, DC)
Gift of Henry Moore, 1974

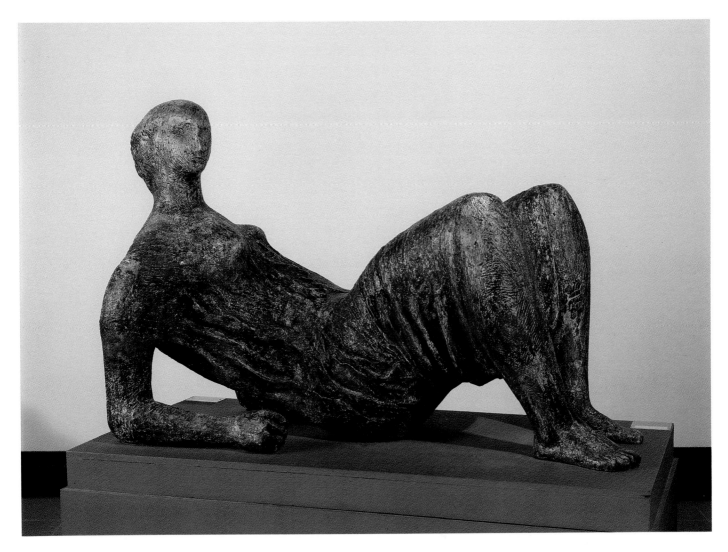

IN 1951 Moore visited Greece for
the first time, on the occasion of
the British Council's touring exhibi-
tion of his work. The following year
he made the maquette (LH 335)
for no. 88 and began work on this
Draped Reclining Figure, the first of
a number of important draped sculp-
tures of the 1950s with obvious affini-
ties to the sculpture of classical
Greece. Other works from what may
be called Moore's neoclassical period
of the 1950s are *Draped Torso* of 1953
(LH 338), *Draped Seated Woman* of
1957–58 (LH 428, no. 127) and *Draped
Reclining Woman* of 1957–58 (LH
431, no. 129). Although neither the
Warrior with Shield of 1953–54 (LH

360, no. 99), nor the *Falling Warrior*
of 1956–57 (LH 405) belong stylisti-
cally to the naturalism of the works
cited above, they are certainly
related in subject matter to Greek
sculpture, the latter bronze in partic-
ular to works such as the *Fallen War-
rior* from the so-called Temple of
Alphaia on Aegina, now in the Glyp-
tothek, Munich.
 Draped Reclining Figure was the
first of two commissions for the Time-
Life Building in London, at the cor-
ner of Bond and Bruton streets (see
no. 90; fig. 71). It was Moore's con-
viction that sculptors and architects
should work together that led him
to accept the double commission for

the building: a reclining figure for
the terrace and a carved stone screen
for the Bond Street end of the terrace
(see nos. 90–93). He thought very
carefully about the open-air setting
for the proposed figure, and its rela-
tion to the building itself:

I knew that the figure would be seen
from the Reception Room and it seemed
to me that in cold weather a nude —
even an abstractish one — might look
incongruous to people looking out at her
from a warm room. So I became absorbed
by the problems of the draped figure,
and for a time I was back in the period of
the shelter drawings [see nos. 47 and
48], whose themes had demanded a con-

89 *Corner Sculpture c. 1952*
(not in LH)
Original plaster, H 16 cm
Gift of Henry Moore, 1974

centration on drapery. But gradually I evolved a treatment that exploited the fluidity of plaster. The treatment of drapery in my stone carvings was a matter of large, simple creases and folds [see no. 74] but the modelling technique enabled me to build up large forms with a host of small crinklings and rucklings of the fabric.[52]

Moore's remarks about the use of drapery in this carving are interesting enough to quote in full.

Drapery played a very important part in the shelter drawings I made in 1940 and 1941 and what I began to learn then about its function as form gave me the intention, sometime or other, to use drapery in sculpture in a more realistic way than I had ever tried to use it in my carved sculpture. And my first visit to Greece in 1951 perhaps helped to strengthen this intention. So ... I took the opportunity of making this draped figure in bronze.

Drapery can emphasise the tension in a figure, for where the form pushes outwards, such as on the shoulders, the thighs, the breasts, etc., it can be pulled tight across the form (almost like a bandage), and by contrast with the crumpled slackness of the drapery which lies between the salient points, the pressure from inside is intensified.

Drapery can also, by its direction over the form, make more obvious the section, that is, show shape. It need not be just a decorative addition, but can serve to stress the sculptural idea of the figure.

Also in my mind was to connect the contrast of the sizes of folds, here small, fine and delicate, in other places big and heavy, with the form of mountains, which are the crinkled skin of the earth....

Although static, this figure is not meant to be in slack repose, but, as it were, alerted.[53]

However much the drapery may remind us of classical Greek sculpture, Moore uses it, as John Russell

has perceptively pointed out, "to romantic ends that would have been incomprehensible to the Greeks. The 'crinkled skin of the earth' was not something that they would have thought of as a metaphor for the folds of costume, but it was one of the quintessential metaphors for emotional states in the England of the 1940s and 1950s ... drapery, for Moore, was another way, and a new one, of mediating between landscape and the human body."[54] Of particular interest in the original plaster, no. 88, are those areas where the plaster has worn away, exposing the fabric that Moore used to create the folds of the drapery.

For all its classical overtones — the naturalism of the figure and the use of drapery — the pose is nevertheless reminiscent of the *Chac Mool* reclining figure (fig. 17) in which the upper part of the torso is similarly supported by the arms, and in which the legs are drawn up with the knees at the same height. Here, however, the head is turned approximately forty-five degrees to the right, whereas in the *Chac Mool* and the 1929 Leeds *Reclining Figure* (fig. 16), the heads are turned ninety degrees. Although no. 88 is one of Moore's more symmetrical reclining figures, mention should be made of the general inclination to the right of the whole body, which is not immediately apparent in a photograph showing a single view. The right shoulder and arm are farther back than the left ones. When the figure is viewed from behind and above the head, a gentle turning movement is seen that is far removed from the rigidity of the *Chac Mool*.

There are no known drawings for this sculpture. As with most of Moore's large works since the war, no. 88 was preceded by a small study, *Maquette for Draped Reclining Figure* of 1952 (LH 335).

THIS WORK, which was never cast in bronze, was almost certainly executed in 1952 when Moore made four sculptures entitled *Mother and Child: Corner Sculpture* Nos. 1 to 4 (LH 307–10), and LH 311 *Family: Maquette for Corner Sculpture*. Whereas these have figurative elements that converge at each of the corners, no. 89 is a more abstract work, although the relief straddling the corner may also represent a mother and child. The organic forms may well be casts of flint stones, similar to those used in the wall reliefs of 1955 (see fig. 94 with no. 138). Elements of hardware, here casts of screws, were also incorporated into the 1955 wall reliefs (see no. 102 and LH 371 and 372).

90 *Time-Life Screen: Maquette No. 1* 1952 (LH 339)
Bronze, edition of 9, H 18.2, L 32.7 cm
Gift of Henry Moore, 1974

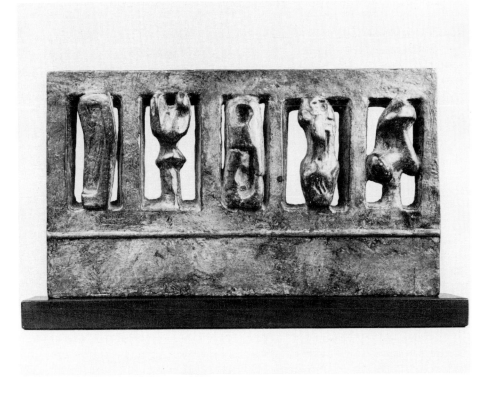

Fig. 71 *Time-Life Screen* 1952–53
Time-Life Building, New Bond Street, London

Bond Street end of the terrace (fig. 71). Moore welcomed the opportunity of working simultaneously on two such entirely different projects.

It seemed to me that the "Screen" should look as though it was part of the architecture, for it is a continuation of the surface of the building — and is an obvious part of the building.

The fact that it is only a screen with space behind it, led me to carve it with a back as well as a front, and to pierce it, which gives an interesting penetration of light, and also from Bond Street makes it obvious that it is a screen and not a solid part of the building.

With the perspective sketch of the building beside me I made four maquettes and my aim was to give a rhythm to the spacing and sizes of the sculptural motives which would be in harmony with the architecture. I rejected the idea of a portrayal of some pictorial scene, for that would only be like hanging up a stone picture, like using the position only as a hoarding for sticking on a stone poster.[55]

The Time-Life screen commission is well represented in this collection with maquettes 1–3 in bronze as well as the original plaster working model (no. 93). Of no. 90, Moore has written: "The first of the four maquettes I rejected because I thought it too obvious and regular a repetition of the fenestration of the building."[56] Inevitably, these five vertical forms suggest standing figures. In fact, as John Russell has observed, the four maquettes "represent a run-through of nearly everything that Moore had done before: a sounding out of theme after theme. Careful scrutiny will reveal standing figures, reclining figures, animal heads, found and altered objects, reinvented torsos, and cryptic forms, half human being, half amphora, half sea-worn pebble."[57]

WHILE MOORE was working on the *Draped Reclining Figure* (no. 88) for the terrace of the Time-Life Building, the architects approached the artist about doing a screen for the

91 *Time-Life Screen: Maquette No. 2* 1952 (LH 340)
Bronze, edition of 9, H 18, L 32.4 cm
Gift of Henry Moore, 1974

92 *Time-Life Screen: Maquette No. 3* 1952 (LH 341)
Bronze, edition of 9, H 8.2, L 32.6 cm
Gift of Henry Moore, 1974

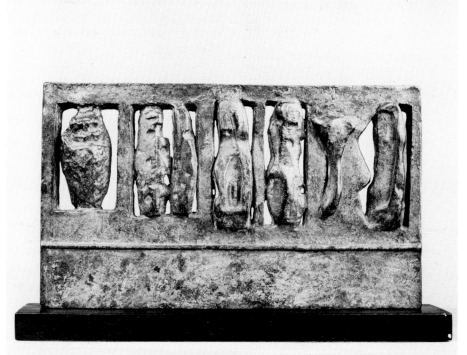

◄

"IN THE SECOND MAQUETTE,"
Moore has written, "I tried to vary
this and make it less symmetrical but
in doing so the rhythms become too
vertical."[58]

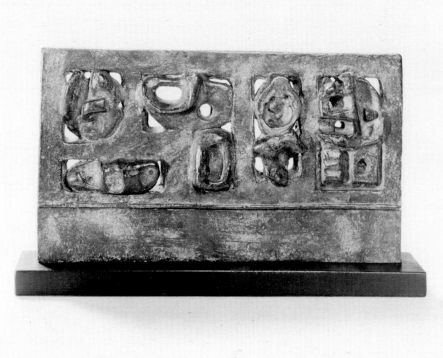

◄

"IN THE THIRD MAQUETTE" I
tried to introduce a more horizontal
rhythm but was dissatisfied with the
monotony of the size of the forms."[59]

93 *Time-Life Screen: Working Model* 1952 (LH 343)
Original plaster, H 38.5, L 101 cm
(Bronze edition of 9 + 1: Time-Life Building, London;
Smith College Museum of Art, Northampton, Mass.;
Arts Council of Great Britain, extra cast)
Gift of Henry Moore, 1974

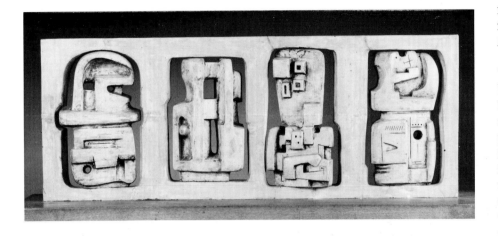

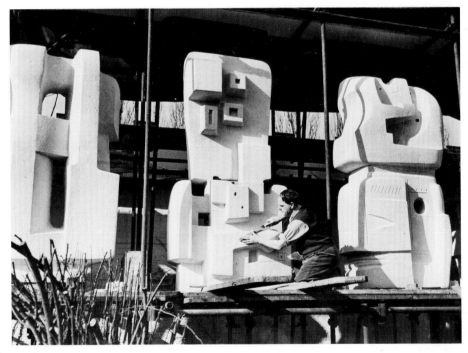

Fig. 72 Henry Moore at work on Time-Life *Screen* in his garden at Hoglands, 1953

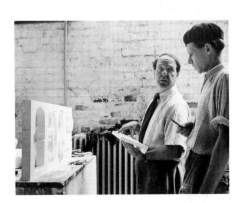

Fig. 73 Henry Moore and an assistant, comparing
Time-Life Screen: Maquette No. 4 (1952)
with the original plaster in progress of *Time-Life
Screen: Working Model* 1952
PHOTO: "Illustrated"

NO. 93, THE DEFINITIVE STUDY
for the screen, was based on the *Time-Life Screen: Maquette No. 4* of 1952 (LH 342) of which Moore has written: "The fourth maquette I thought was better and more varied and so this became the definitive maquette, although a further working model produced other changes."[60] Here the forms are less organic than those in nos. 90–92, and seem to look back to the square-form carvings and drawings of the mid-1930s. In the working model (both in the original plaster and in the bronze edition) each form is fixed at top and bottom with a pin, so they can be turned independently within the fixed framework of the screen itself. While Moore was carving the large Portland stones in his garden at Hoglands (fig. 72), without the stone frame around them, he realized "that they didn't really need a screen at all, the screen had been made and was in position on the building, and all I could do was to arrange for the openings to be made larger, that is to say as large as possible without weakening the structure of the screen. I found too that my project really demanded a turntable for each of the carvings, so that they could be turned, say, on the first of each month, each to a different view, and project from the building like some of those half animals that look as if they are escaping through the walls in Romanesque architecture."[61] Unfortunately the turntable idea was found to be impractical. Each of the blocks weighs four or five tons, and it was thought that having them hinged on a turntable could be dangerous to people in the street below. It is disappointing that since this busy London street narrows at this point, many passers-by do not notice one of Moore's most successful architectural commissions.

94 *Top Half of Form at left in*
"Time-Life Screen: Maquette
No. 4" 1952 (not in LH)
Terracotta, H 8 cm with base
Gift of Henry Moore, 1974

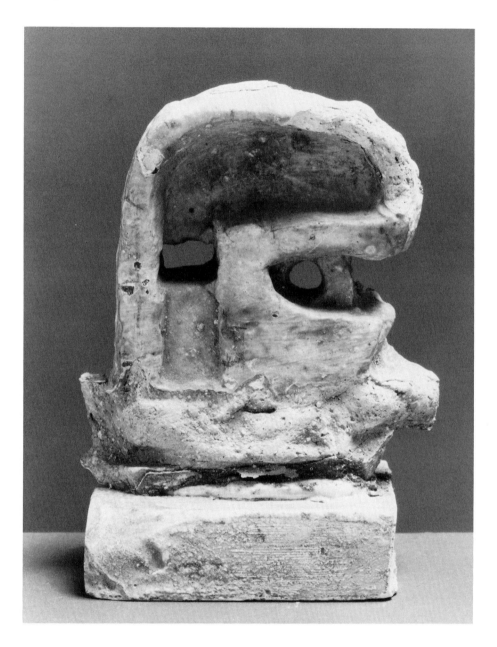

A NUMBER of fragmentary studies
for the Time-Life screen project have
survived, including this version of
the form at left in the definitive
maquette No. 4 (LH 342). See also
no. 95 below. No. 94 was never cast
in bronze.

95 *Top Half of Form at right in*
"Time-Life Screen: Working Model" 1952 (not in LH)
Original plaster, H 14 cm
Gift of Henry Moore, 1974

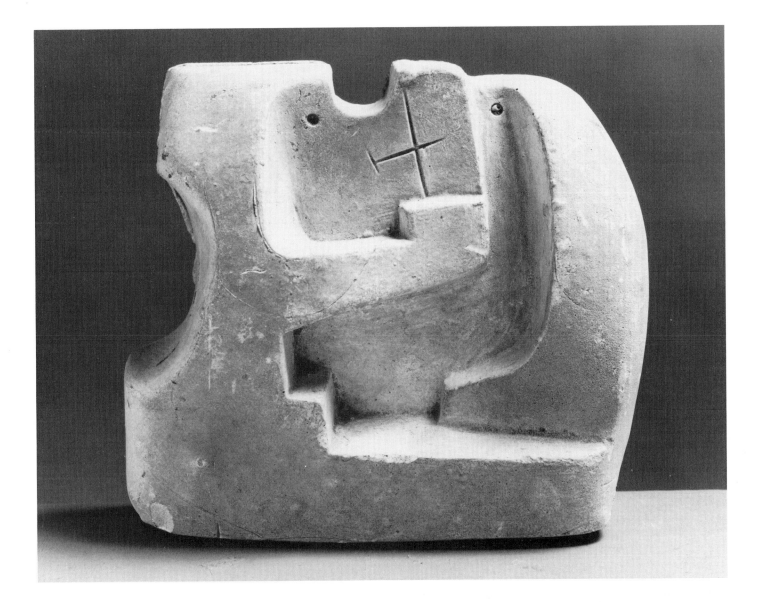

THIS IS another version or cast of
the top half of the form at right in
the working model for the Time-Life
screen, no. 93. The square-form
rhythms, the incised lines, and the
two eyes at the top are reminiscent
of the carvings of the mid-1930s,
such as *Square Form* of 1936 (LH 167;
fig. 74). No. 95 was never cast in
bronze.

Fig. 74 *Square Form* 1936
University of East Anglia, the Robert and Lisa
Sainsbury Collection

96 *Reclining Figure No. 6* 1954 (LH 337)
Original plaster covered with wax, L 22.9 cm
(Bronze edition of 12)
Gift of Henry Moore, 1974

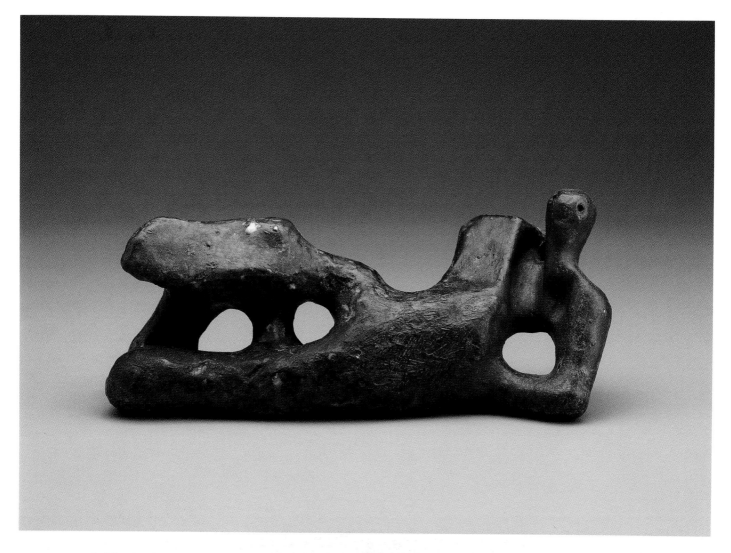

THIS IS probably the definitive
maquette for one of Moore's greatest
carvings, the elmwood *Reclining
Figure* of 1959–64 (LH 452; fig. 75).
Moore told the author that no. 96
was possibly a plaster cast with
which he was experimenting by cov-
ering the surface with wax. On the
other hand, he occasionally used
wax to bind together a damaged
maquette or one that had been cut
into several sections for casting. As
no other plaster of no. 96 is known,
one can probably assume that this
is the original.

The artist told the author, with
understandable pride, that art critic
(the late) Adrian Stokes had said

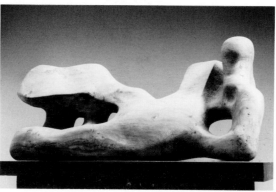

Fig. 75 *Reclining Figure* 1959–64
Private collection

that in his opinion, the large elm-
wood carving was the Moore sculp-
ture best qualified to be mentioned
in the same breath as Michelangelo's
work.

97 *Hand Relief No. 2* 1952 (LH 355)
Original plaster, H 34.4, W 31.8 cm
(Bronze edition of 6)
Gift of Henry Moore, 1974

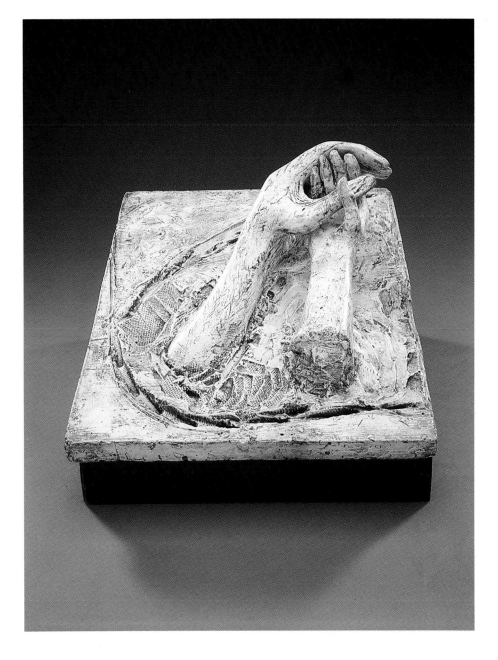

MOORE's earliest known study of
hands, on page 25 of No. 3 Notebook
of 1922–24 (fig. 76), was, the artist
said, "probably influenced by Rodin,"
whose numerous sculptures of hands
are well known. In 1952–53 Moore
made studies of the hands of the *King
and Queen* (LH 350), which have
been cast in bronze (LH 352–53).
No. 97 and *Hand Relief No. 1*, also of
1952 (LH 354) were made in the same
year that Moore began working on
the large version of the *King and
Queen*. He recently told the author
that the two hands in no. 97 were
based on the left hand of his wife,
Irina, and the right hand of his
daughter, Mary. This sculpture is
somewhat reminiscent of Rodin's
stone *Cathedral* of 1908, in which
two right hands arch together.

Fig. 76 *Page 25 from No. 3 Notebook* 1922–24
Henry Moore Foundation

98 *Reclining Warrior* 1952–53
(LH 558b)
Bronze, edition of 9 (cast 1971), L 19.7 cm
Inscr. on back *Moore 4 / 9*
Purchase from the artist, 1972

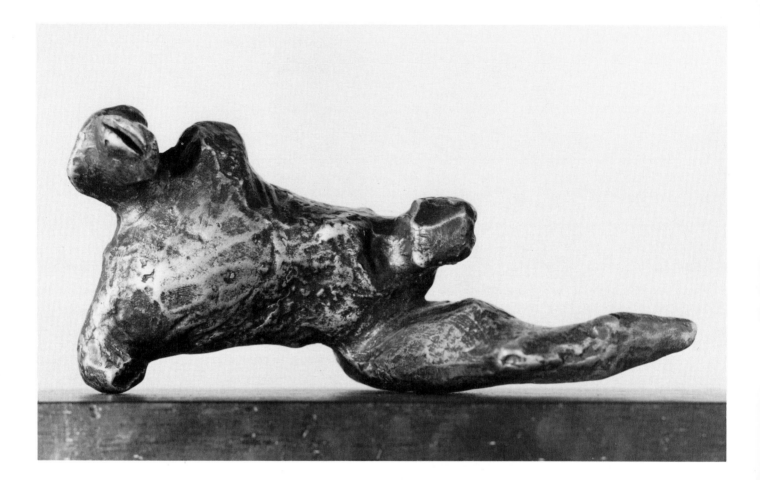

IN 1952–53 Moore made two small
preparatory studies for the *Warrior
with Shield* of 1953–54 (LH 360,
no. 99): *Maquette for Warrior with
Shield* (LH 357, fig. 77) and *Maquette
for Warrior without Shield* (LH 358).
In 1971 he had the original plaster
of the latter maquette cast in bronze
and positioned as a reclining warrior.
In fact the warrior without shield
was in a reclining position in Moore's
original conception. (See notes for
no. 99.)

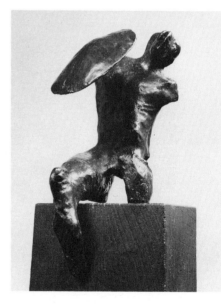

Fig. 77 *Maquette for Warrior with Shield*
1952–53
Private collection

99 *Warrior with Shield* 1953–54 (LH 360)
Bronze, edition of 5 + 1, H 152.5 cm
(Other casts: City of Arnhem, Holland; Minneapolis
Museum of Arts; Birmingham City Museum and Art
Gallery; Kunsthalle, Mannheim; City of Florence, Italy,
extra cast)
Gift from the Junior Women's Committee Fund, 1955

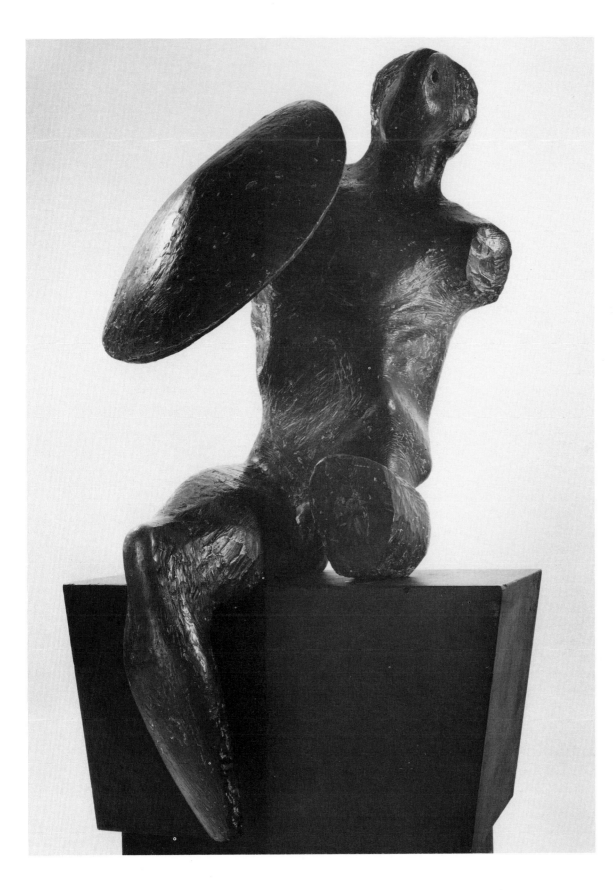

MOORE has stated:

The idea for *The Warrior* came to me
at the end of 1952 or very early in 1953. It
was evolved from a pebble I found on
the seashore in the summer of 1952, and
which reminded me of the stump of a
leg, amputated at the hip. Just as Leon-
ardo says somewhere in his notebooks
that a painter can find a battle scene in
the lichen marks on a wall, so this [peb-
ble] gave me the start for *The Warrior*
idea. First I added the body, leg and one
arm and it became a wounded warrior,
but at first the figure was reclining [see
no. 98]. A day or two later I added a
shield and altered its position and
arrangement into a seated figure and so it
changed from an inactive pose into a
figure which, though wounded, is still
defiant.

The head has a blunted and bull-like
power but also a sort of dumb animal
acceptance and a forbearance of pain.[62]

With the exception of one sculp-
ture of 1924–25, *Recumbent Male
Figure* (LH 24, destroyed, no photo-
graph available) and *Seated Man*
of 1949 (LH 269a), no. 99 was Moore's
first major single male figure. "Except
for a short period when I did coal-
mining drawings as a war artist,
nearly all my figure sculptures and
drawings since being a student have
been of the female, except for the
Family Groups, but there the man
was part of the group."[63]

In spite of the amputated, frag-
mented appearance of the *Warrior
with Shield*, Moore found, while
working on the sculpture, that "all
the knowledge gained from the life
drawing and modelling I had done
years before came back to me with
great pleasure."[64] He also has com-
mented on the influence of Greek
sculpture: "Like the bronze *Draped
Reclining Figure* of 1952–53 [see
no. 88] I think *The Warrior* has some
Greek influence, not consciously
wished for but perhaps the result of
my visit to Athens and other parts of
Greece in 1951."[65]

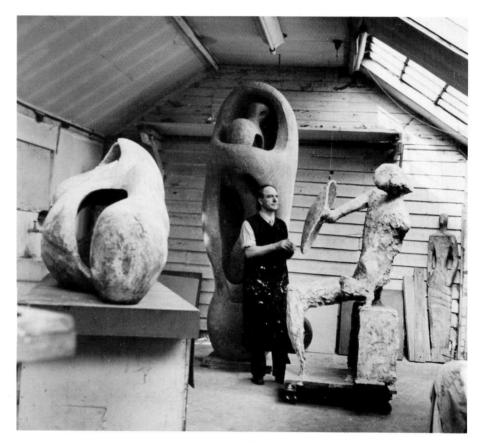

Fig. 78 Henry Moore working on the original
plaster of *Warrior with Shield* 1953–54

This is one of the few sculptures
that Moore specifically connected
with an event in recent history. "The
figure may be emotionally connected
(as one critic has suggested) with
one's feelings and thoughts about
England during the crucial and early
part of the last war. The position of
the shield and its angle gives protec-
tion from above."[66] In the exhibition
"The Drawings of Henry Moore,"
held at the Art Gallery of Ontario in
November-December 1977, the *War-
rior with Shield* was placed at the
entrance to the wartime drawings,
beneath the famous night photograph
of the dome of St. Paul's Cathedral,
December 1940 (fig. 42).

All Moore's subsequent sculptures
of the single male figure have been
on the warrior theme: the *Maquette
for Fallen Warrior* of 1956 (LH 404)
and the large version of this, the
Falling Warrior of 1956–57 (LH 405);
and more recently the *Goslar Warrior*
of 1973–74 (LH 641).

Fig. 79 *Warrior with Shield* 1953–54
Original plaster, in progress

100 *Wall Relief: Maquette No. 2 1955* (LH 366)
Bronze, edition of 10, H 33.7, W 18 cm
Inscr. on right side *Moore*
Gift of Henry Moore, 1974

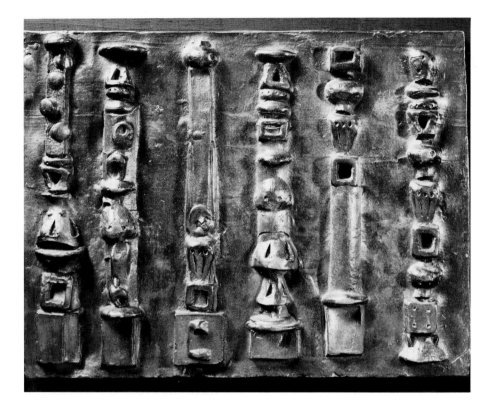

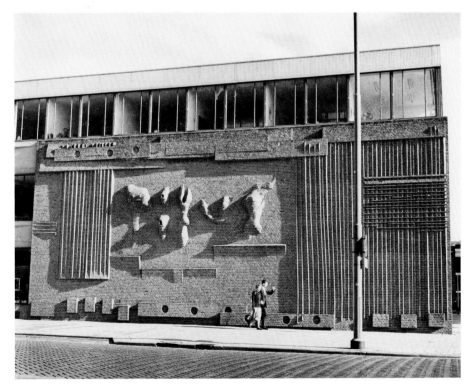

Fig. 80 *Wall Relief* 1955
Bouwcentrum Building, Rotterdam

IN 1954 Moore was commissioned to do a brick wall relief for the façade of the Bouwcentrum Building in Rotterdam (fig. 80). The ten preparatory maquettes (LH 365–74) were executed in plaster and later cast in bronze. Although none of the three bronze maquettes in the collection (nos. 100–02) was the definitive study for the wall relief, they are representative of Moore's inventiveness, as he had demonstrated in the Time-Life maquettes, in creating so many variations on a single theme. In no. 100, the way in which individual forms are piled one on top of another anticipates the upright motives of 1955–56 (nos. 104, 106–112). Here in fact they appear less like reliefs than six fully three-dimensional upright motives half buried in the wall. The ten wall-relief maquettes comprise a fascinating variety of forms. Some are related to Moore's earlier work; others — such elements of hardware as nuts, bolts, and screw-heads, first used in no. 89 in 1952 — appear for the last time in his *oeuvre*. Some of the individual forms in each of the upright motives in no. 100 were taken from the maquette for the large *Bird Table* of 1954 (LH 363), which is now in the garden at Hoglands.

101 *Wall Relief: Maquette No. 4* 1955 (LH 368)
Bronze, edition of 10, H 33, W 45.7 cm
Inscr. on right side *Moore*
Gift of Henry Moore, 1974

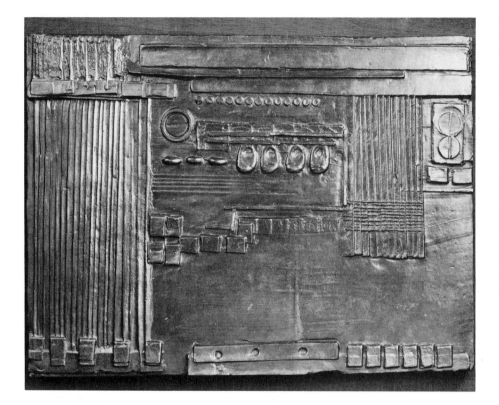

A NUMBER OF FEATURES found in no. 101 — such as the vertical striations in low relief at left, the vertical and horizontal striations at right, the small rectangular reliefs at lower left and lower right, and the long rectangular forms with holes at top and bottom centre — also appear in the definitive maquette (fig. 81). In the latter the centre area is occupied by organic forms, probably flint stones, similar to those found in maquettes 3 and 9 (LH 367 and 373). *Ideas for Wall Reliefs* of 1955 (private collection) is the only known drawing related to the Bouwcentrum commission, although none of the maquettes was directly based on it.

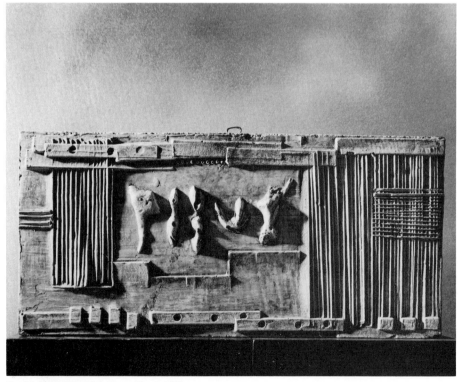

Fig. 81 *Wall Relief: Maquette No. 1* 1955
Private collection

102 *Wall Relief: Maquette No. 6* 1955 (LH 370)
Bronze, edition of 10,
H 34 W 45.8 cm
Inscr. on right side *Moore*
Gift of Henry Moore, 1974

103 *Small Relief c.* 1955 (not in LH)
Original plaster, H 15.6, W 11.4 cm
Gift of Henry Moore, 1974

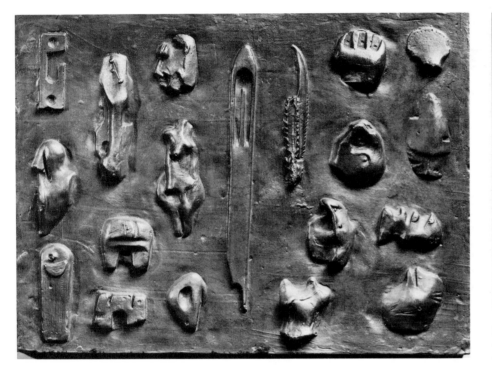

MOORE SAID that no. 103, which
was never cast in bronze, was proba-
bly done about the same time as
the 1955 Rotterdam reliefs (nos.
100–02) and the upright-motive
maquettes, also of 1955 (nos. 104,
107, and 108).

IN THE RANDOM GROUPING of
the forms, no. 102 — one of the most
interesting and varied of the wall
relief maquettes — is reminiscent of
Moore's sketchbook sheets with ideas
for sculpture. Here the reliefs include:
a lobster's claw just left of centre;
at upper right a fragment from a
stringed-figure sculpture almost cer-
tainly made in the late 1930s; below
this a cast of a work related to the
small *Maquette for Head* of 1937
(no. 78); at lower left, turned upside
down, *Small Relief: Lower Half of
Upright Motive: Maquette No. 1* (see
notes for no. 105).

104 *Upright Motive: Maquette No. 1* 1955 (LH 376)
Original plaster, H 31.4 cm
(Bronze edition of 10)
Gift of Henry Moore, 1974

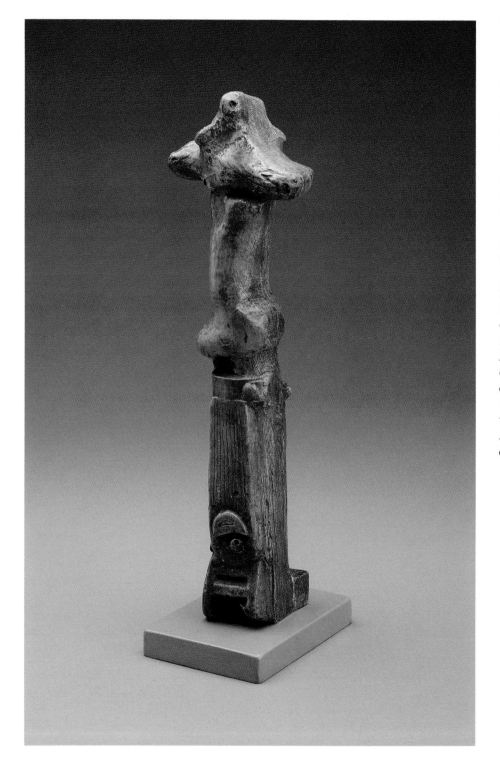

''IN 1954,'' Moore has written, "I was asked to do a sculpture for the courtyard of Olivetti's new office building in Milan. I went out to Milan and met the architect and we looked together at the building then in construction.... A lone Lombardy poplar growing behind the building convinced me that a vertical work would act as the correct counterfoil to the horizontal rhythm of the building. This idea grew ultimately into the *Upright Motives*.''[67]

Moore produced thirteen upright-motive maquettes in 1955, of which five (nos. 1, 2, 5, 7, and 8) were enlarged. Undoubtedly the most powerful and evocative of these is the large *Upright Motive No. 1: Glenkiln Cross* of 1955–56 (LH 377, no. 106), for which no. 104 is the maquette. (*Upright Motive, Maquette No. 13* was not catalogued in Lund Humphries.) Two drawings of 1955 (both entitled *Upright Motives*) are closely related to the 1955 series of maquettes, although none of the sculptures evolved directly from them.

105 *Small Relief: Lower Half of*
"Upright Motive: Maquette
No. 1" 1955 (not in LH)
Terracotta, H 9.8 cm
Gift of Henry Moore, 1974

106 *Upright Motive No. 1: Glenkiln Cross* 1955–56 (LH 377)
Original plaster, H 334.8 cm
(Bronze edition of 6: Sir William Keswick, Dumfries,
Scotland; Tate Gallery, London [artist's copy]; The
Hirshhorn Museum and Sculpture Garden, Washington,
DC; Rijksmuseum Kröller-Müller, Otterlo; Folkwang
Museum, Essen; Amon Carter Museum, Fort Worth,
Texas; Städtische Galerie, Hanover) Gift of Henry Moore, 1974

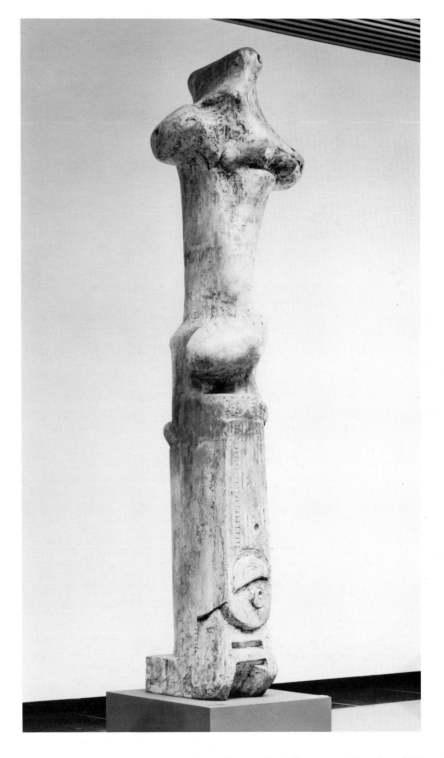

THIS RELIEF, which was never
cast in bronze, is of the same propor-
tions as the similar design on the
front of *Upright Motive: Maquette
No. 1* (LH 376, no. 104), and was
almost certainly done at about the
same time. Features here that are
not to be found in no. 104 are the
two small holes near the top. The
relief appears, turned round 180
degrees, at lower left in *Wall Relief:
Maquette No. 6* of 1955 (LH 370,
no. 102). No. 105 was based on Moo-
re's drawings of an implement or
shield from New Ireland (see notes
for no. 106 and figs. 83 and 84).

UNDERSTANDABLY, a number of
writers on Moore's art see the *Glen-
kiln Cross* as one of his greatest
achievements. The sculpture is
named after Sir William Keswick's

Glenkiln Farm, Shawhead, Dumfries,
where the first cast was placed on a
hillside (fig. 82), not far from a cast
of the *King and Queen*.

John Russell, in his perceptive

discussion of Moore's vertical sculpture of 1950–56, has remarked on the formal elements in the *Glenkiln Cross*, "which go straight back to the African wood *Torso* of 1927 [LH 47]. The smooth line from hip to shoulder is one of these...."[68] Herbert Read has drawn a useful comparison between the head of the *Glenkiln Cross*, which, he writes, "has the same blunted Cyclopic form as the *Composition* in carved concrete of 1933 belonging to the British Council" (LH 133; fig. 23).[69] Useful as these parallels are, it should be noted that the sources of the *Glenkiln Cross* were quite different. The 1933 *Composition* sprang directly from Moore's imagination and was first set down in a sketchbook page, *Transformation Drawing and Study for Composition 1932* (no. 31 verso). By the mid-1950s Moore's working method had changed. Instead of generating ideas for sculpture in the drawings (as had been his practice from 1921 to the early 1950s), he began to work directly in three dimensions, in the form of small maquettes. As we have seen in the wall-relief maquettes, nos. 100–02, many of the ideas were based on natural forms, some of which were used in their original, unaltered state. There were no preparatory drawings for these works. The wall-relief maquettes of 1955 and the series of upright motives of 1955–56 may be said to mark a crucial turning point in Moore's development. As his sculpture became less frontal and began to have, in his own words, "an organic completeness from every point of view," he found that working from a drawing that showed a sculptural idea from a fixed and single view was contrary to his aims. His method of work altered to meet the new demands of his sculpture. As he said, to explain the shape of a sculpture like *The Archer* (no. 170a), "I should require at least twenty or thirty

Fig. 82 *Upright Motive No. 1: Glenkiln Cross* 1955–56
Sir William Keswick, Dumfries, Scotland

Fig. 83 *Page 47 from Sketchbook B: Idea for Sculpture* 1935
Henry Moore Foundation

drawings.... I need to know it from on top and from underneath as well as from all sides. And so I prefer to work out my ideas in the form of small maquettes which I can hold in my hand and look at from every point of view."[70] It is among the hundreds of natural forms in the artist's studios — bones, pebbles, shells, flint stones — that one must look for the genesis of many of the sculptures since the mid-1950s.

The *Glenkiln Cross* is made up of three distinct units. In the top section the small orifice, a feature found in a number of Moore's carvings of the 1930s such as *Figure* of 1933–34 (LH 138), is suggestive of the mouth of some primeval creature. Below this, compressed, eroded shoulders and truncated arms give the sculpture the shape of a crucifix. In the author's opinion, this rugged, irregular section was almost certainly directly based on a flint stone. Below this is the smooth, bone-like form of the torso, the central portion, upon which the head and arms balance, not precariously, but with an organic inevitability. The swelling knob at the bottom of this section resembles waist and hips. Moore has described the third section — the rectangular front of the lower half of the sculpture — as "the column and on it are

little bits of drawing which don't matter sculpturally, which represent a ladder and a few things connecting it with the Crucifixion."[71] In fact this relief was indeed based on several of Moore's own drawings derived from a carving, possibly a shield, from New Ireland. The first of these appears at left in the 1935 *Page 47 from Sketchbook B: Idea for Sculpture* (fig. 83). The inscription *New Ireland*, above the sketch, gives a clue to the geographical area where the object was made, although the original has not yet been identified. The New Ireland work also appears at left in a more finished drawing, *Page from Sketchbook 1935 and 1942* (fig. 84), a preparatory study for a cover design for the magazine *Poetry London*. To each of the forms in fig. 84, which were based on two of the sketches in fig. 83, have been added wings, legs, and feet. Lyre birds were the subject of several of Moore's cover designs for *Poetry London* (see no. 56). The rectangular relief in the *Glenkiln Cross* was based on the form at left in fig. 84. In the sculpture the single ladder obviously derives from the two vertical rows of herringbone designs in fig. 84, the vertical incised lines on each side of the ladder from those in the drawing. In the drawing the crescent shape and, below this,

107 *Upright Motive: Maquette No. 4* 1955 (LH 381)
Original plaster, H 29.5 cm
(Bronze edition of 9)
Gift of Henry Moore, 1974

what becomes the eye of the bird are, in the sculpture, built up in low relief. "When I came to carry out some of these maquettes in their final full size," Moore wrote, "three of them grouped themselves together, and in my mind, assumed the aspect of a Crucifixion scene, as though framed against the sky above Golgotha. But I do not especially expect others to find this symbolism in the group."[72]

The large *Upright Motives*, Nos. 1, 2, and 7 (LH 377, 379, and 386), are grouped together, with the *Glenkiln Cross* at the centre, at the Amon Carter Museum, Fort Worth, Texas, at the Rijksmuseum Kröller-Müller, Otterlo, Holland, and at the Tate Gallery, London. Most would agree with Moore that the single *Glenkiln Cross*, placed high on a hillside in Scotland, is in an ideal setting (fig. 82). Approaching the Glenkiln Farm by road, one sees the sculpture from a distance, a mysterious upright shape on the horizon. As one draws nearer, the form, like a weathered, eroded Celtic cross, gradually becomes discernible. It would be difficult to imagine a more beautiful setting for Moore's work or a more rewarding way to approach and discover one of the greatest works of twentieth-century sculpture.

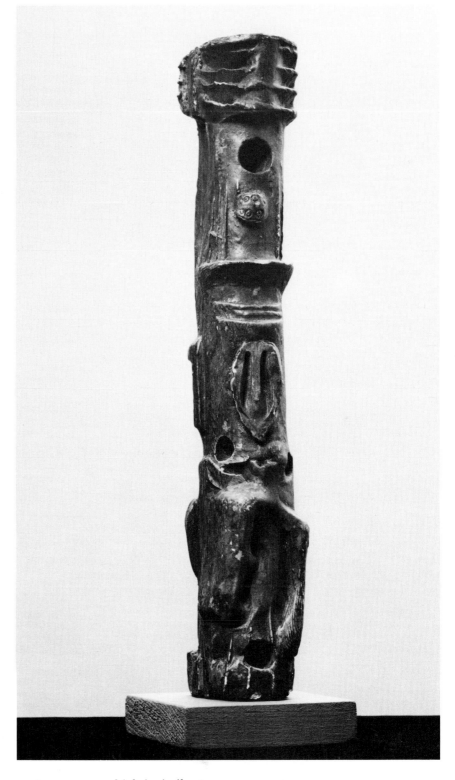

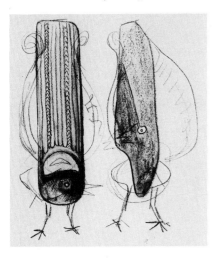

Fig. 84 *Page from Sketchbook* 1935 and 1942
Henry Moore Foundation PHOTO: Errol Jackson

THIS WORK, which is similar to *Upright Motive: Maquette No. 11* (LH 391), was never enlarged.

108 *Upright Motive: Maquette No. 5* 1955 (LH 382)
Original plaster, H 28.9 cm
(Bronze edition of 9)
Gift of Henry Moore, 1974

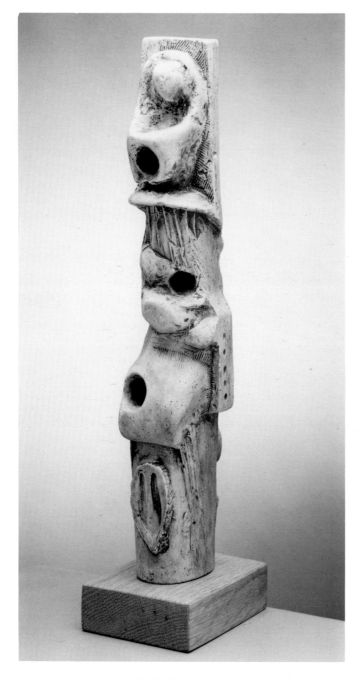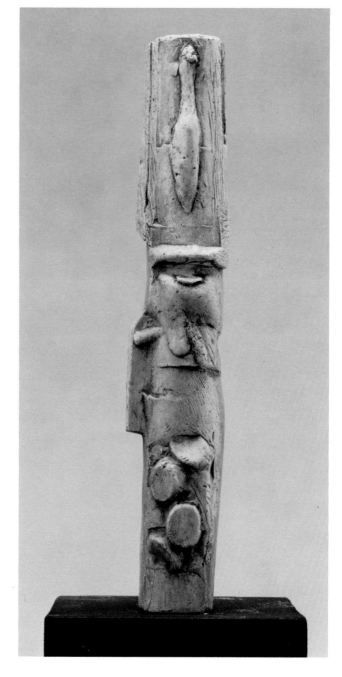

THE COLLECTION includes two
versions of this maquette: no. 108,
which is the definitive study for
Upright Motive No. 5 (LH 383,
no. 110), and no. 109, a variation of
no. 108. The major differences
between the two maquettes are in
the forms at the back of each
sculpture.

109 *Upright Motive:*
Maquette No. 5 (second version)
1955 (not in LH)
Original plaster, H 29 cm
Gift of Henry Moore, 1973

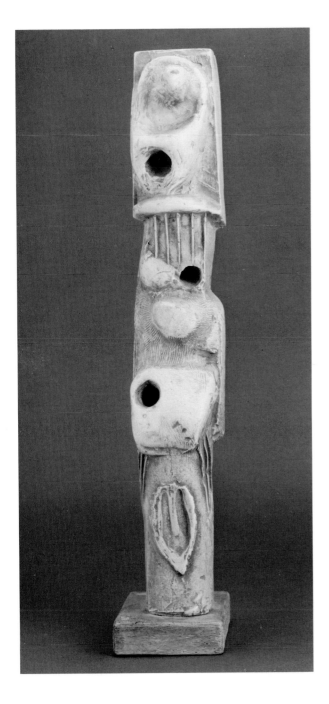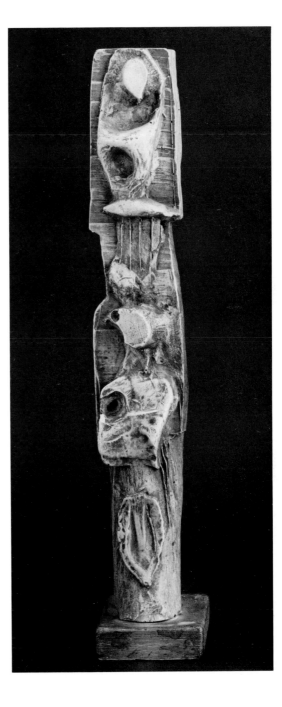

N O . 109 is another version of the
definitive maquette, no. 108 above.
Seen from the front, the two sculp-
tures are almost identical, whereas
the backs are quite different. No. 109
was never cast in bronze.

110 *Upright Motive No. 5* 1955–56
(LH 383)
Bronze, edition of 7, H 214.7 cm
Gift of Henry Moore, 1974

111 *Upright Motive No. 8* 1955–56 (LH 388)
Original plaster, H 201.3 cm
(Bronze edition of 7: National
Museum of Wales, Cardiff; Fogg Art
Museum, Harvard University, Cam-
bridge, Mass.)
Gift of Henry Moore, 1974

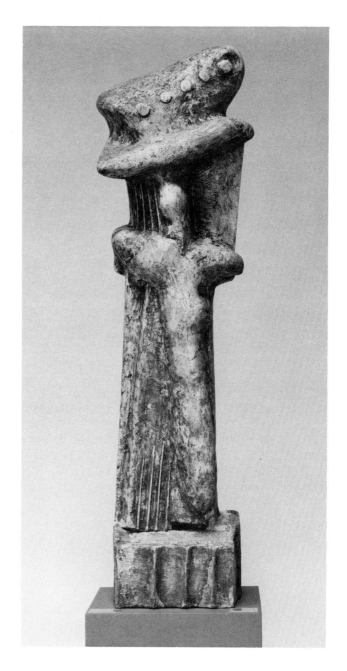

THIS IS one of the five upright
motives that Moore chose to enlarge,
and the only large bronze of this
theme in the collection. No. 110 was
based on the definitive maquette, of
which the original plaster is no. 108.

NO. 111 was based on *Upright
Motive: Maquette No. 8* of 1955 (LH
387). Whereas all the upright motives
have an organic unity, with natural
forms piled one on top of another,
only no. 111 and the *Glenkiln Cross*
(no. 106) have distinctly human,
figurative associations. Here the fig-
ure in relief, set back in a niche like
Gothic cathedral sculpture, is remi-
niscent of the Crucifixion.

112 *Upright Motive* 1955
(not in LH)
Original plaster, H 29.5 cm
Gift of Henry Moore, 1974

113 *Bird* 1955 (LH 393)
Bronze, edition of 12, L 14.7 cm
(Other casts: Zoological Society of
London [T.H. Huxley Award] and
private collections)
Gift of Sam and Ayala Zacks, 1970

114 *Head* 1955 (LH 400c)
Bronze, edition of 7 (cast 1974),
H 14 cm
Inscr. at front near bottom *Moore 4 / 7*
NOACK BERLIN
Purchase from the artist, 1975

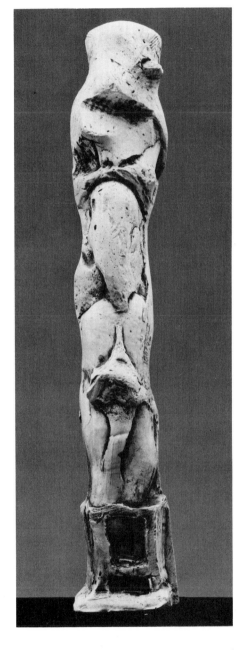

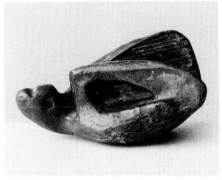

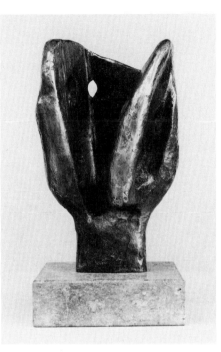

BIRDS, snakes, dogs, horses, and animal heads have been the subject of some two dozen Moore sculptures. The earliest animal sculpture is the 1922 marble *Dog* (LH 2). Other sculptures in the collection of animal, serpent, and bird subjects are: *Maquette for Animal Head* 1956 (LH 395, no. 115); *Animal Head* 1956 (LH 396, no. 116); *Rearing Horse* 1959 (LH 447a, no. 135); *Headless Animal* 1960 (LH 449, no. 136); *Snake Head* 1961 (LH 495, no. 157) and its plaster maquette (no. 156); and *Slow Form: Tortoise* 1962 (LH 502, no. 159). For a variation of no. 113, see no. 114.

THIS SCULPTURE and *Bird* (no. 113) illustrate the interchangeable nature of some of Moore's forms. Here a head is formed simply by the replacement of the bird's head with a neck.

NO. 112 was almost certainly executed at the same time as the thirteen upright-motive maquettes of 1955. This work was never cast in bronze.

115 *Maquette for Animal Head* 1956 (LH 395)
Original plaster, L 11.4 cm
(Bronze edition of 9: Zoological Society of London [Prince Philip Prize] and private collections)
Gift of Henry Moore, 1974

116 *Animal Head* 1956 (LH 396)
Original plaster, L 55.6 cm
(Bronze edition of 10: Rijksmuseum Kröller-Müller, Otterlo, Holland; Tate Gallery, London)
Gift of Henry Moore, 1974

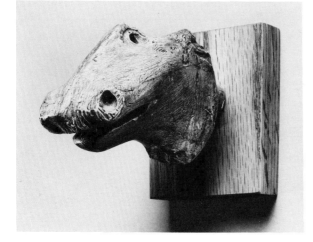

THIS IS the study for the larger *Animal Head* of the same year (LH 396), of which the original plaster is no. 116.

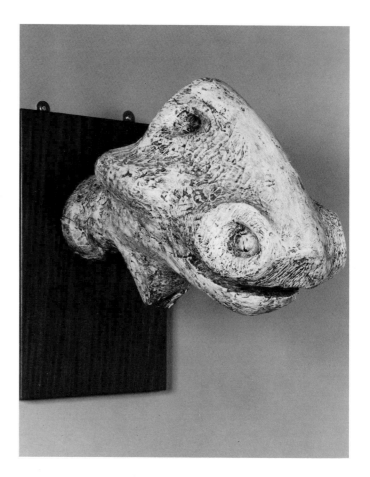

THE ORIGINAL plaster maquette for this work is no. 115. To judge from the exclamations of the school children who are confronted by this sculpture at the top of the ramp just outside the large Moore Gallery, no. 116 might well have been given a title like *Horse's Head, Dinosaur's Head,* or *Head of a Prehistoric Animal.*

117 *Maquette for Head: Lines* 1955
(not in LH)
Original plaster, H 7 cm
Gift of Henry Moore, 1974

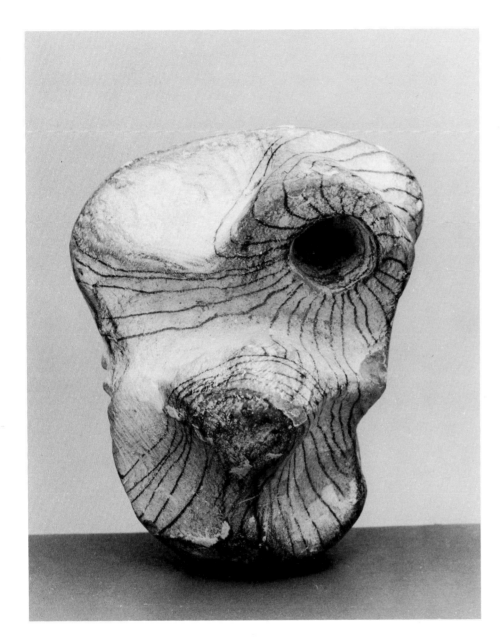

is a technique that I've used sculpturally to emphasise a projection, by drawing lines round the projection so that they gradually disperse in order that the eye is drawn to a focal point.... Similarly, in some of my drawings [no. 57] I have used imaginary sectional lines, going down and across forms to show their shape, without the aid of light and shade.[73]

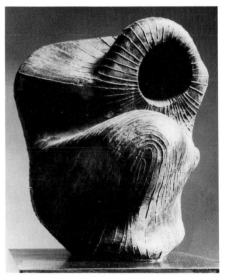

Fig. 85 *Head: Lines* 1955
Private collection

THIS LITTLE MAQUETTE, which has never been cast in bronze, is the study for the 1955 *Head: Lines* (LH 397; fig. 85). In no. 117 the lines have been drawn in pencil, whereas in the larger sculpture the lines, as in the 1950 *Reclining Figure* (no. 85a) are raised in low relief above the surface. Moore has described how the lines were made in the larger version of this sculpture:

Unlike the lines on the figure for the Festival of Britain [no. 85a] that were produced by sticking thin strings on to the original plaster model and then casting them so that they came out as ridges, the lines on this head [fig. 85] were produced by making a mould, and incising the lines into the plaster surface with a sharp metal point. The lines are transformed into ridges because from the mould you get the reverse when cast. It

118 *Seated Figure: Armless* 1955 (LH 398)
Original plaster, H 45.6 cm
(Bronze edition of 10)
Gift of Henry Moore, 1974

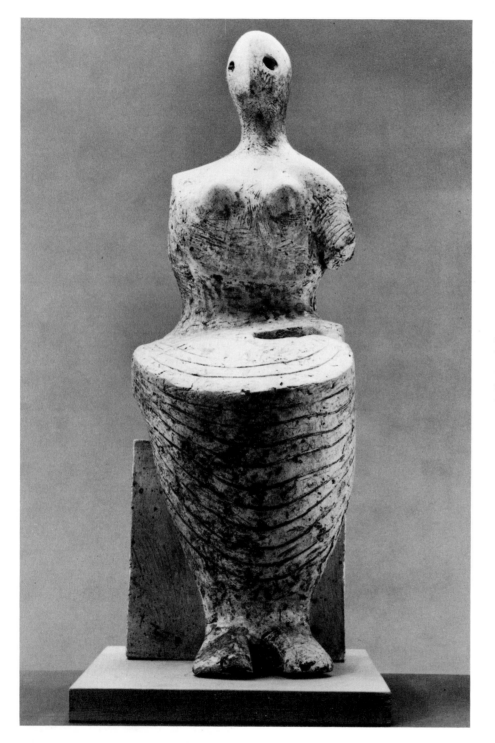

LIKE MANY of the original plasters in this collection no. 118 was of a much darker tonality when it was returned to Moore's studio from the bronze foundry. Not only did some of the plasters need repairing, but most of the larger sculptures also required cleaning — that is the removal with paint stripper of much of the dark shellac that had been applied to the plasters in making the moulds for casting. To give me some idea of the work involved, Moore suggested I clean up no. 118. He recommended that some of the dark shellac should remain, particularly in the incised lines and shallow hatchings, to highlight the texture and surface modelling. Not only do the plasters form a unique collection of the original sculptures that Moore worked on himself, but their textures are far easier to read (and slightly crisper, being the originals) than in the darker patinas of the bronze casts.

119 *Reclining Figure* 1956 (LH 402)
Original plaster, L 236.2 cm
(Bronze edition of 8: Akademie der Künste, Berlin;
National Gallery of Western Australia, Perth; Pepsico
World Headquarters, New York)
Gift of Henry Moore, 1973

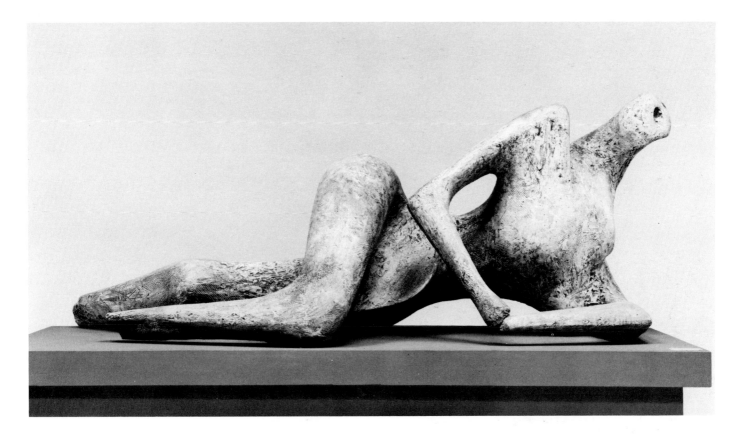

NO. 119 was based on the small maquette for *Reclining Figure* of 1955 (LH 401). Like *Figure in a Shelter* of 1941 (fig. 86), this unusual reclining pose has a feeling of transition, as if the figure were about to raise itself from the ground.

The elmwood *Upright Figure* of 1956–60 (LH 403; fig. 87) in the Solomon R. Guggenheim Museum, New York, was based on no. 119. While Moore was working on the elmwood figure, the original plaster *Reclining Figure* of 1956 was in his studio, fixed to a base and propped up against the wall in an upright position. Moore has written of the Guggenheim carving:

I turned this horizontal bronze figure into an upright wooden one. Although, of course, I changed it considerably, it shows the great importance of gravity in sculpture. Lying down, the figure looked static, whilst upright it takes on movement, and because it is working against gravity it looks almost as though it is climbing.[74]

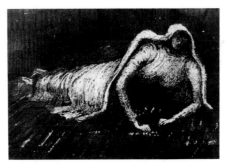

Fig. 86 *Figure in a Shelter* 1941
Private collection

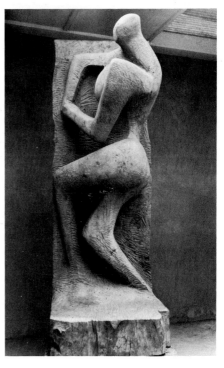

Fig. 87 *Upright Figure* 1956–60
Solomon R. Guggenheim Museum, New York

120 *Reclining Figure: Goujon* 1956 (LH 411a)
Bronze edition of 9 (cast 1971), L 24.1 cm
Inscr. on back of base *Moore 8 / 9*
Gift of Henry Moore, 1972

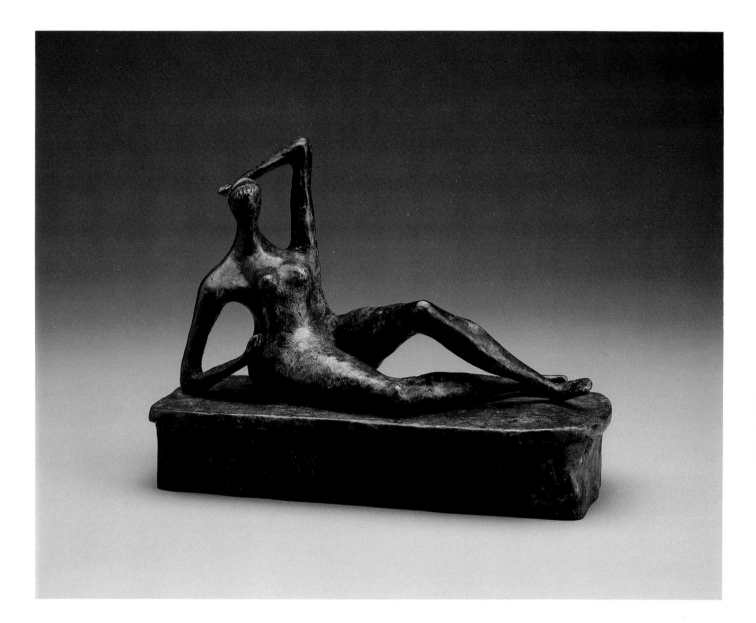

THIS WAS Moore's first sculpture in which the name of another artist is included in the title. On Sir Stephen Spender's suggestion Moore made a three-figure composition, *Three Bathers — after Cézanne*, 1978 (LH 741), based on the Cézanne oil *Trois baigneuses*, 1877–78, which Moore once owned (fig. 8; see notes for no. 12). In almost all Moore's work, the titles were usually assigned after the sculpture was completed. It is less likely that a particular sculpture by the sixteenth-century French sculptor Jean Goujon (active 1540–62) inspired this reclining figure than that, when the work was finished, Moore saw in the thin, elongated limbs of this elegant little bronze similarities to Goujon's work.

121 *Draped Reclining Figure* 1957 (LH 412)
Original plaster, L 72.4 cm
(Bronze edition of 11)
Gift of Henry Moore, 1974

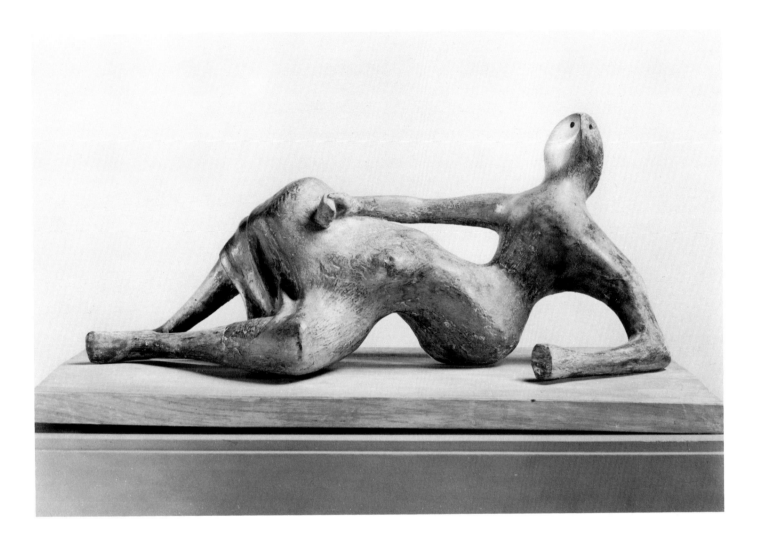

THIS SCULPTURE was based on
the small maquette *Draped Reclining
Figure* of 1956 (LH 411). The pose of
the figure, particularly the position of
the arms, anticipates *Maquette for
Reclining Figure: Angles* of
1975 (no. 195).

122 *Maquette for* UNESCO *Reclining Figure* 1956 (LH 414)
Original plaster, L 19 cm; 24.8 cm
with base
(Bronze edition of 6)
Gift of Henry Moore, 1974

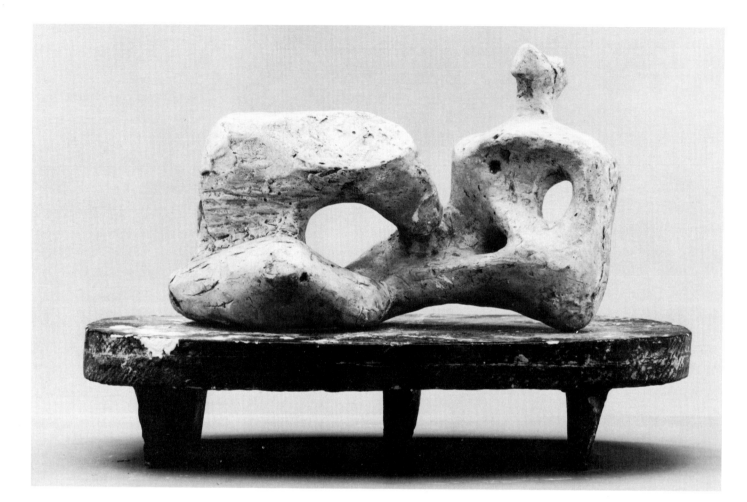

THIS IS the definitive maquette for
the Roman travertine marble *Reclin-
ing Figure* of 1957–58 (LH 416) for
the UNESCO headquarters in Paris
(see no. 123 and fig. 88). A section
from the back of the leg is missing,
probably broken off and lost at the
foundry. Moore made a number of
preliminary drawings related to the
commission. He told the author that
Drawing for UNESCO *Reclining Fig-
ure* of 1955 (private collection),
which is very close to no. 122, may
be a drawing of this maquette. The
UNESCO commission is discussed
in detail in the notes for no. 123.

123 *Working Model for* UNESCO
Reclining Figure 1957 (LH 415)
Original plaster, L 235 cm
(Bronze edition of 5 + 1: Carnegie Institute, Pittsburgh;
Art Institute of Chicago; Stedelijk Museum, Amsterdam; Tate Gallery, London)
Gift of Henry Moore, 1973

WHEN IN 1956 Moore was commissioned to do a large sculpture for the headquarters of UNESCO in Paris, he was faced with two major problems: the choice of a suitable subject, and a difficult site in front of a building with a long, busy fenestration (fig. 88). He discussed with his friend Sir Julian Huxley, the first Director-General of UNESCO, the aims and meaning of the organization. Herbert Read, who was appointed by the Director-General to advise on works of art to be commissioned for the building, has described the difficulties facing Moore and others:

In designing their building the architects had made no provision for works of art and this created the greatest problem. There were no appropriate sites where works of art could function coherently — they could only be added as largely irrelevant décor. Picasso, Miró and Moore were given the commissions for the largest works, and their difficulties were correspondingly most acute.[75]

Read has also described Moore's initial ideas for the commission:

Moore's first "idea" was a female figure reading a book, or teaching a group of children, or just "lost in contemplation," but the sculptural impact of such figures would be entirely obliterated by the background. He therefore tried out the possibility of placing the figures against a screen, which would be an integral part of the group.[76]

For other works in the collection that were possible candidates for the UNESCO commission, see nos. 124–27, 129, and 130.

"Eventually," Moore wrote, "after discarding many preliminary studies I decided on a reclining figure that seeks to tell no story at all. I wanted

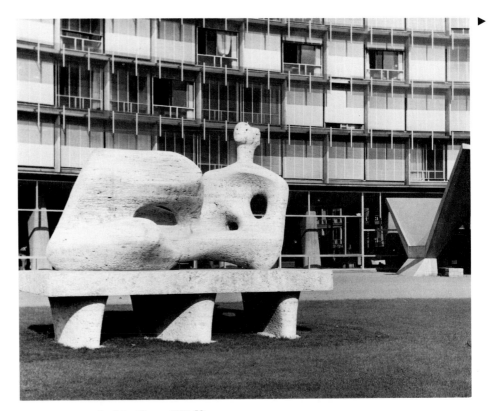

Fig. 88 UNESCO *Reclining Figure* 1957–58
UNESCO headquarters, Paris

to avoid any kind of allegorical interpretation that is now trite."[77] There are three versions of the UNESCO *Reclining Figure*: the maquette (no. 122), which has been cast in a bronze edition of six; the working model (no. 123), which has been cast in an edition of five plus one, and the final and largest of the three versions, the Roman travertine marble UNESCO *Reclining Figure* of 1957–58 (LH 416; fig. 88).

The four blocks of travertine marble were quarried near Rome and brought by Messrs. Henraux to their marble works at Querceta, a small village at the foot of the Carrara mountains, a few miles from Forte dei Marmi where Moore was later to acquire a summer cottage. UNESCO originally asked Moore for a bronze,

but he "realized that since bronze goes dark outdoors and the sculpture would have as its background a building that is mostly glass, which looks black, the fenestration would have been too much the same tone, and you would have lost the sculpture.... So I finally decided the only solution was to use a light-coloured stone they've used for the top of the building — travertine."[78] In producing the working model (no. 123) Moore kept in mind the special qualities of the marble: "I like its colour and its rough, broken, pitted surface. Knowing these characteristics I did not give the plaster working model a smooth surface."[79] Moore sent the working model to Querceta, where he carved the 4.9-metre marble version.

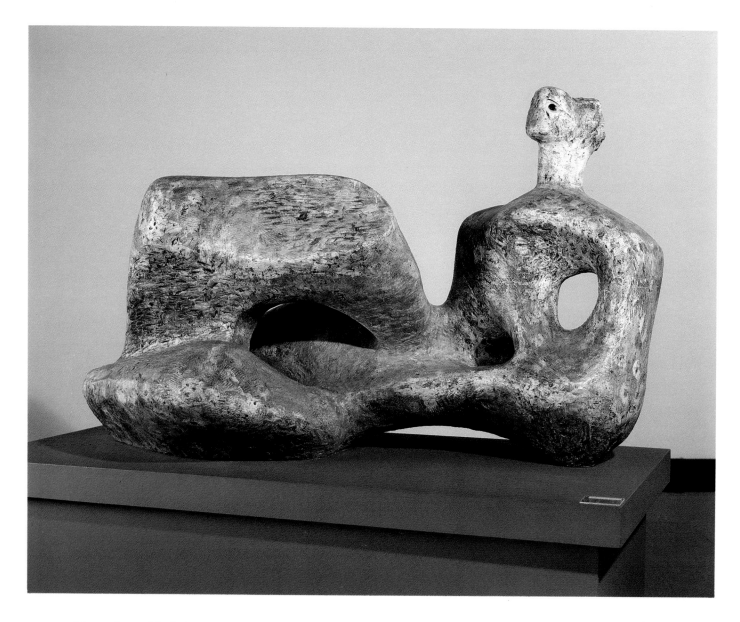

123 Moore has said of the
UNESCO figure: "This particular
reclining figure has perhaps turned
out to be one of those that Sir Philip
Hendy has called 'wild ones' ...
sculptures which are inspired by gen-
eral considerations of nature, but
which are less dominated by repre-
sentational considerations, and in
which I use forms and their relation-
ships quite freely."[80]

124 *Mother and Child against Open Wall* 1956 (LH 418)
Bronze, edition of 12, H 21.5 cm
Gift of Sam and Ayala Zacks, 1970

125 *Seated Woman in Chair* 1956 (LH 418a)
Bronze, edition of 6 (cast 1964), H 26 cm with base
Inscr. on back of base *Moore 3 / 6*
Gift of Mr. and Mrs. Donald B. Strudley, 1976

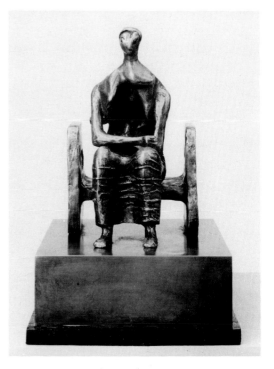

AMONG Moore's preliminary ideas for the UNESCO commission are four sculptures of family groups and of seated figures against curved and open walls, of which no. 124 is the only one that has been cast in bronze. The other three are *Family Group, c.* 1956 (LH vol. 3, pl. 40a), *Two Seated Figures against Curved Wall, c.* 1956 (LH vol. 3, pl. 40b) and *Family Group, c.* 1956 (LH vol. 3, pl. 40c). The seated woman in no. 124 is similar in style to no. 125.

THIS BRONZE, like no. 124, is one of the early studies for the UNESCO commission. It is close in subject matter and style to another sculpture of the same year, *Seated Woman with Book* (LH 418b).

126 *Seated Figure against Curved Wall* 1956–57 (LH 422)
Bronze, edition of 12, L 91.8 cm
Gift of Mrs. Harry Davidson and family in memory of Harry Davidson, 1984

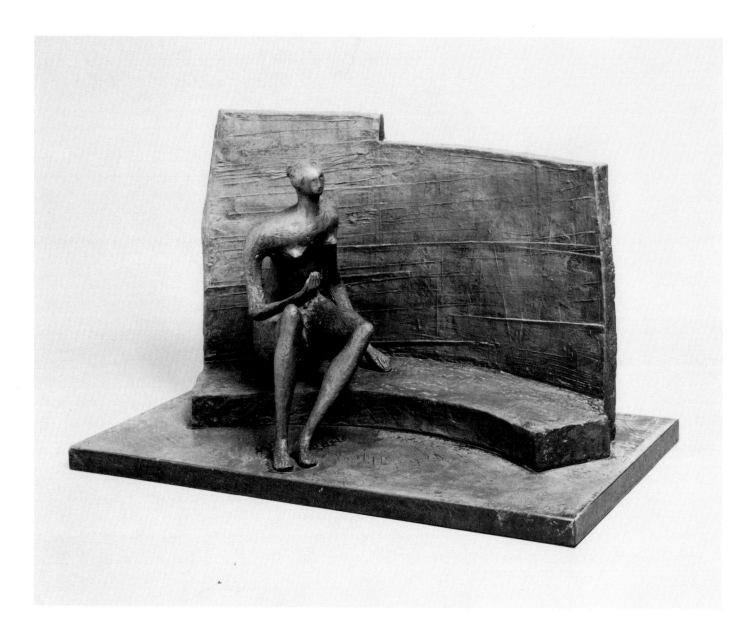

THIS IS ONE of a number of preliminary sculptures for the 1956 commission for the UNESCO headquarters in Paris (see no. 123). In several "tryouts," Moore placed seated figures against flat or curved walls (see no. 126a) in order to block off the busy façade of the building (fig. 88). Moore's distaste for commissions — for having a subject or theme imposed on him — is well illustrated by his final solution to the UNESCO project. He considered such subjects as a female figure reading a book or teaching a group of children, but discarded these preliminary ideas in favour of a massive reclining figure (no. 123) that seeks to tell no story and is devoid of any literary or allegorical interpretations.

126a *Maquette for Girl Seated against Square Wall* 1957 (LH 424)
Bronze, edition of 12,
H 27 cm with base
Gift of Henry Moore, 1974

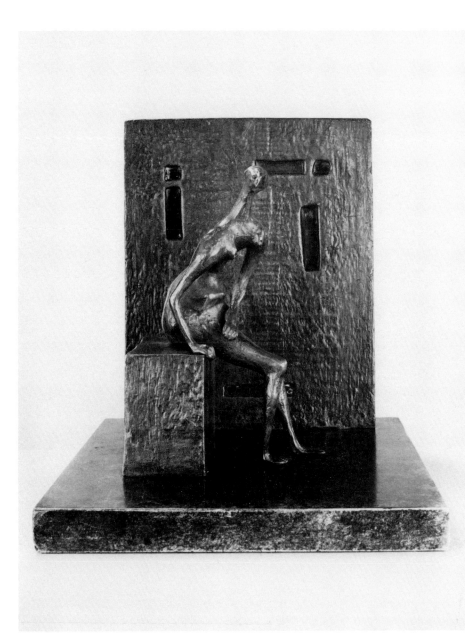

"THIS 'SEATED GIRL against Square Wall,'" Moore wrote, "is one of the ideas which I might have used for the UNESCO sculpture. That was at the time when I thought of doing a very big bronze sculpture against a square wall. The spareness of her bony figure accentuates the articulation of her joints."[81] Rectangular slotted walls first appear in the drawings as early as 1936 as a background for scupltural ideas. In some of the drawings diagonal walls lead into the picture space and with the background wall create a claustrophobic, cell-like setting, as in *Ideas for Sculpture in a Setting* of 1938 (fig. 89). A slotted rectangular wall was used in two sculptures of 1959, *Three Motives against Wall No. 1* (LH 441) and *Three Motives against Wall No. 2* (LH 442), of which the original plaster is in the collection (no. 133).

Fig. 89 *Ideas for Sculpture in a Setting* 1938
Private collection

127 *Draped Seated Woman* 1957–58 (LH 428)
Plaster cast, H 188 cm
(Bronze edition of 6: City of Wuppertal, Germany; Greater London Council
[Stifford Estate, Clive Street, Stepney]; Musée Royale des Beaux-Arts, Brussels;
Yale University, New Haven, Conn.; National Gallery of Victoria,
Melbourne; Hebrew University, Jerusalem)
Gift of Henry Moore, 1974

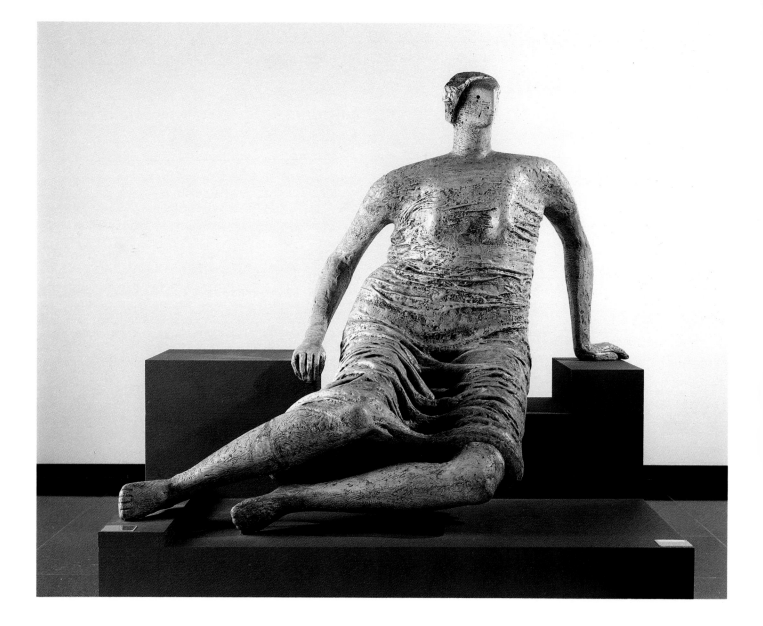

TWO OF THE LARGEST and most important sculptures connected with Moore's search for a suitable subject for the UNESCO commission were undoubtedly the *Draped Seated Woman* of 1957–58 (no. 127) and the *Draped Reclining Woman* of the same year (no. 129). The small study for no. 127, entitled *Maquette for Figure on Steps* (LH 426), is dated 1956, as is *Figure on Steps: Working Model for Draped Seated Woman* (LH 427). No. 127, one of the few plaster casts

in the collection, may have been made for exhibition purposes.

The earliest known works showing the human figure seated and reclining on steps are a series of drawings of 1930, of which the most important is *Figure on Steps* of 1930 (Wilkinson, 1977, no. 87). Another relevant study is at lower left in the collage of c. 1930, *Studies for Sculpture: Reclining Figures*, in the National Gallery of Victoria (Wilkinson, 1977, no. 86). An unpublished sketchbook sheet,

also of 1930, *Ideas for Sculpture: Figure Seated on Steps* is shown here (fig. 90). As is often the case, new compositions and ideas are realized in the drawings long before they are realized in three-dimensional form.

The practical side of Moore's approach to sculpture is well illustrated in his handling of the drapery in no. 127: "I knew that the big, draped, seated figure was going to be shown out of doors and this created the problem that the folds in the

128 *Fragment Figure* 1957 (LH 430)
Original plaster on plaster base,
L 15.9 cm; 29.7 cm with base
(Bronze edition of 10)
Gift of Henry Moore, 1973

drapery could collect dirt and leaves and pockets of water. I solved it by making a drainage tunnel through the drapery folds between the legs. I found that using drapery in sculpture was a most enjoyable exercise in itself."[82]

Both the *Draped Seated Woman* and the *Draped Reclining Woman* (no. 129) have obvious stylistic affinities with the Time-Life *Reclining Figure* of 1952–53 (no. 88), and yet they lack the sense of readiness and alertness of the earlier work. In John Russell's words:

Basically these are undemanding pieces which give enormous pleasure: The *Draped Seated Woman* of 1957–8 has, for instance, a vespertinal look, a ripeness like that of Richard Strauss's "Four Last Songs": with its contemporary the *Draped Reclining Woman* it induces a feeling of unfocused regret, and anyone who has seen either piece in the open, in an environment of dark trees and falling water, will know that as symbols of withdrawal they would be difficult to excel.[83]

Fig. 90 *Ideas for Sculpture: Figure Seated on Steps* 1930
Private collection

THIS *Fragment Figure* was part of the definitive maquette for the large *Draped Reclining Woman* of 1957–58 (LH 431, no. 129). The complete original plaster maquette, of which no. 128 is a fragment, was never cast in bronze. Moore said recently that the maquette had been broken, and without the arms and lower legs he envisaged it as a fragment figure and had a bronze edition cast from it.

Rodin was the first modern sculptor who saw fragmented torsos, arms, hands, legs, and feet as finished works of art. Following Rodin's example, a whole generation of younger European sculptors, among them Matisse, Brancusi, Archipenko, and Lipchitz, created partial figures, as did Moore and Hepworth in England. No. 128 resembles a fragment of a torso from classical antiquity, like those that inspired Rodin in the nineteenth century.

129 *Draped Reclining Woman*
1957–58 (LH 431)
Original plaster, L 215.7 cm
(Bronze edition of 6: Neue Staatsgalerie, Munich;
Federal Parliament, State of Baden-Wurttemburg, Stuttgart)
Gift of Henry Moore, 1974

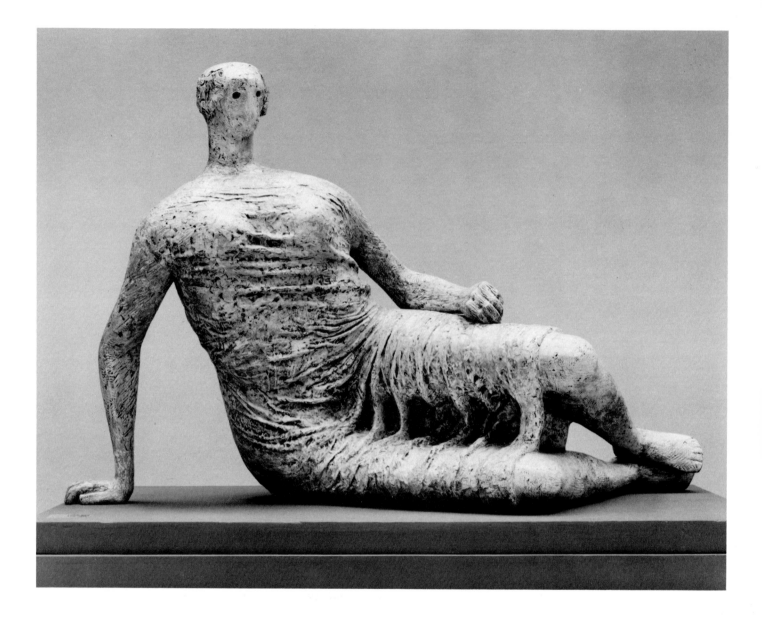

NO. 129 was based on the *Maquette for Draped Reclining Woman*, which was damaged and retitled *Fragment Figure*, no. 128. No. 129 and its pendant, *Draped Seated Woman*, are discussed in the notes for no. 127.

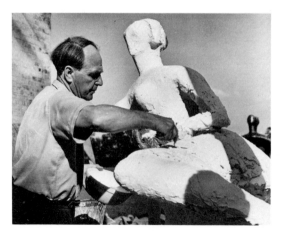

Fig. 91 Moore at work on original plaster of
Draped Reclining Woman, 1957–58

130 *Seated Woman with Crossed Feet* 1957 (LH 432)
Original Plaster, H 17.8 cm
(Bronze edition of 6)
Gift of Henry Moore, 1974

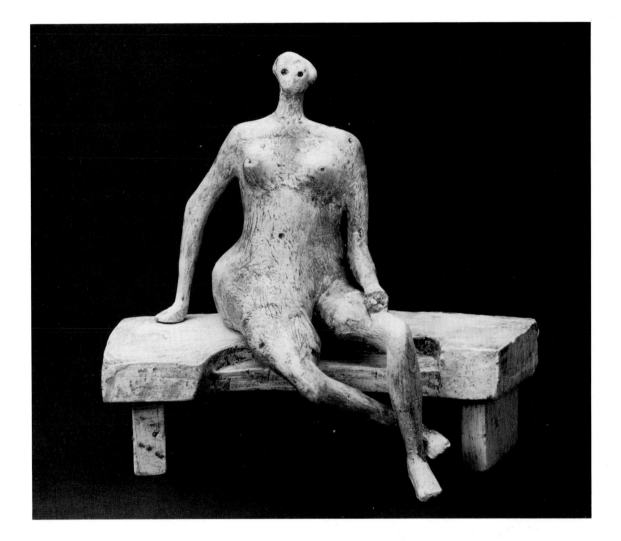

THIS FIGURE, it is stated in the Lund Humphries catalogue (in notes with no. 416), had its origin in the UNESCO commission, as did the two sculptures to which it is related, *Maquette for Seated Woman* of 1956 (LH 434; fig. 92) and the large *Seated Woman* of 1957 (LH 435). Although in no. 130 the stomach is not as large as in *Maquette for Seated Woman*, there is nevertheless the suggestion of pregnancy. As Moore has written of the large *Seated Woman* (LH 435), which was based on fig. 92: "*Seated Woman* is pregnant. The fullness of her pelvis and stomach is all to her right. I don't remember that I consciously did it this way, but I remember Irina telling me, before Mary was born, that sometimes she could feel that the baby was on one side and sometimes on the other."[84]

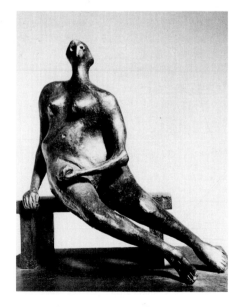

Fig. 92 *Maquette for Seated Woman* 1956
Private collection PHOTO: Errol Jackson

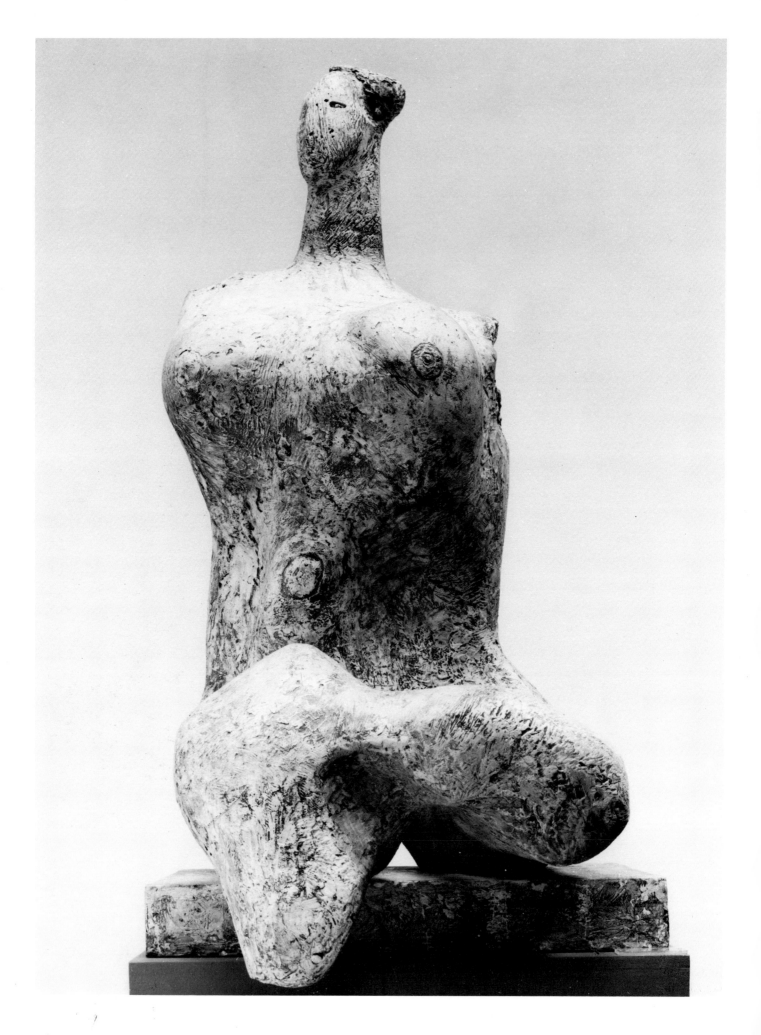

131 *Woman* 1957–58 (LH 439)
Original plaster, H 149.9 cm
(Bronze edition of 8: Museum des 20
Jahrhunderts, Vienna; British Council,
London; Tate Gallery, London;
Art Gallery of Ontario, Toronto)
Gift of Henry Moore, 1973

132 *Woman* 1957–58 (LH 439)
Bronze, H 152.4 cm, edition of 8
(for location of other casts see no. 131)
Gift of Sam and Ayala Zacks, 1970

Woman is a mid-twentieth–century descendant of some of the earliest works of art in the world, the prehistoric sculptures of fertility goddesses. Moore's interest in prehistoric art dates from his frequent visits to the British Museum in the 1920s, where he studied, in the Stone Age Room, originals and casts of Palaeolithic sculpture made some twenty thousand years ago. On page 74 of No. 6 Notebook of 1926 he made drawings of the well known Palaeolithic *Venus of Grimaldi* (fig. 7).

Almost all Moore's figurative sculpture is based on the female form. Early in his career he often associated the female figure with fertility; in fact he wrote in a sketchbook of the mid-1920s: "Woman — fecundity fertility." Of no. 131 Moore has written, "*Woman* emphasizes fertility like the Palaeolithic Venuses in which the roundness and fullness of form is exaggerated."[85] Like the *Venus of Grimaldi*, *Woman* has no arms, and the legs are truncated at the knees. Moore has concentrated on the central part of the figure, emphasizing the gigantic proportions of the breasts and the swollen belly, images of birth, fertility, and nourishment. "The smallness of the head," Moore has explained, "is necessary to emphasize the massiveness of the body. If the head had been any larger it would have ruined the whole idea of the sculpture."[86]

Asymmetry, one of the fundamental tenets of Moore's art, is in evidence throughout the figure. The small but alert head is turned to the right; the left breast is larger and projects farther forward than the right one; the belly is to the right of the centre; the right leg overhangs the base. No two viewpoints are alike. Moving round the figure, one experiences the irregular swelling forms of one of the most potent images of fertility produced in the twentieth century.

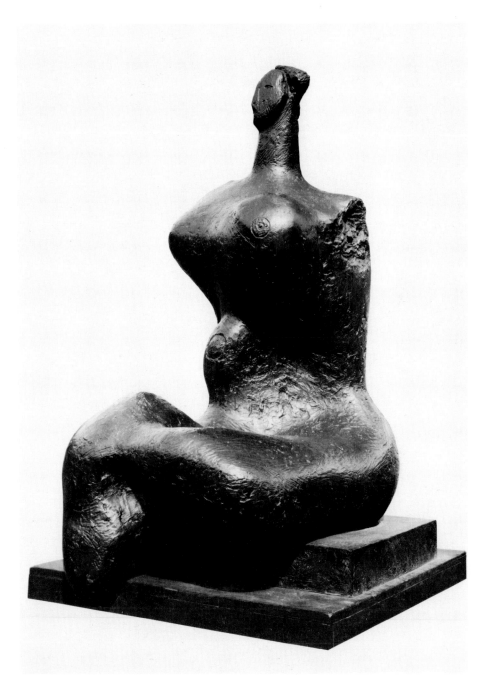

THIS BRONZE was cast from the original plaster no. 131. See notes for no. 131.

133 *Three Motives against Wall No. 2* 1959 (LH 442)
Original plaster, L 106.4 cm with base; H 36.9 cm central motive
(Bronze edition of 10: Tate Gallery, London; The Hirsh-
horn Museum and Sculpture Garden, Washington, DC)
Gift of Henry Moore, 1974

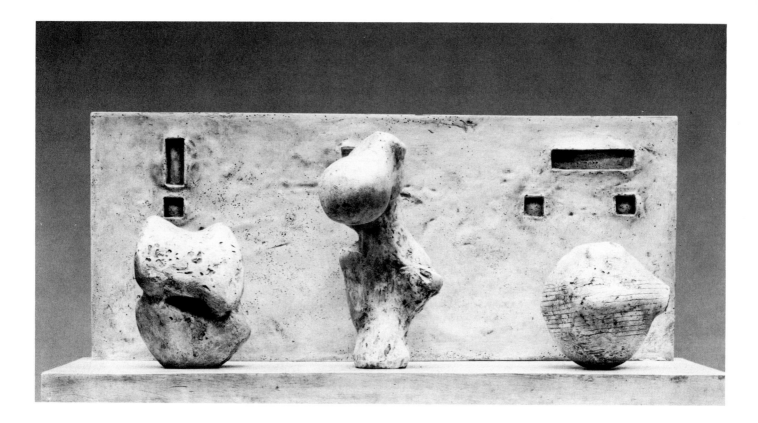

IN NO. 133 and its pendant, *Three Motives against Wall No. 1* of 1958 (LH 441), Moore sets the three motives in front of a rectangular slotted wall. Although slotted walls appear in a number of drawings of the 1930s (see fig. 89), they were not used in sculpture until 1957, in *Maquette for Girl against Square Wall* (LH 424), of which there is a bronze cast in the collection (no. 126). In *Three Motives against Wall No. 1*, the earlier of the two works, the three motives have distinct figurative characteristics; in no. 133 the three elements are more abstract, though the central motive does somewhat resemble the head of a hippopotamus. The three forms were undoubtedly based on flint stones in the artist's studio. Fig. 93 includes, second from the right, the flint stone on which the central motive in no. 133 was based. In the original plaster and in the

Fig. 93 Stones in Henry Moore's studio

bronze casts each of the forms may be turned and positioned in various combinations.

In no. 133, the original plaster wall was broken before the sculpture

was shipped to Toronto. The present one was cast from the wall of one of the bronze casts in the artist's studio. See no. 134.

134 *Maquette for Left Hand Form in Three Motives against Wall No. 2* 1959 (not in LH)
Original plaster, H 11.4 cm
Gift of Henry Moore, 1974

135 *Rearing Horse* 1959 (LH 447a)
Bronze, edition of 9 (cast 1972), H 13 cm
Gift of Henry Moore, 1974

136 *Headless Animal* 1960 (LH 449)
Bronze, edition of 6, L 22.7 cm
(Other casts: Tate Gallery, London)
Purchase from the artist, 1972

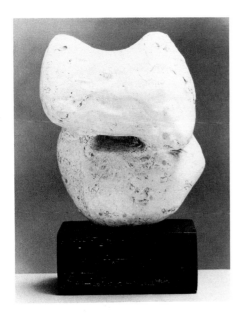

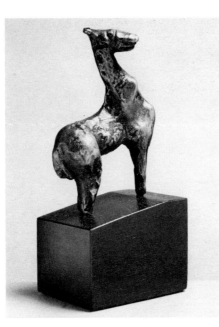

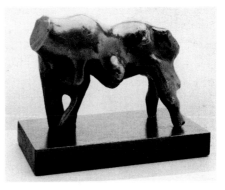

THIS IS the maquette for the form at left in no. 133. The surface of the plaster has been marked in pencil with points of reference for enlarging the maquette. Similar markings are to be found in another original plaster in the collection, *Slow Form: Tortoise* of 1962 (LH 502, no. 159). In all probability maquettes were made for the other two motives in no. 133, although their whereabouts are unknown. No. 134 was never cast in bronze.

THIS, one of three small sculptures of horses executed in 1959, is an example from a group of animal and bird forms made between 1959 and 1960. (See LH 443 and 445–49). Of the two other horses in the series, no. 135 is closest to *Horse* of 1959 (LH 447). See also *Horse* of 1978 (no. 199).

SOME OF Moore's animal sculptures are, as their titles indicate, known species, such as *Rearing Horse* no. 135 and *Sheep* of 1960 (LH 449a); others such as *Animal Head* of 1956 (no. 116) and *Headless Animal* cannot be identified as representing a known species; they are creatures of Moore's imagination. The body of no. 136 appears to have been based on a flint stone.

137 *Maquette for Relief No. 1* 1959
(LH 450a)
Bronze, edition of 9 (cast 1971),
H 12.9 cm
Signed and numbered on back
Moore 6 / 9
Purchase from the artist, 1978

138 *Relief No. 1* 1959 (LH 450)
Bronze, edition of 6, H 220.8 cm; 228.6 cm with base
(Other casts: Tate Gallery, London; Israel Museum,
Jerusalem; Louisiana Museum of Modern Art, Humle-
baek, Denmark)
Gift of Henry Moore, 1974

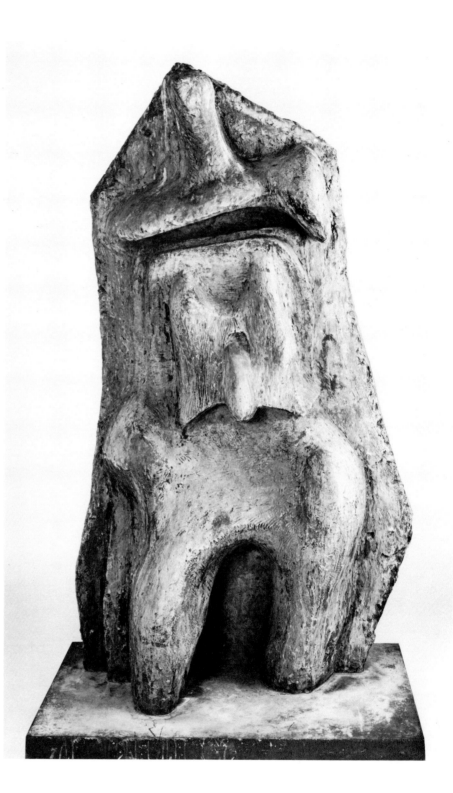

THIS IS the small maquette for the
large *Relief No. 1* of the same year.
See no. 138.

"*Relief No. 1* of 1959," Herbert Read has written, "is essentially an enlargement to gigantic size (88 inches) of one of the motives in the maquettes for the Rotterdam *Wall Relief*, and belongs to the same world of forms as the *Glenkiln Cross*."[87] It would appear that Read was referring to the motive in the bottom row, second from the left, in *Wall Relief: Maquette No. 3* of 1955 (LH 367; fig. 94), in which an upright figure is composed of three distinct sections: head and shoulders, torso, and legs. Another motive related to no. 138 appears in *Wall Relief: Maquette No. 6* (no. 102) just left of centre, in which the broad hips and truncated legs are features to be found in no. 138. If, as Russell has suggested, the 1957 *Draped Seated Woman* and *Draped Reclining Woman* (nos. 127 and 129) represent the tender side of Moore's nature, with works such as *Three Motives against Wall No. 2* (no. 133) and *Relief No. 1* "the tough side of his nature broke out with all the more ferocity for having been so long kept out of sight."[88]

No. 138 was Moore's fourth large relief sculpture, the previous ones being the *North Wind* of 1928 (LH 58; fig. 15), the *Time-Life Screen* of 1952–53 (LH 344; fig. 71), and the Bouwcentrum *Wall Relief* of 1955 (LH 375; fig. 80).

Moore's own writings about his work provide the most illuminating explanation of his aims. In 1962 he wrote about relief sculpture as follows:

Renaissance sculptors used relief pictorially. They reduced depth almost mathematically. They had the same use of perspective as painters. For some time I've thought one might use relief in its own way, to exploit the projection and recession of form and make it more powerful in relief than in realistic rendering of compressed representation. To make the chest more strong, to make it come out more, you send it back underneath. You bring the hips out more, and the umbilicus. One has made the projections of recessions for their own sakes rather than for a pictorial use of relief.... It's the reverse of the naturalistic or realistic approach to relief.[89]

For related works, see nos. 139–40 and fig. 95 and 96.

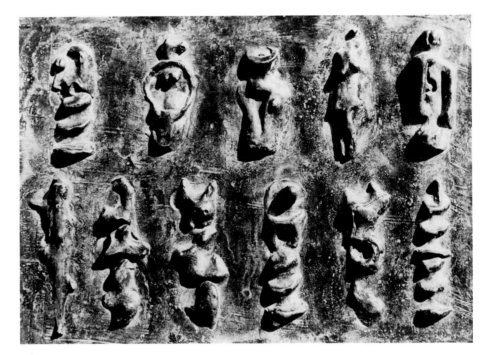

Fig. 94 *Wall Relief: Maquette No. 3* 1955
Private collection

139 *Half Figure Relief:*
Headless c. 1959–60 (not in LH)
Original plaster, H 18.8 cm
Gift of Henry Moore, 1974

Fig. 95 *Relief No. 2* 1959
Henry Moore Foundation

Fig. 96 *Relief A* 1960
Private collection

NOS. 139, 140, and 141, according to
Moore, were done about the same
time as *Relief No. 2* of 1959 (LH 451;
fig. 95), which, like no. 139, was
never cast in bronze. Of fig. 95 Moore
wrote: "The projecting parts are too
evenly spread and too evenly appor-
tioned throughout the figure. There is
no obvious focal point. In the bronze
sculpture [no. 138] you know the
middle and you know where the

shoulders are. It has a centre, a ker-
nel, and an organic logic."[90]

Near the bottom of no. 139 the
cast of a bone fragment, similar to
no. 141, is a feature found in *Relief A*
of 1960 (LH 460; fig. 96). Possibly
nos. 139–41 were executed in 1960 at
the same time as fig. 96 and *Relief
B*, also of 1960 (LH 461).

140 *Half Figure Relief c.* 1959–60
(not in LH)
Original plaster, H 17.2 cm with base
Gift of Henry Moore, 1974

141 *Plaster Cast of Bone Fragment c.* 1959–60 (not in LH)
Plaster cast, L 13 cm
Gift of Henry Moore, 1974

NO. 140, which was never cast in
bronze, is related to figs. 95 and 96.
Bone textures suggest that the figure
was built around a bone fragment.
See notes for no. 139.

MOORE TOLD the author that
no. 141 was cast from a bone frag-
ment. Similar fragments appear in
nos. 139 and 140 and in fig. 96
(see notes for no. 139).

142 *Mother and Child: Arch* 1959 (LH 453a)
Original plaster, H 57.2 cm with base (Bronze edition of
6: Museum and Art Gallery, Bolton)
Gift of Henry Moore, 1973

Fig. 98 *Maquette for Mother and Child: Arch* 1959
Lost or destroyed

IN ORDER to follow the genesis of the sculptural ideas in Moore's work from 1921 to the mid-1950s, one must look through the hundreds of sketchbook pages from these years. By the mid-1950s Moore had ceased to use drawing as a means of generating ideas for sculpture and had begun to work directly with small plaster maquettes, a practice that he continued to the end of his career. The sources of many sculptures of his last thirty-five years were the natural forms — bones, shells, and flint stones — that lay about Moore's studios in great abundance. It is often possible to deduce that a given sculpture

Fig. 97 Flint stones in Moore's studio

was based on or inspired by a shell (no. 193), a bone (no. 148), or a flint stone (no. 170), but it is not easy to find the exact natural form that Moore used as a point of departure. In the case of *Mother and Child: Arch*, however, the photograph of three flints from Moore's studio (fig. 97) shows in the flint at left

the precise source for the sculpture. (Fig. 98 shows the plaster maquette for 142, which has not been cast in bronze.)

As in his transformation drawings of natural forms made in the early 1930s (nos. 27, 31, and 32), Moore altered the shape of the object he used as a point of departure. He has

enlarged the right shoulder and arch form below, and added the right breast of the mother, the eyes, and the nose. Natural forms in themselves, Moore told the author, are dead forms, and merely to copy them would not produce sculptural form: "It is what I see in them that gives them their significance."

143 *Two Seated Girls against Wall* 1960 (LH 454)
Original plaster, H 48 cm, W 31.8 cm
(Bronze edition of 12)
Gift of Henry Moore, 1974

144 *Reclining Figure on Pedestal* 1959–60 (LH 456)
Original plaster, H 129.7 cm
(Bronze edition of 9: Museo de
Bellas Artes, Caracas)
Gift of Henry Moore, 1973

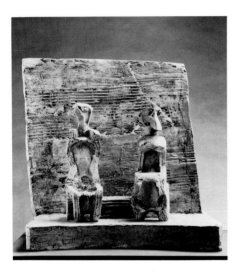

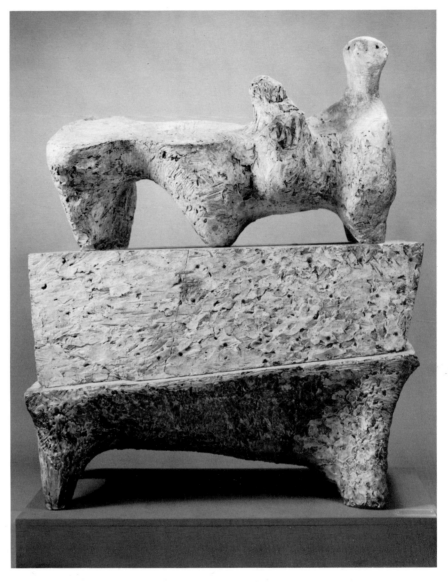

NO. 143 was based on the back halves of two moulds made for the casting of two seated figures. In other words Moore used moulds made at the bronze foundry for two other figures to form the basis of the two figures in no. 143. *Mother and Child: Hollow* of 1959 (LH 453) was also based on the back half of a mould made in casting a seated figure.

THIS RECLINING FIGURE rests on a rectangular pedestal, which, in turn, is placed on a low arched base. The figure, with its flat area at the top, is reminiscent of the larger study in *Drawing* of 1936 (fig. 99). If in the latter study there is the suggestion of a figure rising out of a sarcophagus, here the figure has been removed completely and reclines on the lid.

Fig. 99 *Drawing* 1936
Private collection

145 *Two Piece Reclining Figure No. 1* 1959 (LH 457)
Original plaster, L 212.1 cm
(Bronze edition of 6: Lambert Airport, St. Louis; Lehm-
bruck Museum, Duisburg; Chelsea School of Art, Lon-
don; Albright-Knox Art Gallery, Buffalo)
Gift of Henry Moore, 1973

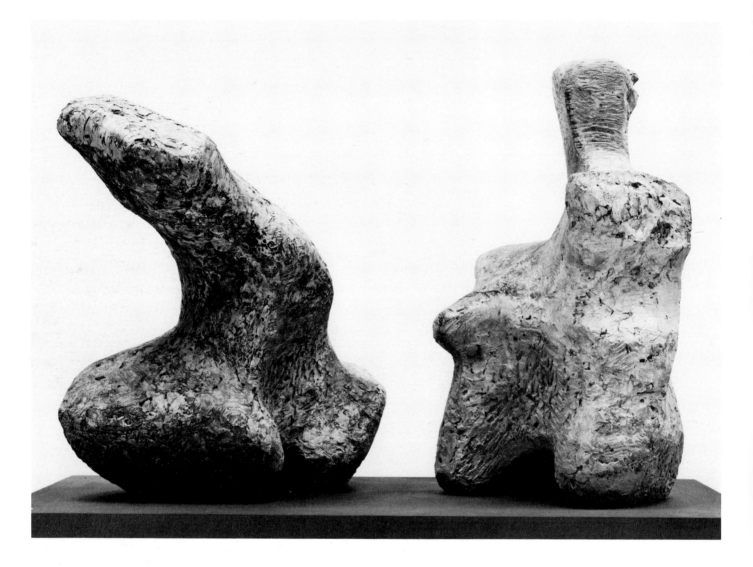

MOORE'S first divided figures were executed in 1934 and include such single figures as *Four Piece Composition: Reclining Figure* (LH 154; fig. 34), which is composed of various dismembered parts of the human anatomy, and compositions of two or more forms, such as *Head and Ball* (LH 151; fig. 28). Twenty-five years later he returned to the theme of multi-part sculptures in the magnificent series of two- and three-piece reclining figures of 1959–63, culminating in his largest sculpture up to that time, the 1963–65 *Reclining*

Figure (LH 519; fig. 110) commissioned for the Lincoln Center for the Performing Arts, New York City. With the exception of the 1963–64 *Two Piece Reclining Figure No. 5* (LH 517), the AGO collection includes the original plasters of all the large sculptures in this series. In the case of the Lincoln Center commission (LH 519), the AGO collection has the large working model, no. 164.

Two Piece Reclining Figure No. 1 of 1959 was the first in the series. In the maquette for no. 144, the head and the leg end are joined. When he

came to enlarge the sculpture "there was a stage where the junction between the leg and the head didn't seem necessary. Then I realized that dividing the figure into two parts made many more three-dimensional variations than if it had just been a monolithic piece."[91]

Moore saw this sculpture as a mixture of rock forms, mountains, and imagery of the human figure:

I realized what an advantage a separated two-piece composition could have in relating figures to landscape. Knees and

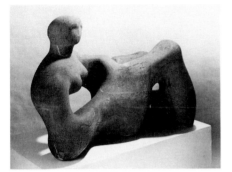

Fig. 100 *Recumbent Figure* 1938
Trustees of the Tate Gallery, London

Fig. 101 Rock at Adel, Yorkshire

Fig. 102 Georges Seurat *Le Bec du Hoc,
Grandcamp* 1885
Trustees of the Tate Gallery, London

breasts are mountains. Once these two parts become separated you don't expect it to be a naturalistic figure; therefore, you can justifiably make it like a landscape or a rock. If it is a single figure, you can guess what it's going to be like. If it is in two pieces, there's a bigger surprise, you have more unexpected views....[92]

In some of Moore's prewar sculpture, notably the Tate's *Recumbent Figure* of 1938 (LH 184; fig. 100), he related the human figure to landscape. This carving was made to be placed in a Sussex garden with an open view of the South Downs, and its smooth, rounded forms echo the landscape of hills against which it was seen. Here the human figure is like a landscape, that is to say the figurative elements in the carving are dominant, with echoes of hills, hollows, and ridges. In *Two Piece Reclining Figure No. 1*, and in the other major two- and three-piece sculptures in the series, the simile is reversed; landscape features — no longer the gentle topography of the South Downs, but cliffs, rocks, caves, and dramatic headlands — are dominant, but have references to the human figure. The landscape is likened to the female reclining form; as a metaphor, the landscape becomes the human body.

John Russell has rightly described the leg end of *Two Piece Reclining Figure No. 1* as "probably the most dynamic incident in all Moore's work."[93] It has been compared to the dramatic outcropping of rock at Adel in Yorkshire (fig. 101) that Moore saw when he was about ten years old. While working on the sculpture, Moore said he was reminded of Seurat's *Le Bec du Hoc, Grandcamp* of 1885 (fig. 102), which was owned by his friend Lord Clark and is now in the Tate Gallery. Interesting as these comparisons may be, this writer suggests that both sections of the sculpture almost certainly derived from flint stones.

146 *Two Piece Reclining Figure No. 2* 1960 (LH 458)
Original plaster, L 249.6 cm
(Bronze edition of 7: Lambert Airport, St. Louis;
National Gallery of Scotland, Edinburgh; Tate Gallery,
London; Rijksmuseum Kröller-Müller, Otterlo; Museum
of Modern Art, New York)
Gift of Henry Moore, 1974

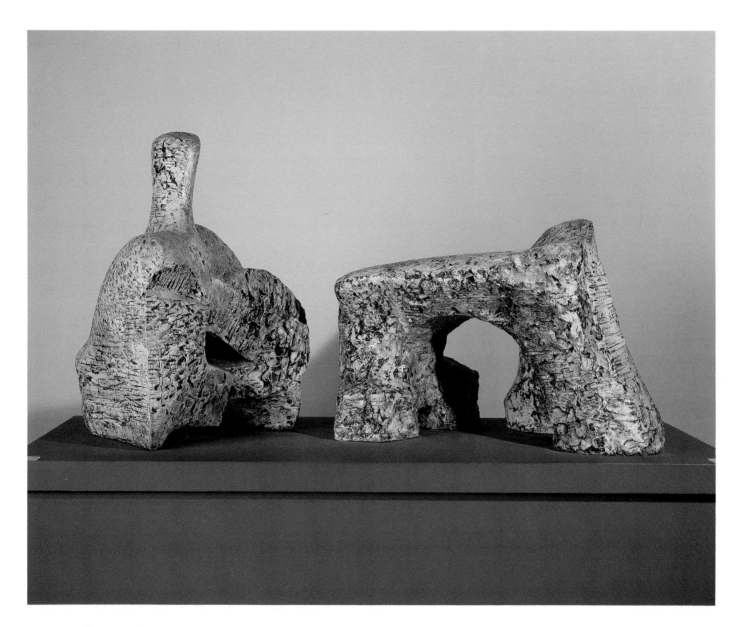

THIS IS the second two-piece reclining figure in the series. Like its immediate predecessor no. 145, it was almost certainly based on a maquette that has been lost or destroyed and was never cast in bronze. The shape and rough texture of the head and torso strongly suggest that this section of the sculpture was based on a bone fragment.

Whereas the leg end in no. 145 reminded Moore of Seurat's *Le Bec du Hoc, Grandcamp*, the leg section in no. 146, Moore wrote, "began to remind me, towards its completion, of Monet's painting of the *Cliff at Etretat*. I kept thinking of this arch as if it was coming out of the sea. This is the figure which led to me agreeing to make the Lincoln Center sculpture which stands in water."[94] (See no. 164 and fig. 110.)

Anyone who has photographed Moore's large sculpture of the last twenty years is aware both of the fully three-dimensional character of the work and of the almost unlimited and constantly changing viewpoints and vistas as one walks around the sculpture. No longer does one think only in terms of front and back, or that a photograph taken from a single viewpoint will provide adequate information about a given sculpture. With the two- and three-piece reclining figures, the journey is even more revealing than moving around a single-form, solid work such as *The Archer* (no. 170). As Moore has written of no. 146:

... as you walk round it, one form gets in

147 *Sculptural Object* 1960 (LH 469)
Original plaster, H 47.5 cm
(Bronze edition of 10: Arts Council
of Great Britain, London; Smith
College of Art, Northampton, Mass.)
Gift of Henry Moore, 1973

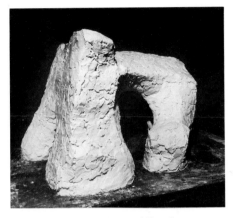

Fig. 103 The original plaster of *Two Piece Reclining Figure No. 2*, nearing completion

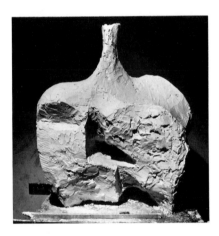

Fig. 104 The original plaster of *Two Piece Reclining Figure No. 2*, nearing completion

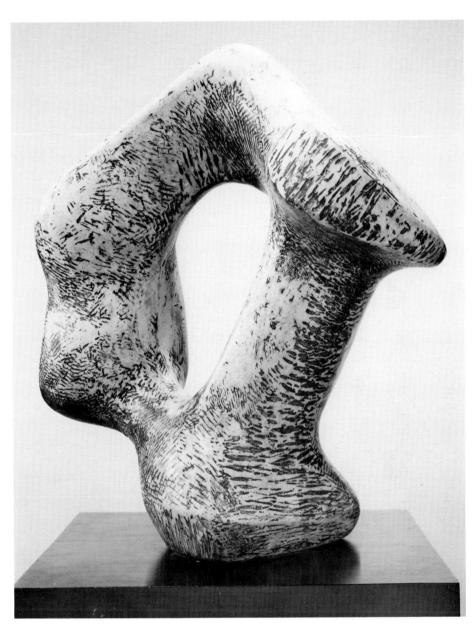

front of the other in ways you cannot foresee, and you get a more surprising number of different views than when looking at a monolithic piece. The space between the two parts has to be exactly right. It's as though one was putting together the fragments of a broken antique sculpture in which you have, say, only the knees, a foot and the head. In the reconstruction the foot would have to be the right distance from the knee, and the knee the right distance from the head, to leave room for the missing parts — otherwise you would get a wrongly proportioned figure. So, in these two-piece and three-piece sculptures the space between the pieces is a vital part of the sculpture.⁹⁵

THIS SCULPTURE is of a similar shape to a number of bone forms that the author saw in Moore's studio. Bone shapes appear in a number of other sculptures of the period, notably *Seated Woman: Thin Neck* of 1961 (LH 472, no. 148); *Two Piece Reclining Figure: Maquette No. 5* of 1962 (LH 477, no. 149) and *Working Model for Standing Figure: Knife Edge*, 1961 (LH 481, no. 153).

148 *Seated Woman: Thin Neck* 1961 (LH 472)
Original plaster, H 163.8 cm
(Bronze edition of 7: Tate Gallery, London; Laing Art
Gallery, Newcastle upon Tyne; Des Moines Art Center,
Iowa)
Gift of Henry Moore, 1973

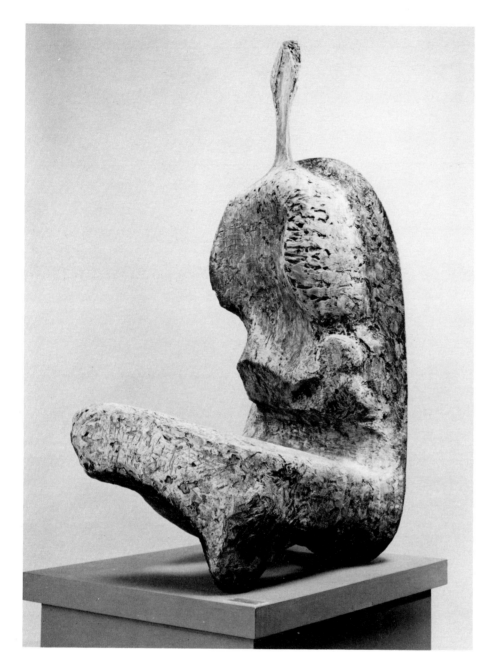

THIS FIGURE was based on the
1960 *Maquette for Seated Woman:
Thin Neck* (LH 471). The origins in
natural forms of many of Moore's
sculptural ideas during the 1960s,
1970s, and 1980s are often more dis-
cernible in the maquettes than in the
enlarged versions. Moore would often
either make plaster casts of bones
(no. 141) or shells or flint stones and
add plaster to them, or add clay or
plaster directly to the natural forms,
as in the maquette (fig. 108) for
*Working Model for Standing Figure:
Knife Edge* of 1961 (LH 481, no. 153).
In the maquette for no. 148, for
example, the thin neck and the tex-
ture of the vertical ridge down the
left side almost certainly indicate
that a bone fragment was incorpo-
rated in the torso.

"Some bones," Moore has written,
"such as the breast bones of birds,
have the lightweight fineness of a
knife-blade. Finding such a bone led
me to using this knife-edge thinness
in 1961 in a sculpture *Seated Woman
(Thin Neck)*. In this figure the thin
neck and head, by contrast with the
width and bulk of the body, give
more monumentality to the work."[96]

149 *Two Piece Reclining Figure:
Maquette No. 5* 1962 (LH 477)
Original plaster, L 11.2 cm
(Bronze edition of 6)
Gift of Henry Moore, 1973

150 *Maquette for Two Piece Reclin-
ing Figure No. 3* 1961 (LH 475)
Original plaster, L 22.9 cm
Bronze edition of 9
Gift of Henry Moore, 1974

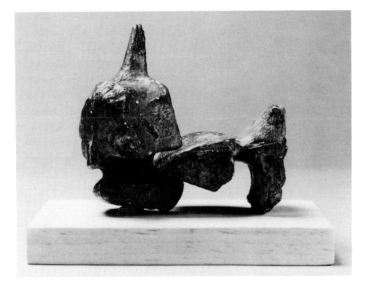

THE ROUGH TEXTURE of the torso
and the T-shaped leg end again indi-
cate that these two forms were based
on bones. It may have been that
Moore altered the bone forms very
little and added the thin pointed
head to the original form as he had
done in a reclining figure composed of
three flint stones (fig. 105). Although
no. 149 was never enlarged, it is
important in that it is the first work
to anticipate later sculptures, such as
the 1962 *Slow Form: Tortoise* (LH
502, no. 159), *Working Model for
Locking Piece* of 1962 (LH 514,
no. 163) and *Two Piece Sculpture
No. 7: Pipe* of 1966 (LH 543, no. 171),
in which the forms fit or lock
together. Here the horizontal section
of the leg end fits into the slot near
the bottom of the head and torso
portion of the figure.

THIS IS one in the series of two-
piece reclining-figure maquettes exe-
cuted in 1960 and 1961. It is the study
for the third large two-piece reclining
figure of the period, which is dis-
cussed in the notes for no. 151.

Fig. 105 Flint stones in Moore's maquette studio,
sculptural idea in progress
PHOTO: A.G. Wilkinson

151 *Two Piece Reclining Figure No. 3* 1961 (LH 478)
Original plaster, L 233.7 cm
(Bronze edition of 7: Tate Gallery, London; SITOR, Turin;
City of Gothenburg, Sweden; Greater London Council
[Brandon Estate], Southwark; Museum of Fine Arts,
Dallas, Texas; Everson Museum of Art, Syracuse, New
York; UCLA)
Gift of Henry Moore, 1974

152 *Two Piece Reclining Figure No. 4* 1961 (LH 479)
Original plaster, L 101.6 cm
(Bronze edition of 8: Stedelijk Museum, Amsterdam;
Wakefield Art Gallery and Museums, Yorkshire)
Gift of Henry Moore, 1973

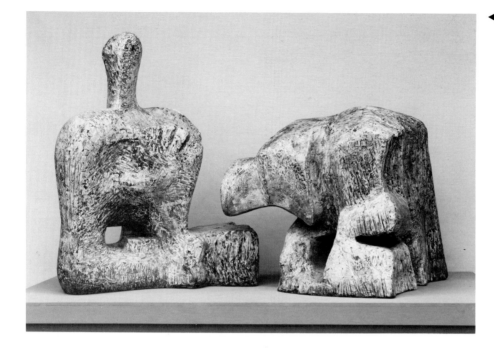

◄ OF THE THREE large two-piece
reclining figures of 1959–61, this
sculpture is the most massive and
ponderous. The vast monolithic leg
end, with its vertical and horizontal
grooves, resembles a weathered boul-
der or ancient menhir. This, like
the head end, was probably based on
bone forms. The way in which the
upper part of the leg end overhangs
the flat plateau that juts out from
the torso suggests that the two forms
were once locked together but have
drifted apart.

152

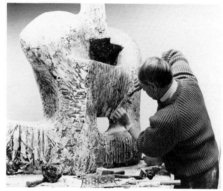

Fig. 106 Henry Moore working on the original
plaster of *Two Piece Reclining Figure No. 3*, 1961

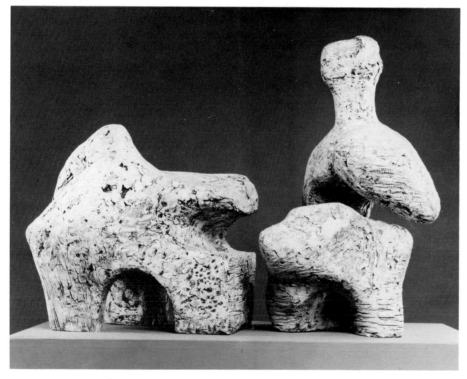

THIS IS the only medium-size work
in the series of two-piece reclining
figures. In fig. 107 the artist is shown
working on the maquette for no. 152.

This maquette has not been cast in
a bronze edition, nor is it listed in
the Lund Humphries catalogue.

Fig. 107 Moore with maquette for *Two Piece
Reclining Figure No. 4*, 1961

153 *Working Model for Standing Figure: Knife Edge* 1961 (LH 481)
Fibreglass, edition of 2, cast 1973, H 171.5 cm
(Bronze edition of 7: Opera House, Frankfurt-am-Main;
The Hirshhorn Museum and Sculpture Garden, Wash-
ington, DC)
Gift of Henry Moore, 1974

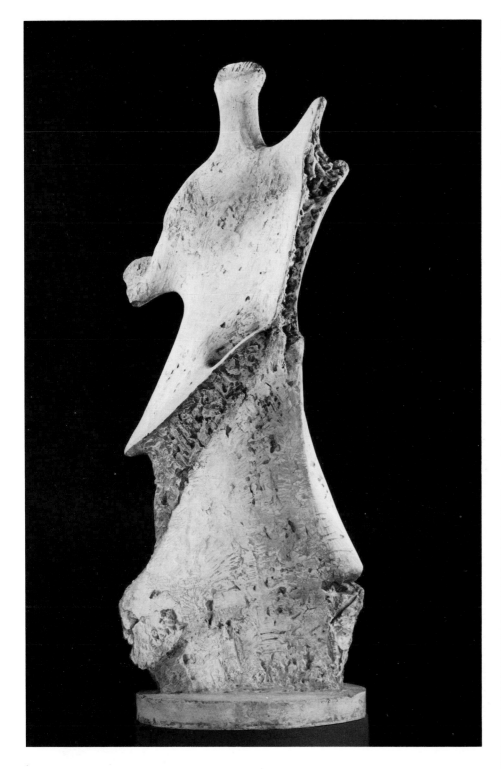

NO PHOTOGRAPH could better
illustrate Moore's use and transfor-
mation of natural forms than the one
shown here (fig. 108) of the maquette
for no. 153. "Since my student days,"
Moore wrote, "I have liked the shape
of bones, and have drawn them,
studied them in the Natural History
Museum, found them on sea-shores
and saved them out of the stewpot."[97]
Whereas in the early 1930s Moore
drew and transformed bone forms
into human forms, in the past
twenty-five years he has often used a
fragment of real bone in producing
the maquette. That bone forms were
the source for a number of sculptures
of the early 1960s is clearly indicated
by the shape and texture of the
works, although in most cases the
individual bones Moore used have
not been identified. John Hedgecoe's
photograph (fig. 108) of the
maquette for no. 153 is an invaluable
record showing the source for one
of Moore's greatest sculptures of the
1960s. It illustrates how little Moore
has altered the fragmented bone.

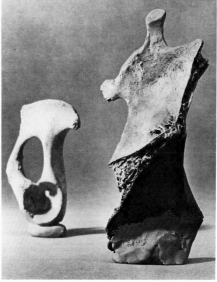

Fig. 108 Bone and clay maquette on which
Working Model for Standing Figure: Knife Edge,
1961, was based
PHOTO: John Hedgecoe

154 *Draped Seated Figure: Headless* 1961 (LH 485)
Original plaster, H 13 cm
(Bronze edition of 9)
Gift of Henry Moore, 1974

The clay that was added at the base of the bone not only completes the figure but provides a flat area so that it can stand upright. Small amounts of clay are visible between the head and the truncated right arm, and also on the neck. This bone maquette was never cast in bronze, but the working model was based directly on it. In no. 153 Moore has carefully recreated the rough, honeycomb-like texture of the bone down the left edge of the figure, and down the front just below centre. The jagged edges of the stump-like arm have been rounded.

Moore has written of no. 153:

This sculpture has been called *Standing Figure – Knife-Edge*, also *Standing Figure – Bone* and again, *Winged Figure*. All three have some relevance to what it is, and how it came about.

In walking round this sculpture the width and flatness from the front gradually change through the three-quarter views into the thin sharp edges of the side views, and then back again to the width seen from the back.

And the top half of the figure bends backwards, is angled towards the sky, opens itself to the light in a rising upward movement — and this may be why, at one time, I called it *Winged Figure*.

In a sculptor's work all sorts of past experiences and influences are fused and used — and somewhere in this work there is a connection with the so-called *Victory of Samothrace* in the Louvre — and I would like to think that others see something Greek in this *Standing Figure*.[98]

A cast of the larger (H 284.5 cm) version of this sculpture, entitled *Standing Figure: Knife Edge* of 1961 (LH 482), stands in St. Stephen's Green, Dublin, as a memorial to the Irish poet W.B. Yeats. In 1976 Moore made an even bigger version in polystyrene, *Large Standing Figure: Knife Edge* 1961 and 1976 (LH 482a), which has been cast in a bronze edition of six.

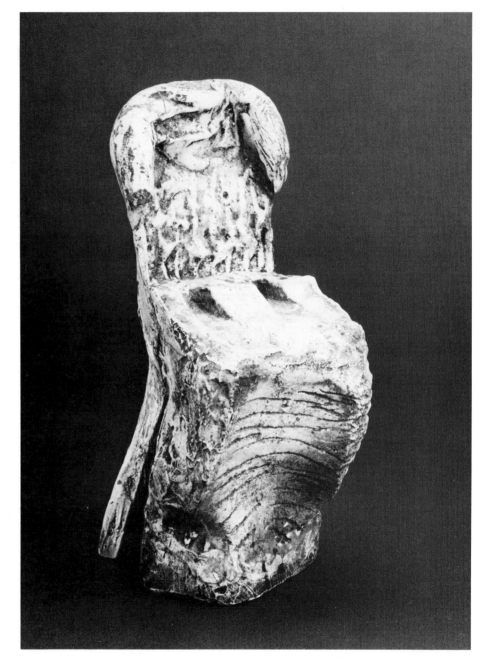

THIS LITTLE SCULPTURE is somewhat reminiscent of the fragmentary seated figures from the east and west pediments of the Parthenon, in the British Museum. In the bronze edition of no. 154, the figure is mounted on a high bronze base.

155 *Head: Cross Hatch* 1961
(LH 492)
Original plaster, H 8.5 cm
(Bronze edition of 6)
Gift of Henry Moore, 1974

156 *Snake Head* 1961 (a version of
LH 495)
Original plaster, H 9.4 cm
(Bronze edition of 6)
Gift of Henry Moore, 1974

157 *Snake Head* 1961 (LH 495)
Bronze, edition of 6, H 9.6 cm
Gift of Henry Moore, 1974

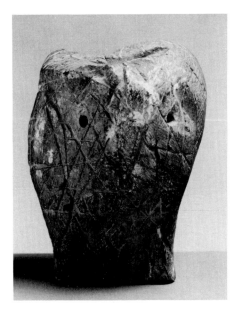

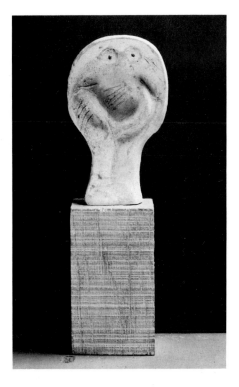

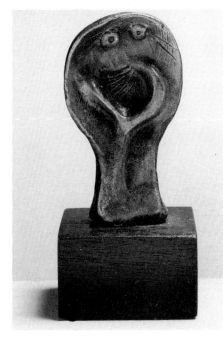

MOORE EXPLAINED the purpose of the cross-hatching in another small sculpture of 1961, *Seated Figure: Cross Hatch* (LH 484): "I was going to work further on the sculpture on page 368 [of John Hedgecoe's book] and change its form. In order to add plaster to previous plaster, you cut and scratch the surface so that it keys in."[99] The cross-hatching in no. 155 may have been made for the same reason.

MOORE MADE three sculptures of serpents: no. 156, the 1924 marble *Snake* (LH 20), and the 1973 bronze *Serpent* (LH 637). He occasionally made several plaster maquettes of a given work, which allowed him to create variations, as he used to do in his drawings for sculpture. Some of these are plaster casts, though it is not always easy to distinguish them from the original plasters. The bronze edition (no. 157) was not cast from no. 156, so another maquette was evidently made. Even if no. 156 is in fact a plaster cast it may however be described as an original plaster, as fresh plaster has been added at the back of the head, forming a circular knob, a feature not found in the bronze no. 157. The incised lines on the front of this head vary slightly from those found in no. 157.

ALTHOUGH this head is very close to no. 156, it appears to have been cast from another original plaster version. See notes for no. 156.

158 *Three Piece Reclining Figure No. 1* 1961–62 (LH 500)
Original plaster, L 254 cm
(Bronze edition of 7: Canadian Imperial Bank of
Commerce Building, Montreal; Tate Gallery, London;
Rochester Institute of Technology, New York)
Gift of Henry Moore, 1974

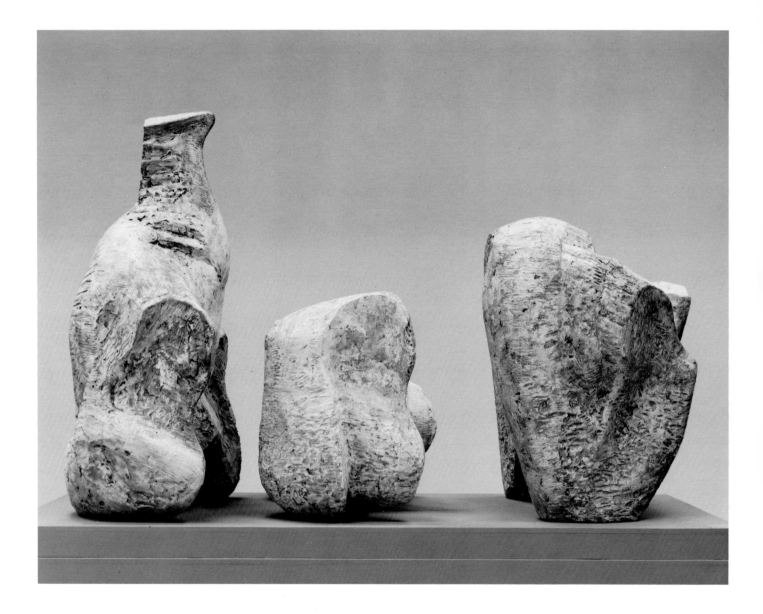

FROM THE 1959–61 series of two-piece reclining figures evolved the three-piece reclining figures of 1961–63, of which the only two large works made are in this collection, nos. 158 and 162. In addition there were two maquettes, *Three Piece Reclining Figure: Maquette No. 1* of 1961 (LH 499), which is not in fact a study for no. 158, and *Three Piece Reclining Figure No. 2: Polished* of 1962 (LH 501). No. 158 was almost certainly based on a preliminary maquette, although no record of one exists.

In this sculpture there are, apart from the bull-like neck and head, only the most tenuous links with the human anatomy. The landscape elements of rocks and boulders are so strong and dominant as almost completely to overpower the minimal figurative references. Had Moore gone much farther in this direction, the tension of the landscape / figurative metaphor would surely have been lost and the sculpture would have become, in John Russell's words, "very imposing and finely-worked boulders, but boulders none the less."[100]

159 *Slow Form: Tortoise* 1962
(LH 502)

Original plaster, L 19 cm
(Bronze edition of 9)
Gift of Henry Moore, 1974

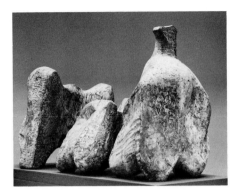

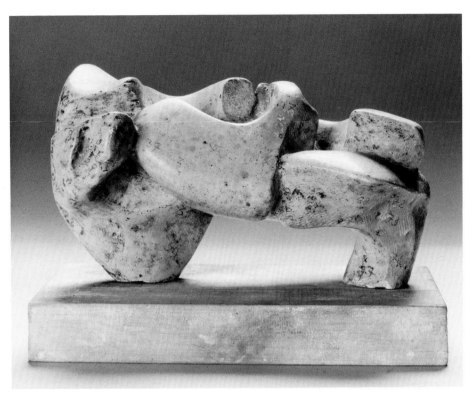

Fig. 109 Head and torso of *Three Piece Reclining Figure No. 1*, in progress

THIS IS the maquette for the working-model-size *Large Slow Form: Tortoise* of 1962–68 (LH 502a) of which there is a cast in the Tate Gallery. The dots and numbers on the surface of the plaster were used as reference points by Moore and his assistants in enlarging the maquette.

Moore has explained how the interlocking forms fit together: "It is one right-angled form, repeated five times, and arranged together to make an organic composition. This repeated slow right-angle reminded me of the action of a tortoise. I think I shall pursue the idea of using a repetitive unit in some future works."[101]

160 *Maquette for Large Torso:*
Arch 1962 (LH 503a)
Bronze, edition of 9 (cast 1971),
H 10.5 cm with base
Inscr. on base *Moore 5 / 9*
Purchase from the artist, 1978

161 *Ear Piece* 1962 (LH 505a)
Original plaster, H 16.8 cm
(Bronze edition of 9)
Gift of Henry Moore, 1974

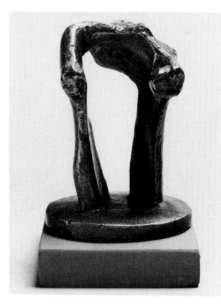

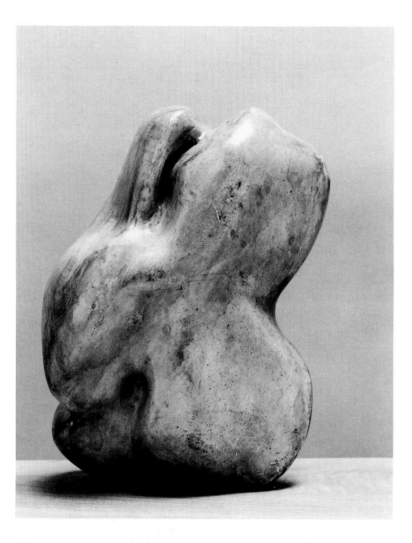

THIS IS the maquette for the *Large
Torso: Arch* of 1962–63 (LH 503).
The latter, almost two metres tall, is
the first of Moore's sculptures through
which one can walk. In 1969 he made
a version of LH 503 six metres high,
entitled *The Arch* 1963 and 1969
(LH 503b), in a bronze edition of
three, plus one fibreglass cast.

"I CALLED this sculpture *Ear
Piece*," Moore wrote, "because while
making it I was reminded of the
human ear. Our ears are remarkable
inventions and can be looked at as
sculptures in themselves. I'm sure
that if we had never seen the human
ear, if Nature had just put a hole in
its place, it would have been incredi-
ble for man himself to have created
so weird a shape."[102]

Ear Piece, in contrast to the thin,
elegant *Working Model for Standing
Figure: Knife Edge* of the previous
year (no. 153), has a feeling of sheer
bulk and solid mass, the antithesis
of such pierced, opened-out forms of
sculptures as the *Working Model
for UNESCO Reclining Figure* of 1975
(no. 123).

The slow, gentle, rhythmic curves
recall Arp's "concretions" of the early
1930s, many of which, like Moore's
work, were made in plaster. "Con-
cretion," Arp wrote, "signifies the
natural process of condensation,
hardening, coagulating, thickening,
growing together. Concretion desig-
nates the solidification of a mass."[103]
This seems to have happened in
works such as no. 161, *Three Way
Piece No. 1: Points* of 1964–65 (LH
533; fig. 117) and *Working Model for
Three Way Piece No. 2: Archer* of
1964 (LH 534, no. 170). Although the
resemblance is probably fortuitous,
Ear Piece may be compared to Arp's
1960 marble *Human Lunar Spectral*.

162 *Three Piece Reclining Figure No. 2: Bridge Prop* 1963 (LH 513)
Original plaster, L 238.2 cm
(Bronze edition of 6: Tate Gallery, London; Leeds City Art Galleries; The Hirshhorn Museum and Sculpture Garden, Washington, DC)
Gift of Henry Moore, 1974

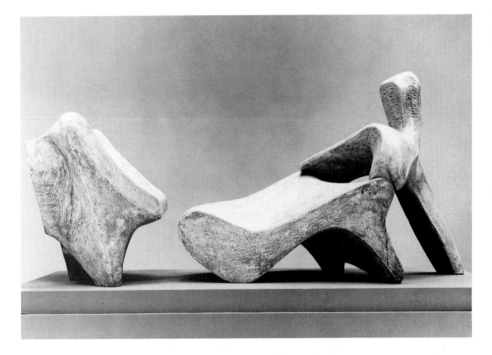

THE LANDSCAPE IMAGES of mountains, caves, cliffs, weathered rocks, and boulders that characterize the earlier two- and three-piece reclining figures of 1959–62 have here been replaced by the functional forms of engineering. Rugged surfaces have given way to smooth forms, crisp edges and, in the central component, to flat planes.

"With the *Reclining Figure: Bridge Prop*," Moore wrote, "the prop is an arm supporting the figure. In making it, I was reminded of the view under Waterloo Bridge which I had passed on numerous occasions. The arches, seen from the Embankment, are strong."[104]

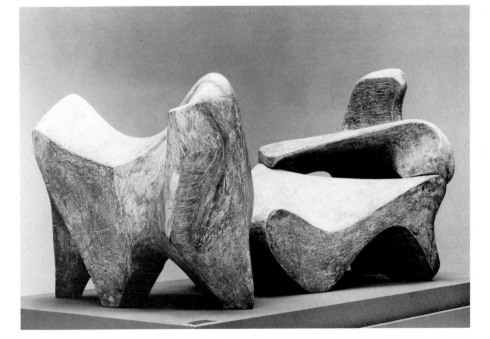

163 *Working Model for Locking Piece* 1962 (LH 514)
Original plaster, H 97.8 cm; 103.8 cm
with fibreglass base
(Bronze edition of 9: Lehmbruck Museum, Duisburg;
Pepsico World Headquarters, Purchase, New York)
Gift of Henry Moore, 1974

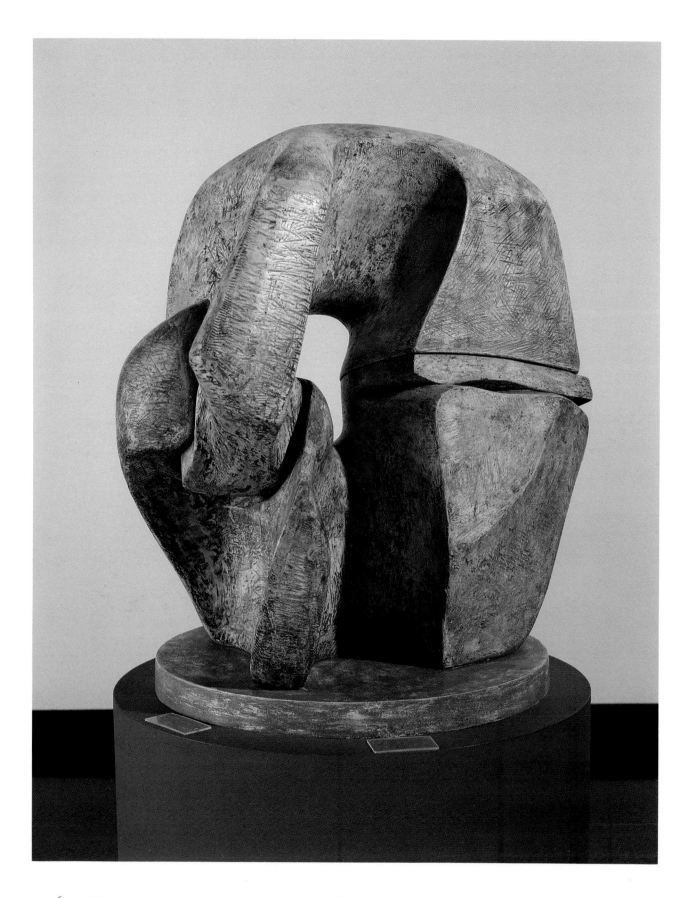

AN EARLIER SCULPTURE in the collection anticipates the interlocking forms in no. 163. In *Slow Form: Tortoise* of 1962 (LH 502, no. 159), a right-angle form is repeated five times and locked together in a solid composition.

Moore has given two different accounts of the source for the *Locking Piece*. In 1964 he said: "the maquette for this two-piece *Locking Piece* came about from two pebbles which I was playing with and which seemed to fit each other and lock together, and this gave me the idea of making a two-piece sculpture — not that the forms weren't separate, but that they knitted together. I did several little plaster maquettes, and eventually one nearest to what the shape of this big one is now pleased me the most and then I began making the big one."[105] In his notes to accompany John Hedgecoe's photographs of the *Locking Piece*, Moore stated in 1968 that, "The germ of the idea originated from a sawn fragment of bone with a socket and joint which was found in the garden."[106] Both the shape and the texture of the *Locking Piece* suggest that the latter explanation is the correct one. None of the several maquettes has survived or was cast in bronze.

Locking Piece is one of Moore's most ingenious sculptural inventions. Like intertwining limbs, the forms turn and twist and fit together with a deceptively simple inevitability. From one viewpoint, the left side of the upper component has the bulk and weight of a massive elephant's leg. From some points the space between the two sections emphasizes their separateness; from others the sculpture looks like a solid, three-dimensional jigsaw puzzle.

In 1968 Moore commented: "*Locking Piece* is certainly the largest and perhaps the most successful of my 'fitting-together' sculptures. In fact the two pieces interlock in such a

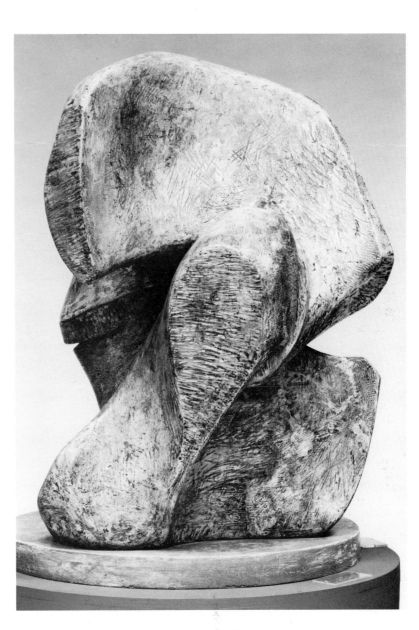

way that they can only be separated if the top piece is lifted and turned at the same time."[107]

In 1963–64 Moore made the 292.1-cm–high version of the *Locking Piece* (LH 515), which has been cast in a bronze edition of three. A fibreglass cast of this version was made in 1972 and belongs to the HMF.

As Alan Bowness pointed out in a lecture on Moore's late work (Art Gallery of Ontario, October 1974), "The fascination with locking forms is one general characteristic of the

late style."[108] He suggests that "what we are offered in the late works is a paradigm of the human relationship, with figures groping, touching, embracing, coupling, even merging with each other. At the centre of the *Oval* [see no. 182] are the points that reach out and almost meet; in the *Locking Piece* (LH 515) the forms are gripped in a tight embrace, like a copulating couple — an impression that the *Large Two Forms* (LH 556) also clearly suggests"[109] (see no. 175).

164 *Working Model for Reclining Figure: Lincoln Center* 1963–65 (LH 518)
Original plaster, L 364.7 cm
(Bronze edition of 2: Tate Gallery, London)
Gift of Henry Moore, 1974

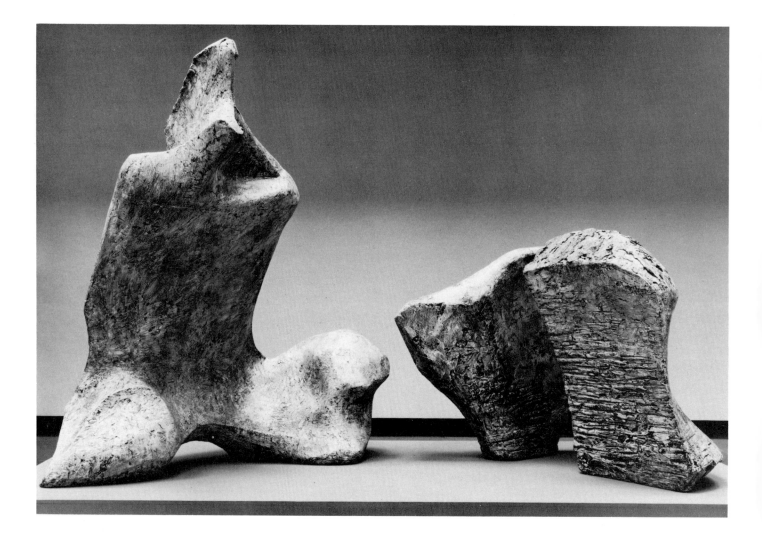

THE MAJOR THEME of landscape as a metaphor for the human body — one that Moore explored in the series of two- and three-piece reclining figures of 1959–63 — culminates in the two versions of the sculpture for the Lincoln Center for the Performing Arts in New York. Moore accepted the commission in 1962 and proceeded to make two large reclining figures for the project: *Two Piece Reclining Figure No. 5* of 1963–64 (LH 517) and no. 164. He chose the latter and enlarged it to an enormous size — 8.5 metres long and 5.5 metres high (fig. 110).

The sculpture was made to stand in a large pool of water at the Lincoln Center. In the notes on no. 146 Moore is quoted as saying that the leg end of *Two Piece Reclining Figure No. 2* reminded him of Monet's painting *Cliff at Etretat* and that he kept thinking of the arch as if it were coming out of the sea. "This is the figure which led to me agreeing to make the Lincoln Center sculpture which stands in water."[110] Although the preliminary study for no. 164 has not survived, Moore did work from a smaller version, for he writes that the small swimming pool in the garden at Hoglands was useful "for trying out the Lincoln Center preliminary model and for working out its reflections in water."[111] Moore was told that the depth of the pool at the Lincoln Center would be one

foot two inches (35.5 cm). In making the large version, he allowed for the base of the sculpture to be submerged to that depth. By comparing the

165 *Hand* 1964 (not in LH)
White porcelain, H 12.9 cm with base
Gift of Henry Moore, 1974

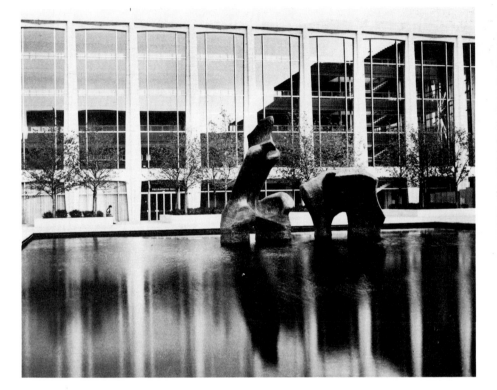

Fig. 110 *Reclining Figure* 1963–65
Lincoln Center for the Performing Arts,
New York City PHOTO: O.E. Nelson

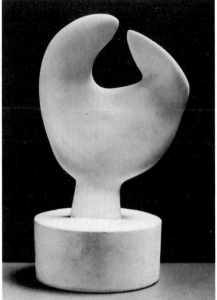

THIS WAS probably cast from a preliminary study for either the 1962 bronze *Maquette for Head and Hand* (LH 505, H 17 cm) or for the 1964 porcelain *Moon Head* (LH 522, H 30.5 cm). The latter was cast by Rosenthal in a porcelain edition of six. Moore told the author that no. 165 was one of the trial casts he had made by Rosenthal. He wanted to experiment with and compare black and white porcelain casts. The seventeen-centimetre–high version (LH 522), Moore has written, "was originally called *Head and Hand*, the hand being the piece at the back."[112] As no. 165 is the study for the back part of the sculpture, *Hand* seems an appropriate title (see no. 166). The author saw a number of porcelain casts of both head and hand sections in the artist's studio.

working model (no. 164) with the final version, one can see the additional height at the base of both sections. Unfortunately the pool has never had more than about fifteen centimetres of water, thus exposing the lower section of the sculpture that Moore had intended to be below the surface.

The shape and texture of the leg end and the thin knife-edges of the torso suggest that no. 164 was inspired by bone forms. Seen from the side, the thinness of the torso is reminiscent of the 1961 *Standing Figure: Knife Edge* (no. 153), a work we know was based directly on a bone fragment (fig. 108).

In the *Two Piece Reclining Figure No. 1* of 1959 (no. 145), the first sculpture in the present series, it is

the leg end that has the dramatic upward thrust, while the head and torso appear static and immobile, like a huge boulder. Here the reverse is true. The leg end, arched like the cliffs at Etretat, is the stable element. The powerful torso, seen from the side, surges upward and forward as if in an effort to reach out towards the rest of the figure.

Although Moore created a considerable body of work after the Lincoln Center commission, it seems evident that, in time, this great reclining figure will be seen to occupy a pinnacle in Moore's total *oeuvre* similar to Cézanne's late bather compositions and Rodin's *Balzac*. It is one of the first masterpieces of Moore's "late style."

166 *Moon Head* 1964 (LH 521)
Original plaster, H 47 cm
(Bronze edition of 9: Tate Gallery,
London)
Gift of Henry Moore, 1974

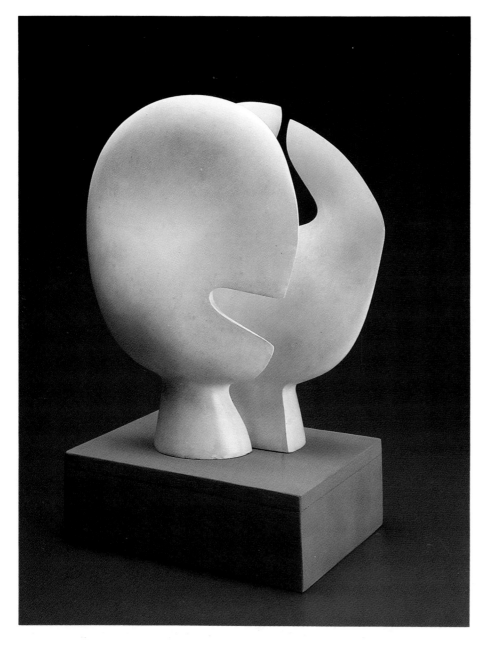

bles, and flint stones served as the point of departure for many of his works from the last twenty-five years of his life. *Moon Head* has been compared to the thin, delicate forms of Cycladic sculpture, but such affinities are merely fortuitous. *Moon Head* would appear to be the last Moore sculpture to have been directly inspired by tribal art. The hand-shaped form was, William Fagg told the author, based on a Nigerian Mama-mask of a buffalo (fig. 111), illustrated in Fagg's 1963 book *Nigerian Images* (p. 610). According to Fagg, the late Harry Fischer, Moore's friend and dealer, gave the sculptor a copy of this book soon after it was published. Moore has transformed the symmetrical Mama-mask into a semi-abstract hand. Moore never ceased to be receptive to the forms in art and nature.

Fig. 111 Mama (northern Nigeria)
Mask of a Buffalo
Nigerian Museum, Lagos

THIS IS the larger version based on *Maquette for Head and Hand* of 1962 (LH 505, see no. 165). "When I came to make it in full size," Moore wrote, "about eighteen inches high, I gave it a pale golden patina so that each piece reflected a strange, almost ghostly, light at the other. This happened quite by accident. It was because the whole effect reminded me so strongly of the light and shape of the full moon that I have since called it *Moon Head*."[113]

Few of Moore's sculptures from the 1960s and 1970s were inspired by Primitive art that had such a profound influence on his work of the 1920s and 1930s. Bones, shells, peb-

167 *Maquette for Atom Piece* 1964
(LH 524)
Original plaster, H 14.7 cm
(Bronze edition of 12)
Gift of Henry Moore, 1974

168 *Atom Piece (Working Model for Nuclear Energy)* 1964–65 (LH 525)
Original plaster, H 120.7 cm
(Bronze edition of 6: Tate Gallery, London)
Gift of Henry Moore, 1973

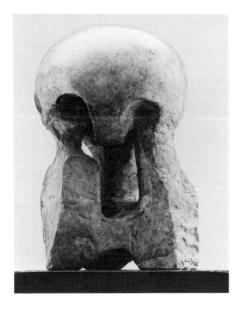

THIS IS the preliminary maquette
for *Atom Piece (Working Model for
Nuclear Energy)* of 1964–65 (LH 525).
See notes for no. 168.

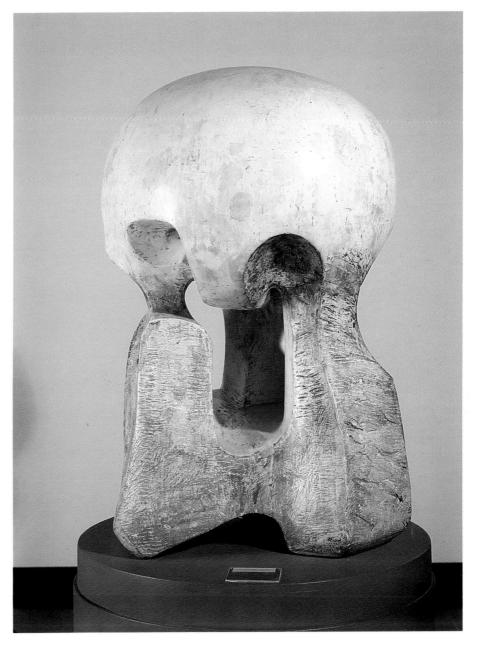

ON NOVEMBER 14, 1963, Professor William H. McNeil of the University of Chicago wrote to ask Moore if he would consider doing a commemorative sculpture to mark the twenty-fifth anniversary of the first controlled generation of nuclear power, achieved at the Chicago campus by Enrico Fermi and his colleagues. The sculpture would be, McNeil wrote, "a monument to man's triumphs, charged with high hope and profound fear just as every triumphant breakthrough has always been."[114] Moore replied in a letter of December 22, 1963: "It seems an enormous event in man's history, and a worthy memorial for it would be a great responsibility and not easy to do. However, it would be a great challenge...."[115]

Soon after this, a University of

Chicago Committee visited Moore at Much Hadham to discuss the proposal. It was during this visit that Moore remembered a maquette he had made that he thought might be a suitable image for the theme. He showed the committee what has since been called *Maquette for Atom Piece*, of which the original plaster is no. 167. He went ahead and made the working-model size, no. 168, which he showed to the committee on its second visit. Approval was given and Moore proceeded with the 3.6-metre–high version, known as *Nuclear Energy*, 1964–66 (LH 526),

shown here *in situ* at the University of Chicago (fig. 112).

It is important to remember that *Nuclear Energy* did not originate in Moore's mind as an interpretation of atomic power. The dome-like skull has obvious affinities to Moore's earlier helmet-head series but, seen in the context of the commission, it becomes an ominous reminder of a mushroom cloud from an atmospheric atomic explosion.

In December 1967 Moore went to Chicago for the installation and unveiling of *Nuclear Energy*. The University of Chicago periodical

Fig. 113 Wooden armature for *Atom Piece (Working Model for Nuclear Energy)*

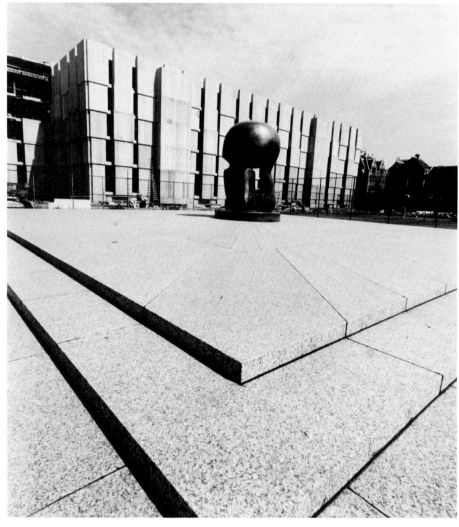

Fig. 112 *Nuclear Energy* 1964–66 University of Chicago

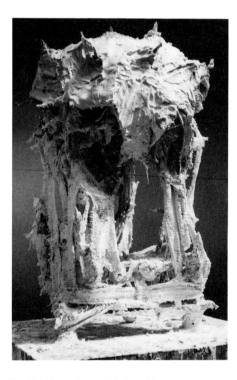

Fig. 114 *Atom Piece (Working Model for Nuclear Energy)* in progress

Chicago Today reported the event as follows:

On December 2, 1942, Enrico Fermi and his colleagues achieved the first self-sustaining nuclear chain reaction in a laboratory under the West stands of Stagg field. The moment, the minute of the advent of the nuclear age, was 3:36 pm.

Twenty-five years later, the time was again 3:36 pm. Many of Fermi's former colleagues and other distinguished scientists from all over the world waited.... Dominating that scene, a huge tarpaulin, encasing a 12-foot high monument, pulsed and buckled noisily in the wind.... At 3:36 pm, Laura Fermi, widow of the Nobel laureate, and Henry Moore, the sculptor, pulled the tarpaulin free, unveiling Moore's massive bronze *Nuclear Energy*.... It gave Chicago a memorial of one of the world's great events and left a monument to the new age.[116]

Fig. 115 Henry Moore with completed original plaster *Atom Piece (Working Model for Nuclear Energy)*

(Note whiteness of the plaster, before casting)
PHOTO: Charles Gimpel

169 *Working Model for Sundial* 1965 (LH 527)
Bronze, edition of 20, H 54 cm with base
Gift of Henry Moore, 1974

170 *Maquette for Three Way Piece No. 1* 1964 (LH 531)
Bronze, edition of 7 (cast 1974), H 7.1 cm
Inscr. lower edge *Moore 5 / 7*
Purchase from the artist, 1985

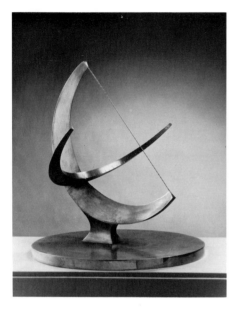

THIS IS the study for the 3.6-metre–high *Sundial* of 1965–66 (LH 528) commissioned by *The Times*, for New Printing House Square, London. This large bronze was sold by *The Times* to IBM in Brussels.

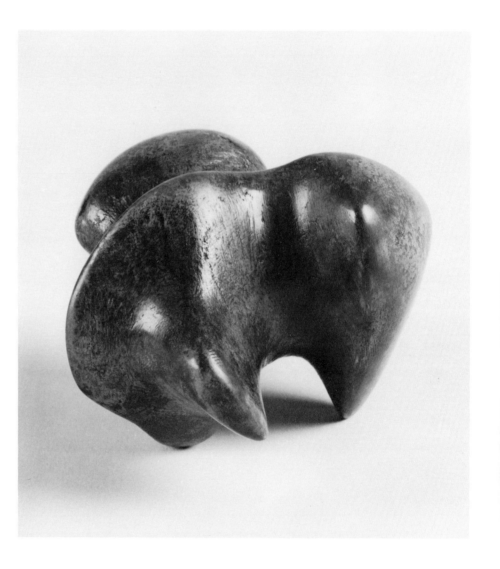

MOORE MADE two larger versions of this work, based on this maquette: *Working Model for Three Way Piece No. 1: Points* of 1964 (LH 532; fig. 116) and the large *Three Way Piece No. 1: Points* of 1964–65 (LH 533; fig. 117). *Three Way Piece No. 1* is closely related to *The Archer* of 1964–65 (fig. 118). In both works Moore was attempting to create a new kind of sculpture that was less dependent on gravity and that could be placed in at least three positions (see figs. 120, 121). Both sculptures are reminiscent of the fully three-dimensional biomorphic bronzes of Arp, although they were undoubtedly directly inspired by flint stones (see fig. 119). Unfortunately the original plaster *Working Model for Three Way Piece No. 1: Points* (fig. 116) was accidentally knocked off its pedestal in the large Moore gallery in December 1974 and damaged beyond repair. No. 170 was recently acquired so that this work, so intimately related to *The Archer*, would be represented in the collection.

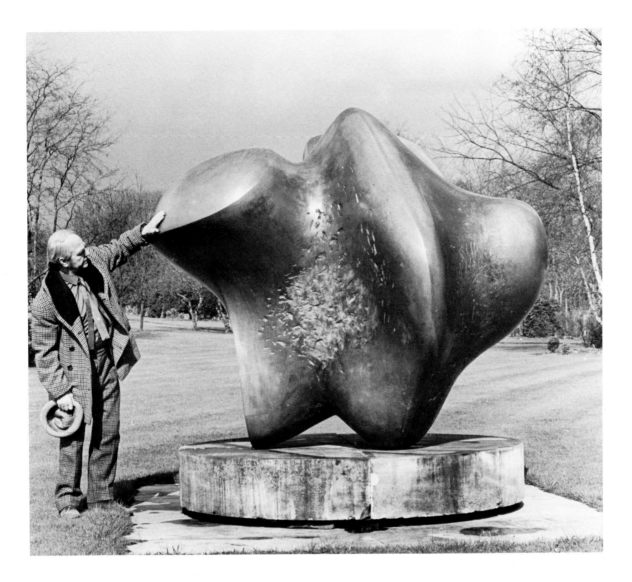

Fig. 117 *Three Way Piece No. 1: Points* 1964–65
Private collection
PHOTO: Budd

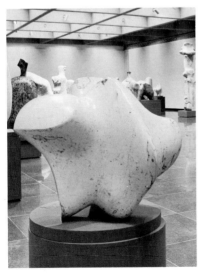

Fig. 116 *Working Model for Three Way Piece
No. 1: Points* 1964 (before damage)
Art Gallery of Ontario

170a *Working Model for Three Way Piece No. 2:*
Archer 1964 (LH 534)
Original plaster, H 79 cm
(Bronze edition of 7: Tate Gallery, London; The Hirsh-
horn Museum and Sculpture Garden, Washington, DC)
Gift of Henry Moore, 1973

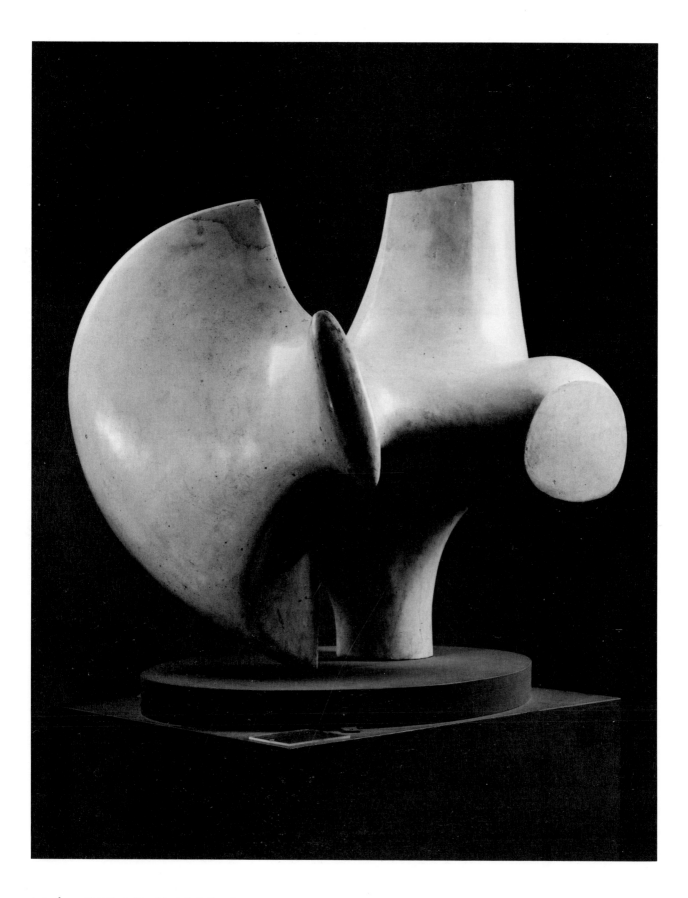

NO SINGLE WORK of twentieth-century sculpture has had such extraordinary and far-reaching consequences for a museum and for the cultural life of a city as *The Archer* has had for the Art Gallery of Ontario and for Toronto.[117] This was the sculpture that Moore and Viljo Revell, the architect of the new city hall, chose for the outdoor setting in Nathan Phillips Square (fig. 118). For a detailed account of the controversy surrounding the acquisition of *The Archer* in 1966 and the subsequent events leading to the opening in October 1974 of the Henry Moore Sculpture Centre, see Chapter One of the text.

The Archer is very closely related to a work of the same period, and of a similar title, *Three Way Piece No. 1: Points* of 1964–65 (LH 533; fig. 117). Like *The Archer*, this large version was preceded by a maquette (LH 531, no. 170) and a working model (LH 532). Both *Three Way Piece No. 1: Points* and *The Archer* attest to Moore's interest in full, three-dimensional realization in sculpture. The former work, David Sylvester has written, "was inspired by a stone fragment with three points touching the ground."[118] In the author's opinion this was almost certainly a flint stone of the sort that abound in the Hertfordshire fields around Much Hadham. Fig. 119 shows four such flint stones, of which the one second from the right has three projections touching the ground. Moore has written that *Three Way Piece No. 1: Points* "was an attempt to show one work from below as well as from on top and from the side. My idea was to make a new kind of sculpture, less dependent on gravity, which could be seen in at least three positions and be effective in all of them; a sculpture which you could understand more completely because you knew it better."[119] The small maquette, in fact,

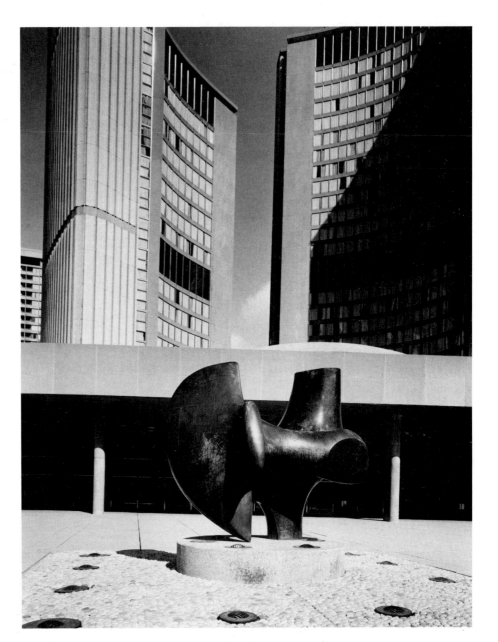

Fig. 118 *The Archer* 1964–65
City Hall, Nathan Phillips Square, Toronto

may be placed in at least seven positions, but the two larger versions are obviously too heavy to be easily turned.

Fig. 120 shows Moore in his studio at work on the *Maquette for Three Way Piece No. 2: Archer*. This was never cast and has therefore not been catalogued with the working model

(LH 534) and large version (LH 535). In selecting original plaster maquettes for this collection, the author found in Moore's studio a fragment of this maquette for *The Archer*. Only the top half could be located. The maquette had been broken across the centre, the lower section was missing, and Moore was reluctant to part

Fig. 119 Flint stones in Moore's studio

with the incomplete maquette.

Like that of its immediate predecessor *Three Way Piece No. 1: Points*, the full title of no. 170a, *Working Model for Three Way Piece No. 2: Archer*, suggests that Moore intended this work also to be seen in different positions. Evidence of this is to be found in two of Errol Jackson's photographs of Moore at work in his studio. In fig. 120 the sculptor supports the maquette with his hand in the position chosen for the two large versions, no. 170a and LH 535. In fig. 121 the maquette rests on its end, with the curved bow at the top.

Ear Piece of 1962 (no. 161) was one of the first sculptures of the decade in which Moore was occupied with solid form and smooth, rounded surfaces — the antithesis of the rugged textures and separate forms found in the two- and three-piece reclining figures of the late 1950s and early 1960s. In *The Archer* and its pendant *Three Way Piece No. 1: Points* Moore continued this concern with abstract sculptural form, rich in three-dimensional variety. The two preliminary maquettes for these works hold the same fascination as certain pebbles one finds on a beach, or flint stones (extraordinarily varied in shape), that almost certainly inspired these works. The title of no. 170a, as so often happens, was assigned after the work was completed. One end of the sculpture is taut like a tightly strung bow. One may read the bridge between the two ends of the work as an arm, straining forward against the pressure of the bow. In a shape inspired by a natural form, Moore has seen something of the controlled tension and pent-up energy of an archer about to release his charge.

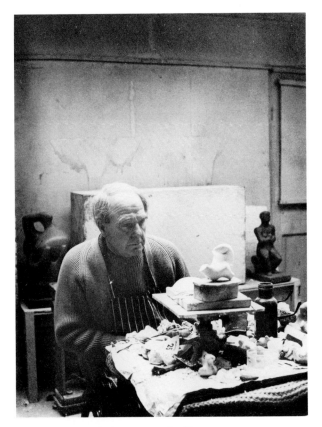

Fig. 121 Moore with the maquette for *The Archer*, 1964 PHOTO: Errol Jackson

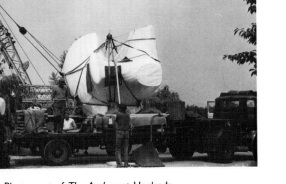

Fig. 122 Plaster cast of *The Archer*, at Hoglands. Installed on a revolving stage of the Globe Theatre, London, mid-June 1965, for an evening of theatrical homage to T.S. Eliot

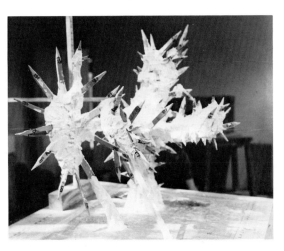

Fig. 123 *Working Model for Three Way Piece No. 2: Archer*, in progress

Fig. 124 *Working Model for Three Way Piece No. 2: Archer*, in progress

Fig. 125 *Working Model for Three Way Piece No. 2: Archer*, in progress

171 *Two Piece Sculpture No. 7: Pipe* 1966 (LH 543)
Original plaster, L 83.5 cm
(Bronze edition of 9: Tate Gallery, London; Whitworth
Art Gallery, University of Manchester)
Gift of Henry Moore, 1974

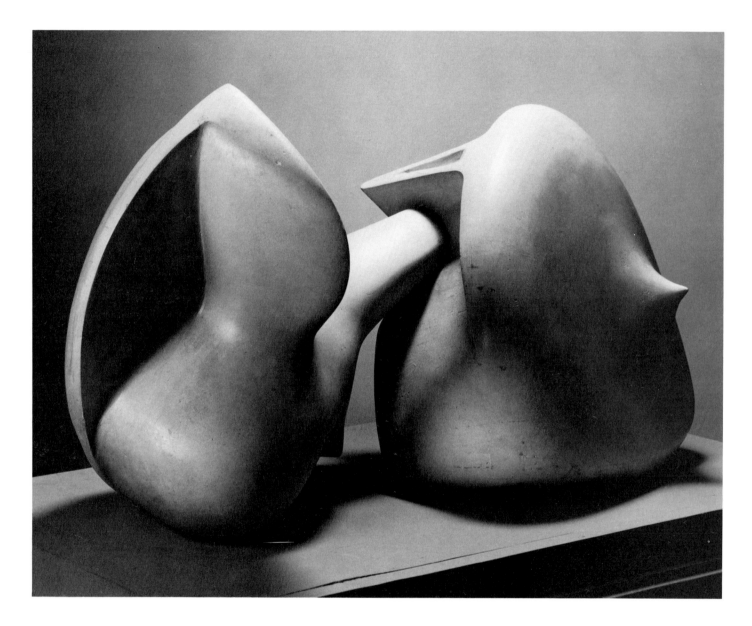

"I CALL this sculpture *Two-Piece: Pipe,*" Moore wrote. "It is an attempt to make a sculpture which is varied in all its views and forms. One piece is very different from the other, and by combining the two I obtain many permutations and combinations. By adding two pieces together the differences are not simply doubled. As in mathematics, they are geometrically multiplied, producing an infinite variety of viewpoints."[120]

One finds in a number of Moore's sculptures of the last twenty years an overt sexuality rarely encountered in his earlier work. In the notes on the *Working Model for Locking Piece* (no. 163), mention was made of the way in which figures and animal forms touch, merge, embrace, and couple. In no. 171, the projection in the form at right suggests a nipple. Alan Bowness has written, "Here the penetration of one form into another seems to refer obliquely to the sexual relationship, and the pipe is an obvious phallic form."[121]

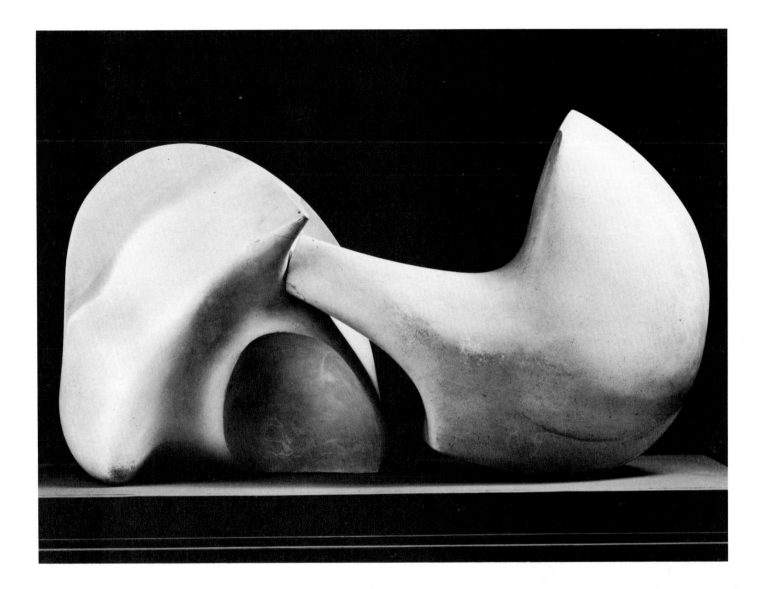

172 *Two Piece Reclining Figure:*
Maquette No. 8 1966 (LH 547)
Original plaster, L 24.1 cm
(Bronze edition of 6)
Gift of Henry Moore, 1974

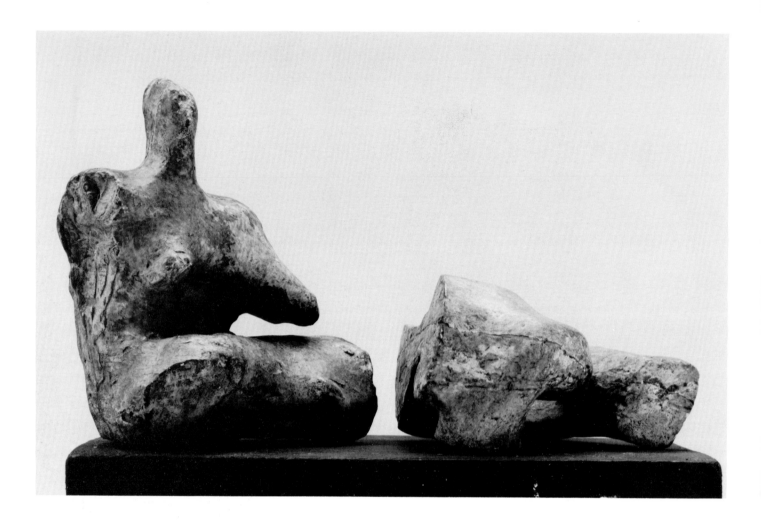

THIS APPEARS to be the last
maquette in the series of two- and
three-piece reclining figures that
began with the 1959 *Maquette for*
Two Piece Reclining Figure No. 1
(LH 457a).

173 *Girl Torso* 1966 (LH 553)
Bronze, edition of 9, H 21.5 cm with base
Inscr. on base *Moore 8 / 9*
Purchase from the artist, 1978

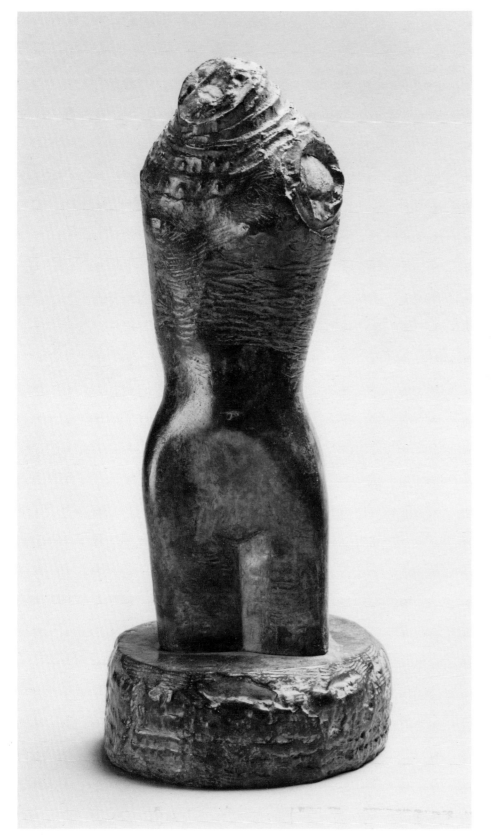

THIS FIGURE is somewhat reminiscent of the modelled clay *Torso* of 1925–26 (LH 29; fig. 126). The texture of the chest, with small rows of three-dimensional dots, is very close to that of a small piece of wood (possibly a root), which the author saw in Moore's studio, suggesting that *Torso* evolved from this natural form.

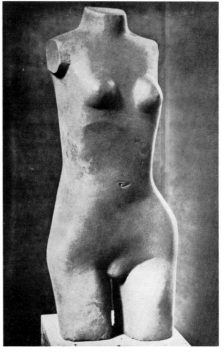

Fig. 126 *Torso* 1925–26
Destroyed

174 *Maquette for Two Forms* 1966
(LH 554a)
Bronze, edition of 9 (cast 1976),
L 16.5 cm with base
Inscr. on side of base *Moore 4 / 9*
Purchase from the artist, 1978

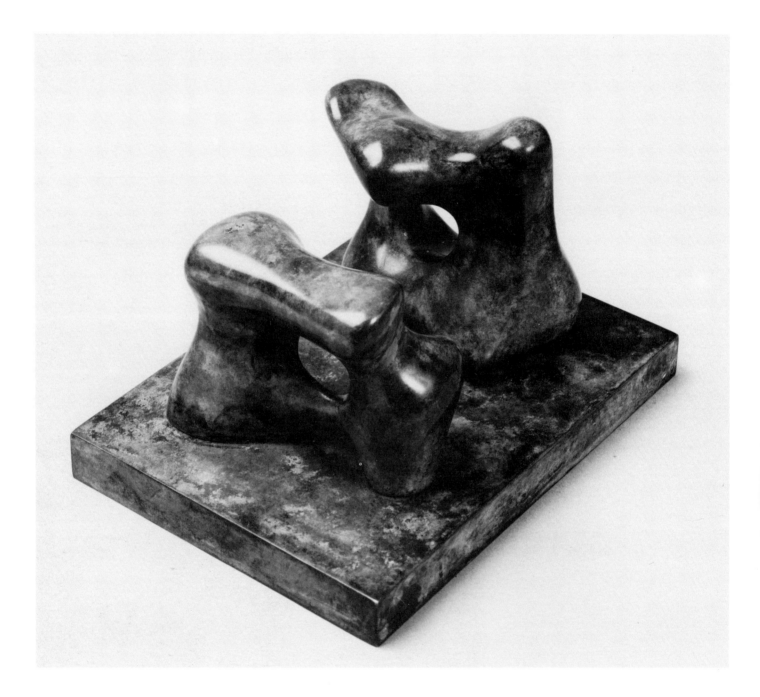

THIS IS the smallest of four versions of this sculpture. In the larger of the two forms, the horizontal projection at the top is closer to the similar pelvic shape in the earlier 1964 marble *Two Forms* (LH 529; fig. 127) than to the corresponding form in fig. 128 and no. 175. In 1966 Moore carved the red travertine marble *Two Forms* (LH 555; fig. 128), which was no doubt based on no. 174. The bronze *Large Two Forms* (LH 556, no. 175) is dated 1966 and 1969; that is to say the initial conception dates from 1966 when the maquette and the marble carving were made, although the large version was not executed until 1969. See notes for no. 175.

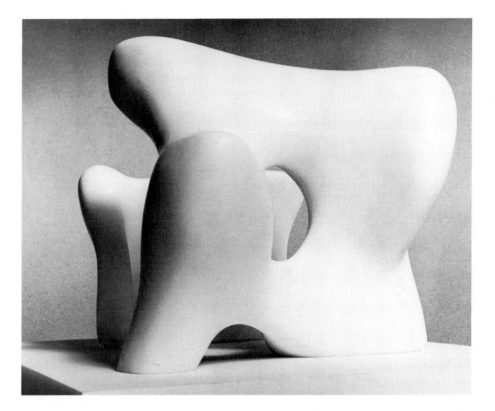

Fig. 127 *Two Forms* 1964
Private collection PHOTO: Errol Jackson

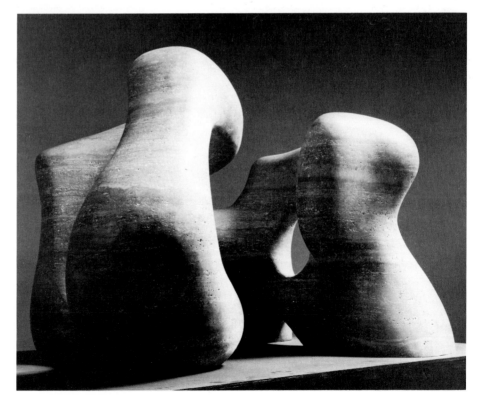

Fig. 128 *Two Forms* 1966
Private collection

175 *Large Two Forms* 1966 and 1969 (LH 556)
Bronze, edition of 4, L 610 cm
(1 fibreglass cast, Henry Moore Foundation)
(Other bronze casts: Neuberger Museum, Purchase, New York; Chancellery, Bonn)
Purchase from the artist, 1973

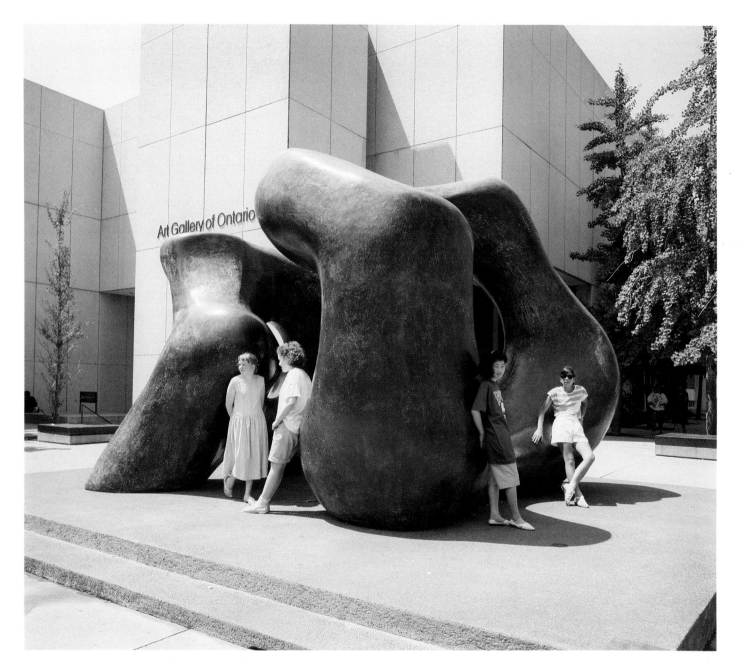

IN DECEMBER 1969, when Moore and his assistants were working on the polystyrene of the *Large Two Forms* (fig. 129), this sculpture was chosen as the major work the Art Gallery of Ontario would acquire from the artist at casting cost and eventually place outside the Moore Centre. Not only was no. 175 one of Moore's largest sculptures to that date, it was also one of the first works in which, instead of using plaster and an armature, Moore used large rectangular blocks of polystyrene. In working on such an enormous scale, polystyrene has a number of obvious advantages over plaster. To begin with, it is extremely light and easy to handle. Instead of having to construct a wooden armature, cover it with scrim and add heavy plaster, the sculptor can roughly shape each section or layer of polystyrene and then pin the sections together (see fig. 129). The material is easy to cut with a hot wire or a saw. Once the approximate shape is roughed out, a layer of plaster may be added directly to the surface of the polystyrene and then worked on to achieve whatever varied textures are required. Unlike plaster, polystyrene does not lend itself to the creation

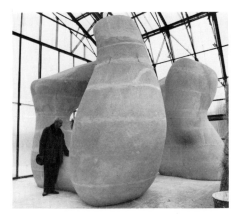

Fig. 129 Henry Moore with *Large Two Forms*
(polystyrene) Hoglands, 1969
PHOTO: Aschieri, Torino

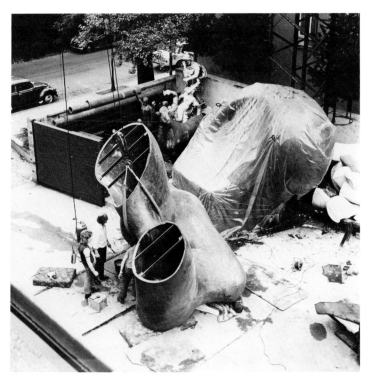

Fig. 130 *Large Two Forms*, bronze
H. Noack Foundry, West Berlin

of either very smooth or very rough
textures. Once the work has been
completed the polystyrene sculpture
is easily cut into sections to be sent to
the foundry for casting. *Large Two
Forms* was sent to West Berlin and
cast at the Noack Foundry.

Large Two Forms follows much
more closely the marble version of
1966 (fig. 128) than the maquette, no.
174. In the latter, the two pelvis-
shaped torsos are proportionately far-
ther apart, and therefore lose the
feeling, found in the two larger ver-
sions, of both protection and
embrace. Also in the maquette, the
central projection in the higher of
the two forms is more pointed, less
rounded than in the marble carving
and in no. 175.

The subject of two forms in close
relationship (but not touching) was
not a new one for Moore. The beau-
tiful pynkado wood *Two Forms* of
1934 (LH 153; fig. 25), in the Museum
of Modern Art, New York, is a dis-
tant relative of no. 175. In the much
earlier work, the larger form arches
forward and over the smaller, more
vulnerable shape in what Moore has
described as a mother-and-child
relationship.

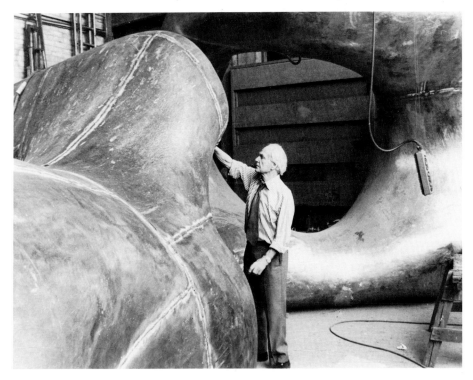

Fig. 131 Henry Moore with *Large Two Forms*,
H. Noack Foundry, West Berlin
PHOTO: Reinhard Friedrich

176 *Maquette for Double Oval* 1966
(LH 559)
Original plaster, L 24 cm
(Bronze edition of 9)
Gift of Henry Moore, 1974

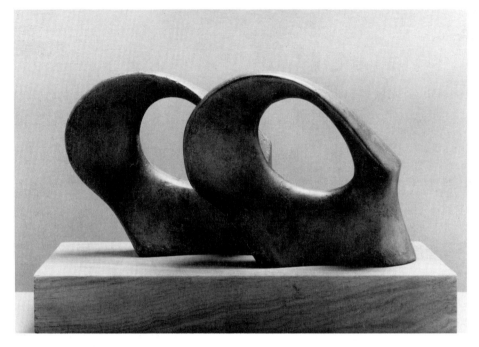

Fig. 132 Flint stones in Moore's studio

The forms of no. 175 may well have been inspired by a flint stone. Whereas most flints are solid — like those on which *The Archer* and *Three Way Piece No. 1: Points* were probably based (fig. 119) — some have holes through them (fig. 132), a feature more commonly to be found in sea-worn pebbles.

"Sculpture," Moore has written, "should always at first sight have some obscurities, and further meanings. People should want to go on looking and thinking; it should never tell all about itself immediately."[122] Much of the fascination of Moore's late works, sculptures such as *Large Two Forms* and *Sheep Piece* of 1971–72 (LH 627; fig. 133), stems from their obscurities and suggested meanings. Unlike Rodin's *Kiss*, for example, there is nothing blatant in the powerful sexuality in these two erotic masterpieces. *Sheep Piece* suggests both a sheep and lamb and a ram mounting a ewe. In *Large Two Forms* the sexuality is human — as John Russell has written, "a mating-dance momentarily arrested."[123]

TWO LARGER VERSIONS were based on this maquette: the rosa aurora *Double Oval* of 1966 (LH 559), and the 5.5-metre–long bronze *Double Oval* of the same year (LH 560). Among Moore's last large original plasters were those for LH 560 and for *Two Piece Reclining Figure No. 9* of 1968 (LH 576, no. 179).

Moore has written of the very large version: "*Double Oval* is of such a physical size that it evokes architecture as well as sculpture in its construction. The two ovals look the same but they are not. Instead they are echoes of each other."[124]

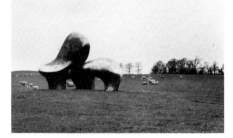

Fig. 133 *Sheep Piece* 1971–72, in field at Hoglands

177 *Study for Head of Maquette for Girl: Half Figure* 1967 (not in LH)
Original plaster, L 5.1 cm
Gift of Henry Moore, 1974

178 *Maquette for Two Piece Reclining Figure No. 9* 1967 (not in LH)
Bronze, edition of 9 (cast 1977),
L 19.8 cm; L 23.1 cm with base
Inscr. on side of base *Moore 9 / 9*
Purchase from the artist, 1978

◄

THIS FRAGMENT, which has not been cast in bronze, is a preparatory study for the head of *Maquette for Girl: Half Figure* of 1967 (fig. 134), a work in the HMF that has not been cast in bronze. The latter is the study for the marble *Girl: Half Figure*, also of 1967 (LH 572).

Fig. 134 *Maquette for Girl: Half Figure* 1967
Henry Moore Foundation

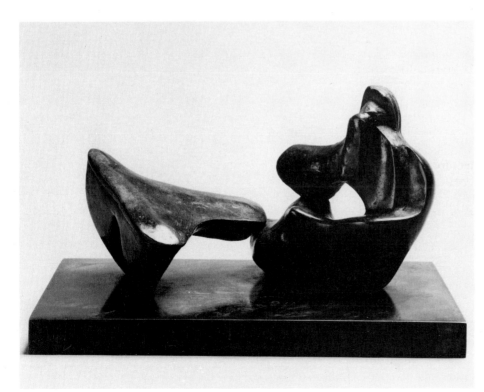

◄

THIS IS the study for the larger *Two Piece Reclining Figure No. 9* of 1968 (LH 576, no. 179). See notes for no. 179.

178

179 *Two Piece Reclining Figure No. 9* 1968 (LH 576)
Original plaster, L 238.8 cm
(Bronze edition of 7: Tate Gallery, London; City of
Canberra; Norton Simon Museum of Art, Inc.; North-
park National Bank, Dallas)
Gift of Henry Moore, 1974

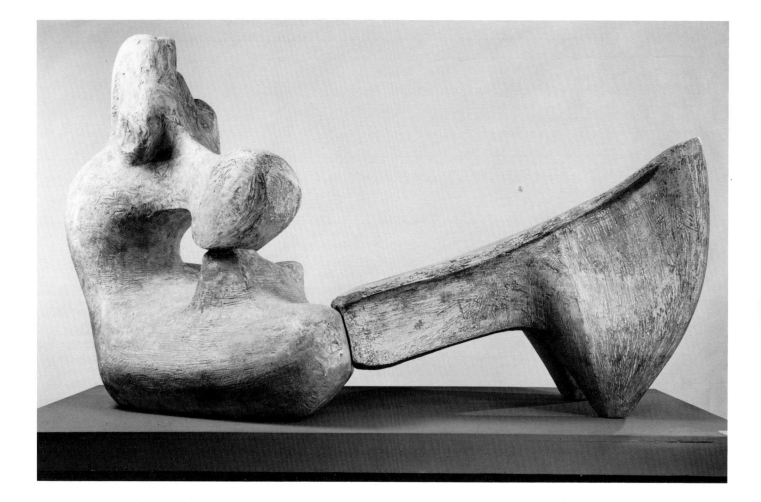

THE LANDSCAPE METAPHOR and
rough textures that characterize most
of the bronzes in the series of two-
and three-piece reclining figures of
1959–65 are here less in evidence.
No. 179 is closer to the smooth, func-
tional forms found in *Three Piece
Reclining Figure No. 2: Bridge Prop*
of 1963 (no. 162). The strut-like part
of the leg end (reminiscent of *Two
Piece Sculpture No. 7: Pipe* of 1966,

no. 171) rests against the other com-
ponent of the sculpture like a beam
that has been lowered into place,
much as the central component in
the bridge-prop reclining figure (no.
162) touches and locks into the
shoulder of the head end. Interlock-
ing forms were further developed
in the three versions of the vertebrae
sculpture LH 578–80 (see no. 180),
and LH 581–84.

180 *Working Model for Three Piece No. 3: Vertebrae* 1968 (LH 579)
Bronze, edition of 8, L 220.4 cm; 236.2 cm with base
Inscr. on base *Moore 6 / 8*; on side of base *H. NOACK BERLIN*
(Other casts: Tate Gallery, London; Memorial Art Gal-
lery, Rochester, N.Y.)
Gift of Henry Moore, 1971

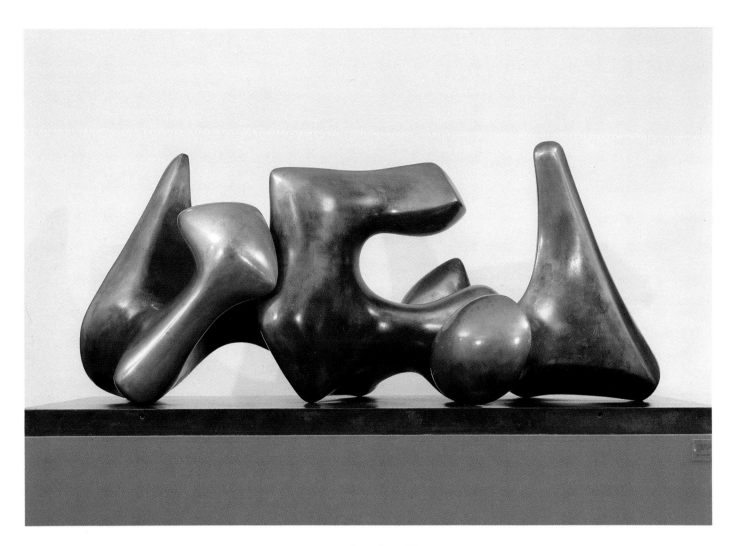

THIS MAGNIFICENT bronze cast was Henry Moore's first gift to the Art Gallery of Ontario.

It was based on the small *Maquette for Three Piece No. 3: Vertebrae* also of 1968 (LH 578). The enormous 7.45-metre–long version was made in 1968–69, in an edition of three (LH 580). One cast is at the First National Bank of America in Seattle; another at the Israel Museum, Jerusalem. Sculptures as different as *Three Motives against Wall No. 2* (no. 133), *Mother and Child: Arch* (no. 142), *The Archer* (no. 170a), and *Large Two Forms* (no. 175) were based on flint stones, a fact that attests to the extraordinary three-dimensional richness of these natural forms. The maquette (LH 578) may have been based on the stone second from left in fig. 119. Although the three interlocking forms create a horizontal sculpture, the words "reclining figure" do not appear in the title. As Alan Bowness has remarked, "In other words, the reclining-figure component is less important than the way in which the three forms lock together like the bones of the spinal column."[125]

181 *Maquette for Oval with Points* 1968 (LH 594)
Original plaster, H 14 cm
(Bronze edition of 9)
Gift of Henry Moore, 1974

182 *Working Model for Oval with Points* 1968–69 (LH 595)
Original plaster, H 110 cm
(Bronze edition of 12: Ulster Museum, Belfast)
Gift of Henry Moore, 1974

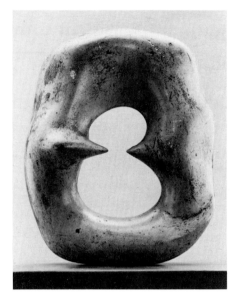

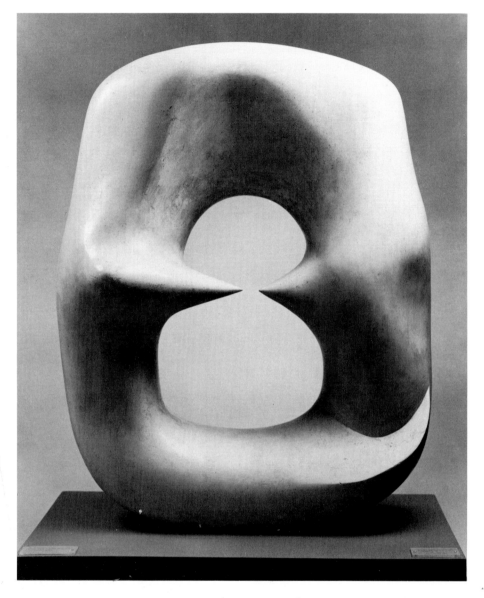

IN MID-1960, with sculptures such as *The Archer* (see no. 170a) and *Atom Piece* (see no. 168) Moore began making three versions or sizes of some of his most important works: first a small hand-size maquette, followed by a working model, and finally the very large version. In the collection are both the maquette and the working model for *Oval with Points* (see no. 182).

THE FIRST EVIDENCE of Moore's interest in pointed forms appears in a sketch of c. 1938, *Drawing for Sculpture with Points* (HMF), which is inscribed "Do drawings of two forms practically touching," and "points practically touching." This was followed by two superb drawings of 1939, *Seated Figure and Pointed Forms* (private collection), and *Pointed Forms* (incorrectly dated 1940) in the Albertina, Vienna (fig. 136). The first sculpture on this theme was *Three Points* of 1939–40 (LH 211; fig. 137), which was based on the study in the top row, second from the left, in the Albertina drawing. David Sylvester has suggested that Moore's source of inspiration for this sculpture "was the School of Fontainebleau double portrait of Gabrielle d'Estrée and her sister in the bathtub. The fastidious pinching of Gabrielle's nipple between her sister's pointed forefinger and thumb gave Moore the idea of making a sculpture in which three points would converge so that they were

only just not touching."[126] Moore no doubt mentioned the Fontainebleau portrait to Sylvester, but to this author he said that it was a mistake to try to track down a single source for *Three Points*. The ideas in the pointed-form drawings, he said, were based on the memory of many things, such as, for example, sparking plugs.

It was nearly thirty years before Moore returned to the pointed form motive in the three versions of the *Oval with Points*. The idea may well have been suggested by a small stone in Moore's studio showing two points touching at the centre of a hollowed-out oval form; yet no. 182 is strikingly reminiscent of the form at bottom, just right of centre, in the Albertina drawing. Herbert Read's comment about the 1939–40 *Three Points* is equally valid for *Oval with Points* — Moore has endowed "an abstract form with an almost vicious animation."[127] See also *Two Piece Points: Skull* of 1969 (LH 600, no. 184) and *Two Piece Reclining Figure: Points* of 1969–70 (LH 604 and 605, nos. 185 and 186).

Fig. 136 *Pointed Forms* 1939
The Albertina, Vienna

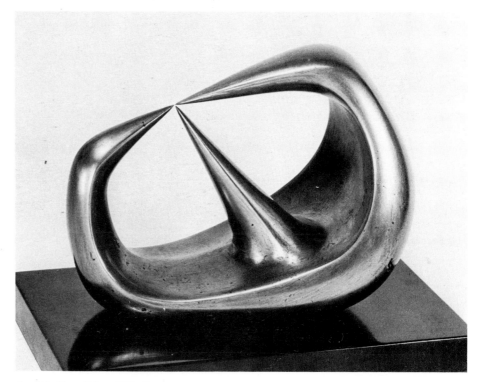

Fig. 137 *Three Points* 1939–40
Private collection

Fig. 135 Moore at work on the original plaster
Working Model for Oval with Points, 1968–69

183 *Maquette for Square Form with Cut* 1969 (LH 597)
Original plaster, H 19.7 cm with base
(Bronze edition of 9)
Gift of Henry Moore, 1974

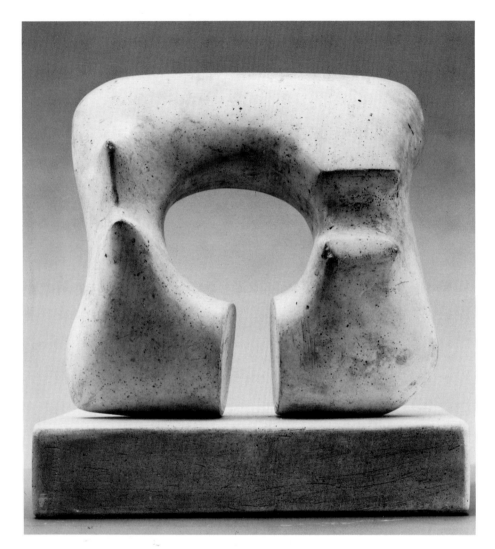

LIKE THE *Oval with Points* (nos. 181 and 182), there are three sizes of this sculpture, each in a different material: the maquette in bronze (LH 597), the black marble *Square Form with Cut* (LH 598); and the 1969–71 rio serra marble *Large Square Form with Cut* (LH 599; fig. 138) belonging to the City of Prato, Italy. This maquette was based on a flint stone in Moore's studio.

In one of his finest prewar pictorial drawings, *Sculptural Object in Land-scape* of 1939 (University of East Anglia: Robert and Lisa Sainsbury Collection), Moore could imagine and dream about creating sculpture on the enormous scale of this bone-like form. Only towards the end of his career could he afford to work and have cast or carved sculptures on the scale of the *Large Two Forms* (no. 175) or the *Large Square Form with Cut* (fig. 138). The latter work, like a gigantic enlarged keyhole, allows the viewer to walk through the cut at the bottom and experience the sculpture from within. *Large Two Forms* invites movement around the entire work between the two forms and through both holes. Moo-re's large sculptures from the mid-1960s onwards not only dominate their environments with their human presence, but involve the viewer in an active, physical way that is only possible with works of their enormous size.

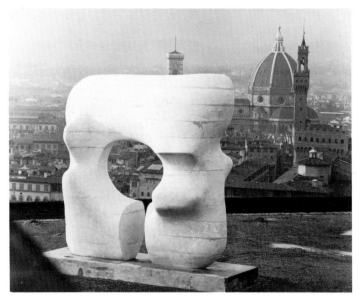

Fig. 138 *Large Square Form with Cut* 1969–71
Prato, Italy
Seen here, Henry Moore exhibition, Florence, 1972 PHOTO: Errol Jackson

184 *Two Piece Points: Skull* 1969 (LH 600)
Fibreglass, edition of 4, H 80.4 cm with base
Gift of Henry Moore, 1974

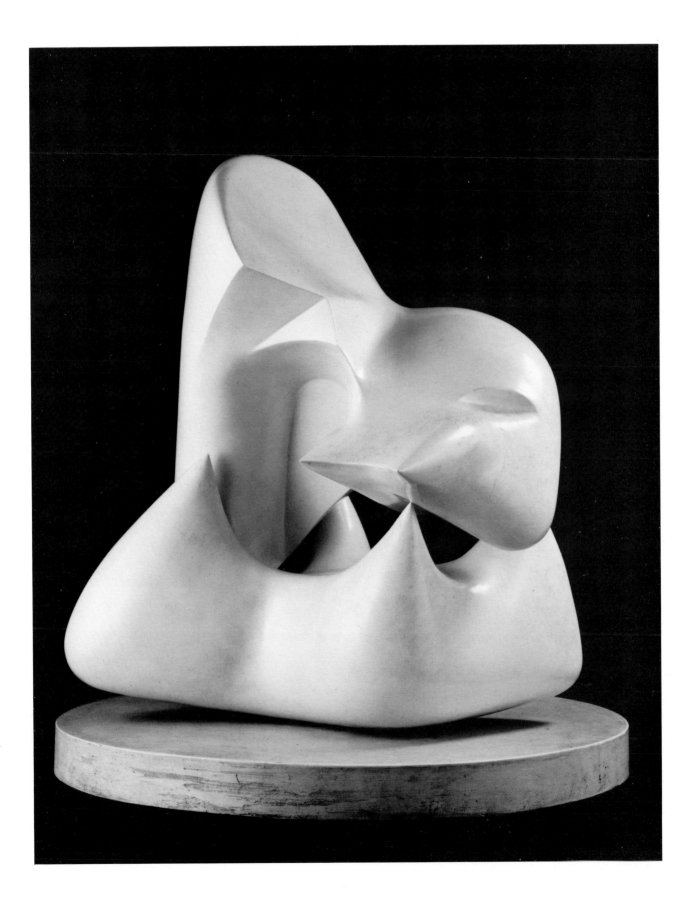

THIS TWO-PIECE SCULPTURE was inspired by the elephant skull (fig. 139) that Moore's friend Sir Julian Huxley gave him in the mid-1960s, and that also inspired the elephant-skull etchings of 1969–70 (CGM 109–46). No. 184 was in fact based on the small maquette that appears in the 1970 etching *Elephant Skull: Plate E* (CGM 146). The plaster maquette for no. 184, in the HMF, has not been cast in bronze.

One aspect of the skull that interested Moore was the way in which, like his own *Locking Piece* (no. 163), the upper part fits or locks into the lower section. When he came to have the two sections of no. 184 cast in bronze, he realized that the four sharp points of the lower section would probably snap off under the weight of the upper section, so he had each section cast as a separate sculpture. The lower component, fixed to a bronze base in an upright position, is called *Pointed Torso* (LH 601; fig. 140). The upper component, which now rests on a base with the sharp edges at the top is called *Architectural Project* (LH 602; fig. 141). In both LH 601 and 602 the pointed forms relate to two earlier works — the *Spindle Piece* of 1968 (LH 593) and *Oval with Points* of 1968–70 (LH 594–96, nos. 181 and 182).

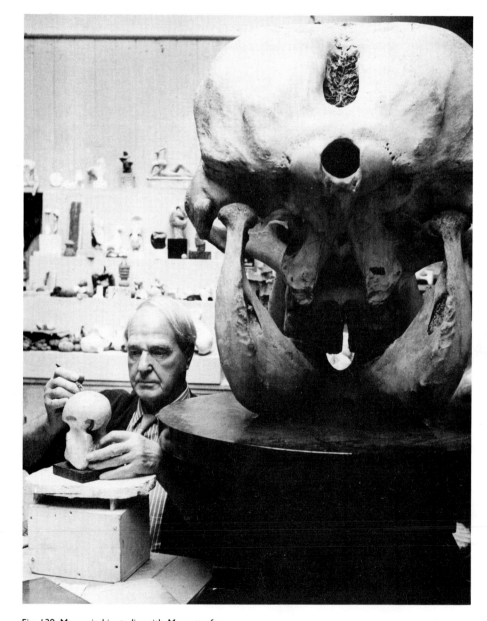

Fig. 139 Moore in his studio with *Maquette for Atom Piece* (no. 167) and elephant skull
PHOTO: Errol Jackson

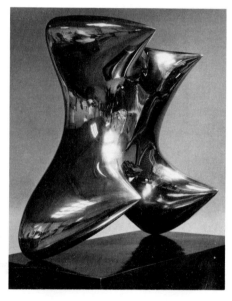

Fig. 140 *Pointed Torso* 1969
Private collection

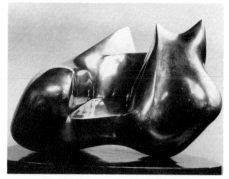

Fig. 141 *Architectural Project* 1969
Private collection

185 *Maquette for Two Piece Reclining Figure: Points* 1969 (LH 604)
Plaster, L 14 cm
(Bronze edition of 9)
Gift of Henry Moore, 1974

186 *Working Model for Two Piece Reclining Figure: Points* 1969–70 (LH 605)
Original plaster, L 122 cm
(Bronze edition of 10: Museo de Arte Moderna, São Paulo)
Gift of Henry Moore, 1974

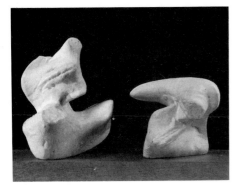

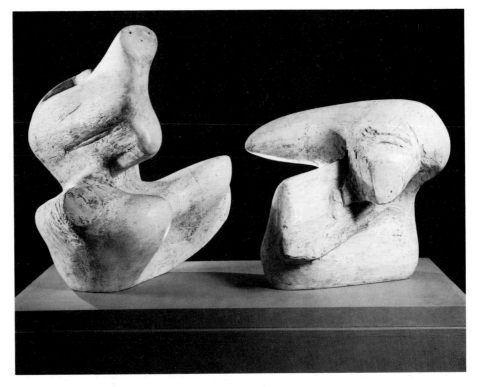

NO. 185 is the preliminary study for *Working Model for Two Piece Reclining Figure: Points* of 1969–70 (LH 605, no. 186). Almost all the original plasters in this collection were the actual sculptures sent to the foundry to be cast in bronze, and their varying patinas were the result of shellacs applied to them in making the moulds. In some instances Moore would paint the maquettes to get some idea of how they would look in bronze (see for example no. 150). This little maquette (no. 185), which was neither painted nor shellacked, possesses, as Moore has described his white plasters, "a ghost-like unreality in contrast to the solid strength of the bronze."[128] Its condition would suggest that this is one of several versions of the maquette, possibly a plaster cast done at the foundry, and that in fact the bronze edition was cast on another plaster. The etching *Two Piece Reclining Figure: Points* of 1969 (CGM 108) was based on either no. 185 or another plaster of it, or on the bronze maquette.

THERE ARE three versions of this sculpture: no. 185, this working-model size, and the large, 3.6-metre-long *Two Piece Reclining Figure: Points* of 1969–70 (LH 606).

A thematic development related to the interlocking sculptures of the middle and late 1960s, such as *Locking Piece* (no. 163) and *Three Piece No. 3: Vertebrae* (no. 180) is that of pointed forms, found in *Two Piece Points: Skull* of 1969 (no. 184), and of pointed forms practically touching, in both *Working Model for Oval with Points* (no. 182) and the present work. Whereas in *Working Model for Oval with Points* the two points create a heightened tension in themselves on an abstract level, here the use of pointed forms in a figurative sculpture makes the viewer aware of the tension between two parts of the human anatomy, where the torso and leg sections almost meet.

187 *Maquette for Reclining Figure:*
Arch Leg 1969 (LH 609)
Original plaster, L 18.5 cm
(Bronze edition of 9)
Gift of Henry Moore, 1974

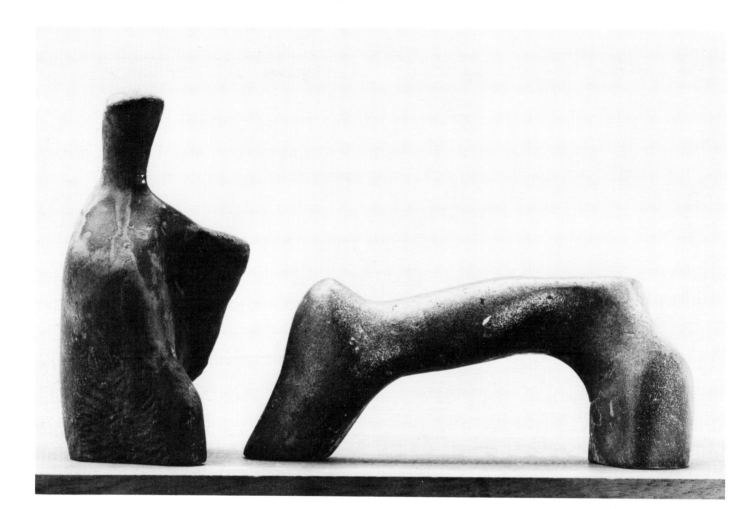

THIS IS one of the few sculptures of the mid-1960s and 1970s that was enlarged from the maquette to the very large size (*Reclining Figure: Arch Leg* 1969–70; LH 610), without an intermediate working-model version.

In 1970 the beautiful green serpentine *Arch Form* was carved (LH 618; fig. 142), based on the leg in no. 187 and LH 610. Bridge forms, which first appeared in the 1963 *Three Piece Reclining Figure No. 2: Bridge Prop* (no. 162), are again suggested in the leg end of no. 187, in fig. 142, and in a related carving of 1971, the black Abyssinian marble *Bridge Form* of 1971 (LH 621). In the 1971–72 *Sheep Piece* (LH 627; fig. 133), the horizontal arch is closely related to the leg in no. 187.

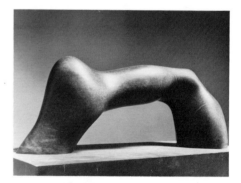

Fig. 142 *Arch Form* 1970
Private collection

188 *Maquette for Two Forms*
c. 1969 (not in LH) Original plaster,
L 8.3 cm
Gift of Henry Moore, 1974

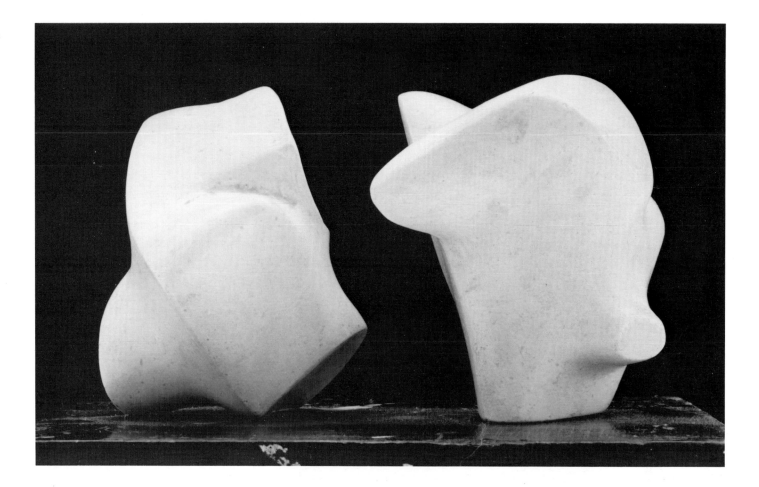

THIS MAQUETTE, which was never
cast in bronze, is the study for the
white marble *Two Forms* of 1969 (LH
614; fig. 143) in the City Art Gallery,
Manchester.

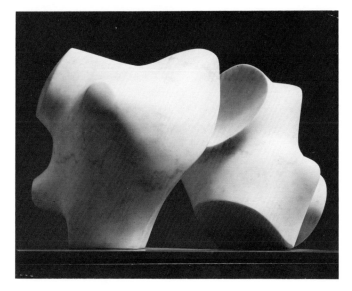

Fig. 143 *Two Forms* 1969
City Art Gallery, Manchester

189 *Maquette for Head* 1 *c.* 1972
(not in LH)
Original plaster, H 6 cm
Gift of Henry Moore, 1974

190 *Maquette for Head* 2 *c.* 1972
(not in LH) Original plaster, H 5.7
cm
Gift of Henry Moore, 1974

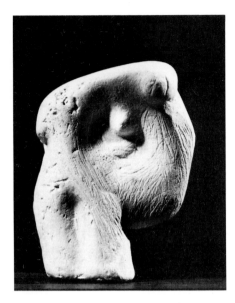

THIS MAQUETTE, less finished
than the other version, no. 190 (nei-
ther maquette was cast in bronze),
is a preparatory study for the traver-
tine marble *Head* of 1972 (LH 633;
fig. 144) in the Bayerische Staatsge-
mäldesammlungen, Munich.

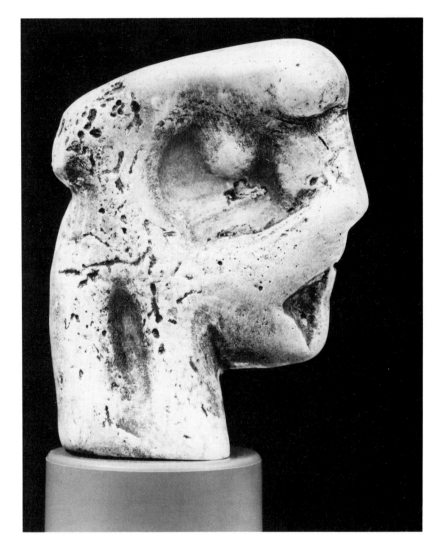

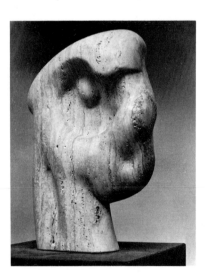

Fig. 144 *Head* 1972
Bayerische Staatsgemäldesammlungen, Munich

THIS MAQUETTE, with the
hollowed-out mouth clearly
indicated, is much closer to the carv-
ing *Head* (fig. 144) than is no. 189.
When the author was selecting
maquettes for this collection, Moore
painted this little plaster to bring
out the modelling and surface
texture.

191 *Reclining Figure: Bone* 1974 (LH 642)
Bronze, edition of 9, L 27.3 cm; 32.4 cm with base
Inscr. on side of base *Moore 6 / 9*
Purchase from the artist, 1975

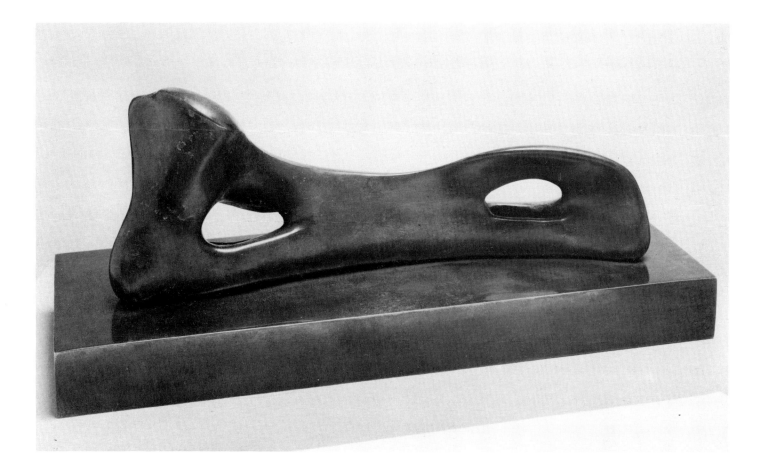

IT WAS on this work, obviously derived from a bone form, that the travertine marble *Reclining Figure: Bone* of 1975 (LH 643, fig. 145) was based.

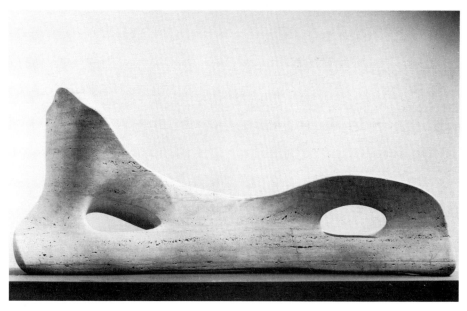

Fig. 145 *Reclining Figure: Bone* 1975
Henry Moore Foundation

192 *Maquette for Reclining Mother and Child* 1974 (LH 647)
Bronze, edition of 9, L 17.8 cm; 22.6 cm with base
Inscr. on back of figure *Moore 8 / 9*
NOACK BERLIN
Purchase from the artist, 1975

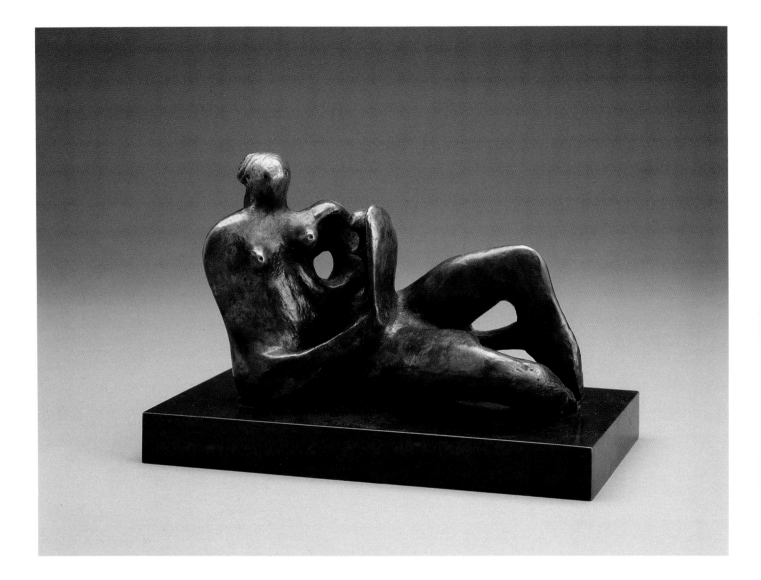

ALTHOUGH the reclining-mother-and-child motive is found in a number of Moore's early drawings, such as the 1928 *Drawing for Sculpture: Studies for Reclining Figure with Child* (fig. 146), it is a subject that rarely appears in the sculpture. A notable exception is the bronze internal / external *Reclining Mother and Child* of 1961–62 (LH 480). See also no. 193.

Fig. 146 *Studies for Reclining Figure with Child* 1928
Henry Moore Foundation

193 *Reclining Mother and Child:*
Shell Skirt 1975 (LH 665)
Bronze, edition of 9, L 17 cm; 20.3 cm with base
Inscr. on side of base *Moore 2 / 9*
Purchase from the artist, 1975

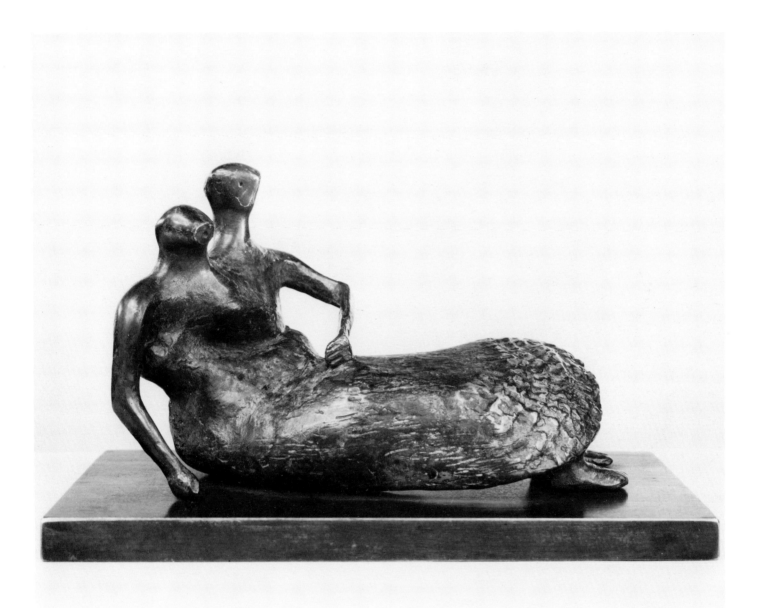

THIS SCULPTURE, like no. 192, is
one of the relatively few representa-
tions of the reclining-mother-and-
child theme. The skirt of the mother
and the skirt in no. 194 were no
doubt based on shells in the artist's
studio.

194 *Standing Woman: Bonnet* 1975 (LH 658)
Bronze, edition of 9, H 18.3 cm with base
Inscr. on base *Moore 3 / 9*
Purchase from the artist, 1975

THIS IS one of four small standing figures of 1975, all of which are stylistically very closely related.

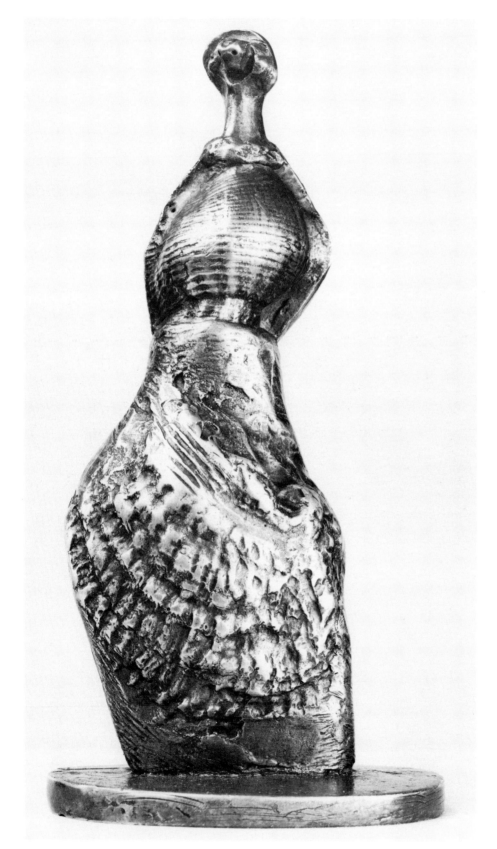

195 *Maquette for Reclining Figure: Angles* 1975 (LH 673)
Bronze, edition of 9, L 20 cm; 23.4 cm with base
Inscr. on side of base *Moore 8 / 9*
Purchase from the artist, 1975

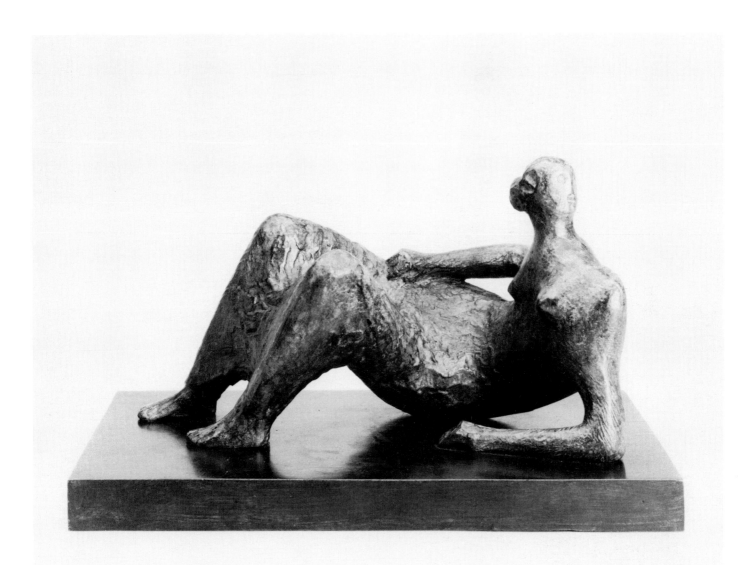

THIS MAQUETTE was followed by
the *Working Model for Reclining
Figure: Angles* of 1975–77 (LH 674)
and by *Reclining Figure: Angles* of
1979 (LH 675). In the use of drapery
and in the pose of the figure, this
sculpture is somewhat reminiscent
of the Time-Life *Draped Reclining
Figure* of 1952–53, no. 88.

196 *Two Piece Reclining Figure:*
Armless 1975 (LH 685)
Bronze, edition of 9, L 54.7 cm; 65.7 cm with base
Signed and numbered *Moore 1 / 9*
Purchase from the artist, 1975

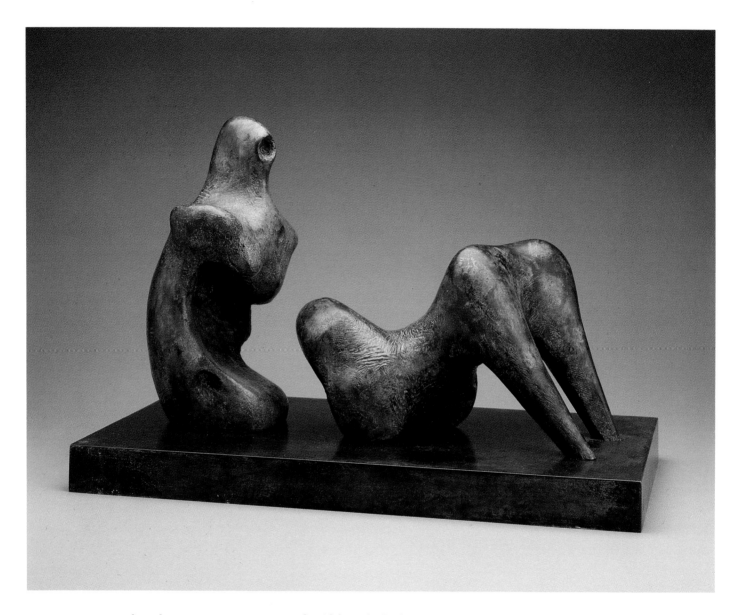

IN THIS WORK, based on a maquette that has not been cast in bronze, Moore returned to the theme of the two-piece reclining figure, the subject of the series of rough-textured sculptures executed between 1959 and 1965. But here the smooth surfaces and minimum of texture are characteristic of much of Moore's sculpture from the mid-1960s onwards. Although the leg end and the head and torso section are quite separate, there is the strong suggestion that the two forms were once joined and, if pushed together, would lock together like a ball-and-socket joint. The black granite carving *Two Piece Reclining Figure: Armless* of 1977 (LH 686) was based on no. 196.

197 *Maquette for Three Piece Reclining Figure:*
Draped 1975 (LH 653)
Bronze, edition of 7, L 21.7 cm; 25.1 cm with base
Inscr. on side of base *Moore 1 / 7*
Purchase from the artist, 1975

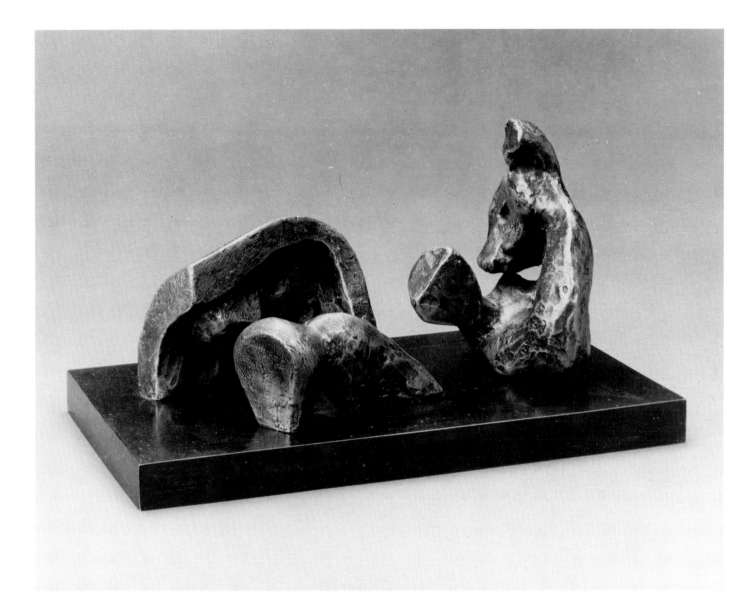

THE PROJECTION of the truncated
leg from the torso recalls the alterna-
tive project for the Lincoln Center
commission, the *Two Piece Reclining*
Figure No. 5 of 1963–64 (LH 517).
Here the drapery is not suggested by
detailed texture, as in the Time-Life
Draped Reclining Figure (no. 88),
but by the curved form that arches
over the smaller leg section of the
sculpture. No. 197 was followed by a
working model (LH 654) and a large
version (LH 655), both of 1975.

198 *Maquette for Helmet Head
No. 6* 1975 (LH 650)
Bronze, edition of 7, H 11.1 cm with
base
Inscr. on back of base *Moore 6 / 7*
Purchase from the artist, 1975

199 *Horse* 1978 (LH 740)
Bronze, edition of 7, L 15.9 cm; 21.3
cm with base
Inscr. on side of base *Moore 1 / 7*
Purchase from the artist, 1978

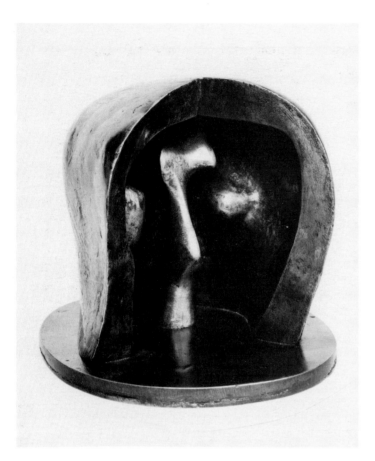

IN HIS SCULPTURE of the 1970s, Moore often returned to and reinterpreted earlier themes, such as the mother and child, the two- and three-piece reclining figure, and internal and external forms. The first helmet-head sculpture was executed in 1939–40 (LH 212; fig. 59). No. 198 is the sixth in the series of helmet-head sculptures made since the war. In all of these Moore explores the internal/external-form motif, one of the major secondary themes of his work. *Helmet Head No. 1* and *No. 2* were made in 1950 (LH 279 and 281). *Helmet Head No. 3*, *No. 4*, and *No. 5* date from the 1960s (LH 467, 1960; LH 508, 1963; LH 544, 1966). No. 198 was followed by a working model (LH 651) also of 1975. *Helmet Head No. 7* of 1975 (LH 652) is a variation on no. 198.

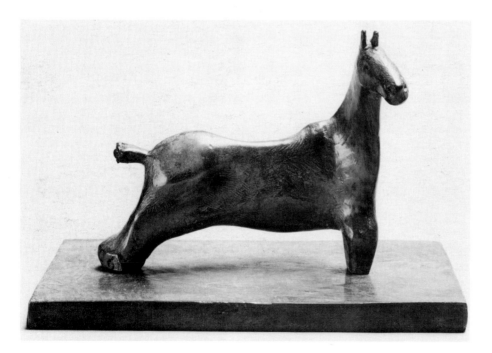

AMONG MOORE'S earliest surviving works are small sculptures of animals, such as the marble *Dog* of 1922 (LH 2) and the bronze *Horse* of 1923 (LH 7). Three small sculptures of horses were made in the late 1950s and early 1960s: *Horse* of 1959 (LH 447); *Rearing Horse* of 1959 (LH 447a; no. 135) and *Animal: Horse* of 1960 (LH 448). No. 199, the latest in the series, is also the most recent sculpture acquired for the collection.

5 Prints*

200 *Figures Sculptures* 1931
(CGM 1)
Woodcut, 12.7 × 19.7 cm
Gift of Henry Moore, 1974

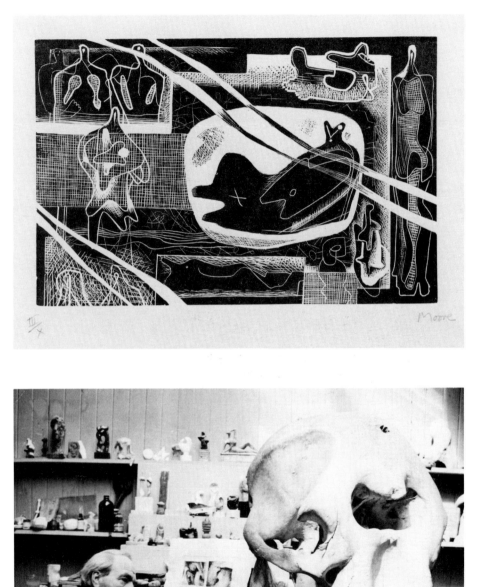

Fig. 147 Henry Moore working on series of
elephant-skull etchings, Hoglands, 1969
PHOTO: Errol Jackson

*The following 21 prints are a small
selection from the 689 Moore graphics
in the collection of the Art Gallery
of Ontario.

201 *Spanish Prisoner* c. 1939
(CGM 3)
Lithograph, 36.5 × 30.5 cm
Gift of Henry Moore, 1976

202 *Figures in Settings* 1949
(CGM 5)
Collograph, 57.5 × 40 cm
Gift of Henry Moore, 1974

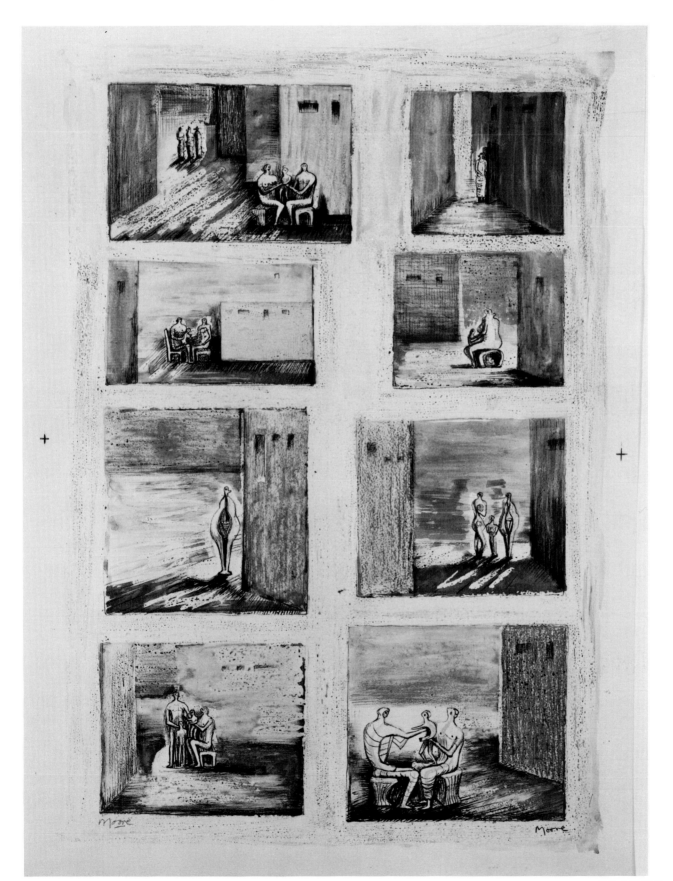

203 *Head of Prometheus* 1950
(CGM 22)
Lithograph, 31.7 × 23.5 cm
Purchase, 1974

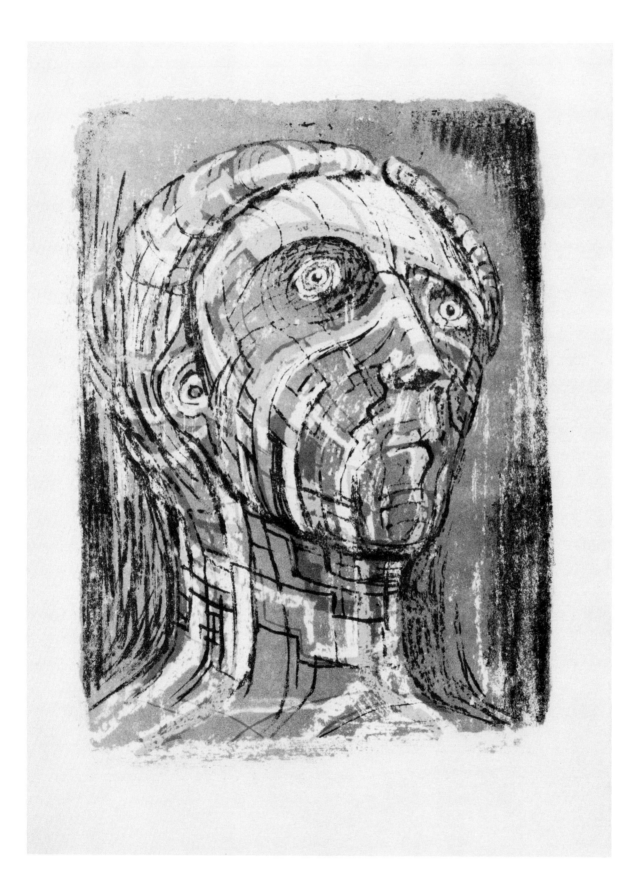

204 *Seated Figures* 1957 (CGM 37)
Lithograph, 53.3 × 36.2 cm
Gift of Walter Carsen, 1976

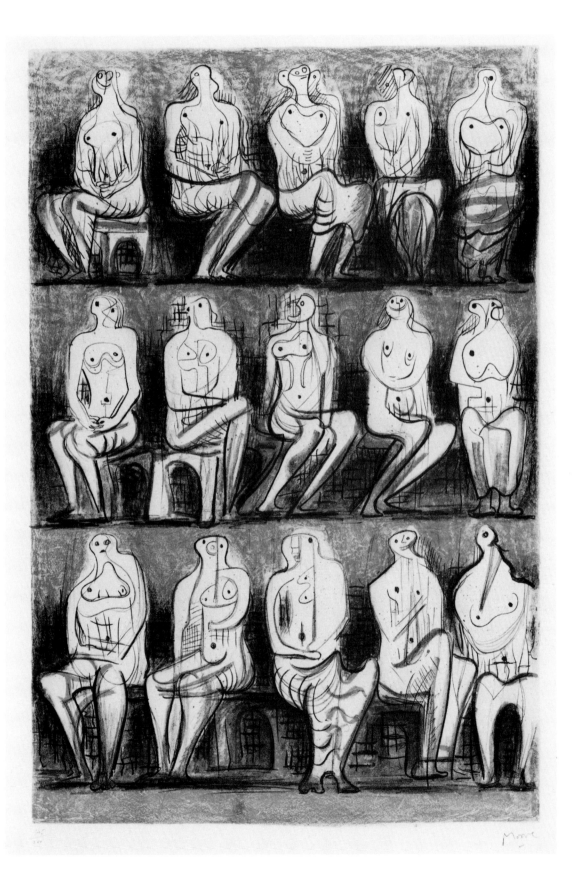

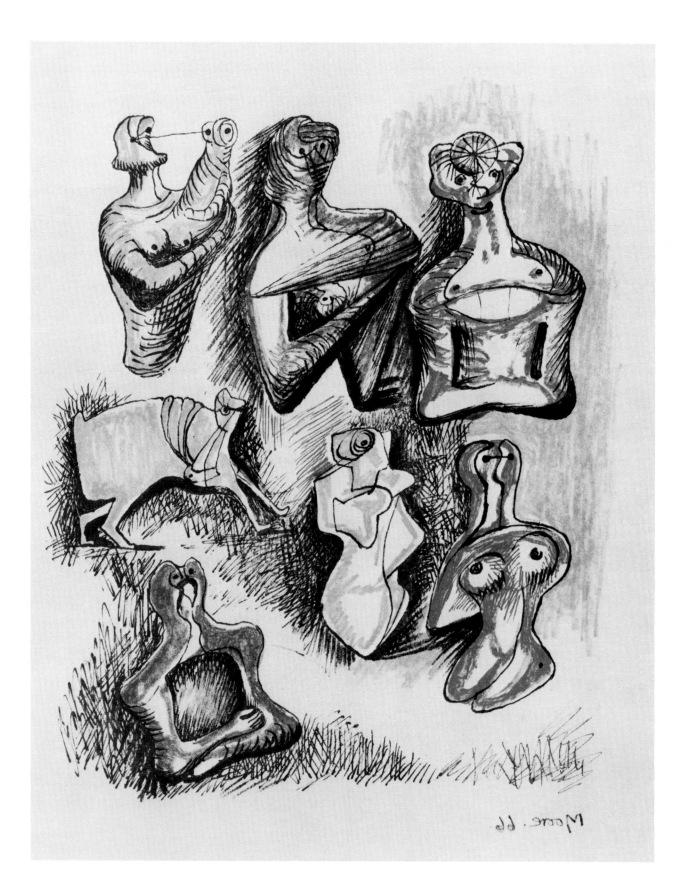

206 *Log Pile I* 1972 (CGM 189)
Etching and dry point,
20.3 × 19.4 cm
Gift of Henry Moore, 1974

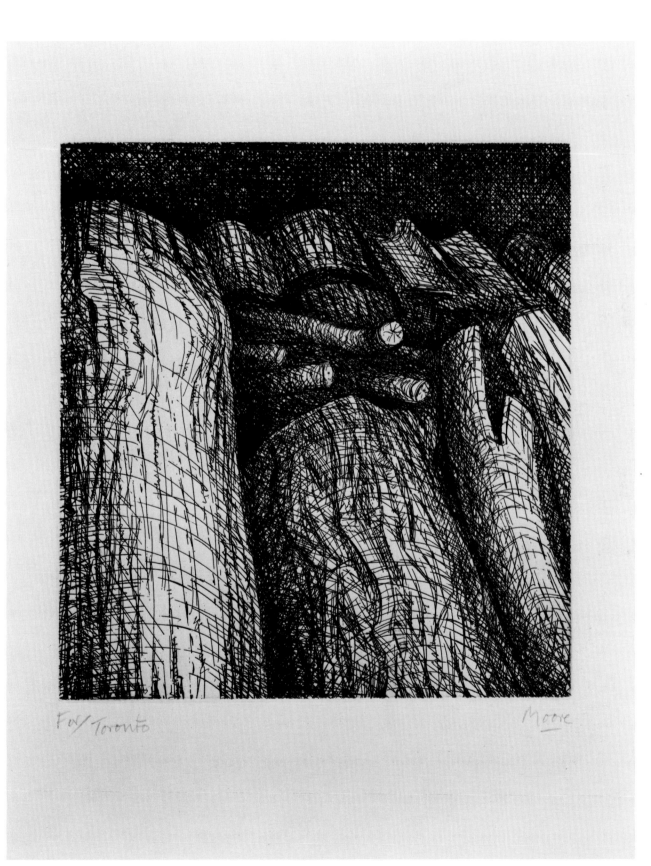

207 *Elephant Skull Plate*
XXVIII 1969 (CGM 141)
Etching, 25.4 × 20 cm
Purchase, 1971

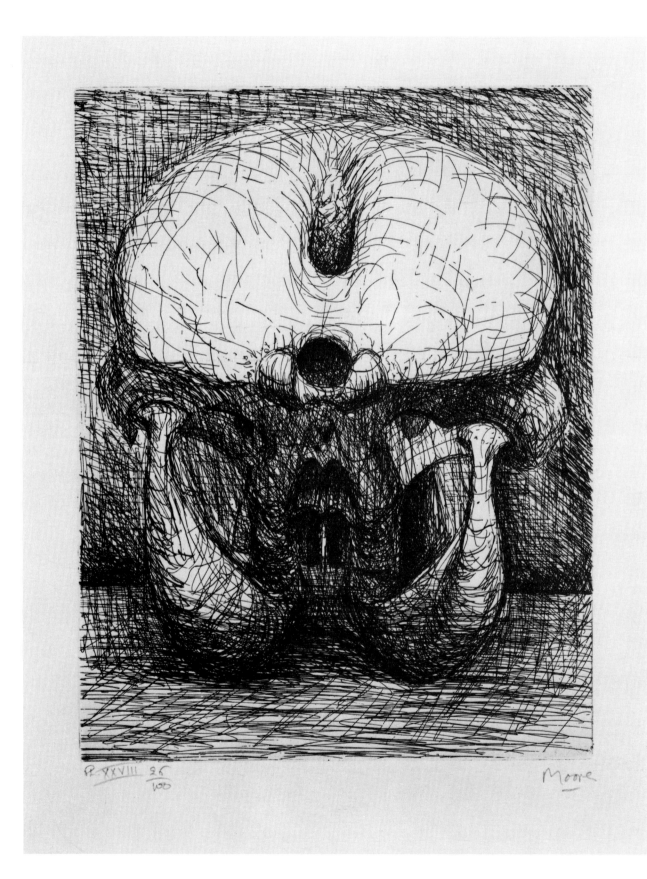

208 *Head* 1974 (CGM 228)
Etching and dry point, 19 × 25.4 cm
Gift of Henry Moore, 1975

209 *Stonehenge IV* 1973 (CGM 211)
Lithograph, 28.9 × 43.5 cm
Gift of Henry Moore, 1974

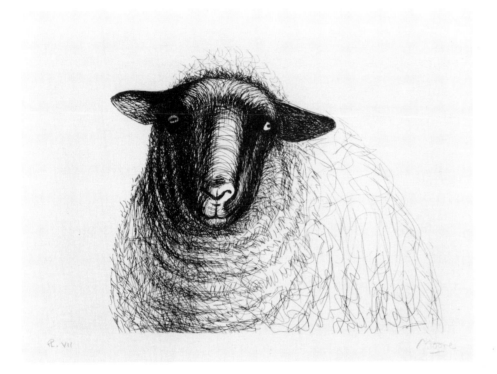

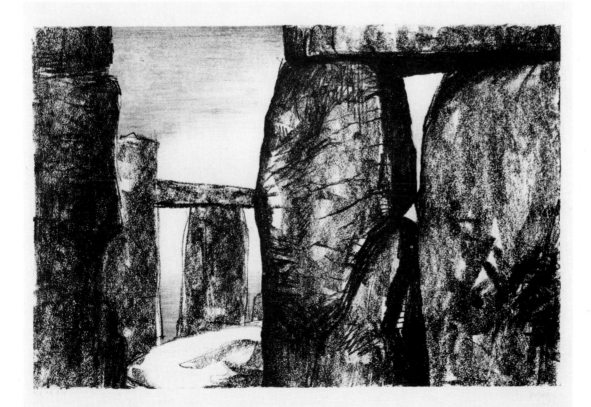

210 *Lullaby Sleeping Head* 1973
(CGM 250)
Lithograph, 27 × 29 cm
Gift of Henry Moore, 1975

211 *Girl Doing Homework III* 1974
(CGM 328)
Etching and aquatint, 22.5 × 17.5 cm
Gift of Henry Moore, 1975

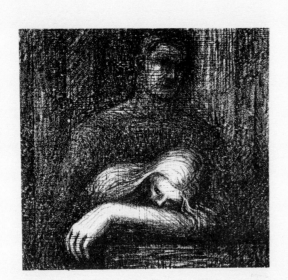

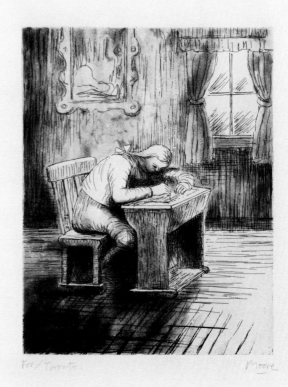

212 *Four Reclining Figures:*
Caves 1974 (CGM 335)
Lithograph, 45 × 59 cm
Gift of Henry Moore, 1974
(Publisher, Art Gallery of Ontario)

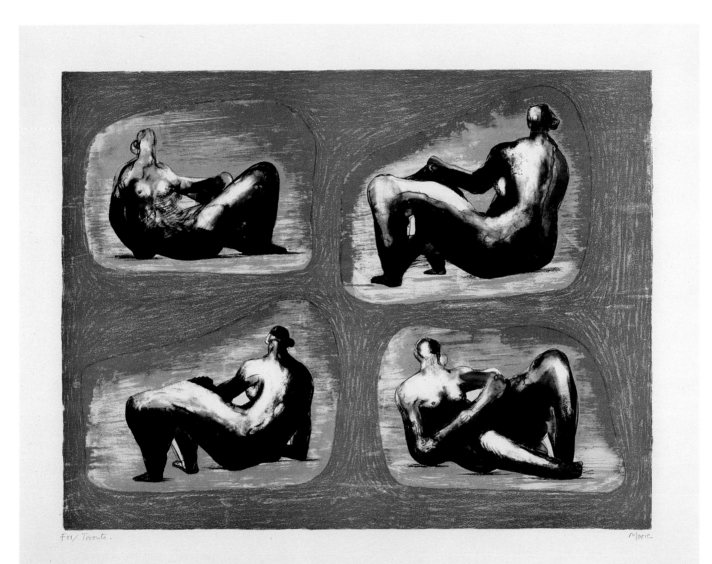

213 *Mother and Child* 1976
(CMG 431)
Lithograph, 29.8 × 26.7 cm
Gift of Henry Moore, 1978
(Publisher, Art Gallery of Ontario)

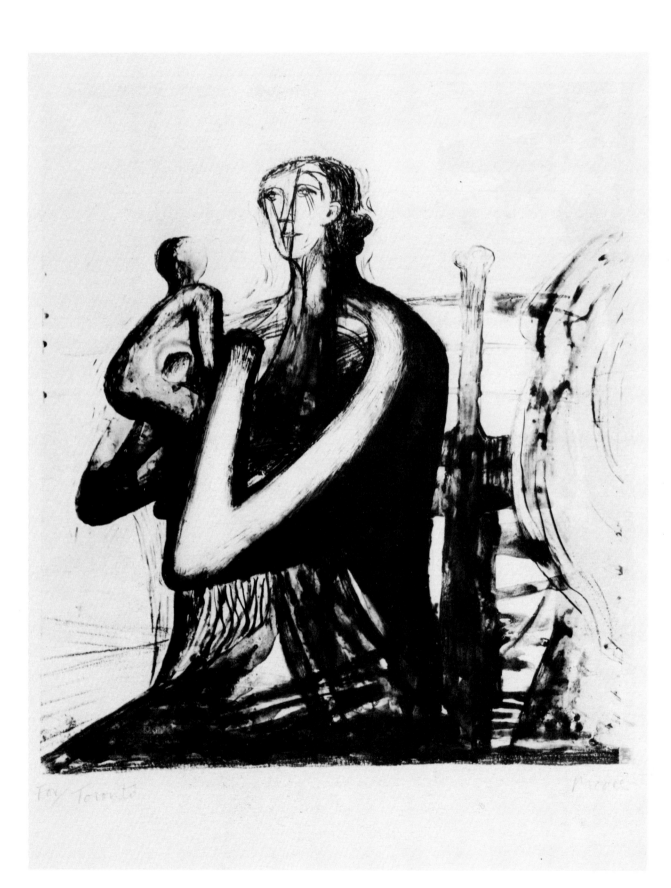

214 *Reclining Figure and Mother and Child Studies* 1977 (CGM 453)
Lithograph, 38.1 × 30.8 cm
Gift of Henry Moore, 1979

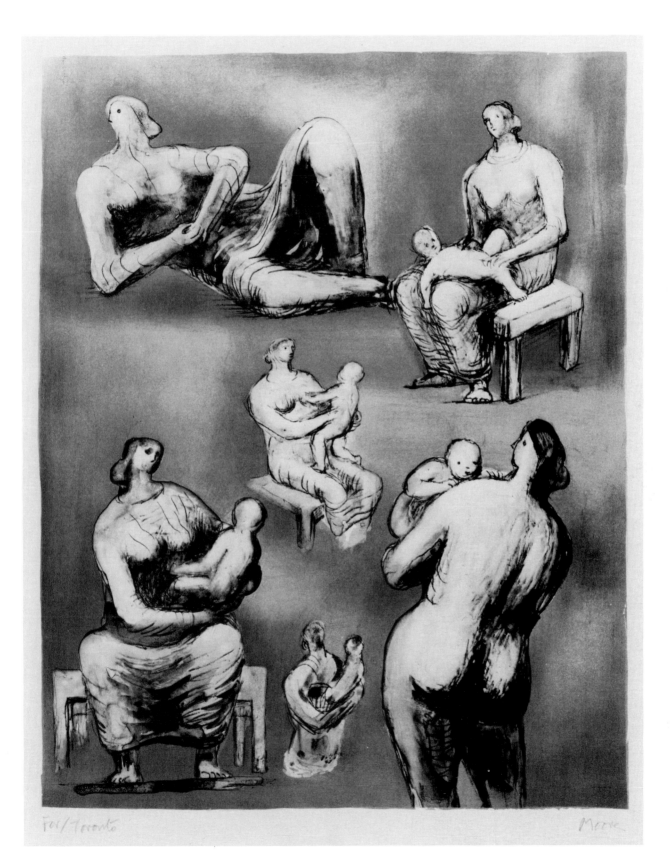

215 *Trees III: Knuckled Trunk* 1979
(CGM 549)
Etching, dry point, and aquatint,
19.0 × 25.4 cm
Gift of Henry Moore, 1985

216 *The Artist's Hands II* 1979
(CGM 554)
Etching, 19.0 × 25.4 cm
Gift of Henry Moore, 1985

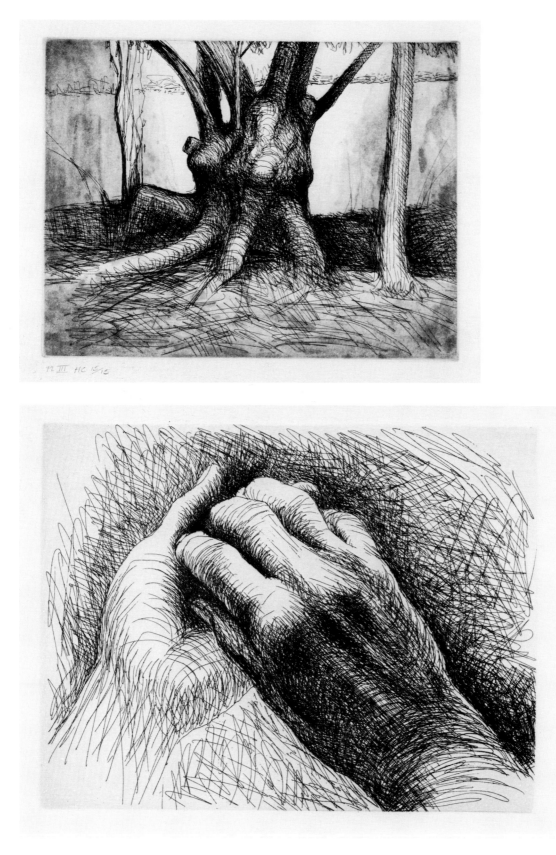

217 *Reclining Woman III* 1980–81
(CGM 593)
Lithograph, 47.7 × 64.8 cm
Gift of Henry Moore, 1986

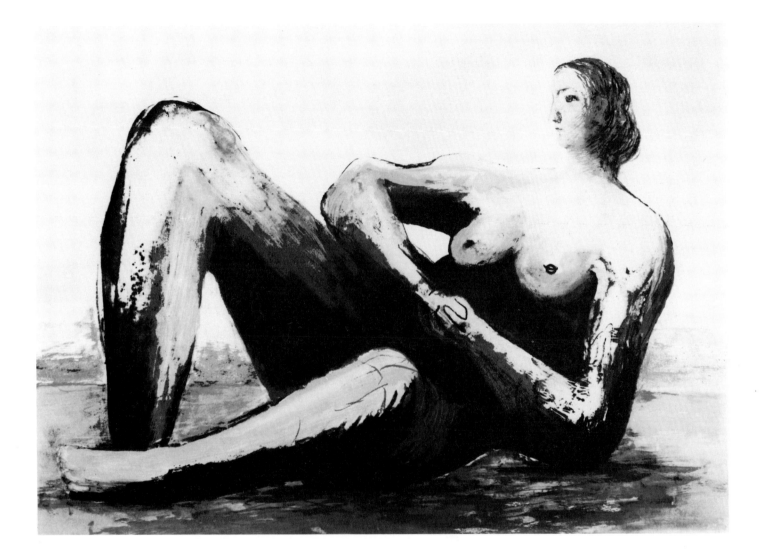

218 *Five Ideas for Sculpture* 1981
(CGM 610)
Lithograph, 35.3 × 25.1 cm
Gift of Henry Moore, 1986

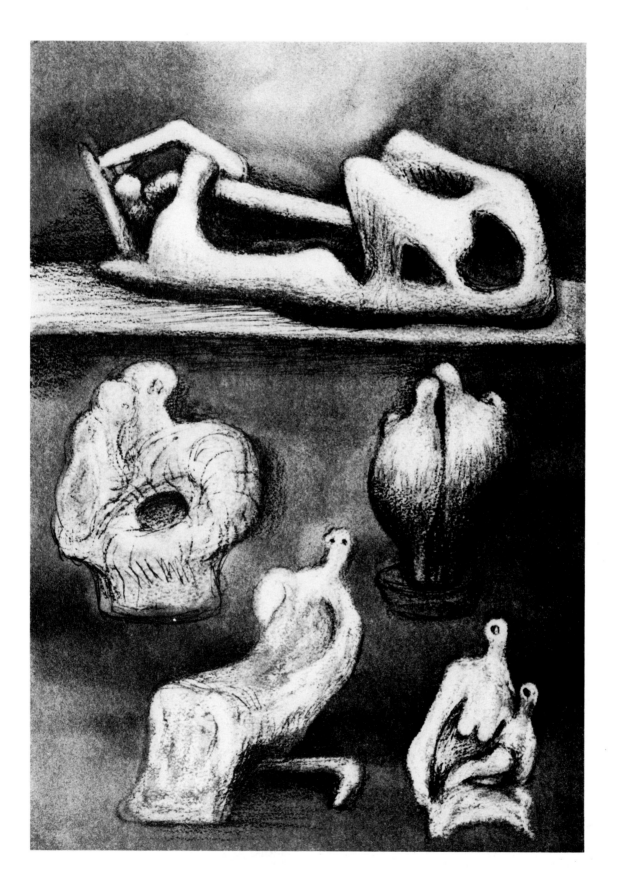

219 *Antelope* 1982 (CGM 642)
Etching, 21.3 × 27.7 cm
Gift of Henry Moore, 1986

220 *Family Group* 1984 (CGM 713)
Lithograph, 25.1 × 33.3 cm
Gift of Henry Moore, 1986

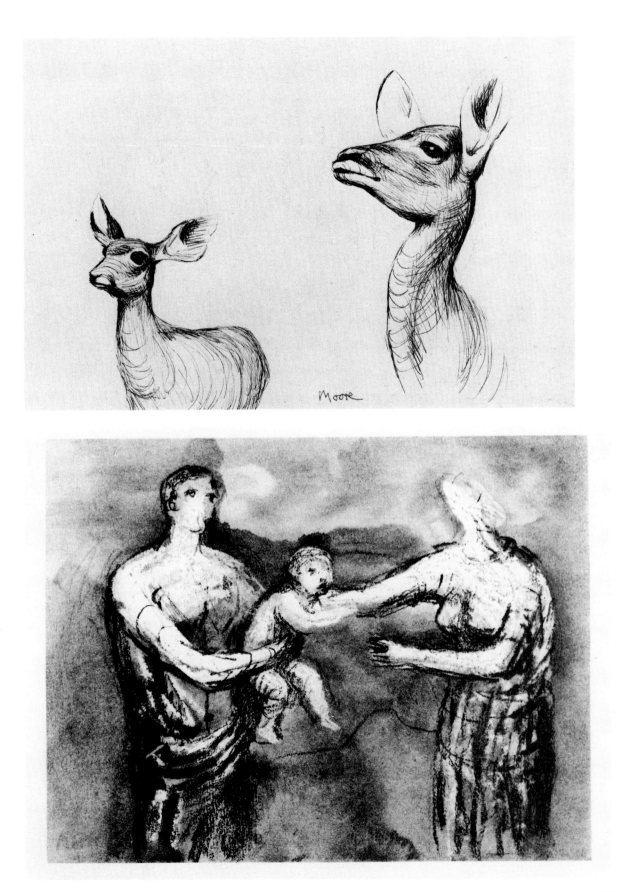

Notes

THE ART OF HENRY MOORE

1 Henry Moore and John Hedgecoe, *Henry Moore* (London: Nelson, 1968).
2 William S. Lieberman, *Henry Moore: 60 Years of His Art* (New York: Thames and Hudson / Metropolitan Museum of Art, 1983), p. 11.
3 Philip James, ed., *Henry Moore on Sculpture* (London: Macdonald, 1966), p. 64.
4 Henry Moore and John Hedgecoe, *Henry Moore: My Ideas, Inspiration and Life as an Artist* (London: Ebury Press, 1986), p. 11.
5 *Ibid.*, p. 10.
6 *Ibid.*
7 *Ibid.*, p. 35.
8 James, *Henry Moore on Sculpture*, p. 131.
9 *Ibid.*, p. 60.
10 *Ibid.*, pp. 29–30.
11 Herbert Read, *Henry Moore* (London: Thames and Hudson, 1965), p. 25.
12 James, *Henry Moore on Sculpture*, p. 117.
13 Moore and Hedgecoe, *Henry Moore* (1968), p. 233.
14 James, *Henry Moore on Sculpture*, p. 32.
15 Roger Fry, *Vision and Design* [1920] (Harmondsworth, Middlesex: Pelican Books, 1961), pp. 86–87.
16 *Ibid.*, p. 88.
17 *Ibid.*
18 *Ibid.*, p. 92.
19 James, *Henry Moore on Sculpture*, p. 33.
20 Ezra Pound, *Gaudier-Brzeska: A Memoir* (London: John Lane / Bodley Head, 1916), p. 35.
21 *Ibid.*, p. 9.
22 James, *Henry Moore on Sculpture*, p. 58.
23 Pound, *Gaudier-Brzeska*, p. 10.
24 James, *Henry Moore on Sculpture*, p. 57.
25 *Ibid.*, p. 49.
26 *Ibid.*, p. 33.
27 E.H. Gombrich, *Norm and Form: Studies in the Art of the Renaissance* (London: Phaidon, 1966), p. 89.
28 Robert Goldwater, *Primitivism in Modern Art* [1938] (New York: Vintage Books, 1967), p. 66.
29 Sandy Nairne and Nicholas Serota, eds., *British Sculpture in the Twentieth Century* (London: Whitechapel Art Gallery, 1981), p. 104.
30 James, *Henry Moore on Sculpture*, p. 159.
31 *Ibid.*, p. 113.
32 Sidney Geist, *Brancusi / The Kiss* (New York: Harper and Row, 1978), p. 9.
33 Moore and Hedgecoe, *Henry Moore* (1986), p. 69.
34 James, *Henry Moore on Sculpture*, p. 135.
35 Moore and Hedgecoe, *Henry Moore* (1986), p. 68.
36 *Ibid.*, p. 155.
37 James, *Henry Moore on Sculpture*, p. 264.
38 *Ibid.*, p. 68.
39 *Ibid.*, p. 204.
40 *Ibid.*, p. 218.
41 *Henry Moore: Volume Four, Complete Sculpture 1964–73*, edited by Alan Bowness (London: Lund Humphries, 1977), p. 17.
42 *Ibid.*
43 Moore and Hedgecoe, *Henry Moore* (1986), p. 90.
44 *Ibid.*, p. 164.
45 *Ibid.*, p. 181.

DRAWINGS AND SCULPTURE

When no reference has been given in the text for a quotation by Henry Moore, the statement was made in conversation with the author.

1 About five years ago Moore trimmed this sheet, cutting off the entire left side of figure 2 showing the man carrying the child. The author's photograph shown here is the only surviving record of the original sketch.
2 James, *Henry Moore on Sculpture*, p. 70.
3 Moore and Hedgecoe, *Henry Moore* (1968), p. 45.
4 For the artist's account of his visit to the Pellerin Collection in Paris, see James, *Henry Moore on Sculpture*, p. 190.
5 *Ibid.*, p. 193.
6 Moore and Hedgecoe, *Henry Moore* (1968), p. 38. On reading this statement, Moore altered the original quotation to this form.
7 John Russell, *Henry Moore* (London: Allen Lane, 1968), p. 28.
8 Letter to Sophie, November 28, 1912, quoted in *Henri Gaudier-Brzeska* (London: Mercury Graphics, 1977), p. 15.
9 Russell, *Henry Moore*, pp. 25, 28.
10 Moore and Hedgecoe, *Henry Moore* (1968), p. 61.
11 Moore told the author that his wife, Irina, may have helped assemble some of the other montages of the late 1920s and early 1930s (see Wilkinson, 1977, no. 86). No. 26 is, however, the only one inscribed in her hand.
12 William S. Rubin, *Dada, Surrealism, and Their Heritage* (New York: Museum of Modern Art, 1968), p. 72.
13 James, *Henry Moore on Sculpture*, p. 67.
14 The architect Charles H. Holden made the designs for the new buildings for the University of London in 1932. It is possible that he first approached Moore in this year about relief sculptures for Senate House and that these studies are related to this project. All the other known drawings (see no. 46 and fig. 40) were, however, executed in 1938, the year in which Senate

House was officially opened.

15 James, *Henry Moore on Sculpture*, p. 159.

16 *Ibid.*, p. 150.

17 *Ibid.*, p. 68.

18 Alan Bowness, *Modern Sculpture* (London: Studio Vista, 1965), p. 70.

19 James, *Henry Moore on Sculpture*, p. 68.

20 Moore and Hedgecoe, *Henry Moore* (1968), p. 76.

21 Alfred H. Barr, Jr., *Picasso: Fifty Years of His Art* (New York: Museum of Modern Art, 1966), p. 145.

22 *Art in Britain 1930–1940 Centred around Axis, Circle, Unit One.* Two essays by Herbert Read; notes and documentation by Jasia Reichardt (London: Marlborough Fine Art Ltd., March–April 1965), p. 5.

23 See note 14 and no. 30 (recto).

24 Moore and Hedgecoe, *Henry Moore* (1968), p. 61.

25 *Ibid.*, p. 175.

26 Kenneth Clark, *Henry Moore Drawings* (London: Thames and Hudson, 1974), p. 255.

27 James, *Henry Moore on Sculpture*, p. 67.

28 *Ibid.*, p. 27.

29 Moore and Hedgecoe, *Henry Moore* (1968), p. 45.

30 James, *Henry Moore on Sculpture*, p. 157.

31 Richard Morphet, in his excellent article on the Tate Gallery's Cumberland alabaster carving *Four-Piece Composition: Reclining Figure* of 1934 (fig. 34) in *The Tate Gallery 1976–8: Illustrated Catalogue of Acquisitions* (1979), discusses Moore's use of alabaster in the late 1920s and 1930s. Moore came to prefer Cumberland alabaster, Morphet writes, "because of its greater density and because of the absence from it of the translucency that is characteristic of alabaster in general."

32 James, *Henry Moore on Sculpture*, p. 97.

33 Manfred Schneckenburger, "Pre-Columbian Stone Sculpture and Modern Art," *World Cultures and Modern Art* (Munich: Bruckmann, 1972), p. 303.

34 *Ibid.*, pp. 303–04.

35 Moore and Hedgecoe, *Henry Moore* (1968), p. 105.

36 James, *Henry Moore on Sculpture*, p. 209.

37 Moore and Hedgecoe, *Henry Moore* (1968), p. 107.

38 David Sylvester, *Henry Moore* (London: Tate Gallery / Arts Council of Great Britain, 1968, catalogue), p. 105.

39 James, *Henry Moore on Sculpture*, p. 209.

40 Read, *Henry Moore*, p. 170.

41 *Ibid.*

42 *Ibid.*, p. 171.

43 James, *Henry Moore on Sculpture*, p. 108.

44 *Ibid.*, p. 101.

45 *Ibid.*, p. 118.

46 Moore and Hedgecoe, *Henry Moore* (1968), p. 188.

47 *Ibid.*, p. 198.

48 Erich Neumann, *The Archetypal World of Henry Moore*, translated by R.F.C. Hull (New York: Pantheon Books, 1959), p. 191.

49 *Ibid.*, p. 174.

50 Read, *Henry Moore*, p. 176.

51 Moore and Hedgecoe, *Henry Moore* (1968), p. 61.

52 James, *Henry Moore on Sculpture*, p. 230.

53 *Ibid.*, p. 231.

54 Russell, *Henry Moore*, p. 132.

55 James, *Henry Moore on Sculpture*, pp. 231, 235.

56 *Ibid.*, p. 235.

57 Russell, *Henry Moore*, p. 139.

58 James, *Henry Moore on Sculpture*, p. 235.

59 *Ibid.*

60 *Ibid.*

61 *Ibid.*

62 *Ibid.*, p. 250.

63 *Ibid.*

64 Moore and Hedgecoe, *Henry Moore* (1968), p. 236.

65 James, *Henry Moore on Sculpture*, p. 250.

66 *Ibid.*

67 *Ibid.*, p. 253.

68 Russell, *Henry Moore*, p. 152.

69 Read, *Henry Moore*, p. 206.

70 Moore and Hedgecoe, *Henry Moore* (1968), p. 269.

71 "Henry Moore looking at his work with Philip James," sound and filmstrip unit. Sound editor John Yorke. Two twelve-inch double-sided 33 1/3 rpm records. Visual Publications, London.

72 James, *Henry Moore on Sculpture*, p. 257.

73 Moore and Hedgecoe, *Henry Moore* (1968), p. 263.

74 *Ibid.*, p. 280.

75 Read, *Henry Moore*, pp. 212–13.

76 *Ibid.*, p. 216.

77 James, *Henry Moore on Sculpture*, p. 258.

78 *Ibid.*, p. 263.

79 Moore and Hedgecoe, *Henry Moore* (1968), p. 313.

80 James, *Henry Moore on Sculpture*, p. 258.

81 Moore and Hedgecoe, *Henry Moore* (1968), p. 306.

82 *Ibid.*, p. 291.

83 Russell, *Henry Moore*, p. 178.

84 Moore and Hedgecoe, *Henry Moore* (1968), p. 329.

85 *Ibid.*, p. 326.

86 *Ibid.*

87 Read, *Henry Moore*, p. 224.

88 Russell, *Henry Moore*, p. 178.

89 James, *Henry Moore on Sculpture*, pp. 275, 277.

90 Moore and Hedgecoe, *Henry Moore* (1968), p. 391.

91 *Ibid.*, p. 338.

92 James, *Henry Moore on Sculpture*, p. 266.

93 Russell, *Henry Moore*, p. 181.

94 Moore and Hedgecoe, *Henry Moore* (1968), p. 325. Monet's 1883 oil *Cliff at Etretat*, in the Metropolitan Museum of Art, New York, is illustrated, plate 125, p. 273, in James, *Henry Moore on Sculpture*.

95 Moore and Hedgecoe, *Henry Moore* (1968), p. 349.

96 James, *Henry Moore on Sculpture*, p. 278.

97 *Ibid.*

98 *Ibid.*

99 Moore and Hedgecoe, *Henry Moore* (1968), p. 370.

100 Russell, *Henry Moore*, p. 187.

101 Moore and Hedgecoe, *Henry Moore* (1968), p. 365.

102 *Ibid.*, p. 505.

103 Herbert Read, *Arp* (London: Thames and Hudson, 1968), p. 93.

104 Moore and Hedgecoe, *Henry Moore* (1968), p. 404.

105 James, *Henry Moore on Sculpture*, p. 144.

106 Moore and Hedgecoe, *Henry Moore* (1968), p. 456.

107 *Ibid.*, p. 455.

108 Bowness, *Henry Moore: Volume Four*, p. 9.

109 *Ibid.*, p. 17.

110 Moore and Hedgecoe, *Henry Moore* (1968), p. 345.

111 *Ibid.*, p. 412.

112 *Ibid.*, p. 466.

113 *Ibid.*

114 Henry J. Seldis, *Henry Moore in America* (New York: Praeger, 1973), p. 128.

115 *Ibid.*, p. 129.

116 *Ibid.*, pp. 131–32.

117 Alan G. Wilkinson, *The Henry Moore Sculpture Centre* (Toronto: Art Gallery of Ontario, 1974).

118 Sylvester, *Henry Moore*, p. 55.

119 Moore and Hedgecoe, *Henry Moore* (1968), p. 501.

120 *Ibid.*, p. 504.

121 Bowness, *Henry Moore: Volume Four*, p. 9

122 Moore and Hedgecoe, *Henry Moore* (1968), p. 83.

123 Russell, *Henry Moore*, p. 209.

124 Moore and Hedgecoe, *Henry Moore* (1968), p. 516.

125 Bowness, *Henry Moore: Volume Four*, p. 9.

126 Sylvester, *Henry Moore*, p. 36.

127 Read, *Henry Moore*, p. 125.

128 Sylvester, *Henry Moore*, p. 349.

Chronology

1898	Born Castleford, Yorkshire, July 30
1902–10	Attended Castleford primary school and won scholarship to the local grammar school
1915–16	Gained Cambridge Senior Certificate and began studying to be a teacher Worked at his old school in Castleford
1917	Joined the army (the Civil Service Rifles, the Fifteenth London Regiment) Sent to the French front, gassed at the Battle of Cambrai, and returned to England
1918	Bayonet Instructor with the rank of Lance Corporal Redrafted to France
1919	Returned to teaching after demobilization Enrolled at Leeds School of Art where he studied for two years
1921	Scholarship to study sculpture at the Royal College of Art, London
1923	First of many trips to Paris, where he visited the Pellerin Collection
1924	Royal College of Art Travelling Scholarship Instructor in the Sculpture School, appointed for a seven-year term
1925	Travelled in France and Italy for six months
1926	Exhibited in a group show at the St. George's Gallery, London
1928	First one-man exhibition at the Warren Gallery, London
1929	Married Irina Radetsky, a student in the Royal College of Art School of Painting
1930	Member of the "Seven and Five Society"
1931	One-man show at the Leicester Gallery, London First sale to the continent, to the Museum für Kunst und Gewerbe, Hamburg Bought small cottage at Barfreston, Kent, for use during vacations
1932	Head of new sculpture department at Chelsea School of Art
1933	Member of the *avant-garde* group "Unit One"
1934	Left Barfreston to take a cottage with a large garden at Kingston near Canterbury where he could work in the open air First monograph on his work (by Herbert Read) Visited Altamira, Madrid, Toledo, and Barcelona
1936	Participant in the International Surrealist Exhibition at the New Burlington Galleries Signed manifesto against British policy of non-intervention in Spain
1938	Participant in Exhibition of Abstract Art at the Stedelijk Museum, Amsterdam
1939	Gave up teaching when Chelsea School of Art was evacuated
1940	Moved to Much Hadham, Hertfordshire, when London studio damaged by bombing Official war artist (1940–42)
1941	Trustee of the Tate Gallery, London (1941–56) First retrospective exhibition, Temple Newsam House, Leeds
1943	First one-man exhibition outside England, at Buchholz Gallery, New York
1945	Honorary Doctor of Literature, University of Leeds
1946	Birth of his only child, Mary Visited New York for his first major retrospective exhibition, Museum of Modern Art
1948	International Prize for Sculpture 24th Biennale, Venice Member of Royal Fine Art Commission (1948–71) Foreign corresponding member of the Académie Royal des Sciences, des Lettres et des Beaux-Arts, Belgium
1950	Foreign member of the Swedish Royal Academy of Fine Arts
1951	First retrospective exhibition in London, Tate Gallery
1953	Honorary Doctor of Literature, University of London International Prize for sculpture, 2nd Bienale, São Paulo Visited Brazil and Mexico
1955	Order of the Companions of Honour Trustee of the National Gallery, London (1955–74) Foreign honorary member of the American Academy of Arts and Sciences
1957	Prize at the Carnegie International, Pittsburgh Stefan Lochner Medal, City of Cologne
1958	Chairman of the Auschwitz Memorial Committee Honorary Doctor of Arts, Harvard University
1959	Honorary Doctor of Literature, University of Reading Honorary Doctor of Laws, University of Cambridge Gold Medal, Society of the Friends of Art, Krakow

	Foreign Ministers' prize, 5th Biennale, Tokyo
	Corresponding Academician, Academia Nacional de Bellas Artes, Buenos Aires
1961	Honorary Doctor of Literature, University of Oxford
	Member of the American Academy of Art and Letters
	Member of the Akademie der Künste, West Berlin
1962	Honorary Fellow of Lincoln College, Oxford
	Honorary Freeman of the Borough of Castleford
	Honorary Doctor of Engineering, Technische Hochschule, West Berlin
	Honorary Doctor of Letters, University of Hull
1963	Member of the Order of Merit
	Antonio Feltrinelli Prize for sculpture, Accademia Nazionale dei Lincei, Rome
	Honorary Member, Society of Finnish Artists
1964	Fine Arts Medal, Institute of Architects, USA
1965	Bought house at Forte dei Marmi, near Carrara
	Honorary Fellow, Churchill College, Cambridge
	Honorary Doctor of Letters, University of Sussex
1966	Fellow of the British Academy
	Honorary Doctor of Laws, University of Sheffield
	Honorary Doctor of Literature, University of York
	Honorary Doctor of Arts, Yale University
1967	Honorary Doctor of Laws, University of St. Andrews
	Honorary Doctor, Royal College of Art, London
	Honorary Professor of Sculpture, Carrara Academy of Fine Art
1968	Retrospective exhibition at Tate Gallery, London, on occasion of his seventieth birthday
	Erasmus Prize, The Netherlands
	Einstein Prize, Yeshiva University, New York
	Order of Merit, Federal German Republic
	Honorary Doctor of Laws, University of Toronto
1969	Honorary Doctor of Laws, University of Manchester
	Honorary Doctor of Letters, University of Warwick
	Honorary member of the Vienna Secession, Vienna
1970	Honorary Doctor of Literature, University of Durham
1971	Honorary Doctor of Letters, University of Leicester
	Honorary Fellow of the Royal Institute of British Architects (RIBA)
1972	Retrospective Exhibition at Forte di Belvedere, Florence
	Honorary Doctor of Letters, York University, Toronto
	Medal of the Royal Canadian Academy of Arts
	Cavaliere di Gran Croce dell'Ordine al Merito della Repubblica Italiana
	Premio Ibico Reggino Arti Figurative per la Scultura, Reggio Calabria
1973	Premio Umberto Biancamano, Milan
	Commandeur de l'Ordre des Arts et des Lettres, Paris
1974	Opening of the Henry Moore Sculpture Centre, Art Gallery of Ontario, Toronto
	Honorary Doctor of Humane Letters, Columbia University, New York
	Honorary member of the Royal Scottish Academy of Painting, Sculpture and Architecture, Edinburgh
1975	Honorary member of the Akademie der bildenden Künste, Vienna
	Membre de l'Institut, Académie des Beaux-Arts, Paris
	Kaiserring der Stadt Goslar, West Germany
	Associate of the Académie Royale des Sciences, des Lettres et des Beaux-Arts, Belgium
1977	Formed the Henry Moore Foundation (HMF)
	Member of the Serbian Academy of Sciences and Arts
1978	Major donation of sculptures to the Tate Gallery, London
	Eightieth birthday exhibitions at the Serpentine Gallery and in Kensington Gardens, London, and at the City Art Gallery, Bradford
	Grosse Goldene Ehrenzeichen, City of Vienna
	Austrian Medal for Science and Art
1979	Honorary Doctor of Letters, University of Bradford
1980	Donation of "Large Arch" to the Department of the Environment for permanent siting in Kensington Gardens
	Grand Cross of the Order of Merit of the Federal German Republic (presented by Chancellor Schmidt)
1981	Full Member of the Académie Européenne des Sciences, des Arts et des Lettres, Paris
	Honorary Freeman of the City of Leeds
1982	Honorary Freeman of the City of Forte dei Marmi
	Honorary Doctor of Philosophy, University of Tel Aviv
	Honorary Freeman of the City of Monterrey, Mexico
	Opening of new extension to Leeds City Art Galleries — the Henry Moore Centre for the Study of Sculpture
1983	Order of Aguila Azteca, Mexico
	Doctor of Letters, National University of Ireland
1984	Commandeur de l'Ordre National de la Légion d'Honneur (award presented by French President Mitterrand on his visit to Much Hadham)
1985	Order of St. Cyril and St. Methodius (First Degree), Bulgarian Republic
1986	Died at Perry Green, Much Hadham, Hertfordshire, August 31